STORYBOARDS

Praise for Mark Simon and *Storyboards: Motion in Art*

"From the business side to the artistic side and everything in between, Simon shows what it takes to be a storyboard artist. If you've ever wanted to create storyboards for your projects but don't know where to start, *Storyboards: Motion in Art* could be the resource for you."

—*Videomaker Magazine*

"This is by far the best book on storyboarding available. It is clear, concise and has plenty of illustrations. Highly recommended."

—Max McCoy

"I thank you for all the things you taught through your book."

—Babak Marjan

"Your book is so informative! I can barely put it down. Anyway, I just wanted to tell you how much your book has helped."

—Amilee Hagon

"He's very good at what he does and has a good reputation in the industry. People know they're going to get something done well with Mark."

—Glenn Wilder, Universal's Second Unit Director, *McHale's Navy*

"Definitely a person who understands all aspects of the business and he illustrated very well how everybody works as a whole to finish the project. He has no weaknesses."

—Stephen Sawran, Cartoon Network animator

"He knew exactly what he was doing and got that across to us with his experience."

—Michelle Leach

"The experience and practical wisdom that Mark Simon shares with his reader is what makes this book special. He offers an exceptional understanding of what is needed to start a career in animation and storyboarding. He then continues by presenting an overview of his own patterns for entertainment industry success that are relevant in nearly any career field.

"In addition to his own ideas, I especially enjoy the sharp contrasts he draws by comparing how his colleagues would handle similar projects. This is an amazing chapter that I often re-read to keep my own thought process open.

"I do teach a program in animation, and we do use Mark's book in our classroom. It has been a valuable part of our curriculum. On occasion we have even invited Mark to present chapters to our classes and we are never disappointed."

—Jeff Scheetz, Founder, Digital Animation & Visual Effects School (DAVE School)

"This book addresses several subjects that are all relevant to individuals who want to make a living from, or involving, storyboards. It is fully illustrated by a variety of artists, a feature that is important for up-and-coming artists to have exposure to. There are many diverse styles of illustration out there, but successful storyboard artists all share an awareness of certain principles of filmmaking, which this book also covers. By virtue of its many explanations and illustrations, it presents a broad and clear description of the business of storyboarding. People who want to pursue this field need to know that being able to draw is not the exclusive interest of a production artist, but also has cinematic conventions and marketing of their product. I recommend this book to my students who express interest in the field."

—Dan Antkowiak, Storyboard artist and teacher

"I'm an illustrator myself with twenty-three years of storyboarding experience. This book is an excellent tool for both the novice and the seasoned, old grizzled vet like me. For the novice it explains the process, offers guides to how to approach a board, what's important, staging, mood, the different types of boards' markets, billing, promotion . . . the whole gamut. For the vets, it jogs our memory. We tend to fall into patterns of how we do things and it gets comfortable and perhaps a bit common place . . . or even sloppy. The book reminded me that there's more than one right way or any single solution and that maybe the first and easiest way isn't the best. There are some great samples of different styles of boards from different artists and a good focus on thinking before drawing. It's a good, useful addition to my ever-expanding library and anyone in the field, or wanting to be in the field, should consider getting a copy."

—Steve Lawton, Storyboard artist

"In one word—*Amazing!* If you are interested in drawing storyboards, then this is the book for you. It covers storyboards from the ground up. *Storyboards: Motion in Art* also discusses resumes, portfolios, pricing, licensing, special effects, and much more that you will not find in any other storyboarding book. This book is a necessity for anyone who is truly serious about developing storyboards for a living or just for fun."

—Jason Teate, Graphic designer

STORYBOARDS
MOTION IN ART

Third Edition

MARK SIMON

AMSTERDAM • BOSTON • HEIDELBERG • LONDON
NEW YORK • OXFORD • PARIS • SAN DIEGO
SAN FRANCISCO • SINGAPORE • SYDNEY • TOKYO

Focal Press is an imprint of Elsevier

Acquisitions Editor: Cara Anderson
Publishing Services Manager: George Morrison
Project Manager: Marilyn E. Rash
Proofreader: Daniel Stone
Indexer: Kevin Broccoli
Marketing Manager: Christine Degon Veroulis
Cover Design: Maycreate
Cover Illustration: Travis Blaise and Mark Simon
Interior and Cover printer: Hing Yip Printing Co., Ltd.

Focal Press is an imprint of Elsevier
30 Corporate Drive, Suite 400, Burlington, MA 01803, USA
Linacre House, Jordan Hill, Oxford OX2 8DP, UK

 Recognizing the importance of preserving what has been written, Elsevier prints its books on acid-free paper whenever possible.

Library of Congress Cataloging-in-Publication Data

Simon, Mark, 1964–
 Storyboards : motion in art / Mark Simon.—3rd ed.
 p. cm.
 Includes index.
 ISBN-13: 978-0-240-80805-5 (alk. paper)
 ISBN-10: 0-240-80805-3 (alk. paper)
1. Storyboards. 2. Commercial art—Vocational guidance—United States.
I. Title.
 NC1002.S85S56 2006
 74.5'8—dc22

 2006024506

British Library Cataloguing-in-Publication Data
A catalogue record for this book is available from the British Library.

ISBN 13: 978-0-240-80805-5
ISBN 10: 0-240-80805-3

For information on all Focal Press publications visit our website at www.books.elsevier.com

06 07 08 09 10 10 9 8 7 6 5 4 3 2 1

Printed in China

Contents

Acknowledgments

The information in this book comes from many years, and thousands of projects, of working with truly talented people. Every director, every stunt coordinator, every special effects supervisor, every animator, every editor and director of photography and production designer I have worked with has taught me something new. They all have different approaches to telling stories, and they are all willing to share their knowledge. Is this a great industry or what?

As good as the information contained here is, the art is even better. Some of the world's best story artists have allowed their work to enhance this text.

You are reading this book because you are interested in storyboarding or are a fan of it. I am both. I love what I do, and I'm inspired by others who do it too. I am a huge fan of all the art in this book and of the artists responsible for it.

My editor, Cara Anderson, has been a great help. She's been enthusiastically supportive and went above and beyond to help me complete this monster text. Thank you.

I would love to say that my wife put up with the late hours of my writing this book. But the truth is, she puts up with my late hours all the time; because of this book (and others), because of my clients, because I'm me. She knows I love her, but I love telling her anyway. I love you, Jeanne.

I also want to thank my twin boys, Luke and Reece, for telling all their friends that their dad is the world's best storyboard artist. None of the other 6-year-olds have any idea what they are talking about, but I appreciate it anyway.

All the artists who have lent their work to this book deserve more than my thanks. They also deserve patronage for their generosity and their talent. Make the world a better place. Hire an artist!

Patronize these people and companies. (I love being subtle.)

◆ Storyboard Artists

Peter Ivanoff
www.PeterIvanoff.com

Craig Gilmore
Film Shots Studio
3304 Golden Heather Drive
Durham, NC 27712
991-475-5773
toonzil@yahoo.com
www.flickfolio.com/craiggilmore/

David Hillman
Hillman Arts
212-285-1995
917-655-0988 cell
dnaHillman@earthlink.net
www.HillmanArts.com

Sean Cushing
Pixel Liberation Front
1285 Electric Avenue
Venice, CA 90291
310-396-9854
310-396-9874 fax
www.thefront.com

Chiodo Bros. Productions, Inc.
110 W. Providencia Ave
Burbank, CA 91502
818-842-5656
www.chiodobros.com

Ovi Hondru
Ovi_hondru@yahoo.de

Ignacio Sardinas
Avda. Juan Andres, N' 60
Madrid, Spain 28035
ijsardi@gmail.com

Alex Saviuk
Animatics & Storyboards, Inc
407-370-2673 studio

Lyle Grant
310-458-1655

Jon Dahlstrom
The Storyboard Doctor
jon@sbdoc.com

Kevin Scully
01635 200619 U.K. phone
07780 797157 mobile
kevinscully@aol.com

Dan Antkowiak
818-723-9468

Kris Kristiansen
Scotopia Pictures
www.ScotopiaPictures.com

Dan Danglo
DanDanglo@dantoons.com

Ted Slampyak
Storyteller's Workshop, Inc
ted@storytellersWorkshop.com

Axel Medellin Machain
Monte Alban 1706
Colonia Monumental, C.P. 44320
Guadalajara, Jalisco, Mexico
(0133) 36 38 66 46
nancynismo@yahoo.com
www.nancynismo.blogspot.com

Andy Lee
818-585-7719
www.AndyLeeStoryboards.com

Craig Cartwright
Manifest Stations, Inc.
917-325-3927
www.manifest-stations.com

Peter Carpenter
Storyboards, Inc.
310-581-4050
www.storyboardsinc.com

Woody Woodman
8615 Rose Hill Dr
Orlando, FL 32818
407-292-9205 phone
407-489-6559 mobile
woodymaria@adelphia.net

Josh Hayes
stormship@sbcglobal.net
Represented by:
Storyboards, Inc.
310-581-4050
www.storyboardsinc.com

Larry Jones
www.LarryJonesIllustration.com

Tim Burgard
Represented by Storyboards, Inc.
310-581-4050
www.storyboardsinc.com

Jeff Dates
Janimation
www.Janimation.com

Bo Hampton
www.BoHampton.com

Mike Conrad
Radical Concepts, Inc.
407-294-9179

John Ryan
Dagnabit!
www.dagnabit.tv

Travis Blaise
Travis.Blaise@gmail.com

David and Helen Lyons
Lyons Entertainment
321-939-2721, 407-346-1241
lyons.ent@smartcity.net
www.lyonsentertainment.com

Mark Simon
Animatics & Storyboards, Inc
407-370-2673
www.Storyboards-East.com
www.MarkSimonBooks.com

▶ Software Companies

PowerPoint Software
800-457-0383
www.powerproduction.com

Red Storm Entertainment
3200 Gateway Centre Blvd, Suite 100
Morrisville, NC 27560

Storyboard Artist
PowerProduction Software
www.powerproduction.com

Frame Forge 3D Studio
www.FrameForge3D.com

Adobe
www.adobe.com

Mirage & Boardomatic
www.bauhaussoftware.com

Corel
www.corel.com

Preface

Storyboarding is a wonderful process. It's also a wonderful job. I love to draw and I love to tell stories. With storyboarding I get to do both. I also get to work with amazingly talented people and learn something new on each project. Plus no two days or projects are ever the same.

I've worked in the entertainment industry for more than 20 years and have worked on more than 2,500 productions as storyboard artist, designer, director, and producer. Every project is so different it's impossible to be bored. Getting up in the morning each day to do my job is easy.

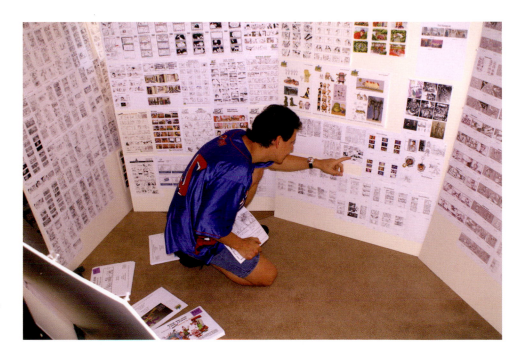

Figure P.1 Author Mark Simon sifting through thousands of storyboards for this book.

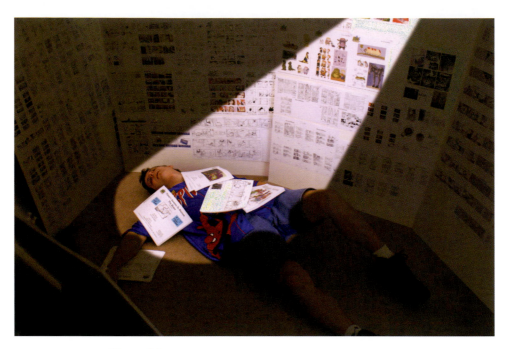

Figure I.2 Organizing this book was too much at times.

This book contains two decades of my experience and a lot of great art from many talented individuals. The information here is not only for the artist who would like to pursue storyboarding as a career; it is also for all those other people who have to quickly "board" something to get their point across and for those who need to be able to work with boards done by others.

Years ago, most people didn't know what storyboards were. Now, with the popularity of DVD behind-the-scenes extras and making-of books, it's a well-known process. What isn't well understood is where the storyboard artist's true talent lies. It isn't in the quality of the art. I've seen a number of beautiful illustrations that made useless storyboards. I've also seen bad art tell a visual story in such a way that an entire crew of production personnel instantly knew what the director wanted. That made a good storyboard. Great visual storytelling is a blueprint for all production.

I hope you allow this book to be your blueprint to understanding the process I love so dearly.

INTRODUCTION

What Are Storyboards?

The storyboard is an illustrated view, like a comic book, of how the producer or director envisions the final edited version of a production will look. This view of the production is the most effective form of communication between the producer or director and the rest of the crew. Just as building plans direct construction crews to build a house the way an architect designed it, storyboards direct film and TV crews to produce a project the way the director designed it. Each drawing instantly relates all of the most important information about each shot and defines a singular look for the entire crew to achieve.

Storyboards actually started in the animation industry. In the early 1900s, the great animator Winsor McCay was creating comic strips for his amazing animations. These were certainly some of the earliest storyboards. Later, in the late 1920s and early 1930s, scripts for the emerging animation field were typed out in the format of live-action scripts. This very quickly caused complications. A written description of an animated action does not necessarily get the right idea across. If the script said a character had a funny expression on its face, what does that mean? It's easy to write the words "funny expression" or "funny action," but animating a character to achieve it is much more difficult. The animators were finding out that a written gag was often not funny when translated into animation.

To remedy this, the "storymen" (there were no women in the story departments back then) began to draw sketches of the salient scenes and gags. Very quickly they started adding more and more drawings to their scripts until it became customary

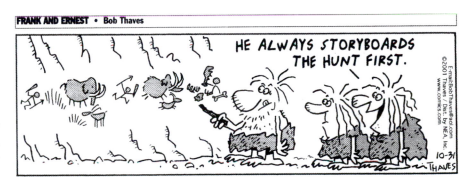

Figure 1.1 *Frank and Ernest* by Bob Thaves. (© 2001 Bob Thaves. Distributed by Newspaper Enterprise Association, Inc.)

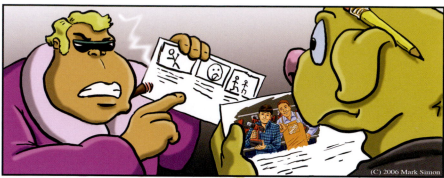

"No! No! No! I want you to draw it more THIS way!"

Figure 1.2 *Hollyweird.* (© 2006 Mark Simon.)

to sketch the entire story. In order for the entire story-writing team to see the sketches, they were tacked up on the wall. Someone had the bright idea of putting these sketches onto large pieces of beaverboard (thus the term "storyboard"). Beaverboard was used extensively for partitions and ceilings, and is a lightweight, fibrous board that is easy to push tacks into. This was advantageous for the storymen, who were tacking up hundreds of drawings. With the drawings on such boards, the entire story could also be moved and viewed in another room.

Cartoon productions at the time started holding written descriptions down to a minimum. Cartoons are best expressed visually, due to the gags. Writing "Billy Bob falls down in a funny way" is not the same as an artist's sketching the pratfall and subsequent events. Writing was limited mostly to dialogue and simple camera instructions. If an idea did not hold up graphically, it was rejected. While the practice of writing full scripts was prevalent in the 1970s and 1980s, John Kricfalusi, creator of Ren & Stimpy, went back to the style of creating the cartoon classics and relied on talented story artists to drive the script instead of just a written script.

Storyboards are now used to help develop a script, flesh out an idea, enhance a script, and/or visualize a finished script. Development of animations often uses storyboards throughout the entire production process. The *Star Wars* epics used storyboards to work out ideas and scenes before the script was complete. They are a great device to help develop a project in all phases of production.

Over the years, the practice of storyboarding has become more prevalent in live-action shooting.

Although animations have every scene storyboarded, without exception, live-action storyboard use is mostly limited to commercials, as well as action, stunts, and special effects scenes in movies and TV shows.

A well-done set of boards is beautifully representative of any visual motion, like a comic book; the images flow together to tell a story. The line work may be somewhat rough, or it may be very tight and detailed, but what is important is properly visualizing the flow of the story.

You've heard that "A picture is worth a thousand words." In the entertainment industry, a picture is worth much more than a thousand dollars. When people read a script, everybody gets a different image of what it should look like. The producer and the director, however, are the ones who make the final decision. Without a set of boards to represent exactly how they want a scene to look, any number of things can go wrong. Statements might be heard on the set like "Oh, that's what you meant" or "What are you doing?! That is NOT what I asked for!" When everyone is working toward the same vision, miscommunications such as these will not happen.

In the golden years of animation, in the days of Chuck Jones, Tex Avery, Bob Clampett, Friz Freleng, and Walter Lantz, the directors drew most of their own storyboards. As animation studios grew, tasks were delegated to others. Only recently has the trend of directors doing their own storyboarding begun to grow again. Some animation directors, such as John Kricfalusi, of *Ren and Stimpy* fame, feel that it's important for cartoon writer/directors to draw their own boards. He maintains that it's important for stories to be written by cartoonists who not only can write but can draw.

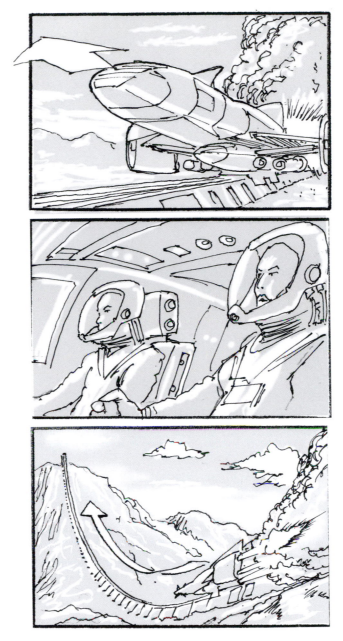

Figure 1.3 *Captain Scarlet* boards by Tracey Wilson, Lee Munday, Chris Drew, and Teri Fairhurst.

Cartoons are not just funny writing; they are funny images and sight gags. Cartoonists know the capabilities and limitations of the medium and can best take advantage of it. Writing alone can't do this. Cartoons are best when they do the physically impossible and deal with exaggeration.

Live-action storyboards are generally done in pre-production, as soon as a script is in its final stages.

Storyboard artists will work mostly with a director to illustrate the images in her mind for the entire crew to see. At times they may work with a producer, if the producer's vision is the guiding force for a project or if a director hasn't get signed onto a project.

The other person a storyboard artist is likely to work with is the production designer. The production designer holds the creative vision of a project regarding

Figure 1.4 Set illustration by Mark Simon. Art direction by: Mark Dillon.

everything behind the actors, including not only sets and locations, but also props and, at times, costuming. The look of the sets and locations will be extremely important to the characters' actions. A storyboard artist may help out with the look of a project in a number of different ways. The production designer will supply the artist with all the visual information needed. Storyboard artists may also be asked to draw conceptual illustrations of what the sets or locations should look like, before detailed designs and construction starts.

The people running a low-budget production may think they are saving money by not using boards, but quite the opposite is true. The lower the budget, the more organized the production has to be in order to accomplish the difficult task at hand. Any misunderstandings or faulty communications can throw the already too-tight schedule out the window. The more a project is boarded, the better the preproduction will be, the less overbuilding of sets and props will happen, and the faster the crew will move in unison to get all the coverage in shots. Instead of shooting every angle for possible edits, every edit is shown on the boards, cutting

the extra cost of film and processing, as well as the labor expense of shooting excess footage and wading through miles of useless film in the editing suite.

For example, I storyboarded a number of scenes on a shoot for Chuck E. Cheese pizzerias. This shoot used a walk-about, (a character suit of Chuck E. that someone walks around in), instead of animation. In one sequence of boards we had Chuck E.'s hair doing something special. During a preproduction meeting when we had all the crew heads together going over the boards and production needs, the woman in charge of the Chuck E. Cheese costume said that the hair on the costume wouldn't do what the boards showed. The director asked her what could be done about it. She thought for a moment and said that she could remove the original hair and have it and a new wig for the special task rigged to be Velcro'd on and off during the shoot. While her task seems simple, it will still take time. Without going over the boards before production, we would have been shut down for a couple of hours just because of some hair. That one delay would have cost much more than the cost of the boards. Multiply that

Figure 1.5 *Hoot* storyboards by Alex Saviuk of Animatics & Storyboards, Inc.
(Images courtesy Hoot Prods LLC.)

times the amount of things that come up during a production and you can easily see the value of storyboards.

Drawing storyboards is a wonderfully exciting and creative outlet. A storyboard artist is crucial in both the flow of a story and in the organization of a shoot. Good storyboarding requires knowledge of directing, editing, storytelling, and camera techniques. Add artistic talent, and the ability to work with others to tell a visual story, and you too may enjoy illustrating in the exciting world of entertainment.

For producers, directors, and other crew people who don't draw, knowledge of storyboarding is just as important, for it will enhance your ability to communicate with your crew and in the end help you tell a better story and run a better production.

PART ONE

GETTING STARTED

Thumbnail storyboards by Dan Antkowiak of Animatics & Storyboards, Inc.

Getting Started

The knowledge of storyboarding is important for everyone in production who has to communicate and understand visuals. You do not have to be able to draw *well* to produce functional storyboards, although lacking such ability will limit your chances of making a career out of it. A director sketching quick boards for the DP (director of photography) does not need quality art to get the point across. Production people simply need to be able to read storyboards to understand and make use of this great production resource.

If you are interested in pursuing storyboarding as a career, the first step in becoming a storyboard artist is understanding what storyboards are and how a storyboard artist works. Since you are reading this book, you're taking the right first step. As important as it is to have the ability to draw, it's not the most important aspect of storyboarding. Storyboards with bad art can still be good storyboards, but storyboards without the story are just art, not storyboards. Even great artists tend to produce poor art at times when the production deadlines are too short. As Tim Burgard, storyboard artist on *The Day After Tomorrow* and *Scorpion King*, says, "There are a lot of successful storyboard artists out there who are just strong story people, and they get their message across, but they aren't necessarily the strongest draftsmen out there. So I would say that understanding story and understanding camera are the main things for a storyboard artist to know."

Larry Latham, animation director and teacher at Walt Disney TV Animation, agrees: "I have held many beautifully rendered boards in my hands that were, from a production standpoint, totally unusable. And I have seen, in moments of deadline panic, fantastic, expressive, workable boards done with stick figures. In animation, gesture and expression are far more important than beautiful technique" (*AWN*, July 15, 2004, by Larry Latham).

To pursue storyboarding as a career, you also need to learn about directing and editing, and you need to learn to sketch the human form quickly. Some directors got their start as storyboard artists, such as Alfred Hitchcock, Joe Johnston (who directed *Jurassic Park 3*, *Hidalgo*, *The Rocketeer*, *Jumanji*, *Honey I Shrunk The Kids*), and others. You will be called on to help solve content problems, flesh out action sequences, and direct scenes on your boards as well as fill out the director's vision.

Next, you will need to be able to draw. There are many great books and classes that can teach you how to draw. I'll show you some helpful hints for the drawing process that relate specifically to storyboarding, but I'll leave the intensive

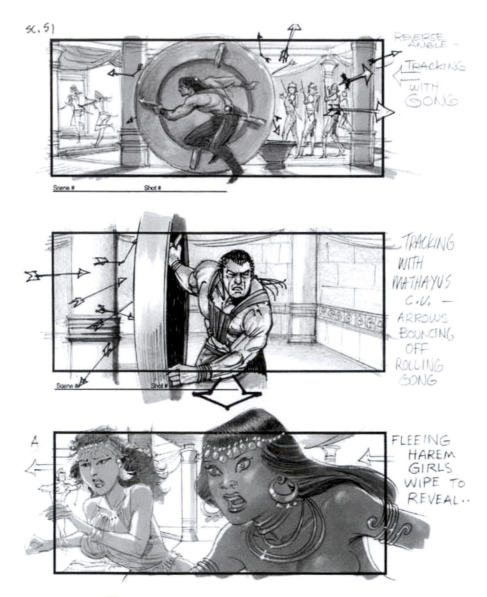

Figure 2.1 *Scorpion King* storyboards by Tim Burgard.
(Courtesy of Universal Studios Licensing LLLP.)

illustration instruction to others. This book, however, will teach you how to be a better, and more successful, storyboard artist.

During your search for that elusive first job, you will need to send out résumés and prepare a portfolio for any meetings. Of course to send out résumés, you need to know who to contact for work. Once you find out who to contact, you need to know what those prospective employers will want to see. One source of the answers to these questions is this book.

Another source of information about storyboards is your local professional storyboard artist. Most artists are more than willing to talk with other artists, so it never hurts to ask. The easiest way to find storyboard artists is to ask around in your local film community, or look in the local production directory, which can be found at the chamber of commerce or film commission for your area.

It is important to understand some basic production and storyboard terminology. We break the script into scenes during preproduction. *Scenes* are sequences that take place in one location at one point in time. If a character moves from inside to outside his house, scene 1 is inside and scene 2 is outside. If while inside, he has a

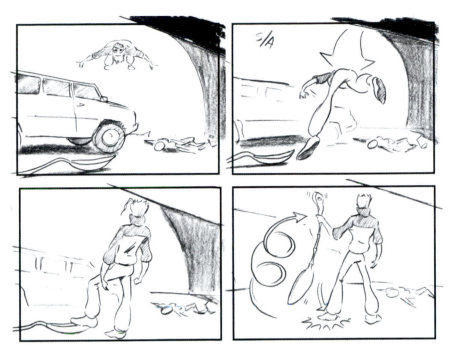

Figure 2.2 One action is shown with four frames. *Spoonman* storyboards by Mark Simon of Animatics & Storyboards, Inc. (Images courtesy of The DAVE School.)

flashback of what happened the night before in the same room, that is also considered a different scene. *Shots* are the different camera angles used to shoot each scene. If the scene inside his living room is shot with a wide establishing shot, a close-up, and a two shot of the actor and his girlfriend, then the scene consisted of three shots. *Panels* are the individual drawings or frames. Each shot may consist of any number of panels. Long and action-oriented shots may need many panels to illustrate the action.

For those of you who are experienced storyboard artists, it's never too late to get started on improving both your boards and your professionalism. If you get just one good idea from this book, it will have been worth it. For those of you just getting started in storyboarding, read on, enjoy, and draw, draw, draw.

CHAPTER 3

What It Takes to Be a Storyboard Artist

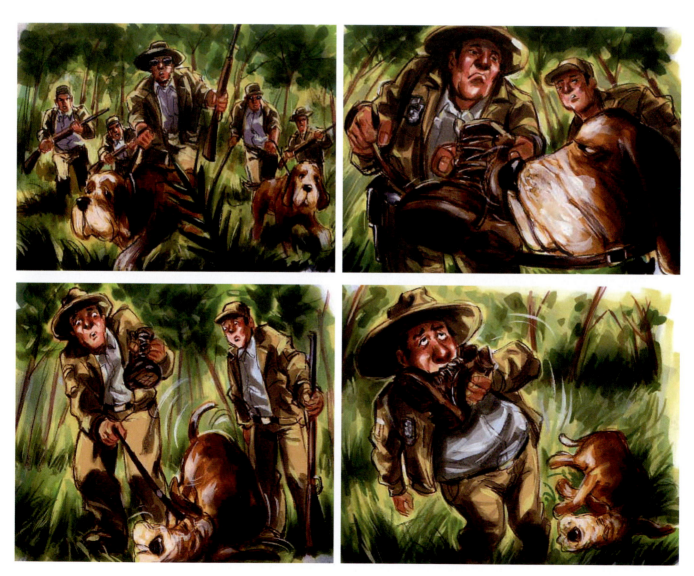

Figure 3.1 Storyboards by German artist Ovi Hondru.

The ability to draw is the most obvious talent needed to became a successful storyboard artist. But just being able to draw well, does not make someone a good storyboard artist. Storyboard artists are visual storytellers. They have to be able to understand directing and editing (see Chapter 21, Directing Shots). They have to know the differences between a long lens (a zoom, or telephoto, lens) and a short lens (wide-angle lens). They have to understand how to work with directors and translate the director's vision to the rest of the crew (see Chapter 22, Working with Directors). They need to know production terminology such as pan, crane, tilt, dolly, track, close-up, long shot, and establishing shot (see Chapter 21, Directing Shots, among others).

Storyboard artists need to understand when and why to use special camera shots. What motivates those shots (see Chapter 24, Staging and Composition)? What makes a scene funny? What makes it scary? How do you make an audience believe a character is a giant? How do you make them believe a character is only 6 inches tall (see Chapter 24, Staging and Composition)? Storyboard artists also have to understand screen direction and line of action (see Chapter 23, Screen Direction).

Understanding storyboards is important in order to work in a production environment. It's especially important if you have to sketch out some boards to describe something to someone. Not everyone wants to storyboard professionally for a career, but many people in live action and animation will need to draw boards at some point during a production.

For those who do wish to storyboard for their career, it can be a lot of fun. It is also a lot of work and consists of weird hours. In addition to the preceding items, to be a professional storyboard artist you have to:

- Have storyboard samples, not just sample illustrations. There is a difference.
- Be able to sketch quickly and accurately.
- Properly and quickly sketch perspective.
- Be able to draw anything from any angle (although you can use references).
- Match cartoon styles to storyboard in animation (see Chapter 13, Animation Boards).

Figure 3.2 The low angle looking up emphasizes the height of the background image. Storyboard layout for *Creepers* by Travis Blaise of Animatics & Storyboards, Inc. (© 2006, Lyons Entertainment, Inc.)

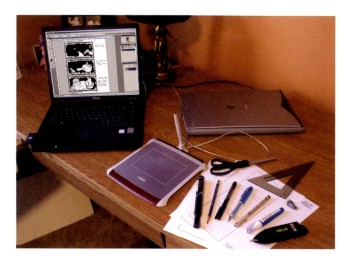

Figure 3.3 Laptop, graphics tablet, scanner, and supplies are needed for some location work.

Figure 3.4 Progressive billboard concept art by Larry Jones.

- Like working in a fast environment.
- Understand you may be turning down excess work one week and searching for work the next. It's a feast-or-famine industry.

Storyboard artists need to have the following:

- Access to a high-speed modem.
- A fax machine.
- A scanner and knowledge of how to use it well.
- An understanding of Adobe Photoshop.
- Promotional materials available at all times for mail, fax and e-mail.
- A copier (or some way of scanning to a printer).

It would be helpful if the storyboard artist also:

- Can make PDF files for clients.
- Has a graphics tablet for drawing and editing on the computer.
- Has a website promoting his or her work.
- Understands special effects and can break down effects as to how they can be shot.
- Has a laptop computer and a portable scanner for location work.
- Has a professional phone manner.
- Keeps copies of storyboards for future marketing.

To have a career, storyboard artists need to understand the following.

- The first one to answer the phone wins. Clients start by calling their first choice and go down the list until they find someone who says he is

available. They don't have time to wait for you to call them back. I once lost a gig because it took me 30 minutes to return a call.

- You may be called at any time, day or night, for a job. Especially in advertising, clients never sleep and expect that you don't either.
- Production happens seven days a week. If you won't work on holidays or weekends, someone else will.
- You need to be available immediately. You may only get an hour's notice that a client needs you on site. Be flexible.
- You need different types of storyboard samples to show clients. If you want to do live-action boards, have live-action samples. The same goes with animation boards. We had one client who wanted to see Batman storyboard samples. We had Superman, Spiderman, Tarzan, and other samples, but no Batman. It wasn't good enough. They went with someone who had Batman samples.
- You must always deliver on time. There are no second chances or excuses.
- You must be able to complete at least 20 finished black-and-white panels per day, preferably 30 to 40.
- You need to love drawing.
- You can make a lot of money drawing storyboards.

One of the great things about storyboarding is that every job is different. You get to work with different directors and tell different stories. Drawing every day is a great way to make a living.

CHAPTER 4

Education

Storyboard artists are hired on their ability to draw and tell a story visually. Experience is a necessity. Education is not. No client will ask what your education is. They will all ask about your experience. I've never listed my education on a résumé (and I have a degree with a double major), and in working on more that 2,000 productions no one has ever asked me about my education. All of the artists interviewed in Part Four of this book said they have never been asked if they have an education.

So do you need an education? Maybe. It depends on the person. Education helps only as much as each artist puts into it. Take advantage of opportunities and equipment available to you while in school. You have to learn to draw and storyboard somewhere. You may learn by working with friends, by working as an assistant for a storyboard artist, at an art school, by reading this book, or even just doing it on your own.

The main courses to take for storyboarding, if they are available at your school, are life drawing, sequential illustration, and film directing and editing.

There are other benefits to an education besides learning how to draw and how to storyboard. Storyboarding is a business, like any other. The more you understand about marketing, licensing and rights, accounting, contracts, writing, math, etc., the better your business will run and the more money you are likely to make. The best advice I ever got was to take business courses along with any other courses I took. (Thanks, Dad!)

One way to gain more benefit from school is to use your time there to get experience. Find filmmakers in your school who would like help storyboarding their projects. They can't afford to hire someone, and you need the experience. It's a win–win situation. Talk to the communications department at your school and see if they are working on any projects on which you could assist with storyboards. There are always opportunities to learn and gain experience—you just have to find them.

DVDs are practically film schools on disk. The behind-the-scenes and commentary features on many disks offer excellent insight into how movies are made, why scenes were shot certain ways, and how directors work. Many of them also feature storyboard samples.

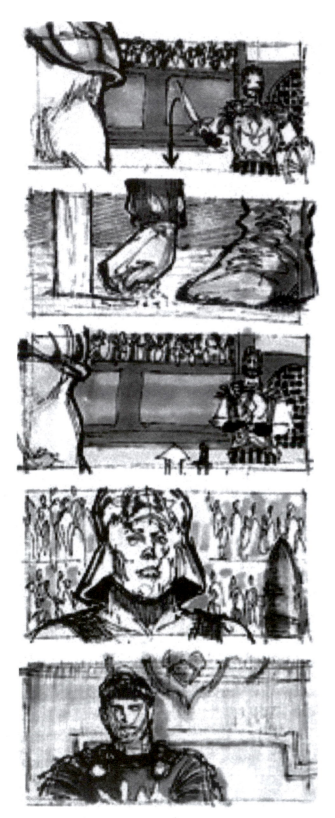

Figure 4.1 Sample practice storyboards by Dan Antkowiak based on scenes he saw in the movie *Gladiator*.

Figure 4.2 Life drawing in charcoal by Mark Simon done while he was in college.

The best education is experience. Storyboard scenes from movies. Storyboard scenes for friends. Offer your services for free for the experience. Pitch your boards to people. The practice of pitching out loud helps you understand when you may be missing elements in your visual story. Your viewers' reactions also tell you whether or not you're hitting the emotional buttons you're aiming for.

Having a degree alone will not get you jobs. If you work hard and learn from your time in school, become a better artist, and build a great portfolio while you are there, your education will have helped.

Figure 4.3 Life drawing by Travis Blaise of his son. Notice the quick but accurate line control. These are not overworked; they're quick drawings to capture weight and balance.

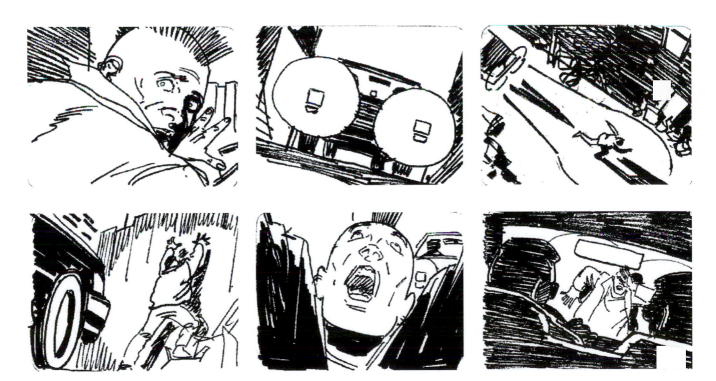

Figure 4.4 Portfolio samples drawn by comic book artist Alex Saviuk to land a job at Animatics & Storyboards, Inc.

CHAPTER 5

Materials

The essential materials needed for a storyboard artist are few, but the list gets longer as you enhance the quality and detail of your work. A number of these materials are simply a matter of personal preference.

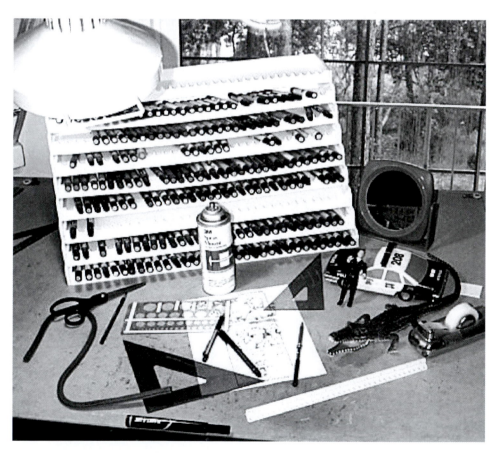

Figure 5.1 Miscellaneous supplies on author Mark Simon's desk at Animatics & Storyboards, Inc. Notice the toys and small mirror used for reference. The marker stand was handmade with foam core to accommodate all the markers.

Here are the materials a storyboard artist is likely to use.

Pencils (mechanical with 2B leads, non-repro, Ebony, Col-Erase in black and blue, etc.)
Computer, scanner, graphics programs, graphics tablet, and printer
Pens (Sharpie, Pilot Fineliner, Pilot Razorpoint, Faber Castell brush pen, Tombow brush pen)
Scale ruler
Markers
Straight edges
Triangles, 30°/60°, 45°, adjustable
Charcoal
French curves
Colored pencils
Eraser shield
Pastels
Mirror
White Conte or China marker
Reference books and objects
Plain or Bristol paper
Templates
Preprinted storyboard templates
Erasers (kneaded, pink, gum, electric)
Light table
Compass
Brushes (for inking large black areas)
Contracts
Ink
Copier
Digital camera
White-out or white ink
Airbrush
Toothbrush
Glue stick or spray mount
X-acto knife or scissors

There is no one correct way to draw storyboards as long as the client is happy with the end result. Different artists use different types of paper, pencils, pens, and so on. There are a number of things to keep in mind when using different materials.

Some artists use regular pencils, and others use mechanical pencils; some use non-reproducible blue pencils and then ink over them; and others draw in charcoal. Each method gives different results. I use a mechanical pencil with 2B leads. This is because I never have to sharpen the mechanical pencil and the 2B leads are extremely dark. I don't ink my boards (except when coloring in a large black area) because it takes too long. The 2B lead is picked up very well by copiers and

Figure 5.2 Cordless electric erasers work great when using soft pencil leads and are helpful when illustrating rain and highlights.

scanners. I let the machines do my inking for me. There are some cautions to using a soft 2B lead. Some copiers and scanners drag the lead across the page when you use the automatic document feeders. Always test it first. Smudging is even worse with ebony pencils and charcoal.

Many Disney layout and storyboard artists use blue or black charcoal for their drawings. Mark Moore of ILM uses blue pencil first and then markers; he then copies the art and finishes with other markers, white pencil, and white-out. Others use different media, depending on the type of project they're working on. Chris Allard uses pencil if he's doing humorous work, "to keep the energy alive," as he puts it, or he uses ink for dramatic boards to get the shadows.

Artists Jon Dahlstrom and Anthony Zierhut work only with ink. They rough out their thumbnails in ink and then trace through another piece of bond paper to refine the images with ink, sometimes doing two, three, or four generations. They find it fast and easy. There's no pencil to smudge on the paper or in copiers. Faxing and copying are extremely clear, and the boards are always ready to show to clients. Every step of the

Figure 5.3 *Creepers* storyboard by Mark Simon. Panels were sketched with non-repro blue first and then cleaned up with a 2B lead. (© 2006 Lyons Entertainment, Inc.)

process is ready for faxing or scanning, unlike when you're using unfixable blue pencils.

Other artists are finding it faster to work directly on a computer. Travis Blaise, Disney animator, draws boards directly in Adobe Photoshop or Flash using a Wacom tablet. He will rough out the boards on one layer and then draw a tighter line on another layer. The layer with the rough lines can then be turned off for printing.

Kneaded erasers are great on light-stock papers and tend not to mar them. They also erase pastels to some degree. Electric erasers and shields allow you to erase around objects and to erase pinstripe lines.

Colored markers are used for some presentational boards along with pastels and colored pencils. Airbrush and markers have been a favorite in the advertising

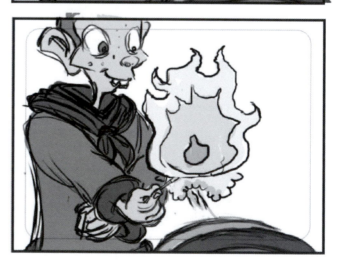

Figure 5.4 *The Troop* boards by Travis Blaise. Travis drew these using a Wacom graphics tablet in Photoshop. He saved time by duplicating panel 2 and adding a flame in panel 3.

world, but more and more artists are using Photoshop for their coloring and effects. Even when artists use markers, they will often enhance the colors, shadows, and highlights digitally once the art has been scanned.

White ink, Conte, and China markers are used for highlighting. The toothbrush can be used to spatter a field of stars onto your work with the white ink. Many artists now use paint programs on their computers for all their coloring.

Every artist has a favorite type of paper to work on. I use regular typing paper. I like its texture, and it runs easily through copiers. I use my computer and both Photoshop and CorelDraw to design and print my own custom forms for each job. Bristol board, a very heavy art paper, holds up better, but you can't run it through copier feeders. It also gets expensive and takes up a lot of space when the average 21-minute animation is 200–300 pages long. The preprinted forms you can buy at art stores do not work at all in a production environment.

You will need a scale ruler and French curves when you are drawing backgrounds and sets for a project. You may also need a computer to help with perspective, text, logos, and signage. Why redraw a client logo when you can import it, scale it, rotate it, and put it into perspective perfectly in the computer?

The Wacom Cintiq is speeding up the drawing process by eliminating scanning and most erasing. It is a tablet display on which you can draw directly. Unlike with a standard tablet, you can use common drawing tools such as straight edges and curves on the Cintiq.

Many laptop computer manufacturers also offer tablet displays. These work great for the artist on the move. The boards can quickly be drawn on the tablet and then printed on site or e-mailed to the production team for their use.

A mirror allows you to use your own hands and face for reference. I use multiple mirrors to see myself from different angles. You can also use books and magazines for reference.

I use the light table when I need to trace over my own boards (lightboxing as a way to remove layout lines) or a background I want to use and don't have the time to redraw it freehand.

The knife and scissors are for replacement panels. There will be times when you have to add, change, or delete frames from your boards.

I like to give clients prints of my boards, not the originals. This prevents them from accidentally smearing the originals in copiers. I also like to hold onto the originals in case there are some last-minute changes. Then I don't have to redraw an entire frame; I can just

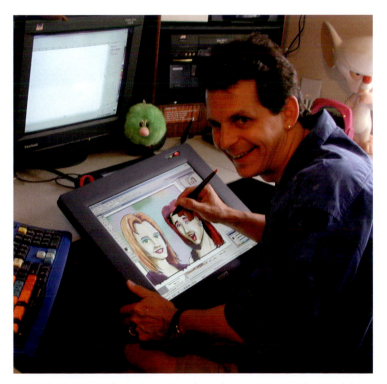

Figure 5.5 Mark Simon cleaning up storyboards on a Wacom Cintiq tablet monitor.

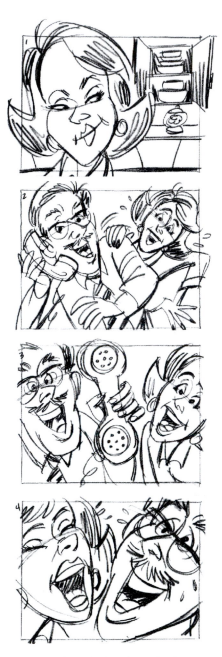

Figure 5.6 Storyboards by Chris Allard. Rough pencil boards for Ocean Spray Craisins®.

erase what I need to fix. Of course, a lot of changes can now be made digitally on the scanned images. I have my own copier to save the time of running back and forth to the copier place. Time is money. I have a copier with a top feeder and $8\frac{1}{2} \times 11$ paper up to 11×17 paper. It reduces and enlarges to 50 percent and 200 percent, respectively. This is handy when converting scaled images.

My website, www.MarkSimonBooks.com, has links for purchasing these and other items that are useful in storyboarding. You will also find free digital storyboard forms.

As technology improves, artists have more and more tools to choose from. The tools you use are not as important as the most necessary tool, the ability to tell a visual story.

CHAPTER 6

Benefits to Production

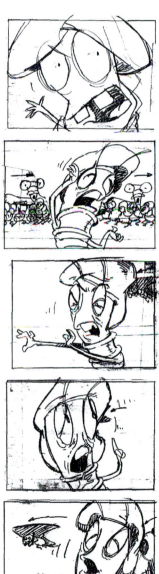

Figure 6.1 *Santo Bugito* storyboards by Klasky Csupo. The detailed acting illustrated here shows the overseas studios exactly what production wants in the final animation.

Time. Money. Communication. These are powerful words in the entertainment industry. Far too often a production team will opt not to pay for storyboards. This is being penny-wise and pound-foolish. Developing and using storyboards solves production problems, saves time and money, and can be used for testing an idea early on.

In animation, the benefits are not only plentiful, they're unavoidable. Nina Elias Bamberger, executive producer for Sesame Workshop animation, has said:

> Storyboards are the blueprint for the series. They convey the emotions; they convey the creative direction of the series. Since oftentimes, like in *Dragon Tales*, we ship to several studios in order to get the work done on time. The storyboards are what will guarantee uniformity throughout the series and its quality control. And it also gives the producers the opportunity to fine-tune what they want the series to look like before it's out of their hands for a while.

Storyboards also help break down the language barrier between countries. When a production is shooting in a country which speaks a different language than the main crew, the storyboards help direct their actions. A picture is truly worth a thousand words, in any language.

In live-action productions, the first scenes to be storyboarded are those with effects, stunts, and special camera moves. Effects and stunts can't be properly budgeted or scheduled without boards, so productions need them boarded as early into the process as possible.

Production story. On the movie *McHale's Navy*, there was a chase sequence between McHale and Vladikov that consisted of only three lines in the script. The second-unit director, Glenn Wilder, designed a huge sequence, far beyond what was written in the script. The sequence ended up needing over 100 panels. Production could not have accurately scheduled or budgeted the second-unit shoot without the boards, since the script would have led them to believe the sequence was much shorter than it ended up being.

If production has enough time scheduled, the storyboard artist will board other scenes to develop the visual flow of the story and develop shot lists after the effects and stunt boards are complete.

One major benefactor of live-action storyboards is the director. Developing storyboards with an artist forces the director to fully visualize the script. When the artist is doing breakdowns (lists of needed camera shots),

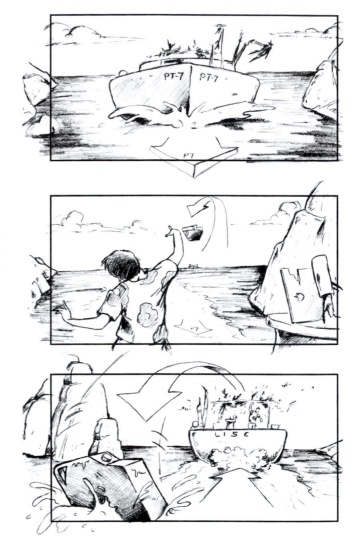

Figure 6.2 *McHale's Navy* second-unit production boards by Mark Simon. Second-unit director, Glenn Wilder. (© 1997, Universal Pictures.)

this also presents directors with options that they may not have considered. The storyboards become a visual shot list. Directors often mark off each drawing as the shooting proceeds to make sure they get every shot.

Storyboards also help with continuity. Screen direction (the direction in which a character or object is moving across the screen) is very important in all scenes, but it is the hardest to control in action and special effects scenes. Successive cuts may be shot on different days or even different weeks. It's hard to keep track of screen direction when different elements and shots of the same scene are shot so far apart. Boards act as a blueprint for each shot and limit potential problems with screen direction.

This is supported by director James Cameron in a November 24, 1986, *Hollywood Reporter* interview as he spoke about his hit movie *Aliens:*

> The scene where she [lead character Ripley] takes over the control of the APC and drives it through the whole structure, that was heavily storyboarded because we were intercutting the full-size action I was shooting with miniatures—they had to get the screen direction, the size of the frame, all of that.

In animation, the storyboards help the animators retain proper continuity. They tell animators working on different scenes what leg the character was standing on, what hand was holding the flashlight, or what direction a character should be running. Continuity mistakes take the viewer out of the story, and the magic of the moment will be lost.

The director may also use the storyboards to explain his direction to an actor and the cameraman. It is always easier to show someone what you want rather than just explain it.

A tremendous amount of work needs to be done on a set at any given time, and there are never enough hours in the day to accomplish it. With a full set of storyboards, the production manager will be better able to schedule the shoot. There will be less chance of cost overruns when the shoot is scheduled properly.

When a scene is boarded and the crew heads have those boards, there are fewer needless questions asked and less time wasted. When the crew can see the director's vision prior to shooting, they are better able to anticipate what is needed—and the shooting will proceed faster and more smoothly because of it. The faster the crew works, the less the production will cost. Time is money.

Film is money too. When each shot is planned in advance with boards, the director and the director of photography are able to shoot less coverage. In other words, they are able to shoot only the exact shots needed to cover the scene, and they don't necessarily have to shoot the entire scene from multiple angles. The boards will also help them plan complex camera moves.

When a designer reads a script and imagines a new set, he feels the need to build the entire four walls of the set in case the director wants to shoot in different directions. When a scene is fully boarded, the designer may find out that only one section of a set is needed, thus saving time and money in construction and set dressing. Of course, the designer may also use the storyboard artist to do a conceptual rendering of a set for approval by production before construction starts.

Figure 6.3 *Scary Things* boards by Mark Simon and Jeff Varab. Boards show which of the character's hands holds the flashlight in each scene, for continuity. (© 2006, A&S Animation, Inc.)

Production story. When I was art directing and designing sets at Nickelodeon, I had a scripted scene that needed a girl's bedroom. I was designing a large four-wall set with lots of dressing. I then storyboarded the scene with the director, only to find out that he wanted the entire scene shot with one angle of the girl sitting in the corner of her room. I was then able to save money from my set and dressing budgets by providing production with only what was needed instead of a full, elaborate set.

Projects with lots of effects and stunts constantly have production problems coming up as different elements of each shot raise their heads. With storyboards, these problems may be fleshed out early while there is still time to deal with them and design properly. Often, different elements in a single special effects shot may be shot months apart. These shots need to be planned completely so that the shot will work correctly and will fit in with the flow of the story and the final edit. The storyboards can break down these shots into their dif-

ferent elements so that all crews—first unit (the director and lead actors), second unit (often a separate director shooting stunts and cutaways without the main actors), and special effects—are working in conjunction with one another.

Every time stunt coordinators or special effects people budget for a stunt or effect, they pad their bid (make the bid more expensive) in preparation for the unexpected. Without storyboards, stunts or effects could be designed differently from what the director is looking for. With storyboards, the look can match the director's vision, each element may be designed down to its minute details, and a more exact budget can be worked out. Stunt and effects people often hire storyboard artists on their own so that they can use the boards as part of the contract specifying exactly what elements are included in their bid.

All crew heads benefit from studying the storyboards of their project. Delays are costly to production. Any element of theirs that is affected by the action in a storyboard is important for them to know about.

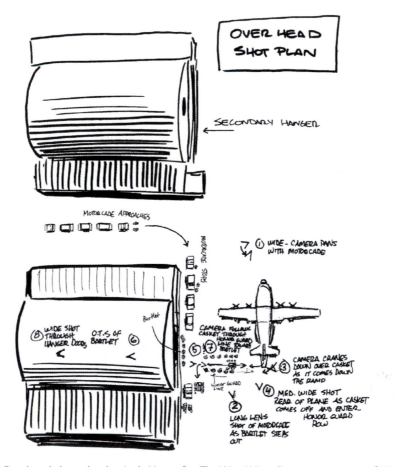

Figure 6.4 Overhead shot plan by Josh Hayes for *The West Wing.* (Images courtesy of Warner Bros.)

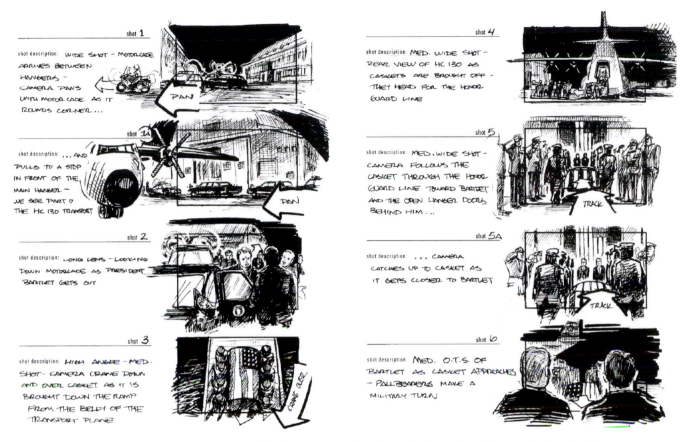

Figure 6.5 Storyboards by Josh Hayes for *The West Wing* based on the shot plans. Director, Christopher Misiano. (Images courtesy of Warner Bros.)

When advertising agencies are pitching an idea for a commercial to a client, they usually use storyboards to carry the visuals of the presentation. These generally are done in color and do not include every shot, just enough information to get the idea across.

Large corporations also use storyboards to present marketing ideas to the decision makers. These may be simple sketches or vibrant color illustrations.

Storyboards may also be used to test the viability of a finished commercial product without the great expense of shooting it. These drawings are shot on video and edited together just like a live shoot. This footage is then dubbed with music and voices. This is called an *animatic* (see Chapter 18, Animatics). The animatic may then be shown to test groups around the country.

Productions benefit from boards in many ways. They may cost money in preproduction, but that cost is much less than the hidden expenses caused by a lack of proper planning or any miscommunication.

Figure 6.6 Commercial pitch boards by Lyle Grant. Used by the advertising agency to pitch their idea to their client.

PART TWO

THE ART OF STORYBOARDING

Interactive museum presentation storyboard by Mike Conrad of Radical Concepts.

CHAPTER 7

Drawing Quick Thumbnail Storyboards

One chapter in a book is not enough to teach someone to draw. However, this chapter does present some important tips on making quick, readable thumbnail sketches while working with a director and on quickly laying out your storyboards.

The best way to learn to draw better is to draw—and keep drawing. Drawing is a skill that, like others, gets better with practice. Keep a sketchbook with you and draw whenever you have a free moment. Sketch people walking around, sketch animals, landscapes, vehicles, anything you see. Try to capture the weight and motion of your subjects in your sketches.

Storyboard artists are called on to draw every aspect of life. The action of drawing something helps train your mind on what it looks like for future reference when the need to draw that object arises.

For books on how to draw, please refer to the subsection "How to Draw" Books in the Reference Books section of Part Seven (Appendices) of this book.

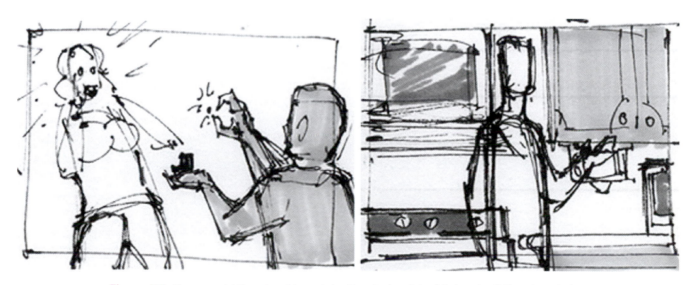

Figure 7.1 Commercial thumbnail boards by Dan Antkowiak of Animatics & Storyboards, Inc.

Those of you who are experienced and are good artists probably have your own quick drawing style. Hopefully you may gain a trick or two here. Those of you who struggle with the drawing of people and with perspective will find that these simple tricks help you rough out your ideas for others.

It might seem weird to think that a storyboard artist may not be able to draw well. But many people other than professional storyboard artists, such as directors, draw their own boards to show crews what they want. Steven Spielberg is known for his directing skills and not his artistic skills. However, he will still sketch out rough storyboards to help explain his ideas.

Special effects supervisors, cameramen, producers, writers, and others do too. Computer graphics (CG) artists and animators are not all good at drawing. But they all should understand how to quickly sketch ideas for others to follow.

Thumbnail boards are not just about sketching well; they are more like graphic notes. Your sketches need to show which characters are which, direction of motion, and other information you will need to have later as you sit down to draw your finishes.

During your meeting with a director, besides thumbnailing your boards, you may also sketch some plot plans and notate character and camera placement for approvals. Keep these sketches along with your thumbnails, and you may even include some plot plans on your final boards under certain panels. If the extra information can help the production team plan the production, they should be included.

There are three main purposes for drawing quick thumbnail sketches of your storyboards.

1. To get director approval before you spend a lot of time doing nice drawings.
2. To quickly get the ideas down during a meeting so that you don't forget what you need to board out.
3. To quickly determine the layout of your shots.

Directors don't need to see tight illustrations to know whether you understand the shot the way they described it. Not much more than a stick figure usually works. Then you can spend time creating better-looking boards when you are not taking up the director's time.

When you are roughing out notes during a meeting, you have to make sure that you can later determine which stick figure is which character. It is very easy to confuse characters in thumbnails after you've had a long meeting about a number of scenes. Here are some quick tips for easy differentiation of your characters in your thumbnails.

- Place the character's initials on each character.
- Make their clothes different.
 - One may have a black shirt, another a white shirt, and another a crosshatched shirt.
 - Give one long sleeves, another short sleeves, another a sleeveless top, and another a jacket.
 - Give one long pants, another shorts pants, and another a skirt.
- Make their hair different.
 - Give one long hair, another short hair, and another a hat.
 - Give one curly hair and another straight hair.
 - Give one black hair and another white hair.
- Make their physical characteristics different.
 - Make one white and another black.
 - Make one tall and another short.
 - Make one fat and another thin.
 - Give one glasses.

C.U. angle on Clay. " There are no choices." intercut C.U.s of Clay

Figure 7.2 Thumbnail sketch by director Jesus Trevino for *seaQuest DSV*. The quality of the sketch is not good, but it shows the type of shot needed and lists details underneath like character name. Such thumbnail sketches helped him describe his shot breakdowns to series storyboard artist Mark Simon. (Courtesy of Universal Studios. All rights reserved.)

You can see how even in the roughest of sketches, these differences will remind you of who is who. The same differences will also help in your final boards.

Figure 7.3 Notice how even though these are rough, it is very easy to see the differences between the characters. Even with an extremely rough sketch you can see that one character is heavy, another has glasses, one is obviously a woman, one has a tanktop on, another wears a button-down shirt, they all have different hair, and so on. This helps make even rough thumbnail storyboards readable.

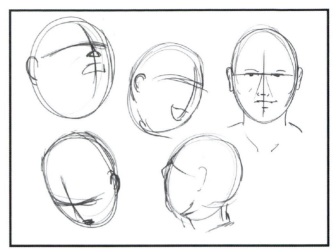

Figure 7.4 The head is usually an oval. A vertical line represents the nose line and shows whether the head is looking left or right. The horizontal line represents the eye line and indicates whether the head is looking up or down.

The biggest problem with stick figures in your thumbnails is that they are one-dimensional. You can't tell which direction they are facing. It is best to give a little dimension to your characters.

Heads are easy. Just draw a simple oval for the basic shape (see Figure 7.4). Then draw a vertical line for the direction the nose is facing. Then draw a horizontal line to show how high or low the face is looking. Without any other details you can quickly show where a character is looking.

Eyes and ears are usually level with each other. The eyes are around midway up the face.

Instead of using just a line for bodies and limbs, try using cubes or cylinders. (The book *Drawing Comics the Marvel Way* does a great job of fully demonstrating this technique.) A cube for the torso shows which way the body is facing. Using a separate cube for the waist helps show the twist in the body. A cylinder for the torso will do the same once the arms are added. Cylinders for the arms and legs, as shown in Figure 7.5, are all that's needed to quickly finish your thumbnail.

Scale is also important in your sketches. The human body can be measured in the number of heads high it is. A normal man may be around 6.5 heads high, while a hero may be between 8 and 9 heads high. A woman would be a bit smaller overall, except with larger breasts, shorter torso, and wider hips.

The adult elbow comes almost down to the waist, and the hand hangs down to about midthigh; and when

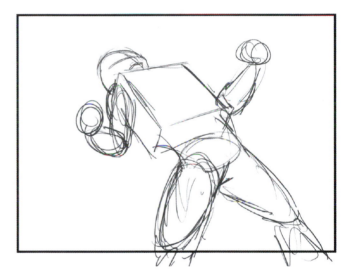

Figure 7.5 The body may be sketched with cylinders and/or cubes for a three-dimensional look.

an adult reaches up, the elbow goes to the top of the head. A young child can only reach the hand to the top of the head. As children grow, their arms and legs grow longer in relation to the body and the head grows smaller in relation to the body.

The centerline of the spine portrays the action of the body. You may want to start by drawing the centerline and then build the rest of your character on it.

Many artists like to start their boards with rough blue-line sketches. Using non-reprographic blue pencils

Figure 7.7 An adult elbow reaches the top of the head, whereas a toddlers whole arm barely reaches the top of the head.

Figure 7.6 A man will stand 6.5 to 9 heads high. A woman will usually be a bit smaller but with larger breasts, shorter torso, and wider hips. Notice how even though the woman is shorter, her legs are just as long as the man's. (Art by David Hillman of Hillman Arts.)

allows you to quickly rough out the panels, clean up the art with a regular pencil or pen, and not worry that your rough lines will show up on copies or scans. Black-and-white copiers and scanners set on black and white won't see light blue lines.

One thing to watch for: If you press hard and the blue line gets dark, it could still show up. Color scanner settings tend to pick up the blue lines, but grayscale settings usually do not. Blue-line sketches can be a problem if you are working long distance or via fax and/or e-mail. To get approvals on your roughs, they have to be faxable or scannable.

One trick is to scan your blue-line sketches in color, increase the contrast, and convert the image to grayscale. In Adobe Photoshop you can also bring up the hue/saturation adjustments (Ctrl+U) and darken the

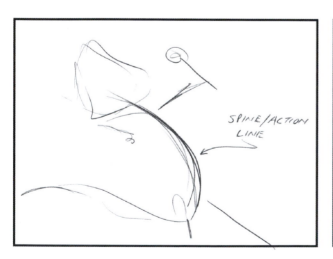

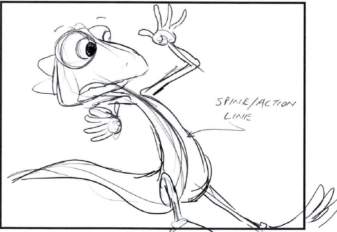

Figure 7.8 The curve of the spine dictates the action of the body.

Figure 7.9 Blue-line thumbnails don't show on black-and-white copies and scans.

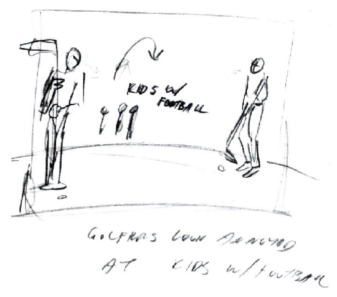

Figure 7.10 Notes are often faster than drawing details. Write it down so that you don't forget. Instead of drawing three kids in the background, I drew lollipop figures with a note as to what they were doing. (Thumbnail by Mark Simon of Animatics & Storyboards, Inc.)

blue and cyan colors and then adjust your levels (Ctrl+L) until your lines are almost black.

Lightboxing can help if you have to work long distance with a director using faxes. Sketch your thumbnails with a dark pencil or pen, get approvals, and then trace and refine your boards onto a new piece of paper using a light table or a lightbox. Doing this eliminates the need for erasing and limits smudges on the paper.

Make sure to write plenty of notes on your quick thumbnails. You don't want to forget anything. It's easier to write a note first than to do revisions due to forgetfulness later.

Good thumbnails lead to approved finals. Going quickly through a sequence helps you and the director get into the story rhythm.

CHAPTER 8

Sketching Perspective

Storyboarding is a quick art. We seldom have the luxury of taking our time to create fine illustrations. Therefore, we have to be able to quickly sketch not only people and cars but any object in perspective.

While we storyboard artists may not use straightedges for our quick perspective sketches, we do have to know the process well enough for our sketches to capture the depth that perspective portrays.

Perspective refers to nonparallel lines in a drawing that converge at a point in space called the *vanishing point*. There are two main types of vanishing points. Horizontal lines have vanishing points that sit on the horizon, where the earth meets the sky, and vertical lines have vanishing points off of the horizon line.

For storyboarding purposes, it is best to discuss perspective as it relates to the camera. A normal camera shot looks straight ahead and will have the horizon line level with the eyes of a person of average height. One or two horizontal-line vanishing points will be on the horizon line (see Figure 8.3). There will usually not be a vertical-line vanishing point.

A low camera angle (LA, or worm's-eye view) looking up will have a low horizon line or even a horizon line below our field of view (see Figure 8.4). The

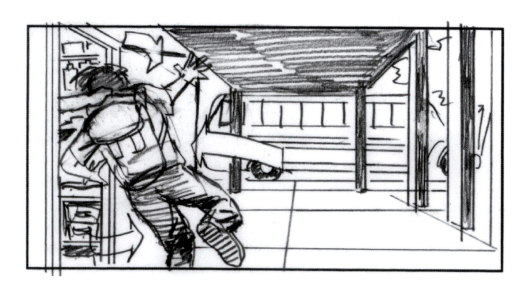

Figure 8.1 *Hoot* storyboard frame by Alex Saviuk of Animatics & Storyboards, Inc.

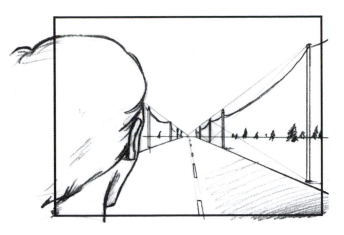

Figure 8.2 One-point perspective with one vanishing point on the horizon line.

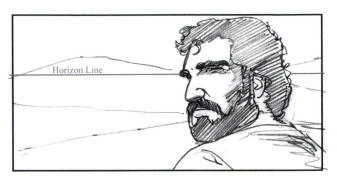

Figure 8.3 *Full Flame* storyboard by Alex Saviuk of Animatics & Storyboards, Inc., showing a horizon line around eye level.

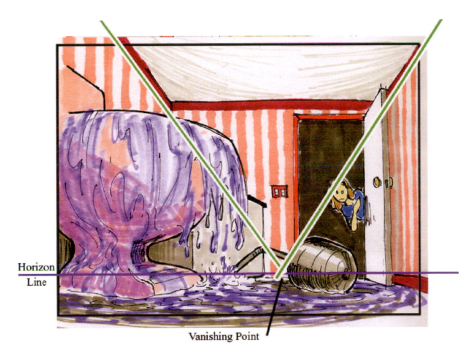

Figure 8.4 The low horizon line makes the camera look up. The vanishing point is on the horizon line. Storyboard by Dan Antkowiak of Storyboards & Animatics, Inc.

horizontal lines will still have vanishing points on the horizon line. All low-angle shots will have vertical-line vanishing points above the horizon line.

A high camera angle (HA, or bird's-eye view) looking down will have a high horizon line or even a horizon line above our field of view. All high-angle shots will have vertical-line vanishing points below the horizon line.

To help get a feel for the perspective layout of a shot, you can predetermine the horizon line and vanishing points. Then you can lightly sketch a grid coming from your vanishing points to help you quickly and accurately sketch your scene in perspective.

A quick way to illustrate concept art in dimensionally correct perspective is to quickly build a 3D model (see Figure 8.7) in a program such as SketchUp

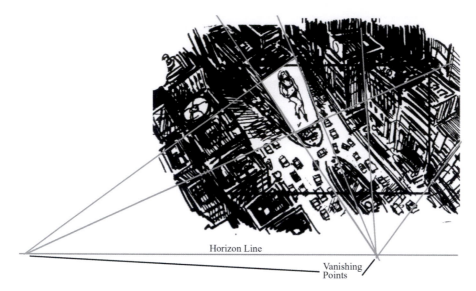

Figure 8.5 Two-point perspective. The horizon line is below the frame, and both horizontal vanishing points are on the line.

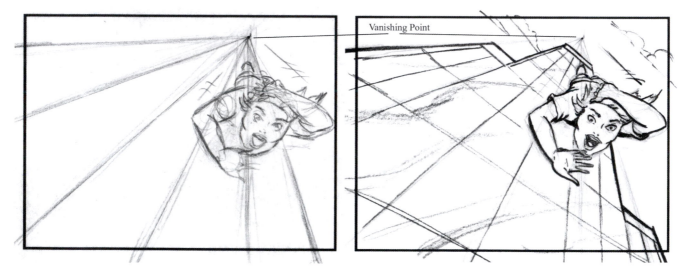

Figure 8.6 A vanishing point is chosen on the left, and lines are drawn from it as a reference when sketching the rest of the panel. The high vanishing point lowers the camera, thus making it look up.

(*www.Sketchup.com*). Simple rooms can be built in just a few minutes. Then just move your virtual camera around until you're happy, and print out a line drawing of the image. You can then lightbox, or trace, this drawing and add any detail you need—and the computer did all the time-consuming detail work of making everything exactly the right size in perspective.

After a great set is designed it has to be presented to those on the production team who will approve it.

You may just present a blueprint, but that's not the most visually satisfying alternative for the director or producer.

Vehicles and round objects may also be sketched properly in perspective. Vehicles can be looked at as a series of blocks drawn in perspective. Round objects, such as wheels, are ovals sketched within a perspective square box (see Figure 8.8).

You can always freehand sketch what the set will look like in 3D, but it takes years of practice to

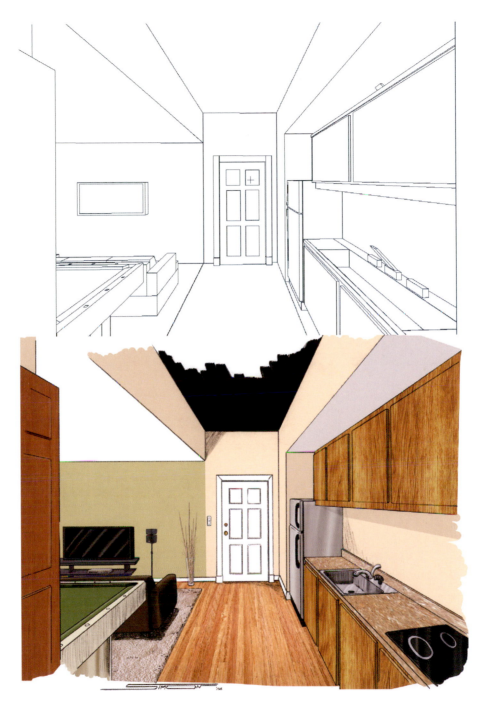

Figure 8.7 The *top* image shows hidden-line removal from a 3D program. The *bottom* image shows the final rendering. The final lines were drawn by hand and colors and textures were painted in using Photoshop.

achieve the right effects. Even a great sketch can misrepresent the proper dimensions. It is, after all, only a sketch. The fastest method for creating a perspective drawing is with a CAD (computer-aided design) program or programs such as SketchUp, Lightwave,

Maya, Softimage, Artlantis R, or other 3D program you are familiar with.

The better you understand proper perspective, the more options you will have in designing your shots and making your sketches accurate and believable.

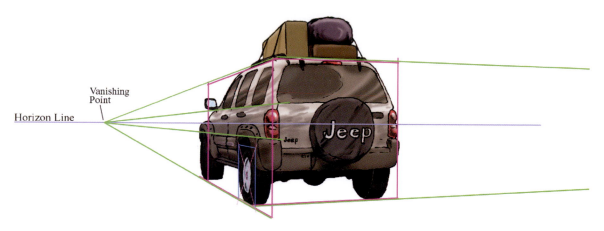

Figure 8.8 Just like buildings, the lines of a vehicle use vanishing points. Both horizontal vanishing points are on the horizon line. Find the center of the wheel by drawing lines from corner to corner of its reference square.

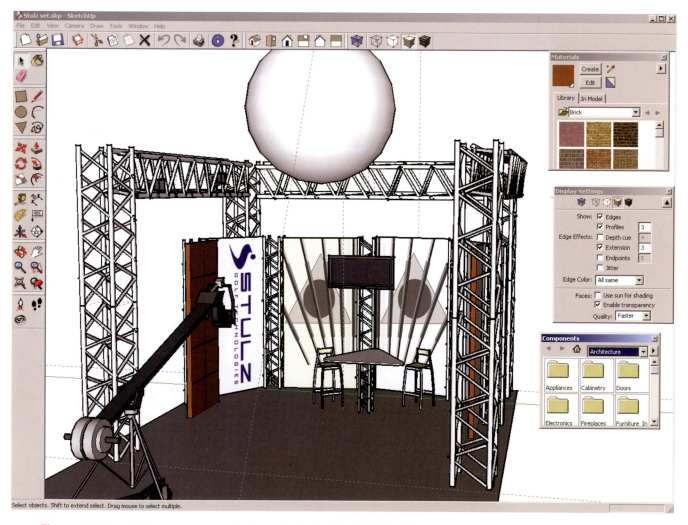

Figure 8.9 SketchUp screen capture. *Stulz* set design by David Kahler. Illustration by Mark Simon. Client, Convergence.

Final Storyboard Art and Clean-Clean-Up

Many artists start with thumbnails as they develop their finished pieces, and not just for quick approvals. They quickly rough out the layout and proportions of each frame before worrying about details. (Elements such as frame design and layout are covered in later chapters.)

Every artist works a bit differently when drawing boards. Some start with a blue-line sketch and then pencil or ink a finished line right on top. Others use a lightbox with a new page over their roughs. Some artists do their thumbnails a different size than their finishes. Sometimes they just redraw the finals or they enlarge the thumbnails on a copier and then lightbox (trace on a light table) the finals.

More artists are starting to storyboard on the computer. There are some storyboard software programs, but the most popular way to draw digital boards is to use Adobe Photoshop, Corel Painter, and Mirage. One of the biggest drawbacks to

Figure 9.1 Finished *Scorpion King* panel by Tim Burgard.

Figure 9.2 Roughs, pencil, and color board by Dan Antkowiak of Animatics & Storyboards, Inc. Notice how the lens height and apparent size of the little girl changed from the thumbnail to the final art. Thumbnails are quick ways of getting approvals and notes without wasting a lot of time.

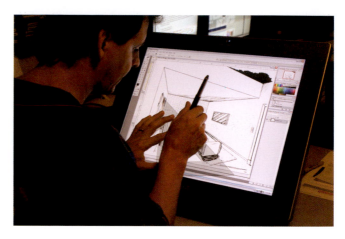

Figure 9.3 Tablet monitors, such as this Wacom Cintiq, allow artists to draw digitally with a straightedge.

drawing on the computer has been the lack of a straightedge to quickly sketch straight or perspective lines. The advent of tablet PCs and the Wacom Cintiq tablet, which lets you draw directly on the screen, allows artists to use the tools they are used to, so there is less of a learning curve than drawing with a regular graphics tablet (see Figure 9.3).

Drawing with a mouse is impractical. Graphics tablets let you draw with a pen on a surface while looking at the computer screen. You can sketch your thumbnails on one layer and finalize your art on another layer. Then you can just turn off the thumbnail layer, leaving a perfectly clean illustration (see Figure 9.4). You'll find more on the use of computers and software in Chapter 31, Computers and Software.

The list of ways, presented in Chapter 7, Drawing Quick Thumbnail Storyboards, to easily differentiate between your drawn characters works for your final artwork as well. The rough layout of the human head and body is also discussed in that chapter.

Many times productions are moving so fast that you can't spend time finishing tightly drawn boards. Production boards are often little more than thumbnails. The quicker you can sketch accurately, the better.

Animation productions often have storyboard clean-up artists. One artist will rough out the storyboards quickly, paying most attention to breaking down the shots and working out the visual pace of the story. The person doesn't worry about how the characters look. The storyboard clean-up artist redraws the boards in either pencil or ink and draws the characters on a model.

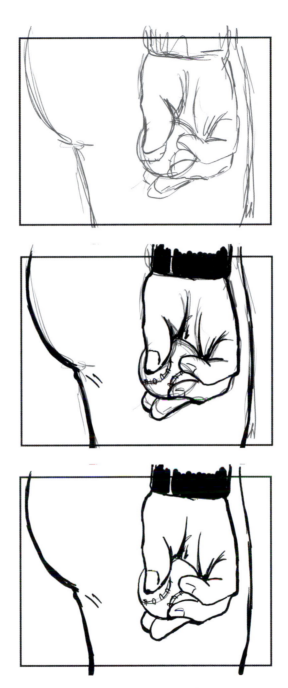

Figure 9.4 Digital storyboards by Mark Simon of Animatics & Storyboards, Inc. The thumbnails were drawn on one layer in Photoshop, the final line on another layer, and then the thumbnail layer is turned off for the final image on the bottom.

When you have enough time to tighten up your art, you need to remember how your work is to be copied and seen. Presentation boards generally can have lots of subtle tones and color and will only be reproduced for a few people. Production boards, however, are copied on the fastest, worst copier around the office, and are distributed to almost the entire crew.

Therefore production boards need to have dark lines with no tone, because tone tends to copy as black smudges. Grey tones should be represented by cross-

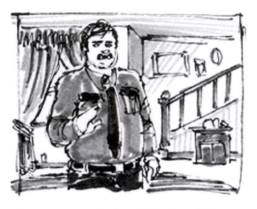

Figure 9.5 Quick sketch thumbnails by Dan Antkowiak of Animatics & Storyboards, Inc. These sketches are good enough for production boards.

Figure 9.6 Travis Blaise digitally duplicated the first frame and just had to redraw Timmy's expression in these boards, saving him time. (© 2005, A&S Animation, Inc.)

hatching. It costs too much and takes too long to make color or tone copies of production boards. However, more and more copiers do a great job with grey tones, and digital and scanned boards can be printed on fast printers. The caveat is that most printers are far slower than copiers and are less likely to be used for multiple prints.

One thing to remember in storyboarding is that there is no such thing as cheating. While it is better and faster to be able to draw out of your head everything from every angle, few of us are capable of that, and we need references at times. Ask production for location,

actor, and vehicle references which have been approved. Search images online for references. Look in a mirror, take digital pictures, anything you need to properly represent the images and action on your boards. If you need to trace a complex object to make it look right, go ahead.

Some boards use a repetition of shots that the director will keep cutting back to. You can copy and paste the original image. You can cut and paste elements of other drawings. Use Photoshop, Illustrator, or Corel-Draw to add text and perspective to elements in your boards.

Figure 9.7 To reframe a shot, simply draw in the new framing and scratch out the old frame. NASA Seals panel by Mark Simon of Animatics & Storyboards, Inc. (© 2006 DAVE School.)

If the client asks for a wider shot, draw a new, wider frame over your initial panel and scratch out the original frame. If they want a tighter shot, just sketch a new, tighter border. Anything you can do to enhance the speed and look of your boards is OK.

Clients tend to like the look of storyboards where the art breaks the frame. It adds energy to the art. This can also help show that a character is entering or leaving frame, and action arrows often need to extend out of the frame to be clear.

The quality of your finished line is important. You don't have to waste a lot of time making a perfect line, but control of how you sketch the line and consistency in your crosshatching can make a big difference in how good your art looks.

Notice how, in Figure 9.10, the line sample on the left looks jagged and rough and not pleasant, while the line on the right has a richness to it, even though it's not a smooth line. Crosshatching takes control. Even when doing it quickly, there needs to be a consistency to it, or it will look messy.

The best way to learn this is to just practice sketching crosshatches in different shapes. Try this whenever you doodle. Crosshatching looks best when it all goes the same direction throughout an image.

The best way to get better and faster at storyboards is to simply draw fast, constantly. Do sketches of people and animals in motion. Restrict yourself to quick sketches only, not long, detailed illustrations.

Figure 9.8 Josh Hayes storyboards from the *Close to Home* television series. When art breaks the frame of the panels, it increases the energy of the art. (Images courtesy of Warner Bros.)

Figure 9.9 Crosshatched panel by Josh Hayes. Notice the fluid line quality and the even direction of the crosshatching.

Figure 9.10 Notice how the panel on the right, by Alex Saviuk of Animatics & Storyboards, Inc., looks more professional. The line quality is better and the crosshatching is even and consistent. The example on the left just looks messy.

Figure 9.11 *Timmy's Lessons in Nature* quick panel sketch by Travis Blaise. Even the quick sketch shows talent, motion, and character.

CHAPTER 10

Storyboard Coloring

There are a few main processes for coloring storyboards. What had been the most popular method for coloring boards, using markers, is quickly being replaced by digital coloring, using programs such as Adobe Photoshop, Corel Painter, Flash, and Mirage.

While most storyboards continue to be hand-drawn on paper, or with graphics tablets, some are now being produced via computer clip art and 3D programs such as Storyboard Artist, FrameForge 3D Studio, Storyboard Quick, and a few others. Most of the library elements in these programs are precolored. Some programs allow you to adjust lighting, some don't.

The other main form of storyboard coloring involves using gouache or other water-based paints. Generally artists working on conceptual art for a film, games, or theme parks are the only ones working with paint. Painting is far too slow of a process for most productions and too expensive for production boards.

One of the reasons coloring with markers is so popular is that it is fast (Figure 10.2). Coloring with a marker can be faster than coloring on a computer. Artists will choose a skin color or a shirt color and quickly lay that color in across the entire scene they are boarding. Then they will choose the next color and go through the scene again. This is much faster than coloring one frame completely and then rechoosing all the colors for the next frame.

Figure 10.1 Storyboard by Larry Jones.

Figure 10.2 Coloring with markers is faster when you go through an entire scene with one color before you move onto the next color.

Figure 10.3 Pantone markers have three different tips for broad, detailed work.

Easy access to copiers, scanners, and laser printers has made life easier for artists coloring with markers. Coloring is often done on toner copies or laser prints instead of on original art. Markers will make original pencil art bleed and blur. Markers will also smear when used on inkjet prints.

Copiers and printers make our lives easier because we no longer have to ink our boards before coloring them. We just scan or copy our pencil art. Markers generally do not affect the toner from copiers or laser printers. The one exception is older-style markers that have a heavy smell; these can sometimes smear toner.

Scanning and printing your storyboards before coloring may be better than using a copier because you can adjust your levels, brightness, and contrast with a scan in order to improve your line quality. Copying and scanning the original pencil lines usually retains more life in artwork than does inking.

When coloring with markers, it is best to start with your lighter color and then work in your darker shades and shadows. You can mix colors to get different shades and textures. Blenders, which are clear markers, may be used to lighten some areas, soften edges, and blend two other colors together.

Digital coloring is becoming more prevalent. Artists often feel freer to experiment with digital coloring because mistakes are much easier to fix than with markers. But because it is possible to zoom in on all areas of digital images, artists generally take more time with digital coloring to make each image perfect. While there are many ways of laying in and managing color, there are some useful steps worth discussing.

Coloring digital art starts with either scanning hand-drawn art or with art drawn directly into a computer. In order to draw directly into the computer, you should use either a graphics tablet or interactive pen displays, such as Wacom's Cintiq (for use with any computer), or tablet PCs, all of which allow you to draw directly on the surface of your monitor (see Figure 10.4). Drawing with a mouse is not practical.

To quickly color scanned art in Photoshop, start by adjusting the levels (Ctrl+L) of your scan so that the lines are as dark and solid as you like (see Figure 10.5). Move the white and black levels as little as possible. Adjust mostly with the gray level to keep the line quality.

Always work in layers when digitally coloring. Keep your original line art on one of the top layers in your document. The best way to convert your scanned image into a layer of line art to color is to copy the scanned background image. *Background* is the default name and position of scans in Photoshop.

Drag your background layer onto the *Create a New Layer* icon in your Layers list (Figure 10.6) and rename it *Ink* or *Lines*. Delete the original background layer. Next you want to set the blending mode for that layer to Multiply. This makes all the white in that layer transparent and the shades of gray semitransparent (although it won't be apparent until you start coloring on lower layers).

Using the Multiply trick is far superior to deleting the white from inside your drawing. Multiply maintains the anti-aliased quality of your line, you don't lose any thickness from your lines, and you have no halo around the lines. It's also faster because you don't have to delete each white area to color (see Figure 10.7). If you erase

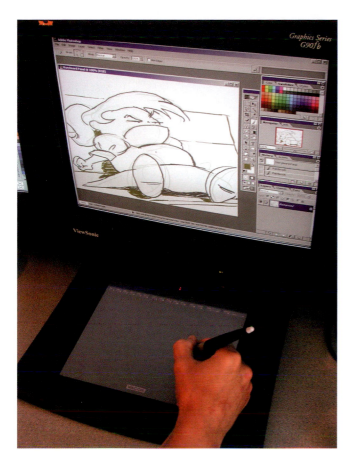

Figure 10.4 Wacom graphics tablets enable artists to draw naturally on computers.

Figure 10.5 Adjust the levels (Ctrl+L) of your pencil scans so that the background is white, the lines are dark, and the line quality is maintained.

Figure 10.6 Find the Multiply blending mode in the Layers drop-down box. Notice the "Create a New Layer" icon on the bottom of the Layers menu.

the white, you also have to erase part of the line or you get a halo effect around the lines. The lines are now aliased and not as nice.

Simply add new layers to your document (by clicking on the Create a New Layer icon on the bottom of the Layer drop-down menu.) To color under your original lines, simply color on a layer below your ink layer. Drag your ink layer to the top of the list if necessary.

When you keep your colors on separate layers (skin tones on one layer, props on another, backgrounds and sky on others), you can color your image faster and you can more easily make changes if necessary (see Figure 10.8). Make sure you properly label each layer as you work.

Once you color the foreground elements, you can simply lay in a color or texture behind them, on another layer, without having to meticulously color around every line. Client notes will be quicker to execute with this method. If a client asks for warmer skin tones, you would only have to adjust the color balance on the skin tones layer without affecting the other elements.

Figure 10.7 Using Multiply is faster because it enables you to color under the lines. It also maintains the quality of the line. Notice aliased edges, poor line quality, and no color under the gray areas of the lines on the erasing white sample.

Figure 10.8 Separate your colors into layers for easy editing and to enable you to color under other colors.

Figure 10.9 The wood floor texture was dragged into this file from another file and adjusted to fit the angle and perspective of the drawn floor area via the Distort tool in the Edit/Transform drop-down menus.

Textures can also be used for coloring. You can lay in a wood texture for a floor and twist it in perspective rather than hand-drawing the look of wood (see Figure 10.9). You can do the same with grass, bricks, marble, and so on. Whether you color digitally or by hand, digital painting programs allow you to enhance your scanned or digital images (see Figure 10.10).

Each layer can be adjusted with blur, color, brightness, contrast, and more, at any time during the coloring process. If your client wants the flesh tones to have more red, select your skin layer, bring up the color balance (Ctrl+B), and add red just to that layer.

Dodging and *burning* are photographic terms meaning, respectively, to *lighten* and to darken areas of an image. You can quickly shade or darken shadowy areas of your image with the Burn tool; you can increase or add a new highlight to an area with the Dodge tool

Figure 10.10 The Dodge tool allows you to selectively lighten areas of your photos and drawings, and the Burn tool allows you to selectively darken areas.

Figure 10.11 Original scan (*left*), adjusted levels (*center*), and dodged and burned (*right*).

Figure 10.12 Samples of different effects you can attach to text and individual layers.

Figure 10.13 Five different types of fills using the Fill tool. Select an area in your art and fill the selection with a combination of colors and transparency.

(see Figure 10.11). Dodging and burning can be done on boards whether they are colored digitally or with markers.

Glows, bevels, and drop shadows are just some of the effects that can be added on layers above or below your colored objects (see Figure 10.12). Specific areas can be filled by using any number of selection tools.

The Gradient Fill tool allows you to fill an area with two or more blended colors in linear, radial, angle, reflective, and other styles of fill (see Figure 10.13). Text can be added quickly and easily. Not only is digital text easier to read than handwritten text, but it is also great for putting text into perspective.

Client logos can be digitally inserted into commercial boards to achieve the best look. If you can't get a digital logo from the client, it should be fairly quick to find their logo on the Internet. You can also purchase CDs of thousands of corporate logos for use in production art from companies such as LogoClipArt.com, LogoTypes.ru, Lots-O-Logos.com, and others. The logo clip art galleries feature vector versions of corporate logos with transparent backgrounds for easy compositing.

The list of digital coloring possibilities is endless. It is, however, very easy to waste a lot of time adding details and perfecting the art, which may not be necessary. Part of the beauty of marker coloring is the roughness. The same effect can be achieved quickly when working digitally. It's all up to the artist.

Figure 10.14 Logos and text were warped to fit the angles of the screens and thus to look better than handwritten text. Storyboard by Dan Antkowiak of Animatics & Storyboards, Inc.

Presentation Boards versus Production Boards

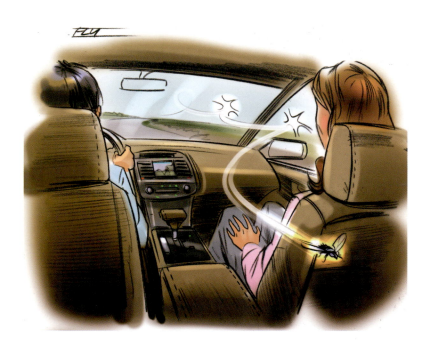

Figure 11.1 Presentation board at the *top* is by Lyle Grant, and production board at the *bottom* is by Alex Saviuk of Animatics & Storyboards, Inc.

The term *storyboards* can refer to different types of work. While not all producers and directors are familiar with the difference between the terms *production boards* and *presentation boards*, there is a difference. Presentation boards are illustrations that get across the idea of the story but not necessarily of every shot of the director's vision. Production boards, or director's boards, are boards that represent each shot that is to be filmed in a scene. These boards are the ones used by a production crew during shooting.

◗ Presentation Boards

It is important to know which style boards your client wants. If the client wants presentation boards, they don't need the action broken into every camera angle. They may only want key elements drawn out as part of a presentation for their client. The number of panels in a presentation board will always be less than the number of panels for production boards on the same project. Often, clients want presentation boards to be drawn in a larger size than most production boards (and usually in color), to enable people in a meeting to see them easily across a room and to allow for greater detail.

Clients are more likely to ask you to mount presentation boards than production boards. You may be asked to mount your individual panels onto a black piece of foam-core board. Some clients may have specific presentation formats or supplies that they use to keep their presentations uniform. Inquire about this. Mounting your storyboards allows the client to present the drawings in a professional manner to many people at once.

Ask your client whether they would also like a copy of the boards to include in their presentation package. Once you mount the storyboards, they are very hard to copy. Try to keep a set of copies ready to run through a copy machine for convenience.

Ad agencies will at times produce *photo boards*. These are presentation storyboards made from stock photo images. They will be slick and beautiful photos, but the models are not likely to be the same throughout, for it is hard to find the exact image you are looking for, and it takes a lot of time to search through photo libraries for all the images you want. Some photo boards are composited (comped) together using images from different sources. An actors head may be comped onto a sunset or in front of a new car.

◗ Production Boards

When you are drawing production boards you will need to go over every detail of each scene with the director. At times you may sketch ideas of a scene without much input, when the director is looking to you to use your storytelling knowledge and abilities to bring some fresh ideas to a project. Other times the director will give you a breakdown of every shot. Sometimes it's a mixture of both. In any case, every shot, cutaway, reaction, movement, or special effect is shown and notated on production boards.

Production boards are more likely to be rougher sketches created over a shorter period of time. They will very seldom be in color, unless the project has a very large budget and a lot of prep time. Segments of an animation may be boarded in color to get the visual feel of the color palette for a project. They are called the *color keys*. Very seldom will you need to worry about detailed backgrounds in production boards.

Artists vary in their desire and ability to render backgrounds quickly; the decision is up to you. There usually isn't time for repeatedly drawing detailed backgrounds. When great detail is desired, a *production rendering* is usually called for. This is a larger version of one of your production panels that may be fully illustrated in greater detail and color. These larger renderings usually function to conceptualize a look for a set or special effect.

On some productions, your production boards will be mounted individually on a tackboard (foam core, beaverboard, or corkboard). This allows production to move, remove, and add elements as they go through a script. In large story meetings it is helpful to be able to view an entire scene at once, instead of flipping pages of boards. Production can then carry these boards to a set or a location as a reference while shooting.

You may run into projects where you draw both presentation and production boards. During prepreproduction, the client may need presentation boards to pitch their project or idea to a client or their superior. After the project has gotten the go-ahead and production nears, the director may produce his own production boards.

Figure 11.2 Presentation/agency boards by Larry Jones, showing key moments of a commercial for client approval.

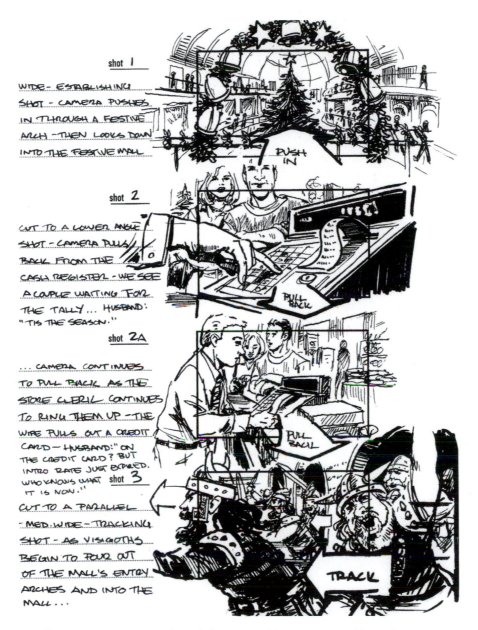

shot 1

WIDE - ESTABLISHING
SHOT - CAMERA PUSHES
IN THROUGH A FESTIVE
ARCH - THEN LOOKS DOWN
INTO THE FESTIVE MALL

PUSH IN

shot 2

CUT TO A LOWER ANGLE
SHOT - CAMERA PULLS
BACK FROM THE
CASH REGISTER - WE SEE
A COUPLE WAITING FOR
THE TALLY ... HUSBAND:
"TIS THE SEASON."

PULL BACK

shot 2A

... CAMERA CONTINUES
TO PULL BACK AS THE
STORE CLERK CONTINUES
TO RING THEM UP - THE
WIFE PULLS OUT A CREDIT
CARD - HUSBAND:" ON
THE CREDIT CARD? BUT
INTRO RATE JUST EXPIRED.
WHO KNOWS WHAT **shot 3**
IT IS NOW."

CUT TO A PARALLEL
- MED. WIDE - TRACKING
SHOT - AS VISIGOTHS
BEGIN TO POUR OUT
OF THE MALL'S ENTRY
ARCHES AND INTO THE
MALL ...

PULL BACK

TRACK

Figure 11.3 Production boards for a Capital One commercial by Josh Hayes.
Every shot is illustrated, and directors notes are written in.

CHAPTER 12

Live-Action Boards

Live-action productions often make use of storyboards, but seldom (except for commercials) for every shot. The most important elements to storyboard are special effects and stunts. Those boards are used for budgeting and scheduling. If time permits, then special camera moves are boarded.

Figure 12.1 Commercial storyboards by Peter Ivanoff.

In any sequence of shots, there are always fairly normal shots in between effects shots and stunts. These normal shots will also be boarded to make sure that the action edits together properly.

The amount of storyboarding on a live-action production is usually determined by the available budget. Producers and production managers predetermine how much they want to pay for storyboards in many productions. You then start with boarding the most important shots and work until you've used the budget. Then the director begs for more boards and you work a little longer.

Commercials tend to be completely boarded. There may be many sets of boards for each commercial. I have often drawn the agency pitch boards and was later hired by the production company to draw the production boards as well.

Since commercials generally cost the most per second of any form of production and clients are very particular about how their product is shown, every shot counts and is boarded.

The bigger the film, the more storyboarding there is. Some large films have anywhere from two to five storyboard artists working from three months to a year. Sometimes the director creates his or her own thumbnails to give to the storyboard artist, and sometimes the artists are left on their own to work out certain sequences.

Television uses storyboards less frequently. This is due more to the speed at which production moves than anything else. Scripts are so often being finished as the shooting is happening that it doesn't leave a lot of time for storyboarding.

Effects series, such as *seaQuest DSV*, sometimes do extensive storyboards (see Figure 12.3). I worked on the staff of the *seaQuest* series during production. *The Cape* and *Second Noah* only needed boards for certain episodes, and I was just brought in as needed.

Figure 12.2 *Lonely Hearts* feature storyboards by Alex Saviuk of Animatics & Storyboards, Inc. John Travolta is one of the stars, and Alex drew the character in the bottom panel to look like Travolta.

Figure 12.3 *seaQuest DSV* storyboards by Mark Simon. (© by Universal City Studios, Inc. Courtesy of MCA Publishing Rights, a Division of MCA, Inc.)

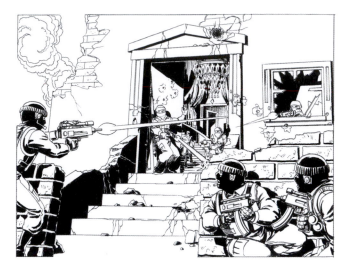

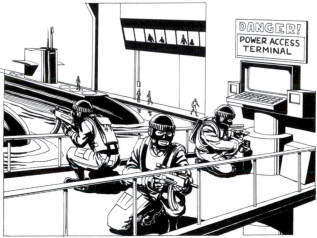

Figure 12.4 Video game cinematic boards for *Seal Team* by Mike Conrad of Radical Concepts, Inc.

Music videos use boards only when there are big effects. Many music video directors have an overall idea of what to see but don't break down the shots. They

just shoot the entire performance in each set or location and then spend a lot of time editing.

Video games are heavily storyboarded to work out the story and continuity. Games based on live-action movies are also including more video segments within the game play, and those segments are usually boarded out as well so that they can be planned within the movie shoot.

Some live-action productions think they don't have enough of a budget for storyboarding. The opposite is usually true. A lack of storyboarding will typically result in miscommunication, lost time, and lost dollars—more than the boards would have cost in the first place.

CHAPTER 13

Animation Boards

While the elements of telling a story in a visually exciting way are common to both animation and live-action boards, animation boards involve a number of elements all their own. Since animation is created frame by frame, storyboards are inherently more important here than in live action. Every scene, every shot, every action must be boarded out to act as a blueprint for the layout artists and animators.

As many differences as there are between live-action and animated boards, most of the chapters in this book are relevant to both. Proper storytelling and dynamic visuals are important in every format. Use of arrows, numbering, camera direction, and every element listed in Chapter 24, Staging and Composition, is just as important in animation.

While live-action boards are used mostly for portraying special effects, stunts, and fancy camera moves, animation boards are very much about acting. Animation boards can seldom get away with not showing characters' reactions, how they walk, or how they chew food. Just as in a live-action show, how characters act and what idiosyncrasies they have are what attracts the viewers. Acting is what makes an animation come alive.

Figure 13.1 *Felix the Cat* storyboards by Dan Danglo, FTCT, Inc. (© 2006. *Felix the Cat* images and storyboards provided courtesy of Don Oriolo, Felix the Cat Productions, Inc.)

The quality of the acting portrayed in storyboards becomes increasingly important as more animation is done overseas (see Figure 13.2). Commercials, because of their larger budget per second of animation, are still produced mostly in the United States. But half-hour animated series, with much smaller budgets, are generally drawn in other countries.

Although doing the animation may be less expensive overseas, one potential problem stems from language, cultural barriers, and misinterpretations. Quality storyboards limit these potential problems. What you see (storyboards) is what you get (finished animation).

Animators overseas will draw exactly what they see on the storyboards. If your boards show a scene where a character has no reaction to something, the animators may draw it that way too. You can't assume the animators will know to frame a shot differently. They are told to draw exactly what's on the boards. The boards are the blueprints.

Television animation storyboard artists generally have to be more flexible in their artistic style than live-action artists. Because each animated series has a very specific look, the storyboards should match that look. An artist's style is often cast just as an actor would be. Since the boards sometimes act as key-frame animation (the extreme poses of a character), they should look like the finished product. The boards don't have to be tight renderings, but the characters in a *Batman* episode shouldn't look like those in *Foster's Home for Imaginary Friends*.

Some animated series use both rough storyboard artists and clean-up storyboard artists. The rough storyboard artists concentrate on breaking down the shots and setting up the action. The clean-up artists tighten the drawings and make sure the characters are all on model.

The storyboard supervisor on a series oversees all the artists and gives visual notes on the boards to keep them all similar in storytelling style.

Feature animation storyboards artists seldom worry about style or drawing characters on key (exactly like the final design). Features seldom have final character designs during the boarding process, plus most features don't have the same overseas issues as television productions.

When my company, Animatics & Storyboards, Inc., was trying to make a deal with Sunbow Entertainment to draw some of the boards for a new Nickelodeon series, *The Brothers Flub*, we looked through the samples of our different artists. I had found some visuals for the *Flub* series and one of our artists had drawn some other boards that looked just like the *Flub* art. I

Figure 13.2 *Howl High* storyboards by Mark Simon. Acting is very important in animation boards. (© 2006 A&S Animation, Inc.)

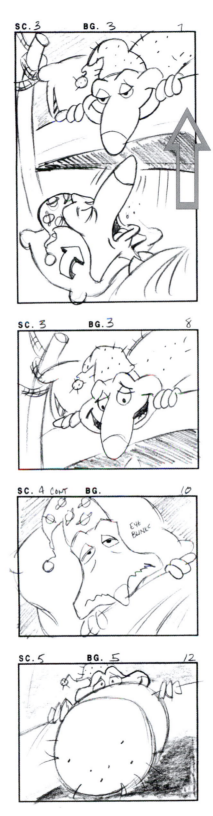

Figure 13.3 *The Brothers Flub* storyboards by Wolverton of Animatics & Storyboards, Inc. (© Sunbow Entertainment.)

Good action & good silhouette

Good action & bad silhouette

Figure 13.4 *Timmy's Lessons in Nature* storyboard by Travis Blaise for A&S Animation, Inc. Notice how the top line shows a clear action with a clear silhouette. The bottom line has almost the same action, but the silhouette is unclear, so the action would be harder for the audience to read. (© 2006 A&S Animation, Inc.)

showed those samples to the production manager and we were able to land the job for that artist.

Since every action and every shot needs to be storyboarded in animation, there are hundreds of panels per episode. An 11-minute cartoon may have as many as 600 storyboard panels. For a half-hour episode, which is usually 22½ minutes of animation, there may be 800 to 1,200 storyboard panels. An artist will generally be given around six to eight weeks to complete the boards for an entire half-hour, including revisions.

An animation director may go over notes with a storyboard artist prior to drawing out the boards, or an artist may be left totally on his own to interpret the script. Many times the director of an animated series is the voice-over director. Storyboard artists usually direct the visuals. The board artists are normally given a set of sample boards to demonstrate the look and action of the series.

A director, producer, or storyboard supervisor will look at the boards after the first pass and make notes on action, acting, and direction. The storyboard supervisor may be the only contact a storyboard artist has on

a project. The artist then makes whatever changes are necessary and delivers the final boards.

One thing that greatly helps storyboard artists is the actor's recorded audio. Some shows supply rough audio of the actors to the artists to listen to prior to drawing. This is very helpful, because an actor's inflection of a line may have a totally different mood or attitude than you thought when you read the script.

In one episode of *The Brothers Flub*, we went back and changed a number of panels after we heard the actors. The line was "I will beat him in a battle of the brains!" We had boarded the character saying this like he was really angry, but the actor recorded the line with a cocky attitude. We had to change the acting in the boards to reflect the recorded attitude.

In laying out animation boards, keep the character silhouette (the backlit outline of a character) in mind. The stronger the action looks in silhouette, the better and clearer it will look in the finished animation.

Animation boards don't need full backgrounds in every panel or even detailed character drawings. The panels usually have only the background elements

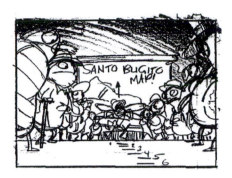

Figure 13.5 *Santo Bugito* storyboard. The first panel shows all the characters and the background. Only the main character moves, so to save time everything that does not move is not drawn again but is represented by the term S/A ("same action").

sketched that are needed, either to place the characters into the scene, or for the characters to interact with.

When there are a number of characters in one shot, the first panel may show all the characters in their poses, but in following panels any of the characters that remain static may only be represented as outlines, or sometimes not at all. When a character is stationary and only an outline is used, the letters S/A (for "same action") are sometimes placed in the outline. This helps the animators know which character to concentrate giving motion to (Figure 13.5).

If a character has some minor motion that needs to be shown, like an arm moving up or down, separate panels are not always needed for each extreme. Two extremes may be shown on one drawing, with an arrow or numbers indicating the motion path. Some artists also sketch the change in motion just under a panel. For instance, if you have three characters on the screen and one raises an arm, you may have just one panel of the three characters standing there. Just under that panel may be a smaller sketch of the one character raising his arm.

Animation scripts probably won't have numbered scenes on them. It's important to number your boards for easy reference. Final scene numbering will be handled by production sometime during the preproduction process. In 3D animation live-action, scene numbers advance each time there is a change in location or time. In 2D animation, background changes signal a new scene number because new backgrounds have to be drawn for each shot. If you have a wide shot, cut to a close-up, and then go back to the first wide shot, that's actually three separate scenes in 2D animation.

Some animation productions ask for each shot to start on a new page. You may have lots of blank frames on the pages, but this helps the studio when handing

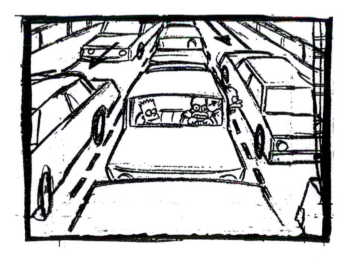

Figure 13.6 The two positions of Homer Simpson's head are shown in one shot. The arrow dictates starting and ending positions. (*The Simpsons* board, © Twentieth Century Fox Film Corporation. All rights reserved.)

Figure 13.7 Storyboards from *Santo Bugito*. Notice how the sketches below the storyboard frame show the action of one character's hands. This saves having to redraw the entire panel two more times. (© Klasky Csupo.)

Figure 13.8 *Santo Bugito* storyboard. The wide artwork shows a pan up the street following a tumbleweed and then a slight push in toward Carmen's. Indicating this framing on one panel helps production understand the action. (© Klasky Csupo.)

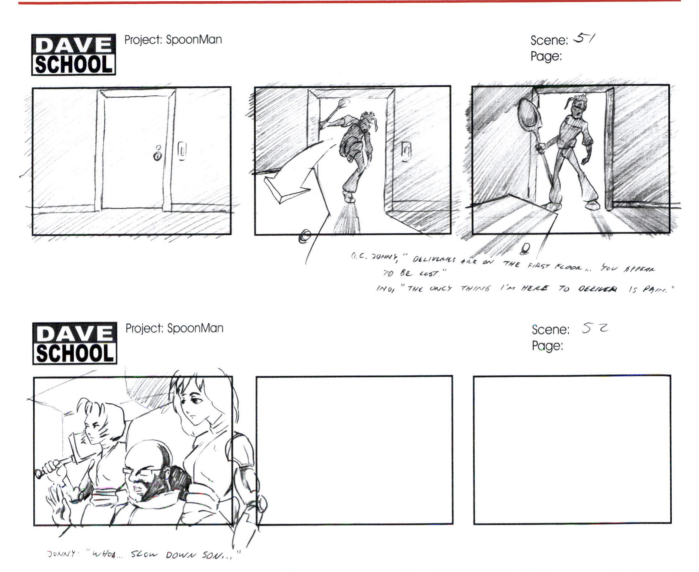

Figure 13.9 *Spoonman* storyboards by Mark Simon for director William Vaughan of the DAVE School. Each page contains the panels for only one scene, making it easier to give assignments to the animators.

out scenes to their animators. This way, the only information given to each animator is his scene. It also helps keep it clear when there is a cut to a new scene.

Action descriptions and the full dialogue need to be written under the storyboard panels. It is important for the animators to know where the audio goes in the action for all production personnel to be able to follow the story.

For those of us who dislike hand lettering, you can copy the script, cut out sections of the dialogue, and tape them to your boards.

An animated television series may have as many as 12 to 15 storyboard artists working simultaneously.

Each artist will work on one episode at a time. If one artist were to try to draw the entire series, it would take years just to complete the boards.

On a feature animation, the first sets of boards are generally very rough. These are used to get a flow of the story without taking up much time. As the story develops and characters are designed, the storyboards will start resembling the approved character designs.

Animation boards become plans for all the key animation. Most extremes are represented. Animation is so time-consuming that proper planning of every shot saves not only a great deal of money, but also a great deal of time.

Figure 13.10 Beat boards from the animated film *Tugger, The Little Jeep Who Wanted to Fly* by co-creator and director Woody Woodman.

CHAPTER 14

Gaming and Multimedia Boards

Games are becoming more popular every year. These are prevalent on gaming systems, computers, mobile phones, the Internet, and handheld devices. For the most part, the elements in games are all animated, so they need to be storyboarded. But storyboards serve an even bigger part of games, for they also act as a map or flow-chart, to organize the complex structure of any multimedia production.

Figure 14.1 *Baja Race* game storyboards by Mike Conrad of Radical Concepts, Inc. Produced by Mediatech for Lockheed Martin.

Many gaming companies do not hire someone just to do storyboards. Often the game designer will sketch his own boards. Cinematic artists are called on not only to sketch storyboards but also to produce 3D scene files and 3D camera movement and to work in Adobe Premiere and Adobe After Effects. Some studios skip hand-drawn boards altogether and simply use their 3D assets to build 3D animatics that are edited together for timing.

Storyboarding a game is much like a flowchart for any multimedia project, except with art, and not just text. Storyboarding a game helps organize animation, graphics, navigation, and game play. Many times it is the lead designer who does the interactive storyboards.

Storyboards are also used for cinematics. *Cinematics*, also known as *cut scenes*, are, the mini-movies that play before and during some games that offer no interaction. They can be animated or live action. They help the flow of the game story. The boards for cinematics are exactly the same as boards for other animations.

In the interactive portion of games, not only do storyboards show the animation, but they also describe each interaction and the multiple results possible. For instance, a storyboard could show a character being shot. The actions could be:

A: Not much happens to the character on the first shot.
B: The character is injured.
C: The character is killed.
D: The character wins.
E: The character could fight back or die or run away.

The result of each action also needs to be planned. After each of the previous actions, any of these results could follow:

A: Action continues.
B: Game ends.
C: Character dies, loses a life, and then comes back and continues.
D: Player goes back to an earlier start point.
E: A different sequence follows, depending on the action.
F: A brief cinematic occurs showing the result.
G: Something blows up.

There may also be differences in actions and reactions according to the difficulty settings of a game.

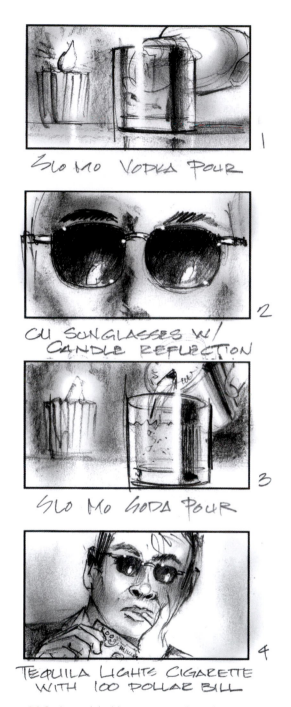

Figure 14.2 *Stranglehold* game storyboards by Janimation. (© 2006 Janimation, Inc.)

Some games may have completely divergent paths from any number of points in the game play. For instance, a movie is very linear and moves from the beginning to the end. In game play, the player could choose to go up the stairs or around the stairs. Both options need to be boarded.

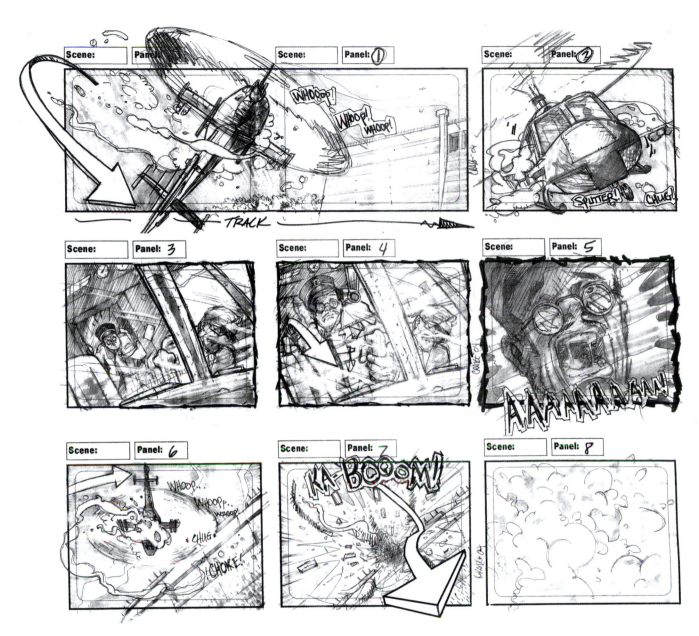

Figure 14.3 *Ghost Recon 2* game storyboards by Craig Gilmore for the game finale.

As in any other form of animation, the storyboards act as guides to the production crew as to how the characters will move, such as their signature fight moves, or what the locations are like.

Since many games allow the viewer to control how and where a character moves, the boards do not necessarily dictate specific directions or camera views; rather, the boards show interaction and game navigation. A character may need to jump a moat. The action is what's often important, not the angle at which the player sees it.

The more options designed into a game, the more complex it is and the more important it is to have it completely flowcharted and storyboarded.

CHAPTER 15

Live-Event and Theme-Park Boards

Theme parks and live events (event boards) differ from film and TV because they are environments to be experienced and are not projected on a screen. There is no defined size or format for event boards. However the artist wishes to portray actions and designs of an area is fine, as long as it suits the client's needs.

Each illustration may be designed to take advantage of the angle that best shows the elements being portrayed. You do not have to be concerned with camera placement or direction.

Event boards need to show the key scenes. They are not broken into individual shots. These key scenes are used not only for development but also to gain approval from a board of directors. Some key illustrations also become marketing images for upcoming attractions. They may even be displayed in theme parks to entice patrons to come back and see the finished product.

While production boards tend to be rather small and quickly illustrated, event boards are usually larger and more detailed and take longer to produce. Event

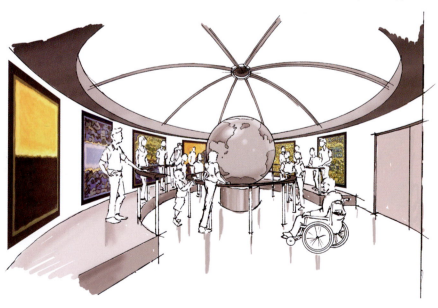

Figure 15.1 *Experiencia* exhibit in a Puerto Rican church. Illustration by Mark Simon. Design by Mike Carwile. Produced by Convergence.

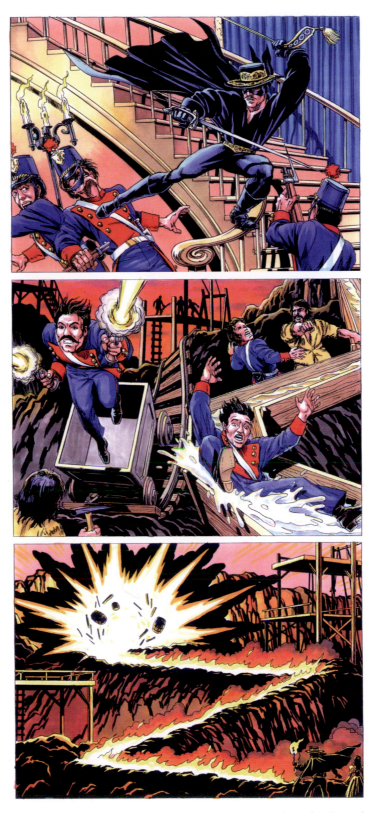

Figure 15.2 *Zorro* live theme-park show illustrations by Mike Conrad.
Concept produced by Renaissance Entertainment.

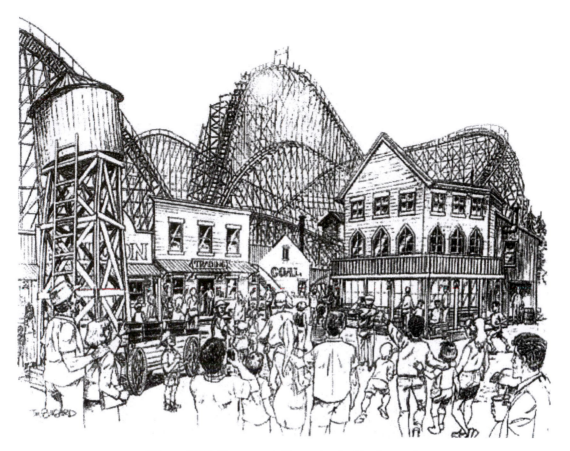

Figure 15.3 Theme-park illustration by Tim Burgard.

boards are often illustrated or painted. The good news is that you can also charge more for them.

Clients also like to have event boards show audience reaction. Sometimes that means illustrations of people within the environment, though the audience is usually shown from behind as they react to the main visuals in the illustration.

The single biggest problem with event boards is that most companies make the artists sign nondisclosure contracts to work on them. It is understandable, considering the amount of money theme parks spend on new attractions, but it makes it hard for artists when they can't show their latest and greatest pieces in their portfolio. Some artists will show portions of their event board illustrations to indicate the quality of their work without disclosing the important elements of the attraction.

CHAPTER 16

Laser-Show Boards

Figure 16.1 *Rock Lobster* laser storyboards for projection onto a dome. Notice the flyout area on the bottom. That's the sweet spot where the viewer's eyes are most comfortable looking, although animation covers the entire dome. Storyboards by Willie Castro. (© AVI.)

Laser light shows are a growing industry. Like many other types of productions, sometimes they tell a story and other times they are abstract images used to enhance music at some kind of event. Laser shows can be seen in planetariums, large theaters, and many live sport or performing events.

Two styles of laser shows are handled in totally different ways. A laser show that is projected onto a flat surface is designed and storyboarded much like normal production. The three most common laser show storyboard formats are 1 × 1, 1 × 2, and 3 × 4.

The other style of laser show is projected onto the inside of a dome. Because of the curvature in a dome, designs of visual movement and of individual elements are different than of those projected onto a flat surface. Straight lines need to be curved to look straight when they're projected onto the dome.

There is also what's known as the *sweet spot* in a dome; that's the area where the eye is most comfortable looking. Most of the action will take place within that spot. In storyboarding for laser shows, you will board the entire dome, but the sweet spot is shown as a *flyout* to allow the artist to draw the most important elements larger.

When boarding laser shows, the storyboard artist often acts as the director, along with the show's producer and sometimes the client. For corporate events the show design is bound by the client's specific requirements.

Theme park laser shows often combine story elements with abstract design. Laser shows in parks and science centers tend to have the most creative freedom. While the main elements of laser shows are storyboarded, a number of the elements come together during production. Abstract images and timing to the music are often added and changed in the production studio with the producer.

Laser shows have to have simple images (see Figures 16.2 and 16.3). Lasers can only reproduce so much line work before the image starts to vibrate and become distracting. Laser lines are in only one width, and there is no shading. Imagery is often repeated and resized throughout a show.

While these simple line drawings can be animated, simplicity is the key. These design elements need to be adhered to when storyboarding.

Laser shows are a medium for which knowledge of the laser industry is a must. The limitations of the science must be designed to and used to their best advantage.

Figure 16.2 *The Yellow Submarine* laser light show storyboard. Notice the simple line work used so that the laser can better track the image. Storyboards by Willie Castro of AVI. (© AVI.)

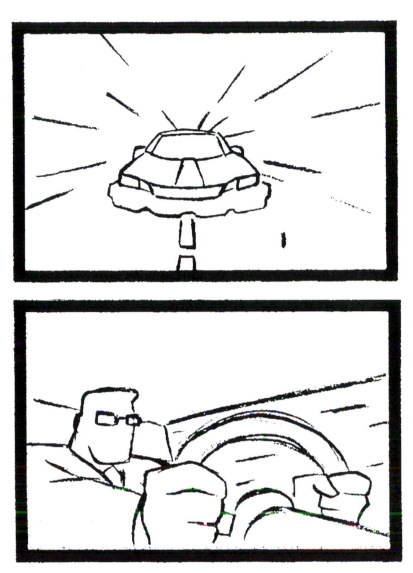

Figure 16.3 Laser storyboards produced to the music of the movie
Men In Black. Storyboards by Willie Castro. (© AVI.)

CHAPTER 17

Comps

Comps, or comprehensives, are storyboards primarily for the print medium. These are usually used as preproduction art for magazine ads and billboards. Their purpose is much like that of presentation boards: to help an agency convince a client to give them the account or sign off on a campaign. Unlike production storyboards, the quality of the art in comps is extremely important.

Comps are often cut-and-paste works of art. You may render a vehicle, cut it out, and paste it onto a separately painted background. You may also place *greeked* type into your rendering. Greeked type is a term for a series of nonsensical letters or a series of horizontal lines mocked up to look like a typed page or paragraph that doesn't really say anything. Greeked type functions to focus the client's attention on the layout, not on what's written. The following paragraph is greeked text.

Uaerh kjhsi ih sohoht ikhsoie h
oshoi. Tlkjo soi s os oijs oiek noksn
oksdokjfheh lalsk,
soisje t soi soijdhhg oid
wh dosj, sokjdoj gosor ks soid r sl. Ds os dof
oiiso: sojhg osij thso soioihs hed.

The paragraph in Figure 17.2 is a graphical representation of "greeking" the look of text. Figure 17.3 presents another example of greeked text.

Figure 17.1 Truck comp by Peter Ivanoff.

Figure 17.2 Graphic sample of greeked type used in layouts to show how a finished piece will look with text.

Figure 17.3 Comp art for a mail advertisement. Notice the greeked lettering on the envelope. Comp by Alex Saviuk.

Figure 17.4 SUV comp by Lyle Grant.

Figure 17.5 Doner Progressive billboard comp by Larry Jones.

For years, the primary rendering tool of choice for comps has been markers, although computers are being used more and more. Comp artists may use a combination of markers, colored pencils, airbrushing, and gouache to achieve the desired visual effect. Many artists will also use Adobe Photoshop to color and manipulate their drawings. The tools you use are unimportant; you just need to present a great piece of art to your client that gets across their ideas.

The main person a comp artist will work with is the agency art director. The art director will supply you with a rough sketch of what she is looking for along with instructions. She will typically tell you the look of the backgrounds and sometimes the colors she wants. She should also provide you with some references for the project. She will be the one to approve your sketches before you go to finals, the completed artwork. Agencies

look for comps to be visually exciting, so it's up to the artist to take the art director's sketch and improve on it, not only in the quality of the art but in the layout as well.

Since the comp is presented to a client, it is imperative that you make the product look as good as you can. You will need to work quickly, for the turnaround time is usually one day. It will take experience to work quickly and supply the agency with the quality they require. You should remember that comps are not supposed to be pieces of finished art, just giving general idea of how the ad should look. It is easy to add too much detail and to let the job end up taking too much of your time.

Once the comp is approved, your work may be done. There are times when the comp artist gets to illustrate the finals as well. You know the comp was successful, at least for you as the artist, when the art director likes it and she keeps calling you to do more.

CHAPTER 18

Animatics

Animatics, in a word, are video storyboards. They are a way to see the final project in motion before going through the expense of actually shooting or animating it. Animatics can be as simple as an edited video of static storyboard frames, or as complex as limited-motion animation.

The term *animatics* has been blending into the term *previz*, or *previsualization*. However, previz has become the next stage in animatics, adding camera moves in 3D and providing camera and set information to the crew. (See more on previz in the next chapter.)

Simple animatics take the original storyboards and either digitize them or shoot them with a camera. The frames can be edited together in time to the audio, with or without panning and zooming in to the art. Complex animatics can be thought of as storyboards that have moving parts. They use artwork made up of several pieces that may be manipulated to provide a simple animation.

Animatics are often used to test a proposed "spot," or commercial, or sequences of a movie or TV show. They are also used as inexpensive television pilots and for design and timing of special effects.

If you've ever been asked to preview some commercials and saw beautiful illustrations that moved along with a soundtrack, you've seen an animatic. Some

Figure 18.1 Jeep animatic frame illustrated and composited by Mark Simon of Animatics & Storyboards, Inc. Agency, BBDO Detroit. (Compliments of DaimlerChrylser Corporation.)

production companies, such as Nickelodeon, may use animatics to test a show without going through the expense of producing an entire pilot. This test show is then shown to sample audiences around the country to gather feedback, which determines whether the network will invest in the show or not.

A complex animatic will usually consist of backgrounds and moving elements on each background as well as some limited effects and a soundtrack. The moving elements on the background will be cutout figures or objects that can be moved around the background. A figure may also have different moving parts, such as arms that swing or legs that move. If a character moves his head, there may be two different drawings—one with his head looking in one direction and the other with his head looking in a different direction.

The animation in animatics is much the same as Flash animation, in that characters are broken into elements that are moved around instead of being redrawn. Many high-end animatics also use morphing to smooth the transitions between the drawings.

If a client needs printed storyboards along with an animatic, it's usually best to generate the final storyboard frames from the animatic.

The testing of animatics has become popular because the advertisers involved desire greater test marketing before going through the expense of a full production. Agency art directors also get to see how the finished commercial will actually look and can make the changes they feel are necessary for the final project. Once the animatic is cut together, not only do you get to see the final result, but you also get a clear

Figure 18.2 Jeep animatic frame layers and timeline composited by Mark Simon of Animatics & Storyboards, Inc. (Compliments of DaimlerChrysler Corporation.)

understanding of the strengths and weaknesses of the concept.

Once the animatic has been drawn, shot, scored (music and voices), and edited, it will be tested in malls or in focus groups. These focus groups may be asked to watch a reel with a number of commercials or shows on it. Some of these commercials may be animatics. Afterwards, the test subjects are asked what they remember or think of the different things they saw. If the message behind the animatic is properly conveyed to the group, it stands a good chance of becoming a finished commercial.

Pricing art for animatics is dependent on the complexity of the project, how long it is, and how many renderings and characters there are. Artists usually price their work according to either the number of frames involved or how long they expect to work on the art. One background and one to one and a half cutout

characters are generally considered to be one frame. Two cutout figures and their moving parts could also be considered one frame when backgrounds are used for several scenes.

Video storyboards, or "pan and scan," are simple animatics. They have no moving elements, but the camera may move across or zoom in on the art. Films and TV shows may shoot video storyboards to edit into a show while they are waiting for the final footage or effects to be shot. On the season 2 premiere of *seaQuest DSV*, they shot and edited in my storyboards while they were waiting for the computer special effects to be completed. This was to help the editor and director plan the timing of specific scenes and the entire episode.

Computers and just a few programs are used to produce virtually all animatics. The main programs for 2D animatics are Adobe After Effects, Shake, Adobe Premiere, Avid, Final Cut, Mirage, Storyboard Artist,

Figure 18.3 Animatic background with replaceable bodies and heads.

and Adobe Photoshop. Virtually all 3D programs can be used for animatics. Frame Forge 3D Studio is one of the few 3D programs written specifically for storyboarding. While it won't (when this book was written) export movies, it will export slide shows where you can set the timing, which will play like the simplest of animatics.

Compositing programs such as After Effects, Mirage, and Shake are used for 2D and simulated 3D camera moves, animating multiple levels, compositing, and multitudes of effects. Editing programs such as Premier, Avid, and Final Cut are used for compiling your different shots, adding DVEs (digital video effects, or transitions), and adding audio. Photoshop helps you to adjust and clean up scanned images and build mattes around portions of your images. Mirage allows you to storyboard, paint, and composite all in one program.

Three-dimensional (3D) programs allow you to design and move in real 3D space. (see Figure 18.5). However, it often takes longer to develop the assets for use. Compositing programs allow you to work in a virtual 3D environment using 2D illustrated elements.

To produce animatics on a computer, the main elements you need are a fast computer and a scanner. It also helps to have a graphics pad for touching up your graphic images. Many animatics are delivered to clients as digital .MOV or .AVI files. If you have to be able to export your animatics onto tape, you need either a graphics card into which you can plug your tape recorder or a firewire connection to export the video to a digital video camera. Clients are also asking for DVDs for delivery. There are many programs that convert video to DVD.

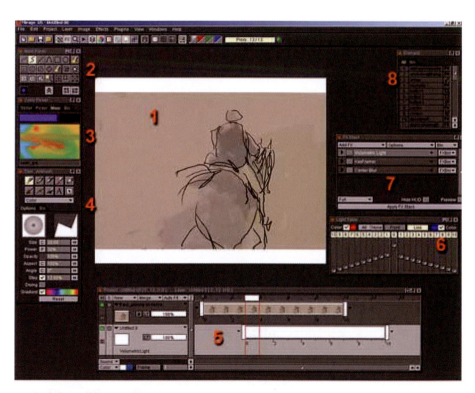

1. Interactive workspace
2. Main Panel provides all standard brush, masking, and fill tools.
3. Color Controls and Mixer, similar to an artist's palette
4. Fully configurable and customizable natural-media brushes
5. Timeline and Layer Control
6. Digital Light Table, for in-betweening
7. Mirage FX Stack, including blurs, particles, lights, and keying
8. Element Controls, for customized scripting

Figure 18.4 Screen capture and description of elements within compositing software Mirage.

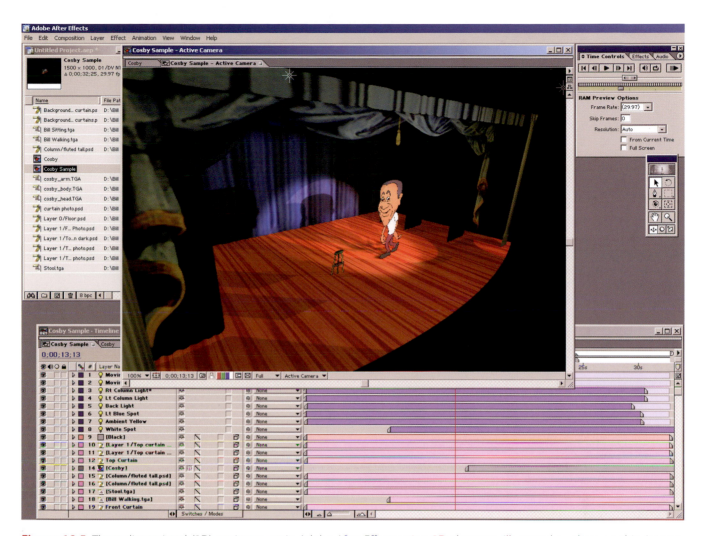

Figure 18.5 Three-dimensional (3D) environment in Adobe After Effects using 2D elements, illustrated or photographic. Interactive lights and camera moves in 3D space are possible.

Figure 18.6 Computer video connections: SVHS and RCA analog and i-LINK digital video connections.

Once you draw all of your images, you have three choices. You can leave the image in black and white to scan (unless you drew straight into the computer) and animate; you can hand-color the images and then scan and animate them; or you can scan the black-and-white image (or draw straight into the computer), color it in Adobe Photoshop, Corel Painter, Mirage, or some other paint program, and then animate it.

In programs like After Effects you have a number of options for editing, arranging, and manipulating your images. You can choose from a number of digital effects and dissolve and tweak each one to your own liking. You can place any image over or under any other image and change that placement while animating a scene.

You are not limited just to using hand-scanned images. You can build images in other computer programs and import them. Photos can be scanned for use as background or foregrounds. You can even include digitized video.

The sizes for the classic artwork used in animatics tend to range from 4 × 5 to 18 × 24 inches. The artwork can be smaller than 4 × 5, but the art may not hold up well when blown up to view on a TV screen. Anything larger than 8½ × 14 can be time consuming to draw and scan.

Digital drawings should be large enough to be broadcast resolution. If an image has to fill a frame, it needs to be at least 720 pixels wide by 520 pixels high. Images that must be larger than a frame because of close-ups and/or zooms should be scanned at higher resolutions.

On the television series *The Cape*, we had unprecedented use of all of NASA's original space footage. Much of each episode centered around a story based on existing space footage. While NASA's footage was great, it wasn't always enough to tell our story. Therefore we had to match some of the space shots with our actors and special effects.

I would sit down with the director, producer, script, and NASA's footage, and together we would figure out what shots were needed. I would storyboard the new special effects scenes, and then produce an animatic using my approved boards. The editor would then edit the animatic together with the space footage to make sure the shots all worked. This allowed the production team to produce only the shots that were necessary and not needlessly waste time and money on special effects that wouldn't be used.

Illustrating for animatics starts with doing thumbnail sketches for every scene. You have to determine what elements need to move, and illustrate them separately from the background. If a car is moving

Figure 18.7 Frames from an animatic produced for NASA's Visitors Center. This animatic combined art, photos, and video to simulate how the images would look on a video wall. Client, SounDelux. Produced by Animatics & Storyboards, Inc.

down a street, not only should you draw the car separately, but the wheels should be separate from the car so that you can spin them. The same goes for a person raising an arm. Keep the person off the background, and draw a separate arm that you can rotate.

BBDO Detroit commissioned a Jeep animatic from my company, Animatics & Storyboards, Inc. They provided us with a simple storyboard. Over the phone, we discussed what they wanted and determined what elements needed to be illustrated separately to produce the animatic (see Figures 18.8 and 18.9).

In the spot, the distant volcano is smoking. It erupts and rains rocks in the foreground. A red-hot jeep lands in the foreground, cools, and then turns and drives back toward the volcano. You may have seen the final spot on TV.

All the illustrations were drawn in pencil, scanned, painted in Photoshop, and composited in After Effects. The smoke plume was animated with three cycling images of smoke. The eruption was illustrated in six steps. The falling rocks involved two separate images that were moved in After Effects. In order to have the wheels compress into the truck when it lands, the chassis was drawn separate from the body. The color shift from glowing red to tan was accomplished in After Effects with one image. The ground was painted with a photographic texture and the clouds moved slowly in the background.

Use a stopwatch to time each action. If a character raises an arm to do something, do it yourself three times and time each take. Calculate the average and use that length of time for your animatic move.

If you have to do a camera move on a shot, make sure the resolution of your images is higher than TV resolution (720 pixels × 486 pixels for standard definition or 1920 pixels × 1080 pixels for high definition). Do all your character animation in a larger-than-you-need composition, and then *nest* that composition (place it within another composition so that it acts as one unit instead of individual elements) into a standard- or high-definition composition. This allows you to do camera moves on the entire composition instead of tracking each element one at a time.

Animatics can be as simple or as complex as you want, depending on time, money, and need. As production costs continue to increase, the need for, and value of, testing a production prior to an actual shoot will also increase.

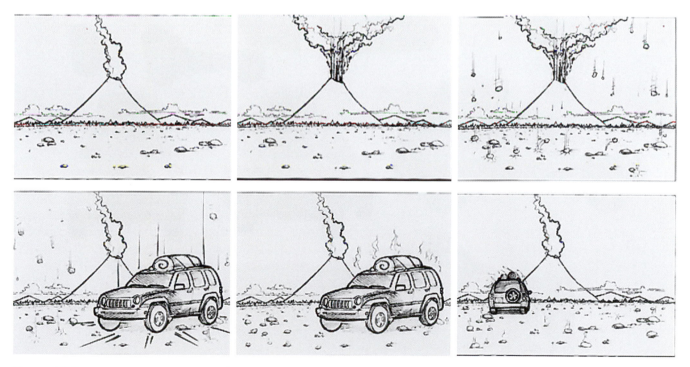

Figure 18.8 Agency Jeep animatic storyboard by BBDO Detroit and provided to Animatics & Storyboards, Inc. (Compliments of DaimlerChrysler Corporation.)

Figure 18.9 Elements for the Jeep animatic by Mark Simon for Animatics & Storyboards, Inc. (Compliments of DaimlerChrysler Corporation.)

Figure 18.10 Final frames from the Jeep animatic. (Compliments of DaimlerChrysler Corporation.)

CHAPTER 19

Previz

Previz, short for previsualization, is the popular term for 3D animatics that approximate the design and action of the final film or video and allows for camera moves in 3D space and for interactivity. Previz starts with hand-drawn storyboards, just as any other show is prepped. Classic storyboard artists are still faster and cheaper than artists with computers when it comes to quickly laying out shots. The storyboards become the blueprints for the next phase in previz, just as they do with any other animation or production.

Once production has worked out the main shots and angles on paper, it may decide to further define a series of shots, stunts, and effects. The sets and locations are built in 3D, and low-resolution characters and props are imported into the scene and moved around in a limited style of animation.

The previz allows the effects teams and director to better approximate the actual motion of the camera, actors, and objects. Speed, camera moves, and timing are hard to show in illustrated storyboards. The previz is the next step in working out timing and production requirements before production begins.

George Lucas relies heavily on the use of 3D animatics for his previz. He has used them in the development of all the *Star Wars* movies. The animatics for *Star Wars, Episode 1: The Phantom Menace* were very detailed, taking on the look of a video game. "I've done it on all my movies," says Lucas. "It's very hard for me to visualize. I'm an editor, so to me the moving image is what's important, not the frame" ("Brave New Worlds," Cheo Hodari Coker, *Premiere Magazine*, May 1999).

Previz seldom uses textures, lighting, shadows, or motion blur, because that slows the process due to render time. The animation itself is clunky, often no more

Figure 19.1 Previz from *The Matrix* by Pixel Liberation Front. (© 2003 Warner Bros. All Rights Reserved. Images courtesy of Pixel Liberation Front.)

than a stationary sprite (a two-dimensional character with transparency) being moved around the frame. As computers get faster, more details and animation are being included in the previz footage. However, the more details and animation an artist has to include, the longer the process takes. Sometimes simple things work best.

Previz can also provide production with other information. Not only are the computer-generated locations dimensionally correct, they can also provide directors with specific camera lenses, camera gear, how sets need to be built, what motions are possible, and more. Dolly moves, camera requirements, and location of dolly tracks can be printed for the crew.

Some studios use common 3D programs for their previz work, but there are some programs designed specifically for production that include camera and lens specifics. The more common programs, such as Maya and Lightwave, are used when a studio already has CG

assets built and they can use them in their previz without duplicating work.

Some cinematographers prefer working with 3D previz than with classic storyboards. They feel that 2D storyboards don't represent life limitations and don't properly represent what they can actually shoot.

Previz also allows a director to experiment with shots on a location before he actually gets to the location. The process is much like a video game, and the director can "play the game" and then save any version he likes. Video game engines are being implemented more and more for this purpose. Visual effects house Digital Domain, for instance, set up interactivity and a joystick for director Rob Cohen to previz the aerial sequences in the action movie *Stealth*.

Visual effects supervisor Rob Legato and director James Cameron have been (at the time of this writing) working on a new previz process called *virtual coverage*. They will choreograph a scene in a motion-capture

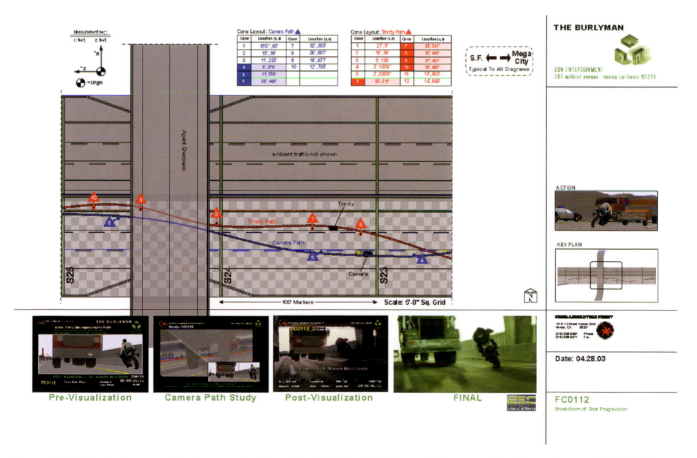

Figure 19.2 Previz plans and shot progression from *The Matrix* by Pixel Liberation Front and Eon Entertainment. (© 2003 Warner Bros. All rights reserved. Images courtesy of Pixel Liberation Front.)

Figure 19.3 Previz image from the software Storyviz.

studio in order to place the actions of the characters inside the computer.

They also shoot or build backgrounds for the scenes. Then they are able to use a camera, which is also connected to the computer, to photograph the virtual scene as they walk around on the stage. It allows them to work out shots like in live action but with the convenience of being digital, so, any camera move is possible and you can get multiple angles of the same action. (For more details about this, see Ann Fisher's article in the November 2005 issue of the *Post Magazine*.)

The approved previz shots are edited together with any live footage that has been shot for timing and continuity purposes. As each shot progresses to the next level of finish, it simply replaces the previous version until the project is complete.

For more specifics on how previz works in production, see the summary of an interview with Sean Cushing, executive producer at Pixel Liberation Front—one of the leading previz companies in the industry—in Chapter 54.

CHAPTER 20

Styles

Style can have a few meanings when you're talking about storyboards. It can refer to your particular style of drawing. For instance, two comic book artists may each have very different looks. Some board artists' drawings are cartoony and some are more realistic.

Style can also mean technique. Everyone has his or her own style and favorite techniques for drawing storyboards. Some artists prefer pencil, as I do; others use pen and ink or gray-tone markers; and others may prefer full color or handling all the illustrations digitally.

Part of the decision as to which technique to use is based on the needs of the project. Pencil boards can be rough sketches or detailed line drawings. They are

Figure 20.1 Cosmetology storyboard by Mark Simon of Animatics & Storyboards, Inc. This art has an elegant style for a cosmetic client.

Figure 20.2 *Falsons* boards by John Ryan. Illustrated digitally with Painter.

Figure 20.4 *Full Flame* storyboard by Alex Saviuk of Animatics & Storyboards, Inc. Alex has a loose style with lots of emotion and energy.

Figure 20.3 Tone storyboard by J Parris.

obviously faster to draw, so more can be completed in one day. Complex art, also referred to as *tone*, means the drawing is more than just line work. It may be finished and shaded pencil work, gray-tone markers, or color.

Digital illustration, using Adobe Photoshop, Flash, Mirage, or Corel Painter, can be extremely fast if you have a graphics tablet or tablet monitor. It also saves the time of cleaning up and scanning images.

Style can also refer to the story content provided by the storyboards. Two content styles of storyboards are narrative and image association. I often refer to these styles as production and presentation, respectively.

Production boards (sometimes called *narrative*) go over each shot in detail, dealing with each line of dialogue and action in the script. Presentation boards (sometimes called *image association*) demonstrate the overall visual feel of a project. These boards may only highlight the key action, lighting styles, or even the color usage (called the *color script* or *color keys* in animation).

Style also relates to how a story flows visually. A Steven Spielberg film will look different than a Francis Ford Coppola film. Some directors like to tell their story with close-ups, and others always have their camera moving; some hold on long shots, while others prefer quick edits. Each director has his or her own style of telling a story.

Feature films use storyboards to work out production problems and detail special effects shots. There is generally no need for more detail than finished pencil. Some segments may call for more detail than others, but quite often the time available is not enough to allow time-consuming boards to be drawn.

Certain panels of a storyboard, or the key frames, can be drawn out as a production rendering for use in approvals, construction, and effects. These will definitely have more detail and are often in color.

Commercials may ask for different styles of boards, depending on how they are to be used. Some directors like tight illustrations, while others prefer loose sketches. The benefit to loose commercial storyboard art is that the client is less likely to try to lock a production into details shown in the boards.

Boards drawn for presentation will usually be in color in a large format and may be mounted. Boards done for a director to use in production need not be more than pencil, as long as the shots are represented so that everyone knows what the director wants. Because commercials have the largest budget per second

URGENTLY CONNECTING

Figure 20.5 *Tugger* feature storyboard by Woody Woodman. A sketchy style dealing mostly with camera angle and acting, not details.

Figure 20.7 Commercial presentation board with a detailed product shot by Kevin Scully.

Figure 20.6 AHS commercial boards by Dan Antkowiak of Animatics & Storyboards, Inc. He has a rough, sketchy style.

of air time of any medium, they often can spend more on storyboards.

Television is a fast-moving industry. You generally won't have time to sit around and perfect each drawing. When you are under the gun and need to get 50 to 70 boards drawn in one day, they are likely to be rough.

Animation production boards need more action detailed in the storyboards compared to any other medium. A single action, such as a character chewing, may need three or four panels to demonstrate the humorous way the character does it.

Storyboards for animations are basically like the key frames of animation, showing each extreme action

Figure 20.8 *Cousin Kevin* TV special storyboard by Charles Chiodo of the Chiodo Bros. illustrates a cartoony style for live-action production.

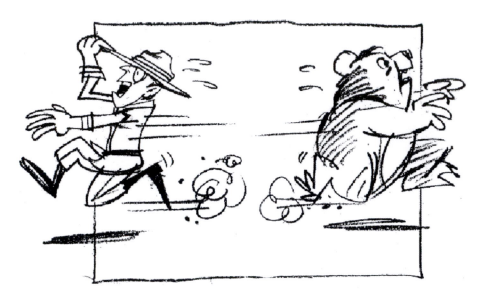

Figure 20.9 Animated commercial storyboard by Chris Allard.

of a character. When an animation is in its early stages of development, the boards may be story sketches that follow the action but do not show every key frame of action as do the production boards. Story sketches help the animation team determine and keep track of the story.

The style of your technique may never vary, but the style of storytelling will change with every project. That's what keeps storyboarding fresh and fun. As a final note, when you are talking about style with production, make sure you are all talking about the same thing.

Directing Shots

As a storyboard artist, you will often be called on to act as the director when working on a script. This is not to say that you will actually direct the crew, but you will develop shot ideas and arrange the style, look, and staging of the action. Even when the director is calling the shots when going though a script, you may be expected to offer suggestions and solutions to the action in the script. This is particularly true in animation. Television animation board artists are usually the visual directors, determining all the shots. The title of *director* almost always refers to the voice director.

Some directors have training in or a love for graphic arts and may sketch out their own storyboards. In these cases, either you won't have a job or you will be refining their boards. Steven Spielberg has been known to supply rough boards to his artists for some scenes.

Ridley Scott, Martin Scorsese, and Tim Burton also sketch their own boards. Joe Johnston, the director of *Jurassic Park III*, *Hidalgo*, *Jumanji*, and *The Rocketeer*, started as a storyboard artist. He was also one of the conceptual illustrators on the first *Star Wars*. Even Alfred Hitchcock started in the film industry as a storyboard artist.

On *seaQuest DSV*, two of our directors sketched out boards. One director, Bruce Seth Green, drew out rough boards when he was doing his shot breakdowns and did not need finer boards. This gave me more time to draw conceptual designs for the production designer. The other director, Jesus Trevino, would sketch out thumbnails of some scenes and ask me to redraw them and flesh out the action.

When you are doing your own breakdowns for a script, you need to keep in mind any nuances that a director likes to use, and what type of emotion any one scene is supposed to convey. Some directors like to move the camera and stay mostly with master shots for scenes, for example, Woody Allen. Others prefer a more hectic pace to their editing, for instance, John Woo. Action scenes tend to demand faster edits on key action. Love scenes tend to be paced more slowly, with darker, warmer colors and contrast.

You may also look for shots that are motivated. If the moon is important, show a character looking up and then have a shot of the moon (see Figure 21.3). You can also use a shot to portray the passing of time, such as showing the setting of the sun or slow-moving clouds.

It is crucial that storyboard artists understand the techniques of directing and editing. This knowledge is invaluable in allowing the artist to contribute to the flow

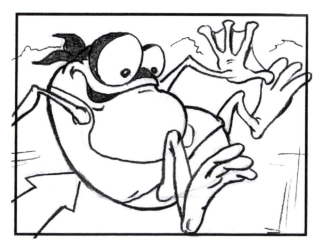

Figure 21.1 *The Creepers* storyboards by Mark Simon of Animatics & Storyboards. I directed the shots based on notes by the creators of the show. (© 2006 Lyons Entertainment, Inc.)

of a project. It is also important that the storyboard artist understand industry lingo and how shots work when a director is giving instructions to an artist. A storyboard artist will probably not be asked back if she doesn't understand the basics of directing. However, if the artist is capable of introducing wonderfully creative directing elements and adds to the visual development of the project, she will do quite well.

The lists that follow describe some concepts to keep in mind while visually directing sequences, which not only tell a story but also are visually stimulating and add movement.

Tell a Visual Story

- Cutaways help define characters. Shots of trophies tell the viewer of a character's success. Family photos help define who is who. A messy or clean home defines characters as well as the type of decorations they have.
- Lonely or scared figures shown from a high angle emphasize that a character feels lonely, scared, or separated from others by showing them alone (see Figure 21.4).
- Quick action cuts build energy in scenes.
- Romantic scenes are best edited with long cuts and dissolves—nothing abrupt.
- Use of shadows helps make scenes mysterious and scary (see Figure 21.5).
- Allowing the viewer to see things that the actors don't see can be scary or humorous. A character lurking unseen in the shadows is scary. A child acting crazy behind a parent who is describing his calm child is humorous.
- Allowing characters to completely exit frame at the end of a scene or enter a scene from off screen allows a perception of passing time. If you need a character to move a long distance from a house to her car, have the character out of frame for a moment and the audience will allow any amount of time to seem to pass.
- Looking up slightly at a character makes the character seem more important.
- Special camera tricks or angles can help tell a story if properly used, but they can also detract from the story if used for no reason.
- Looking up sharply at a character on a ledge or hanging somewhere adds peril to the scene (see Figure 21.6). The same goes for looking straight down past a character seeing a great drop below them. Looking straight at a character who is in

Figure 21.2 *seaQuest DSV* storyboards from the episode "Sincerest Form of Flattery." The director, Jesus Trevino, drew his own thumbnails, shown on top. I went over them with him and drew the panels shown here. (© by Universal City Studios, Inc. Courtesy of MCA Publishing Rights, a Division of MCA, Inc.)

Figure 21.3 Redrawn storyboards from the feature *The Walking Dead*. The soldier looking up motivates the point-of-view (POV) shot of the moon. Boards by Mark Simon.

peril up high does not emphasize why the character is in peril.

- Fast-moving objects need to pass stationary objects to emphasize speed. Planes against a blue sky look like they are just hanging there, but add clouds and mountains around them and you can see how fast they are moving.

- As you work, lay out your thumbnails and boards so that you can see an entire sequence at once. This allows you to make sure your pacing is good

Figure 21.4 *Hoot* storyboards by Alex Saviuk of Animatics & Storyboards, Inc. (Images courtesy of Hoot Prods LLC.)

Figure 21.5 Mysterious storyboard by Alex Saviuk of Animatics & Storyboards, Inc.

Figure 21.6 High-angle shot showing the peril a character is in. *The Creepers* storyboard by Mark Simon of Animatics & Storyboards, Inc. (© 2006 Lyons Entertainment, Inc.)

and that you don't reuse too many of the same shots. This is one of the difficulties of storyboarding on the computer, referencing an entire sequence in one glance.

Create Visual Interest by Varying Shots

- Use extreme close-ups to heighten emotion. For example, if a character is crying, bring the camera in to see the tears.
- Give the viewer a sense of place by using an *establishing shot*. This is a wide shot showing the layout of the location of the action. This also helps the viewer understand the visual relationships among the actors (see Figure 21.7). This is important when you see a close-up of an

actor talking toward screen right. The establishing shot tells the viewer who is to the actor's right.
- Use over-the-shoulder (OTS) shots during conversations and confrontations to give the viewer a sense of being part of the action.
- Introduce interesting camera angles to disorient viewers or make them feel uncomfortable, when justified by the script. The POV of a shot of a drunk character may be tilted to the side and swayed around to demonstrate his being drunk and off balance (see Figure 21.8). (Angles that are off the horizontal axis are called *canted frames* or

Dutch or *Chinese angles*.) Tilted angles can also intensify scenes of violence.

- POV shots allow the viewer to see what the character is seeing. And POVs always need to be motivated by first showing the character looking at something (see Figure 21.9).
- Vary the distance of your shots. A film becomes visually boring if you always see characters from the same distance.
- Mix wide, medium, and close shots in the same scene. Don't be afraid to really pull the viewer in close if it enhances the scene. Mixing different-width shots can make a scene dynamic.

Figure 21.7 The wide shot shows the viewer the spatial relationships among the characters, allowing the viewer to know who the woman is looking at in the next frame. *Lonely Hearts* storyboard by Alex Saviuk of Animatics & Storyboards, Inc.

Figure 21.8 A canted, swaying frame can show that the character is out of sorts.

Figure 21.9 The soldier looking up in the first frame motivates his POV in the second frame.

Figure 21.10 Stay clear of tangents, such as the ones shown here. Tangents draw the eye's attention away and flattens the image.

Figure 21.11 The 3D arrow shows that the bottle enters from out of frame and slides back to the man.

- Don't have any part of a character *tangent*, or adjacent to, the edge of the frame. It gives the visual impression that the edge of the frame is a wall or floor (see Figure 21.10).

Introduce Movement

- Keep the camera moving to prevent the film from feeling static. The amount of camera movement will depend on the director's style. Camera movement should, however, be used mostly in action scenes or when there is a reason for it. Camera movement should not replace good framing.
- Use 3D arrows to show movement of the camera or of a character (see Figure 21.11). 2D arrows can be misleading because they can't show depth.
- Move the camera to follow or lead a character. The viewer feels a sense of being a part of the scene.
- Pan the camera to track an object as it approaches and passes the viewer, to give a sense of what a character sees, for example, when a car approaches, passes, and recedes into the distance.
- Involve the viewer by moving into the action. For example, in a fight scene, using OTS and POV shots gives the viewer a sense of being in the middle of the action.

Figure 21.12 The wrecking ball flies right at the camera, putting the viewer in jeopardy. Storyboard panel by Lyle Grant.

- Follow an object or character to lead the camera into a scene. For instance, follow a waiter up to the table featuring your characters.
- Make the viewers feel as if they are in jeopardy by creating shots where objects or people move toward the lens. These are usually POV shots showing a character in peril (see Figure 21.12). More recently in films, debris from an explosion or accident will fly directly at the camera, making the audience want to duck. For instance, in the movie *King Kong*, Kong throws a car directly at the camera during his New York rampage.

Figure 21.13 The camera flying, with the arrow, at a man. Moments like this are memorable effects shots in movies.

Figure 21.14 The line of action is being crossed. The choppers on the left are moving camera right, and the choppers on the right are moving camera left. In back-to-back shots, objects need to move across the screen in the same direction.

- Move the camera with an object, carrying the viewer along (Figure 21.13). Kevin Costner's *Robin Hood* has a great shot where the camera rides an arrow into the bull's-eye of a target.
- Do not cross the *visual line* or line of action, which means maintain a constant sense of direction for an object or person moving across the screen (see Figure 21.14). It is disorienting to the viewer if the direction of a character or object suddenly appears to change. For instance, if a car travels from the left of the screen to the right in a chase scene and then in the next shot is seen traveling from the right of the screen to the left, the car will look like it quickly turned around. It is easy for this to occur inadvertently when shooting, because these shots may be separated by days during shooting and only appear together when edited. This is precisely the type of problem that can be prevented by using a good storyboard. Straight-on shots are neutral angles that allow movement in either direction to follow. (See Chapter 23, Screen Direction, for more information.)

CHAPTER 22

Working with Directors

Every director has a different method of working with artists. Some write out lists describing each shot, some prefer to tell you what they want to see, and others have no idea in advance what the shots are going to be. In any case, it's up to you to get all the pertinent shot information in such a way that you'll be able to accurately translate it when you're back at your drawing table.

Storyboarding is seldom a one-way street. One of your roles as a storyboard artist is to offer ideas to help the director make the best of each scene with your insight. Jesus Trevino, episodic director of *seaQuest DSV, Tru Calling, The O.C., Prison Break,* and *Star Trek* fame, agrees but cautions artists, as follows, about directors' egos.

> I think that a storyboard artist needs to be sensitive interpersonally to making the director feel comfortable about his participation. I think the worst thing a storyboard artist can do is to come in and start telling him how to shoot the sequence. I do think at the same time that a storyboard artist needs to be courageous enough to say, "You know, you might want to consider what would happen if we did this angle or that angle or if you have an insert shot of this." And I think if you convey that in a collaborative spirit, I think it would be helpful to the director.

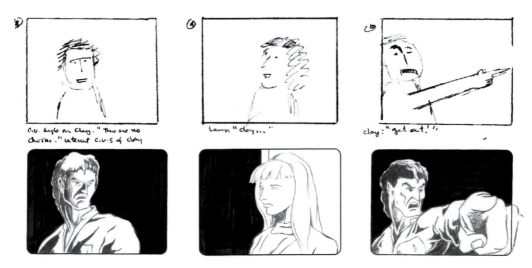

Figure 22.1 *seaQuest DSV* boards showing director Jesus Trevino's thumbnails on top and Mark Simon's below.
(© by Universal City Studios, Inc. Courtesy of MCA Publishing Rights, a Division of MCA, Inc.)

Another of your roles is to understand what the director wants and to illustrate it in the form of storyboards. It is important that you be able to communicate your ideas and understand a director's ideas. You can do this in a number of different ways. The most important way is to have read the script before meeting with the director. You need to know the overall story before you can start on the details. Another way to communicate is acting. You may act out a scene with a director. Other times you may need to sketch thumbnails, refer to movie clips, draw out shot plans, or simply explain an idea verbally.

A great way to start a meeting is by asking the director to quickly explain his vision to you. This should basically be a quick, broad pitch to give you a general feel of his visual direction.

Understanding a director's vision is sometimes like translating a foreign language. Directors communicate and visualize a story in different ways, and you need to understand these variations. Some directors may work well off of plot plans, others use lists, and some only tell you what they need. You may be lucky and have a director who draws her own thumbnails. You may run into a director who only works in concepts. Concepts are easy to misinterpret, so be sure you do everything you can to clarify what it is she wants.

If you don't understand what a director wants, find a happy medium that you both can work with. Thumbnails of storyboards help. If a director can't read plans (overhead views), don't try to work with plot plans. If a director is familiar with plans, this may be your best bet for determining blocking. If you are fast enough, nothing beats a quick thumbnail showing the framing and the blocking.

It helps to understand what a location looks like when working on scenes with a director. When possible, it's always best to walk a location with a director. However, that is often not possible. Location photos then become very important. Always ask for copies of any location photos. You can also ask the art department for any sketches or plans of locations and sets.

Some commercial directors will also use photos from magazines or stock photos to represent a look they wish to achieve. These can be invaluable in understanding what they want.

Flexibility is key. Since each director thinks and works differently, you have to adjust yourself to the particular style. If one of your tricks to get into a director's head doesn't work well, try a different approach.

One thing to be cautious of when working with directors is that some of them use the term *pan* incorrectly. Many people in production use this term for any type of camera movement. Make sure you clarify what someone is asking for when he says that the camera pans. You might hear, "The camera pans up the building." What may be meant is "The camera tilts up to show the building." *Pan* means to rotate the camera on its stationary axis. *Tilt*, in this usage, means the camera rotates its view vertically.

Another common miscommunication happens when directors talk about the size of a shot. There are very specific rules about how close a close-up is versus a medium shot and so on. Very few people stick to those rules, so it will be up to you to make sure you understand exactly how a director wants the shots framed. For example, some people look at a medium-close shot as being closer than a close-up, and others think it's a little wider than a close-up.

The best way to make sure you understand is to thumbnail the framing for the director for approval. In Figure 22.2 you see a graphic demonstrating the standard framing terminology for shooting a character.

Many directors make up camera shot lists when they are breaking down a shooting script. This is a written description of every shot in a scene. You may get a list from a director that looks like the following list. (There are a number of production terms and abbreviations in the shot list: CU is close-up, FG is foreground, POV is point of view, LA is low angle, and HA is high angle. These are explained in greater detail in the Glossary.)

- LA shot behind propeller as Wilde's boat beaches itself up toward the lens.
- Reverse. Wilde's feet drop into frame, CU, as he runs away from camera.
- Track camera left with Blaylock through the trees; see trees pass in FG.
- Track camera left through the trees with Wilde.
- Wilde's POV as he gains on Blaylok; push into a medium shot.
- Back to tracking shot with Wilde as he tackles Blaylok.
- LA from inside a gorge of the men as they fall over the ridge.
- HA of the gorge as the men fall. Pan with the men as they roll past camera down the hill.

This list is much more detailed than you may get from some directors. Often, directors tend to be quite cryptic in their descriptions. Each director is different. Try to get as much visual information as you can.

Basic Framing Heights

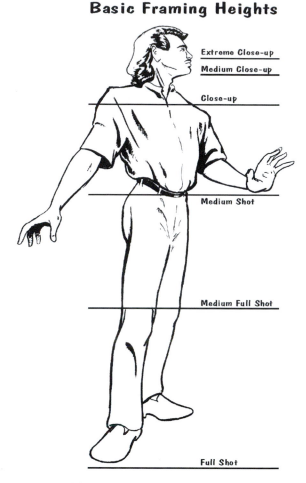

Extreme Close-up
Medium Close-up

Close-up

Medium Shot

Medium Full Shot

Full Shot

Figure 22.2 Basic shot framing.

will be going over a lot of shots with the director, and it can get very confusing when you sit down at your drafting table hours later.

The following is another director's shot list. It too was missing many important details needed to storyboard the scene the way the director saw it. Asking lots of questions about the shots is the way to better understand her vision. The storyboard artist's notes are added in parentheses. Figure 22.3 shows how the final boards turned out. (You may need to consult the Glossary to decipher the abbreviations.)

- The guy with the Mohawk runs at and past camera. (Low angle. He enters at the far end of the alley and runs right up past camera. He's wearing an unbuttoned Levi jacket. Use multiple frames to show how he runs past camera.)
- Reverse. (Low angle. He runs away from camera toward a dead end.)
- Close-up reaction. (He turns to see the car lights hitting him. Show lighting effect.)
- Car approaches. (Lights flare into lens and car is a silhouette. Canted frame. We never see inside the car.)
- Mohawk keeps running. (HA as the car chases him in its headlights.)
- He runs to the dead end. (He tries to climb the fence as the front fender of the car enters frame.)
- CU struggle to climb. (He is reaching for a handhold. We see the car in BG.)
- Reverse OTS behind car passengers. (Silhouette of guys in car. Mohawk is blinded by headlights beyond.)

The sample director's notes may break down the action shot by shot, but they leave out a lot of information that he may want in the final picture. The director may have many more details in mind, but he may not have written them down. Information that he has left out may include which characters are in which shots and in which direction the action should move. Are the characters happy or angry? Are they looking behind them as they run? What are they wearing?

This is when you need to ask a lot of questions and add your own notes to the shot list. Not asking questions will result in your having to redraw a lot of boards. You should never guess about a shot. Problems arise when the director doesn't give you as much information as he thinks he has and you haven't asked enough questions. Also, don't rely on your memory. Write everything down and you won't have to worry about whether you remembered everything or not. You

The set of storyboards in Figure 22.3 were based on the shots just described. You should refer to the boards while reviewing that shot list.

Many directors will not hand you written shot lists. Half of the time you will be working with a director who has not thought much about the specific shots by the time you meet with him. When you go over a scene to be boarded, the director is then forced to figure out what he wants to see. It is your job to capture what he says and quickly make it legible for yourself for later, when you need to decipher your notes and make sense of the scene.

Commercial director David Nixon works with storyboard artists this way: "I usually like to just give an artist my vision verbally and let him sketch a little bit. I let him start and then we hone it in from there."

When going over scenes with directors, don't worry about taking too many notes. Don't fool yourself to

Figure 22.3 Storyboards by Alex Saviuk.

think that you can remember everything a director says. Even though the shots make perfect sense and you can't see any other way to draw the scene when you're with the director, you may very well forget it by the time you're ready to draw your boards.

Between the sheer volume of shots being described to you at once (I've come out of meetings with more than 130 specific panels to draw) and the number of times the director may change shot ideas slightly as she describes them to you, it is all too easy to forget which concept was finally approved and what details were discussed. Don't feel bad about asking her to repeat herself. It's better to be safe than sorry. You may also want to repeat back to her what you've written to make sure you've understood her clearly.

You may also act out scenes with the director to get a feel for the blocking of a scene and how the characters need to interact. On the film *Wilde Life*, the director and I rearranged the furniture in his room to simulate a location. He and I jumped over the furniture and acted like kids as we developed the action in each scene. I have even used toys to block scenes. With toy cars and action figures, we can simulate a scene and view how a camera may see it.

On the film *The Walking Dead*, director Preston Whitmore III wanted his action scenes to have the look of the Hong Kong action director John Woo's films. We looked at different John Woo scenes on video and used those as a reference for how to set up certain shots in our movie.

Figure 22.4 The *top* storyboards were thumbnailed by Mark Simon during a meeting with David Nixon. The finals (*bottom row*) were drawn by Mark Simon and Dan Antkowiak of Animatics & Storyboards, Inc.

If you're sketching thumbnails, you can go over the sequences with the director to get a quick OK that you both understand the same concepts and shots.

Thumbnails are quick, rough sketches that are your best notes. If a director does her own sketches, go over them and add your own notes to make sure you understand exactly what she wants. Even with stick figures in your thumbnails, a director can look at them and tell you if the shot is what she had in mind. She may tell you she wants a tighter shot or maybe that the character should face the other way.

If the director wants a frame to be tighter, you simply sketch in a tighter frame inside your thumbnail until it's right (see Figure 22.5). If other elements need to change, you can simply write a few notes about it and change it in your final drawings. You will most likely have fewer changes if the director is able to see sketches before you finish the boards.

I suggest that you combine thumbnails with written notes. I may show the major action in one sketch, but my notes may expand on the action, which may result in more details and drawings in my finished versions. Written notes may also contain a portion of a charac-

ter's dialogue. Notes on my thumbnail sketches may show who is who in my drawing. Thumbnails may need a character's name marked on them to make it clear.

Floor plans are 2D designs of the layout of a set or location. These are also called *plots* or *plot plans*. When camera and actor locations are marked on them, they are often called *shot plans*. When a director is telling you where he wants the camera and where the actors are, it may be difficult to imagine exactly what he is talking about without reference. Use a floor plan, when appropriate, and mark out character and camera positions.

Many directors like to work with floor plans, as does director Jesus Trevino: "The first thing I do when I get on a show is get the floor plans for all of the existing sets. I'll get their floor plan, and then I'll miniaturize them, and then I'll incorporate them into my shot list."

The floor plan can show blocking and camera moves. Don't try to figure out too many shots on one plan; it quickly gets confusing. Make sure you mark each camera position in relation to the shots in your written notes or thumbnails. You should clearly mark

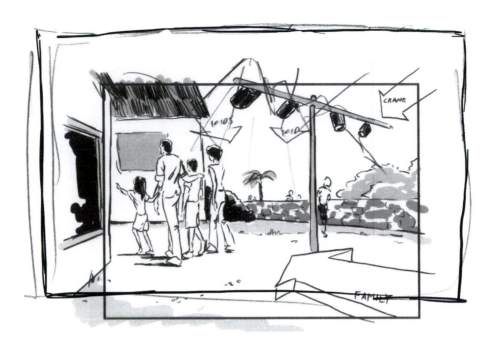

Figure 22.5 The director, Antoine Fuqua, asked for this frame to be wider, which was accomplished by simply drawing a new frame outside of the original frame.
Storyboard frame by Mark Simon.

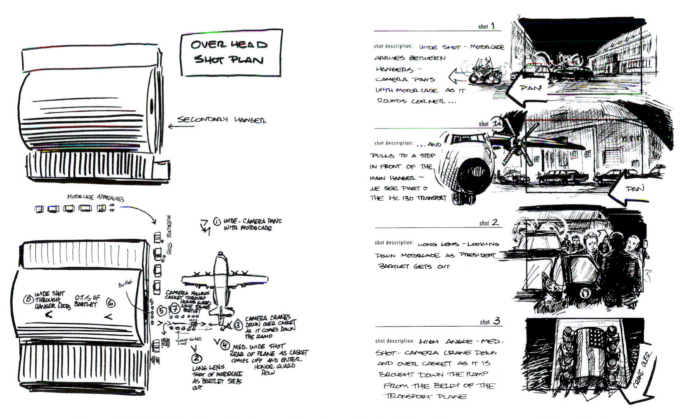

Figure 22.6 *The West Wing* plot plans and storyboards by Josh Hayes. (Images courtesy of Warner Bros.)

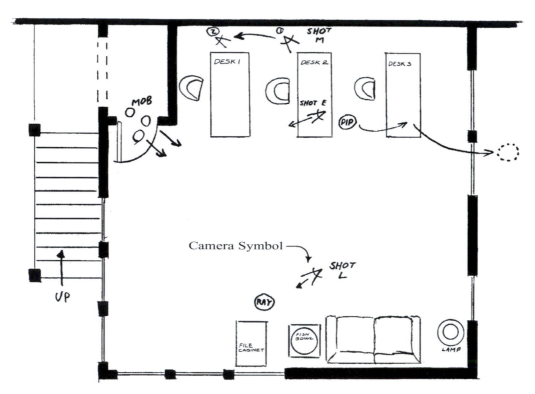

Figure 22.7 Redrawn floor plan from *The Walking Dead*. Camera angles, actor blocking, and movement of both the actors and the cameras are plotted. Shot M shows a camera move from Position 1 to Position 2. Notice that the open end of the angle symbol represents the direction the camera is facing.

each character, too. If you use more than one floor plan, label them. By referencing a floor plan you will know exactly who and what the camera will see. Your boards will be that much more accurate and beneficial to the production.

When you work with floor plans, it's a good idea to give a copy of them to the director along with your storyboards. Use of floor plans can help not only you as the artist, but also the rest of the crew. The artist can conceptualize what the camera would see. The director can use it for her shot list. The camera department can use it to plan their setups. The gaffers will know what they need to light. The art department will know what they need to dress and prep.

Figures 22.7 and 22.8 show, respectively, a floor plan and the boards drawn from it.

For the ABC Movie of the Week *The Miami School Bus Hijacking*, the director and I worked with plot plans in a different way. A lot of the movie had to do with car and bus chases. The location scouts had determined the locations for most of the sequences. I took large pieces of paper and drew crude maps of the streets for our major action scenes. The maps were drawn roughly

to scale with Hot Wheels cars. I had a school bus, cop cars, and regular cars to play with.

The director and I played with the toy cars on the maps to determine both the actions and the best camera angles. I would mark the locations of the camera, with notes by these locations giving the size of the frame and what action it was recording.

When working with action figures and toys, your hand can become a camera demonstrating camera angles. Holding your fingers in a peace sign serves the purpose of showing where a camera is looking. This is the quickest way to work out shots with the director when using toys and models.

Regardless of how the director likes to communicate his ideas to you, there are a number of questions you may need to ask. While any shot list or group of thumbnails will give you guidance for framing shots, other details important to the story may not be so clear. Following are example questions for directors before you start boarding.

- Are the characters happy or sad (or other emotion)?

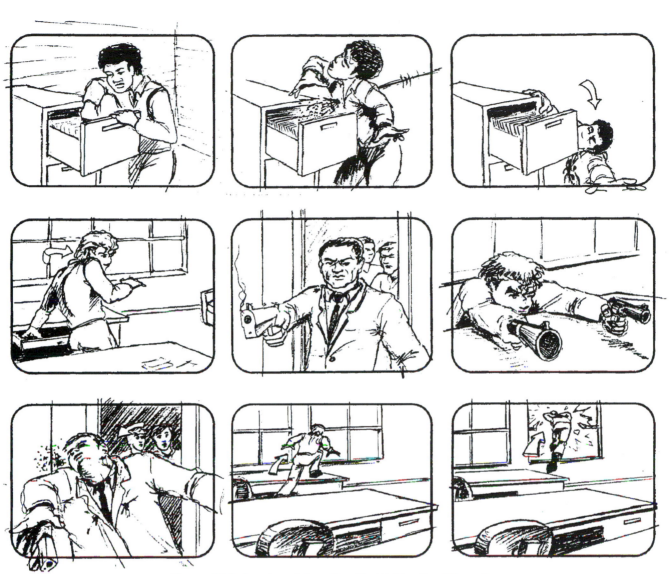

Figure 22.8 Storyboards based on *The Walking Dead* floor plan.

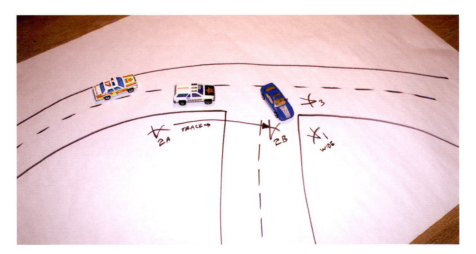

Figure 22.9 Toy cars on drawn street map used with a director to design shot sequence. Notice the marked camera angles and the one camera move.

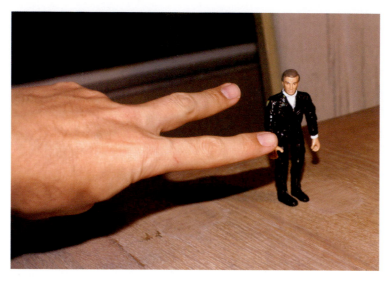

Figure 22.10 Your fingers may serve as a camera when demonstrating a camera angle on toys. Notice how the fingers represent the plot plan camera symbol.

- How are they dressed?
- Is it day or night?
- In what screen direction do you want them looking or moving?
- Which location is used in this scene? Do you have photos of it?
- What is the character's reaction to what is happening?
- Have these characters been cast?
- Have the custom props been designed?

- Do you have reference photos of the vehicles you want to use?
- Do you have copies of these product shots and logos?

Not only does working professionally with directors make your storyboards more effective for the production, but you will also enjoy each project more—and you are more likely to be called again for subsequent projects. But it doesn't mean you can't have fun.

CHAPTER 23

Screen Direction

Screen direction refers to the direction that objects or characters move on the screen. Consistent screen direction is important in visual storytelling because it often tells the viewer where a character is going and when the character changes direction. For instance, when Homer Simpson drives to work, in every shot he moves from camera left toward camera right, also stated as *moving camera right*. When he drives home, he *moves camera left*. Even as he walks in the door, he's still moving camera left. If Homer were going to work and was moving camera left in one of the shots, it would look as if he turned around to go back home.

There are rules in filmmaking that help ensure that the camera is not accidentally placed in a position where the characters seem to move in the wrong camera direction. There is an invisible line in a set or location that the camera may not cross. It's called the *line of action*. If the camera is placed on the other side of this line, it's called *crossing the line*, and characters will seem to move or look in the wrong direction, confusing the audience. Once this line of action is established in a scene, it must stay the same unless the character changes relative positions in a shot or the camera physically moves across the line during one shot.

The camera may, however, move onto the line of action. That's called a *neutral position*, where the camera is looking straight at the front or back of a character. Since the characters do not have to look camera left or right, this position will work.

If you look at the way sports are filmed for television, this may become clearer. All sports are filmed by the same rules. All the cameras are placed on the same side of the field and on the line of action.

For instance, in a basketball game the players are constantly running back and forth and up and down the court. It could be difficult to follow whose goal is being advanced on, but it isn't. Why? Because the viewer knows that Team X always goes to the camera-right goal and Team Y always goes to the camera-left goal. If cameras were shooting the action from both sides of the line of action, the viewer wouldn't be able to follow the action. The cameras placed behind the goals are the neutral shots.

The line of action becomes more difficult in scenes with multiple people, especially if they are moving around a set. Let's look at a simpler way of determining screen direction without trying to find that invisible line. The easiest way to keep proper screen direction is to look at your character eye lines. The direction they have to look to see other characters has to stay constant in a scene unless their movements or the camera's movements shift that direction during a shot. The last frame of a shot dictates the screen direction for the following shots.

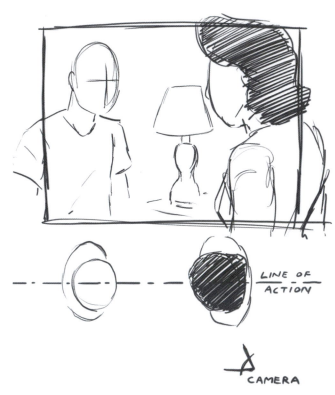

Figure 23.1 Two characters talking. The man is looking camera right to see the woman. The line of action *(dashed)* is drawn on the eye line between them. No camera position may cross that line once it is set. This shows framing and overhead setup.

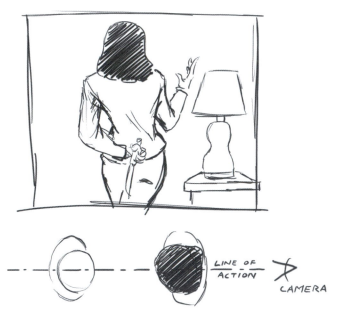

Figure 23.2 The same two characters are speaking, but the camera is now on the line of action looking straight at the woman's back. This is a neutral camera position.

Figure 23.3 This layout of a basketball court shows the line of action and possible camera placements.

If we take a sample living room scene with four people in the room (see Figure 23.4), the wide shot, or establishing shot, shows the audience where the characters are in relation to one another (see Figure 23.5). The wide shot tells us that the person on the couch needs to look camera right to see the person in the doorway. If we place the camera in such a way that the person on the couch looks toward camera left, we've crossed the line of action and the audience will not know who she is talking to (see Figure 23.6).

Let's look at another scene, involving a couple driving in a car. We've all seen shots like this. Figure

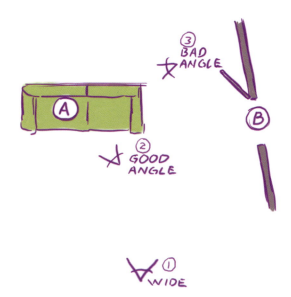

Figure 23.4 A living room plot plan.

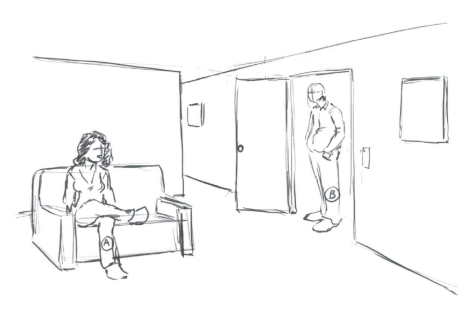

Figure 23.5 Camera Angle 1, wide establishing shot. Actor A has to look camera right to see Actor B.

CROSSED THE LINE

Figure 23.6 Camera Angle 2 *(left)* still shows Actor A looking camera right. We know she's looking at Actor B on the right. Camera Angle 3 crosses the line of action. She has to look camera left, confusing the audience as to where she is looking.

23.7 shows some possible camera positions around the car, the driver (D), and the passenger (P). Camera angle 1 will look like Figure 23.8. The driver has to look camera left to see the passenger.

Camera 2, which is on the opposite side of the car, will look like Figure 23.9. Even though the camera moved to the opposite side of the car, the driver still has to look camera left to see the passenger. Cameras 1 and 2 will edit together perfectly. Camera 3 looks straight in through the windshield. The driver still has to look camera left to see the passenger, as shown in Figure 23.10.

Camera 4 shows that the driver will now have to look camera right to see the passenger. The camera has therefore crossed the line of action (see Figure 23.11). This camera shot will not edit together with the other

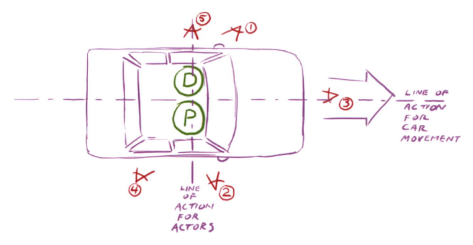

Figure 23.7 Shot plan showing camera positions and actors in the car.

Figure 23.8 Camera angle 1 shows the driver looking camera left to the passenger.

Figure 23.9 Camera angle 2 shows the driver still looking camera left to the passenger.

Figure 23.10 Camera angle 3 shows the driver looking camera left again to see the passenger.

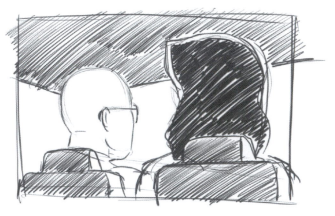

Figure 23.11 Camera angle 4 shows the driver having to look camera right at the passenger. The camera has crossed the line-of-action.

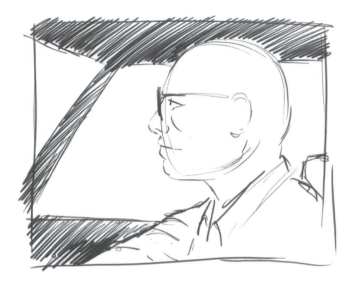

Figure 23.12 Camera 5 is the neutral angle between the actors. The driver has to look away from camera to see the passenger.

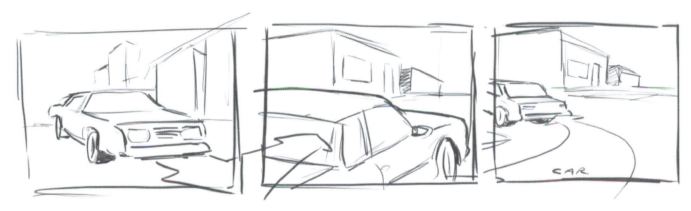

Figure 23.13 The first frame sets up the screen direction (camera right) that the car needs to move in this sequence. The middle frame continues the proper screen direction. The last frame shows the car turning toward camera left, setting up a new screen direction for the following scene.

shots. Camera 5 is the neutral angle for the actors (see Figure 23.12). The driver has to look away from camera to see the passenger, which is neither right nor left.

The actors have a line-of-action and the car has a line-of-action. You need to pay attention to eye lines for actors and direction of travel for vehicles. Sometimes, as shown, you will have both in the same scene.

During chase scenes, whether it's planes, trains, or automobiles, the vehicles are turning, skidding, sliding, and changing directions. The line of action still has to be watched in order for the shots to be edited together

properly. The screen direction in which vehicles are moving in subsequent shots has to be the same screen direction; otherwise, it will look as though they are moving away from each other, rather than the scene looking like a chase. The biggest thing to remember is that the last frame of the shot dictates the screen direction of the next shot.

In Figure 23.13 you can see that the car entered the frame moving toward camera right but turned in the shot and is heading camera left on the edit. The next shot needs either to show the car moving camera left or to be a neutral shot (see Figure 23.14).

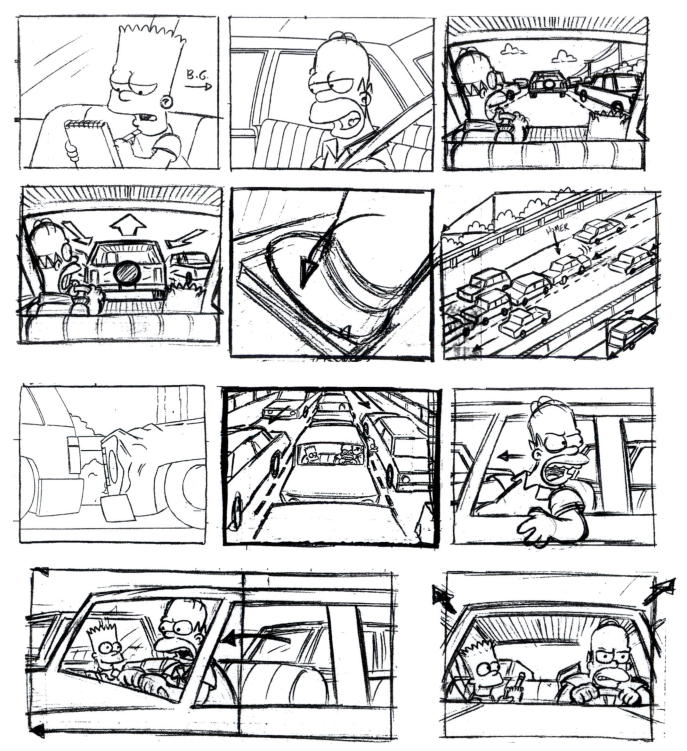

Figure 23.14 All frames of Homer driving either are neutral angles or show him driving camera left. Proper screen direction is followed. (*The Simpsons* boards™.)

CHAPTER 24

Staging and Composition

Drawing boards does not just mean sketching the characters going through their paces. You need to be able to work visually with the director, producer, production designer, stunt coordinator, effects coordinator, or whomever and give the project a visual dynamic. The viewer, director, or other crew member needs to be drawn into the action, and their interest in the visual story must be carried throughout the scene.

Staging is the placement of cameras, actors, and set pieces. Staging can make the visuals interesting or it can make them bland. Staging a scene properly allows

Figure 24.1 Interesting shot design showing action and guiding viewers' eyes to the important elements of the shot. Scorpion King storyboards by Tim Burgard. (Images courtesy of Universal Studios Licensing LLLP.)

the viewers to be scared when you need them to be, laugh when you want them to, and to always understand what is happening. Bad staging can confuse the audience. Great staging can make each and early frame a work of art.

Composition is much like staging, but it refers specifically to the visual layout of each frame, how the visual elements in the frame balance each other, like in a painting.

The best way to learn staging and composition is to watch well-directed and well-designed movies. The trick is to watch them with the sound turned off. This is important because it's very easy to get swept into the story of a good movie. With the sound off, it's easier to pay attention to the staging of the scenes and not the story. Try this with any Spielberg, Cameron, Hitchcock, Wu, Lean, Coppola, or Pixar film.

There is no one correct way to illustrate any scene. A good storyboard artist can help make a scene more interesting as well as present the production with enough information to help it run more smoothly. A good artist does not necessarily make a good storyboard artist.

Fine storyboard work is executed by a person who understands how production works and who can visually get across all of the information mentioned here—and a person who works well with a director to capture his or her vision for the production. The storyboard artist also adds his or her own expertise to make each project that much better.

The 34 design elements detailed in this chapter are used to create effective and exciting storyboards. These elements are common not only to storyboard production, but to directing and editing as well. They are organized under various design goals.

Horizon Lines

1. Lower horizon lines and camera angles give more importance to a subject and make them look bigger. As Brad Bird, director of *The Incredibles*, says, "When in doubt, lower the horizon." It tends to make shots and layouts more dramatic. (From *Storyboarding the Simpsons Way*, an AnimationMeat.com pamphlet.)

2. A higher horizon line means the camera is higher and looking down. This can help make a character look smaller or even demonstrate despair or loneliness.

3. Perspective will help properly represent camera angles and positions. Proper use of perspective also makes shots more dynamic. You can add depth to a

Figure 24.2 The low-angle shot of the Shaman character gives us a sense of his importance. *Creepers* storyboard by Mark Simon.

shot, even in a 2D medium, by using perspective. Try not always to look straight toward a wall. If you change the angle to keep the floor and ceiling lines from being parallel to the frame it will look much better.

Use Artistic Design Elements to Give the Film a Distinctive Look

4. Design a visual balance in each panel. The panel should be a work of art, not necessarily in the finished quality of the rendering itself but in its composition. Don't place characters dead center in a frame. Place them in the frame on the side that allows more room in the direction the character is looking.

5. Try not to have your characters be parallel to the frame. Move some closer to the camera and others farther away.

6. Try not to have elements of your image, such as floors and tabletops, be parallel to the frame. Put things in perspective in order to show more depth. (See Figure 24.3.)

7. Use inserts or cutaways to an object or person that advances the story or fleshes out the characterization, as was done so brilliantly in *Citizen Kane*. An extreme close-up of a nervously shaking hand on an outwardly calm and composed character gives the viewer information beyond what the dialogue reveals. A pan showing objects in a character's home or office tells the audience information about the character without requiring dialogue.

Figure 24.3 From *left to right*: The first panel shows good visual balance, with space left in front of the character. The second panel shows a cutaway, and the third shows how a foreground tree adds depth to a shot. Art by Klasky Csupo, Mark Simon, and Alex Saviuk, respectively.

Figure 24.4 The first two panels show the man looking through the keyhole, which motivates his POV through it. The last panel demonstrates how the character's arms and body are foreshortened. The first two panels are by Mark Simon. The last panel is by Chris Allard.

8. Add depth to shots by placing objects in the foreground. For example, a shot of scenery in the distance gains perspective if framed by trees close to the camera.

9. Give the viewer perspective by tilting the frame up to emphasize tall objects, down to emphasize short objects, or sideways to indicate disorientation or confusion, as in the case of an intoxicated character. (For pan or tilt shots, use more than one panel to depict the beginning and end of a camera move. For a tilt, one drawing may encompass two panels stacked vertically, while a pan may require two drawings side by side.)

10. Ground the viewer in the middle of the action by using reverse shots, wherein the camera appears to be between two characters.

11. Use the silhouette of an object that a character is looking through as the border of a frame. For instance, if a character is looking through binoculars, cut to a POV shot bordered like the view actually seen through binoculars.

12. Motivate your shots, meaning keep the action and the camera angles in sync. For instance, show a character looking up and then have the camera angle look up. Or shoot a character standing on a balcony and follow with a shot looking down from the balcony. These second shots would be considered motivated. Always be on the lookout for an action or situation that might motivate an inventive or unusual shot. (See Figure 24.4.)

13. Use foreshortening, a device in which one element of an object is so prominently featured in the foreground of a shot that it blocks the view of the entire object, as in the depiction of an outstretched hand being

much closer to the camera than the rest of the actor. This can be very dynamic.

Be Inventive

14. The story should be completely understandable without words, based on the storyboard alone. If it isn't, change it. The visuals should be able to convey the story.

15. Use more than one frame if you need to show a character's complete reaction (see Figure 24.5). Even if there is no overt action in a shot, if a character's reaction is critical to advance the story, detail it on the board.

16. Use quick cuts between objects and characters to create suspense and to accelerate the action.

17. Show only portions of a character, to build suspense or fear, as in showing a hand with a gun coming around a corner or a character's face slowly emerging from the shadows (see Figure 24.6).

18. Show a person or object of which the characters are unaware, moving in from the edge of the frame,

to heighten suspense. For example, show a character looking away from the camera as a dark, shadowy figure moves into the extreme background. Seeing the character's peril before the character senses it involves the viewer emotionally.

19. Have an object move close up into the frame and stop, as in a car pulling up toward the camera and stopping, with its headlights filling the frame. This is a dramatic way to introduce a character into a scene.

20. Wide-angle lens, both high and low, can make people and objects appear large and small. The size and scale of objects are relative to how we see things on a daily basis. If we have to look up, we're looking at something big. If we have to look down, we're looking at something small. If we are shooting a *Gulliver's Travels* movie where we have small people and giants, we should photograph them (and thus storyboard them) in different ways. All shots of the little people should be from a high camera angle looking down. All shots of the giants should be from a low camera angle looking up. If we use a wide-angle lens on these shots, it will help emphasize the size differences.

Figure 24.5 The Santo Bugito boards show multiple expressions. (© Klasky Csupo.)

Figure 24.6 The shadowy figures add to the fear in the scene. Boards by Alex Saviuk.

Animation Boards

21. Frame your boards accurately (see Figure 24.7). Animators, especially overseas, take the framing of each shot directly from storyboards. If you illustrate characters' heads too close to the top of the frame, their heads will most likely be partially cut off in "TV safe." (TV safe is a grid marking on field guides that lets you know where some TV reception will likely crop the image up to 10%.) Your boards need to make allowances for TV safe.

22. Keep your drawings "on character" (see Figure 24.8). Your storyboards will basically be the key frames for 2D animation. The closer your drawings are to the *character sheets*, approved illustrations of how the characters should look, the more it helps the animators.

23. Animated movements and visual gags. The main reason to animate a show is because animation can do things live action can't. Your boards need to exaggerate to the degree the producers of each cartoon allow (see Figure 24.9).

Figure 24.7 Standard TV frame with the TV-safe area shown.

24. Show expression change and acting nuances. Some of the funniest moments in animation are the subtleties. Animation demands many more storyboard panels per action than live action because all the characters' acting has to be illustrated.

Composition

25. Another title for this chapter could be "Balance." Visual balance on a theater or TV screen does not necessarily mean centering an object on the screen. More often it refers to giving room to an object or character in the direction that it or she is facing.

26. The rule of thirds was developed with building a pleasing frame design in mind. It states that you should break a frame into vertical and horizontal thirds. Align your main elements and characters to the line intersections. Horizon lines should be along one of the lines instead of through the center. When shooting a close-up, align a character's eyes on the top-third line instead of the middle of the frame.

27. Design the frame to lead the viewer's eye to what is important in the frame (see Figure 24.10).

28. When you look at a painting, you probably don't see one object in the center and equal-sized and numbers of objects surrounding it. What you probably do see is a placement of objects on the canvas that is visually pleasing to the eye and lets your gaze move about the image equally. Frame design in storyboards moves your eye too.

29. The biggest difference in the frame design of film or TV and that of comic books or paintings is that you are designing the look over a sequence of moving images, not just a single image.

30. When you have a close-up of a character looking camera right (viewer's right) you should frame

Figure 24.8 *Pilgrim Program* storyboards are "on character." Boards by Chris Allard.

Figure 24.10 Proper framing is shown, with space left in front of the character. Storyboard by Keith Sintay and Mark Simon.

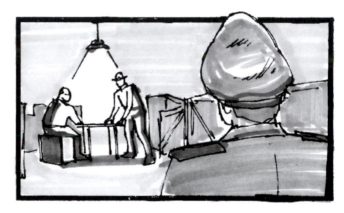

Figure 24.11 OTS shot showing asymmetrical balance between the one man in the *foreground* and the two men in the *background*. Storyboard by Dan Antkowiak.

Figure 24.9 Animation works best when actions and reactions are exaggerated. *Boogers* storyboards by Mark Simon of Animatics & Storyboards, Inc.

the character on the left-hand side of the frame. This leaves room, the *lead space*, in front of where the character is looking, which gives the shot a nice balance. The same goes for a moving vehicle, a person riding a bike, or a flying object: Lead the object with more space than is behind it.

31. Over-the-shoulder (OTS) shots have the foreground characters very close and very large, to one side and up close to the camera. The character(s) they talk to are on the opposite side and are much smaller (see Figure 24.11). The frame will balance, even though the images are not evenly placed in the frame. This is called *asymmetrical balance*.

32. Using extreme angles, foreshortening, and interesting layouts makes scenes visually exciting.

33. The balance of the frame may also change during a shot. When something is moving in the frame, it may start small in the distance and move to an extreme close-up or pass right by the camera. How an object or character moves across the frame and affects the visual design is also a key feature of an exciting set of boards.

34. Directors look for the storyboard artist to add exciting staging to their shots. Always look for interesting angles and setups for shots, as long as they work within the overall look of the project.

Figure 24.12 Panel shows an interesting angle through a woman's legs. Board by Dan Antkowiak.

References and Research

As a storyboard artist you need to know how to draw any number of items quickly and accurately. This does not mean that you have to work only from memory when you are illustrating. Of course, it helps to have a great memory of how everything looks, but using visual references minimizes the risk of missing important details.

No artist can draw everything from the top of his or her head. We need references for what different objects, animals, and characters look like in different positions. Early on I used to think that using a reference was like cheating. Not so. Using references allows your boards to be drawn more quickly and more accurately.

There are many different types of references artists can use. References can be photos, illustrations, mirrors, objects, video, living beings, sound, or just about anything else.

Mirrors are the most prevalent source of references, and thus artists are their own most often-used models. Most illustrators will have at least one mirror at their

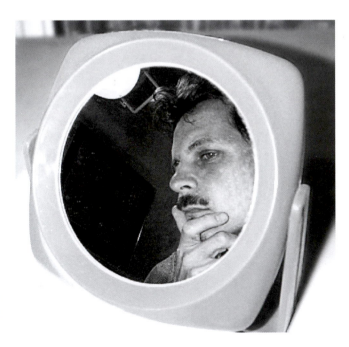

Figure 25.1 Mark Simon using a small mirror on his drafting table for reference.

desk. A makeup mirror may be on the desk for hand and expression references. A wall mirror may hang to one or both sides of the desk.

Some artists have been known to design intricate configurations with their mirrors to view themselves at all angles. Holding a mirror in front of you and looking at a mirror behind you will show you what your backside looks like. A mirror on your ceiling is helpful in getting a bird's-eye view of yourself (but it is also dangerous). A bunch of properly angled mirrors will let you see yourself from numerous sides all at once.

Of course, you can't always pose for yourself, especially if your character is of the opposite sex or is some sort of creature. That's where live models, both animal and human, come in. When I need a female character reference I ask my wife to pose for me. I've also used neighbors and friends for child and elderly reference. Even my dogs have been models at one time or another.

While developing a large photo reference file, I produced the book *Facial Expressions*, for all artists. It contains more than 3,000 photos of 50 models, each holding a variety of expressions and shot from different angles. The models range in age from 20 to 83 years old and are of different sizes and nationalities.

My book also features references of skulls, muscles, phonemes, and hats and headgear. You will also see how other artists have used the photos as inspiration. Other books on facial expressions are about kids and teens, hands and feet, and so on.

There are also art classes that have live models to draw. You're never too old to continue to improve.

Figure 25.2 *Facial Expressions* by Mark Simon, available at www.MarkSimonBooks.com.

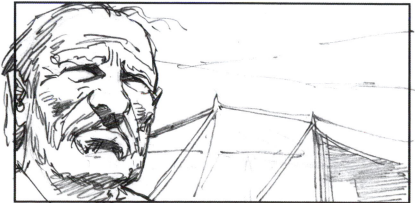

Figure 25.3 Samples from *Facial Expressions*. A photo of book model Mohammed was used by Alex Saviuk of Animatics & Storyboards, Inc., for storyboarding the film *Full Flame*.

Many animation studios offer life drawing classes as a part of employment. In the early days at the Disney studio, these classes were part of the daily routine. These Disney classes started in 1932 at the home of animator Art Babbitt. Walt soon offered the artists the use of a soundstage at his studios on Hyperion Avenue in Hollywood. By 1934, this school was converted to a full-time basis, with part of the schooling taking the artists to the zoo.

Many artists, myself included, spend time at the zoo sketching the animals and the people watching them. I also do a lot of character sketches whenever I'm waiting at the airport. Any place where people of different cultures gather is great for sketching.

For the animated film *Bambi*, Walt Disney had trainers bring in deer and other animals for drawing sessions. More recently, Jim Fowler did the same thing for Disney Feature Animation with lions and other animals for the movie *Lion King*. This obviously helps artists get a feel for the look and movement of the characters.

Professor of biology, and anatomical consultant, Stuart Suminda has worked on more than 30 films, such as *Garfield*, *Tarzan*, *Brother Bear*, and *Scooby Doo*. He teaches artists comparative anatomy so that their work is based on reality, regardless of how cartoony it is.

Besides real animals being used for reference, skeletons are often used. Skeletons teach artists the support structure of an animal and how they're capable of moving.

Sketching from a live reference is the best way to get a good feel for the volume of your subject. Sketching a moving subject forces you to sketch quickly to capture what you see. This helps you speed up and keeps you from overworking the art. Some of your best sketches are likely to come from quick live-action studies.

Even though sketching live models is the best, the advent of cameras was a great advance for artists. All of a sudden an artist could pose a model, take a picture, and send the model home. Models were no longer needed to pose for hours or days at a time. Using photos to draw from instead of models saves artists time and money. In addition, when you use a photo you can draw from, you can keep it for later use.

Digital cameras are getting faster, less expensive, and better every day. You can take pictures endlessly on the same memory card without spending an extra cent on film or processing. The only ongoing cost is the expense of printing the pictures on either a laser or color printer. Reference images seldom need to be in color, so a color printer is not always necessary.

Figure 25.4 Life drawing by Travis Blaise.

Figure 25.5 Life sketching with ink, at the zoo, by Mark Simon. Drawing an animal in motion keeps you fast and teaches you to keep your lines to a minimum.

To capture moving references, motion film or video is needed. The problem with video is that it has a tendency to produce very blurred images when you look at them a frame at a time. Some of the better cameras have fast shutter options that decrease the blur. Shooting video in bright daylight or other well-lit area also helps reduce blur. Resolution of the tape format also has a lot to do with how clear the image is.

Figure 25.6 A small portion of the reference books in my library. You will find these and others listed in Part Seven, Appendices, under the head Reference Books.

VHS cameras capture with the lowest resolution. DV cameras are affordable and offer great resolution and easy input into computers. HD, or high-definition, cameras offer the best images and the highest flexibility. Some of these cameras get rather pricey, but even the lowest-resolution video can be a great help.

Good VHS decks and most professional-quality video decks offer great slow-frame and still-frames to study motion. If you have access to a video capture system on a computer, you can also print out individual frames to study. Running a video slowly back and forth is an excellent way to get a good feel for how an object moves.

Back in the late nineteenth century, Eadweard Muybridge shot numerous studies of motion on film with both people and animals. His nude figures generally walked, ran, or jumped in front of a grid background. Most of the actions he shot were recorded from more than one angle, giving the viewer multiple perspectives on every movement.

There are two great texts of his motion photos, *The Human Figure in Motion* and *Animals in Motion.* Each contains more than 4,000 wonderful references of motion. *Animals in Motion* has reference photos of horses (with and without riders), dogs, cats, lions, kangaroos, deer, jaguars, elephants, raccoons, eagles, and many others. These action photos were taken at speeds of up to 1/2000 of second to keep each image clear.

The limited-edition laser disc of *Snow White and the Seven Dwarfs* contains wonderful examples of the reference film that Disney shot and the footage illus-

trated from it. This footage includes Snow White running and a heavy man dancing a jig. The dancing man is a great example of fabric follow-through and bounce. Walt also filmed the actions of three real dwarfs as reference for how they walk and move.

Many DVDs have storyboards and conceptual art as bonus features. Some even run the storyboards along with the movie. Some of these DVDs will also run in a computer and offer even more features.

There are times when you need reference of inanimate objects. You often need to draw objects such as cars, bikes, buildings, planes, props, and trees. There are times when you need to see reference not only of an object, but how it interacts with a person. You may need a model to hold a prop gun or sit on a bike.

Car manufacturer websites are great resources too. They often include 360° interactive views of their vehicles, both inside and out. Toyota's site, www.Toyota.com, is of particularly great use for reference. Their interactive car fly-arounds let you see the vehicle from any angle, including worm's-eye and bird's-eye views.

The Internet is invaluable in researching. Using any of the large image search engines—Google, Yahoo, MSN, AltaVista, AOL, and others—you can find pictures of virtually anything in just a few minutes. The more specific you are in your search, the better your results will be. Instead of just searching for fire engines, search for a 1946 fire engine. Many of these search engines also offer video searches.

Sometimes you need references of objects from very specific angles that you are not likely to find online. As you take photos of reference material, you should catalogue them. This way you can build your own supply of photo, also called a *morgue.* If you set up a good system, you'll find yourself turning to it more and more often. You need to make sure that it's organized properly so that images are easy to find.

Break your references into major and subcategories, such as the following. (I keep my printed references in photo boxes so that they are easily accessible and quick to replace, and I keep my digital images saved on a hard drive.)

- Men
- Women
- Kids
- Sports
 - Football
 - Baseball
 - Basketball
 - Soccer

Figure 25.7 3D fly-arounds of Toyota vehicles shown on the company's web site (www.Toyota.com).

- Hands
- Feet
- Vehicles
 - Planes
 - Trains
 - Boats
- Animals
 - Dogs
 - Cats
 - Goats
- Locations
- And so on

Mail-order catalogues and magazines are also great sources for references. I also keep my reference magazines organized according to source material: people, tools, guns, sports, and so on.

Books work the same way. Our company's studio has many, many books on different types of architecture, interior design, countries of the world, history, nature, art, and cartoons. Even our old encyclopedias are helpful when we need some obscure reference.

Some books are used for style reference. When making *The Lion King,* the Disney creative designers also studied the painters of the American West. From their paintings, Disney directors and designers drew inspiration for their background layouts and color composition.

Comic books can also be a great reference. Most storyboard artists are or were comic book fans. I learned how to draw from comic books. The characters are ideal examples of the muscular system, even if exaggerated, and the backgrounds and vehicles are wonderfully drawn in perspective.

Thanks to computer technology, reference material is even more plentiful. You can use CD-ROM clip art and CD-ROM encyclopedias, which have not only still images but often video, too.

The software CorelDRAW comes with a huge selection of clip art and photos that can be great for reference. Their clip art contains images of thousands of items. Some of the most helpful are flags from around the world, insignias, road signs, and symbols.

There are also CD-ROM collections of corporate logos, which are very helpful when you are doing commercial storyboards. For example, www.LogoTypes.ru, www.LogoClipart.com, and www.Lots-O-Logos.com each have well over 10,000 logos you can download and purchase. You can either use the logos for reference or add them to your artwork digitally.

Some of the best reference to have on hand is the type you can manipulate in 3D. Models, toys,

Google **Images**

Web **Images** Groups News Froogle Local **more »**

Fire Engine [Search] Advanced Image Search
 Preferences

SafeSearch is off

Images Results **1 - 20** of about **45,800** for Fire Engine [definition]. **(0.13 seconds)**

Show: **All sizes** - Large - Medium - Smal

engine.jpg
261 x 196 pixels - 26k
www.hatsoff.info/hatsoff_supporters.html

fireengine1024.jpg
1024 x 534 pixels - 186k
www.woodlands-junior.kent.sch.uk/
customs/ques...

fire_engine_puzzle.JPG
400 x 311 pixels - 47k
www.smartstart-toys.co.uk/
images/fire_engine_...

fire engine number 1.jpg
1600 x 1200 pixels - 257k
www.sethwhite.org/images/
mcmurdo/mcmurdo%20st...

Plush **Fire Engine**.jpg
485 x 354 pixels - 38k
www.salixonline.co.uk/
rugs/fireengine.html

fire-**engine**-san-francisco.jpg
700 x 478 pixels - 63k
simongurney.co.uk/america/
california/fire-eng...

fire engine.jpg
778 x 518 pixels - 36k
www.detroitfirefighters.net/
images/fire%20eng...

G5P a **Fire engine**.jpg
200 x 237 pixels - 11k
www.woodentoys-uk.co.uk/
images/G%20childrens%...

YAHOO! SEARCH

Web | **Images** | Video | Directory | Local | News | Shopping

fire engine [Search]

Image Results SafeSearch is ON Advanced Search Preferences

Results **1 - 20** of about **70,250** for **fire engine**. Search took 0.15 seconds.

Show: **All** | Wallpaper - Large - Medium - Small | Color - Black & White

Also try: cartoon **fire engine**, **fire engine** red hair More...

274 **Fire Engine** new.jpg
504 x 473 pixels - 67.6kB
www.greatlakeshobby.com/images

fire_engine.jpg
328 x 201 pixels - 18.5kB
www.uk-emergencyservices.../
new/**fire**/index.asp

sm_**fire_engine**.jpg
818 x 525 pixels - 90.1kB
www.vass.co.uk/**fire**_equipment.htm

39107061**fire**_...bc.jpg
203 x 152 pixels - 13.7kB
www.**fire**.org.uk/BBC_News/.../
bbc170403a.htm

40663272**fire**_...03.jpg
203 x 152 pixels - 13.7kB
news.bbc.co.uk/go/rss/-/2/.../
4128968.stm

343 **Fire Engine**...le.jpg
1225 x 900 pixels - 868.7kB
www.greatlakeshobby.com/images

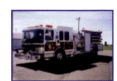

hart-simon-**fire**...80.jpg
450 x 450 pixels - 23.5kB
www.poster.de/Hart-Simon

Engine33.JPG
1512 x 1050 pixels - 166.0kB
www.go.firebuff.com/pics1/**fire**_ap

Figure 25.8 A search engine page of results for fire engines.

Figure 25.10 Collection of magazines organized for quick reference.

Figure 25.9 One of my many photo reference files where I store hard-to-find images.

Figure 25.11 Clipart samples from the CorelDRAW files that come with Corel products. Great references include worldwide flags and insignias.

sculptures, and dolls can be held and posed in any position. Many artists have the wooden hands and the wooden figure for reference. The wooden figure doesn't portray the body very well, and it's not nearly as flexible as it could be. Better figure references are dolls and action figures.

For male references I find Spider-Man to be the best action model. One large Spider-Man in particular has more than 70 axes of motion—and muscles—but no clothes. The smaller Spider-Man action figure is easier to carry around in a briefcase for when I'm working on location.

Figure 25.12 The large Spider-Man action figure has more than 70 axes of motion. Having an assortment of figures provides you with great reference tools.

Figure 25.13 Toy model of the *seaQuest* ship I used as a storyboarding reference.

For female reference, nothing is better than Mattel's Workout Barbie and Workout Theresa. These fully flexible dolls stand 12 inches tall, have real hair, and have a full line of clothes available for them. These dolls may not be available in stores anymore, but you can find them online and on eBay.

For vehicles, any toy store will have multitudes to choose from. Whether it's a spy plane, a 1930s hot rod, or a battleship, it's available. When I was storyboarding the CG (computer graphics) animation effects on Amblin's *seaQuest DSV*, the squid-shaped ship was fairly difficult to draw in varying perspectives. By the second season, the toy stores had models of the ships that we then built and used as reference at our drafting tables. The model also came in handy when working

Figure 25.14 *Top:* Normal photo of toy plane. *Middle:* Door viewer. *Bottom:* Image of toy plane through door viewer. Notice how huge the plane now looks.

with the directors. We could move the ship around to plan the shots before they were storyboarded.

One problem with using toys as references is that they still look small. A great trick is to use a door viewer, available at any hardware store, which has a fish-eye (very wide-angle) lens. When you look at a toy through the door viewer, it distorts the image, making it look much larger. This is the same visual trickery movies use when they film miniatures with wide-angle lenses.

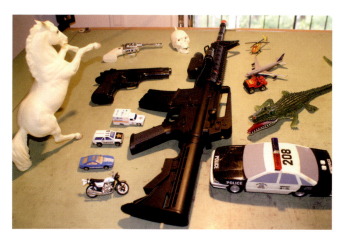

Figure 25.15 A sampling of toys that make great reference tools.

Figure 25.16 Maquettes sculpted by Mark Simon and Dan Antkowiak used for reference when storyboarding and animating.

Figure 25.17 Character design sheet from the animated series *Timmy's Lessons in Nature* by Travis Blaise. (© 2006 A&S Animation, Inc.)

Toy guns are great to keep around as well. Not only do they act as a great reference to look at, but it is great to be able to hold the guns to determine the poses you want to illustrate.

Maquettes are some of the best references. These are sculptures of animated characters. Studios have special artists to carve these maquettes and make sure they are perfectly on character for the artists to draw. Smaller studios may outsource maquettes or have the artists sculpt them. An advantage to sculpting a maquette yourself is that it gives you a better 3D feel for the character just by modeling it.

The fastest way to carve maquettes is to use Sculpey, which is a polymer modeling clay that stays soft until it is baked in an oven. You can bake Sculpey in a regular home oven in just a few minutes to a hardness that can then be sanded, added to, and painted. Paint it with acrylic and spray varnish on top.

You can also use nonhardening modeling clay to sculpt reference. On *seaQuest DSV* I sculpted a dolphin as a reference for the Darwin character. The clay was great to use because it offered a malleable character that I could bend just like a dolphin as an adjustable reference tool.

In animation, the greatest references you can have are character and prop design sheets. These show the characters from various angles and often include sample gestures and expressions.

Another great reference source, which may not be quite as obvious as others, is audio. The audio of the

SC. 144 BG. 63 217

SC. 144 BG. 63 218

SC. 144 BG. 63 219

Figure 25.18 *The Brothers Flub* storyboards by Wolverton of Animatics & Storyboards, Inc. (© Sunbow Entertainment.)

recorded character's voice can give you insight into what the character may be doing. Listen closely for the character's tone, mood, and speed of voice.

When we were storyboarding Nickelodeon's animated series *The Brothers Flub*, we didn't get the audio until after we had boarded a number of scenes. Hearing the way the voices interact gave us a totally different idea of how some scenes would look. We went back and redrew some of the boards using the inspiration we got from the audio track.

Using reference material not only can improve the quality of your boards, but it can also increase your output. Artists who have a hard time sketching a character or object tend to draw slowly and keep redrawing the same elements over and over. No one is expected to know how to draw everything. A little reference can help a lot.

The production you are working on may have reference material for you as well. Always ask; it could save you a lot of time. For instance, when I'm drawing storyboards for the major Orlando theme parks, I ask for references of their parks and characters. Productions could also have set plans, location photos, vehicle references, and other research available for you to use.

Using references saves you time and allows you to make more money in less time. And perhaps even more importantly, reference helps you deliver better-looking boards.

Illustrated Camera Techniques

Camera moves and transitions can be shown with special markings on your storyboards. Arrows to show camera or object movement are the most common type of special markings. Other illustrated camera techniques in storyboards include the cross-dissolve between scenes, tilts, pans, and canted frames.

Arrows indicate to the viewer the direction the camera, actor, or object is moving. Any time there is movement in a frame, you should use arrows to make the action clear to all viewers.

The arrows shown here are just a sampling of the types of arrows that work well in storyboards. Three-dimensional arrows are more accurate that 2D arrows in representing motion in a 2D representation of 3D space.

Unlike road signs, an arrow pointing up does not mean move straight ahead. An up arrow means something goes up, or it could mean a camera tilt or boom. You need an arrow pointing away from the viewer in perspective to show something moving away from the camera.

If you just place an arrow in a storyboard, it may not be enough to tell the viewer what is moving or happening. Let's say you're trying to show that the camera tilts up. You can draw an arrow pointing up out of the frame. All that says is that something is moving up.

Figure 26.1 Sample arrows that can help clarify the meaning of a storyboard image.

Figure 26.2 The arrow shows the rabbit turning and moving back into the distance. *Timmy's Lessons in Nature* storyboard by Mark Simon. (© 2006 A&S Animation, Inc.)

Figure 26.3 Two of the arrows are labeled to make clear which actions are being shown. *Captain Scarlet* board by Tracey Wilson, Lee Munday, Chris Drew, and Teri Fairhurst.

Figure 26.4 When an object is within an arrow, it becomes clear as to what the arrow represents. *Captain Scarlet* board by Tracey Wilson, Lee Munday, Chris Drew, and Teri Fairhurst.

If you simply write "Tilt" inside that arrow, it becomes perfectly clear that the arrow is referring to a camera tilting on its axis and pointing up. If you write "Crane" in the arrow, it would mean that the camera itself moves vertically. If an object or character is shown moving, then you should write the name of that object in the arrow to tell the viewer to what or whom the arrow relates.

Another style for showing what object an arrow represents is to encase the object within the arrow itself. Arrows can also be used to show something or someone turning around or spinning or to illustrate an erratic route. A two-headed arrow shows the cycle an object makes, such as a swing or someone's arm waving back and forth.

The dissolve or cross-dissolve symbol used on storyboards shows the viewer when one image is supposed to dissolve into the next image. This is done with an X placed between the two consecutive frames connecting opposing corners. Dissolves are used to soften transitions between scenes or to show that time has elapsed.

The symbol for a scene cut, normally used only in animation boards, is a small solid triangle pointing

Figure 26.5 The path of the arrow shows the erratic movement of the wine bottle.
Storyboard by Mark Simon of Animatics & Storyboards, Inc.

Figure 26.6 On the *left* the arrow shows the man's arm waving back and forth. *Captain Scarlet* board by Tracey Wilson, Lee Munday, Chris Drew, and Teri Fairhurst. On the *right*, the arrows show the path of the snake swinging. *Timmy's Lessons in Nature* storyboard by Mark Simon. (© 2006 A&S Animation, Inc.)

down (▼) between two consecutive panels. This means there is a cut between two backgrounds.

Camera moves can be indicated in a few ways. Pans, tilts, and tracking can be shown by drawing one image over two or more frames and using arrows to indicate the camera movement. Zooming in or out can be shown by outlining the framing of both extremes in one frame and using arrows to show the direction of the zoom. Camera shakes can be illustrated by drawing multiple canted frames around a panel.

An arrow that enters or exits a frame represents an object entering or leaving frame. To show a camera shake, usually due to a large impact or explosion, you can draw lines around the corners of the frame. Camera zooms can be indicated by drawing the beginning and ending framing of the shot with arrows showing which direction the zoom goes, in or out.

These camera and transition symbols, when used properly, help make storyboards more valuable and easier to understand for the entire crew.

Figure 26.7 There is a cross-dissolve between the first two frames, as shown by the X drawn between the corners of the frames. There is an edit between the second and third frames, shown by the small solid triangle drawn between them. *Creepers* storyboards by Mark Simon. (© 2006 Lyons Entertainment, Inc.)

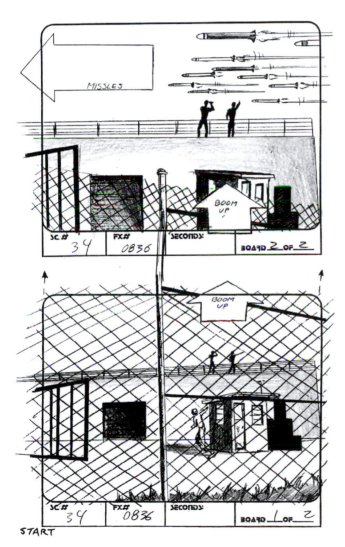

Figure 26.8 The labels on the arrows are there to show the type of camera movement in this shot.

Figure 26.9 The book enters frame, as shown by the arrow, and the camera shakes on impact, as shown by the lines on the corners. *Howl High* storyboard frame by Mark Simon.

Figure 26.10 The camera zooms tighter on the pilot to the final framing that's shown here. *Captain Scarlet* board by Tracey Wilson, Lee Munday, Chris Drew, and Teri Fairhurst.

Figure 26.11 *seaQuest DSV* example illustrating a tracking shot. The camera
follows from frame 1 to frame 3 along the route shown. Board
by Mark Simon. (© Universal City Studios, Inc. Courtesy of
MCA Publishing Rights, a Division of MCA, Inc.)

Numbering

Numbering may seem simple enough. Just mark down a new number for every drawing and that's enough, right? Wrong. Improperly numbered boards can become a major waste of time for productions.

There are three main reasons to properly number your boards. One is to make it easy to view the boards in the correct order. Two is to keep them in the correct order. The third reason is to help the production team break down the number of shots needed for any particular scene. If a script is broken into scene numbers by production (never come up with scene numbers on your own), use those scene numbers as reference.

In live action, you may need to number the scenes, shots, and panels. Not every director wants storyboards numbered according to each individual shot, so ask first.

Numbering your panels for continuity (the order in which they should be viewed) means each new panel should have a new number. Let's say you draw a sequence. When you are finished, the boards go out to the crew and then the director tells you that she wants to add a new panel in the middle. It is to be placed between panels 83 and 84.

This new panel will be numbered 83A, to make sure the entire crew is working with the same information. Many times changes occur after storyboards get distributed to a number of people. If you change the numbering scheme on your existing boards, it will confuse all the crew members who have been working with the original numbering scheme, and mistakes between crew members would likely happen.

Production is broken into sequences, scenes, shots, and storyboard panels. A *sequence* contains one connected series of actions and/or dialogue. Many animations number their sequences; live-action productions almost never do.

Each sequence may have one or more scenes. You will have a new *scene* every time there is a change in location or time. If a character walks from his living room to his car, the living room shots are in one scene and the car shots are in another. If he stays in his living room and there is a flashback to what happened there the night before, the flashback is also another scene. (In 2D animation, we count new scenes every time we have a new background, even if it's in the same room.)

Scenes are not numbered by production until they feel the script is just about locked. Do not make up your own scene numbers. Number by shot until production gives you scene numbers to use.

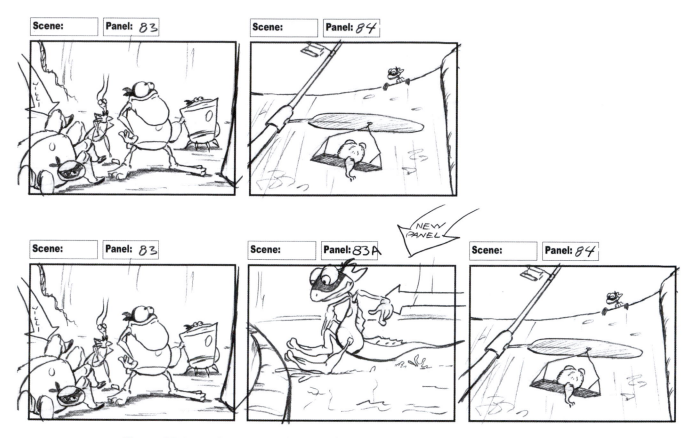

Figure 27.1 Numbering stays the same for existing panels when a new panel is added.

Each scene is made up of one or more shots. A *shot* is one camera angle. Every time the camera rolls from a new position or portrays a new period of time, it is a new shot. If you are in a room with two characters speaking and you start with a wide shot of the room, cut to a close-up of one character, and then cut to a tight two-shot, that scene will have had three shots.

In storyboarding, each shot is illustrated with one or more *panels*, *frames*, or *drawings*. The number of panels is dependent on the action. Some shots can be illustrated with one panel. Some may take dozens of panels. You always start each shot with panel number 1. Animation boards will always have more panels than live-action boards. In animation, the boards help dictate the acting, so every nuance should be demonstrated on the boards.

The most basic form of numbering, and no less important, is numbering the pages. This helps keep your dozens, sometimes hundreds, of pages in the correct order. Always number your pages as you work and fill in the other numbers as necessary.

When scanning panels and pages, always use a common numbering formula so that your images in the computer are saved in the proper order. If you have 99 or fewer pages (or panels if you scan each panel), start numbering with 01, 02, and so on. If you have more than 100 pages or panels, start numbering with 001, 002, and so on.

Figure 27.4 shows how improperly numbered files are arranged in a computer. After panel 1, you see panel 11, then 12, and then 2. Figure 27.5 shows how properly numbered files appear in the correct order. Proper numbering benefits the entire production and ensures easy insertion of new and revised boards.

In addition, you should give each set of files a specific name, such as scene number or a title—for example, "Rose_panel_01.jpg" or "Sunflower_panel_01.jpg." This way if you send boards for more than one scene or commercial, the client won't get two sets of boards called "Panel_01.jpg."

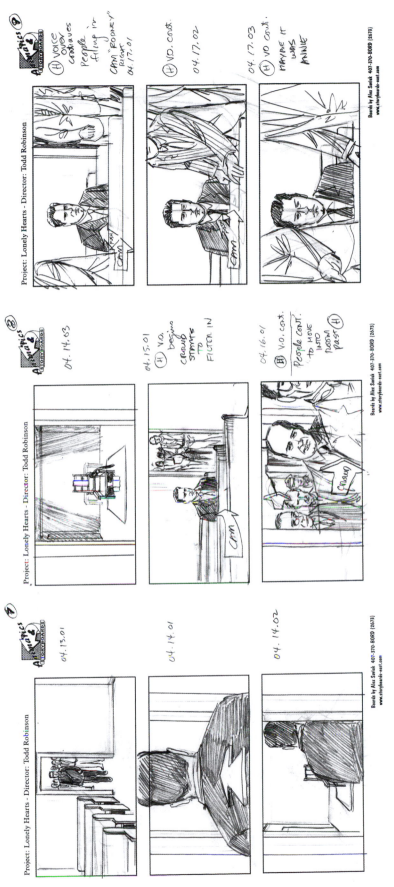

Figure 27.2 Production on this movie, *Lonely Hearts*, already had broken the script into scene numbers. The numbering on these panels refers to scene, shot, and panel. Scene 04, shot 13 takes only one panel to draw. Shot 14 takes three panels to draw, and so on.

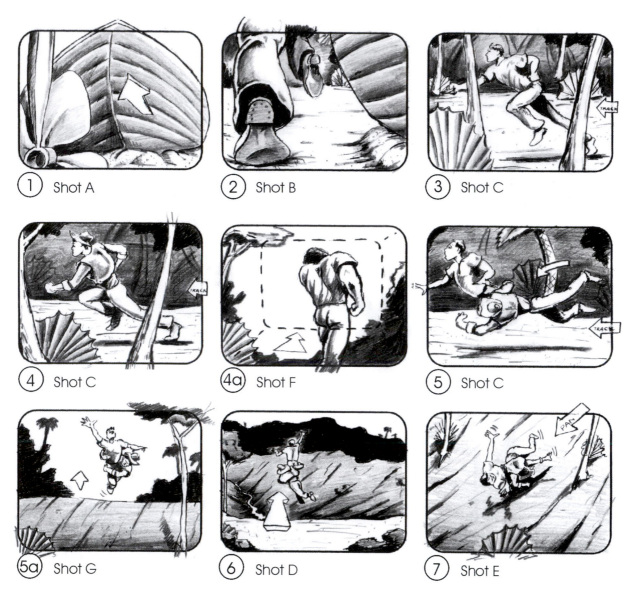

Figure 27.3 Redrawn boards from Fox's *Wilde Life* TV movie by Mark Simon. Panels are numbered and broken into separate shots. Notice that even though there are nine panels, there are only five shots, or camera setups (**a** through **e** equals five shots). Panels 3, 4, and 5 are all the same shot. Panels 4a and 5a are new, inserted shots.

Figure 27.4 Improperly numbered files arranged in the wrong order in a computer.

Figure 27.5 Properly numbered files appear in the correct order in a computer.

Contrast and Mood

Contrast and mood is also known as *chiaroscuro*: the pictorial representation in terms of light and shade without regard to color; the arrangement or treatment of light and dark in a work of art. That's great, but what does it mean to a storyboard artist? The term itself doesn't say much, since most clients will have no idea what it means. The concept, though, means a lot when it's used properly.

While a client may not understand why some images jump off the page when they look at them, they remember the ones that do. Contrast can be used simply to make an image stronger without affecting the feeling of a scene. It can just as easily be used to set a strong visual tone for the scene.

In Figure 28.1, the *top* storyboard panel shows a simple yet well-drawn sequence. All the lines in the drawings are of about equal weight. There are no black or hatched areas. When you look at the overall feel of the art, it's rather airy, and your eyes don't flow in any special direction over the art. The drawing may be good, but it is light.

The *middle* storyboard makes use of contrast without changing the feel of the scene. The lighting seems to be the same, but the drawing has more power. The black and shaded areas move your eyes around and make the art more interesting.

The *bottom* panel of the storyboard uses contrast to change the feel, the emotion, of the scene. The art now reflects intense and moody lighting. The illustration of shadowed areas, streaks of light, and partially masked features gives this sequence a more ominous feel.

Filmmakers and lighting designers use the same elements to draw viewers into the mood they are trying to set. Dark areas give the sense of something ominous. A sense of fear and anxiety is much easier to get across in a darkly lit scene. Light and airy scenes are more jovial and lighthearted. A change in contrast and lighting from light to dark can be used to show characters change as they become more twisted, sad, or morose.

The best places to find great examples of contrast that help set the tone and make images "pop" are comic books. There are many gifted artists working in comics, and they use contrast extremely well to show mood and character. Some artists use it more than others. Frank Miller and Todd McFarlane are masters, as are some older artists, such as Gene Colan and Bill Sienkiewicz.

Frank Miller's stylistic comic book *Sin City* is a great example of the use of contrast and mood to help tell a visual story. Director Robert Rodriguez used Frank Miller's amazing comic book as a storyboard for his feature version of the comic.

Comics are quite a bit like storyboards, both in storytelling and in art. While storyboard art isn't usually as detailed as comic art, the use of artistic elements such as contrast works equally well in both.

Figure 28.1 Progressive contrast mood storyboard
by Mark Simon from *The Disciples*.

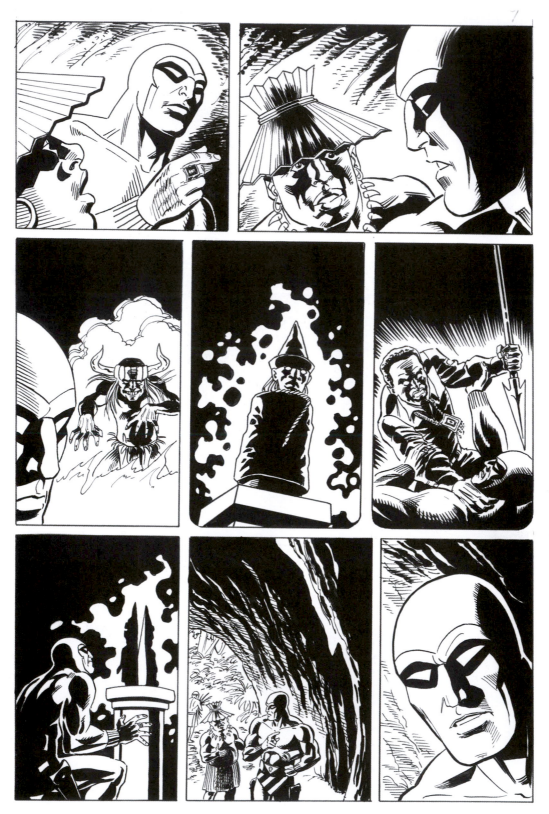

Figure 28.2 *The Phantom* comic book page by Alex Saviuk. The shadowed faces of the characters in the middle panels make them look evil and mad. The shadows in the panels also help design the framing and where the viewer looks.
(© King Features Syndicate Inc, New York.)

Figure 28.3 Moody storyboards by J Parris. The dark shadows help give this sequence a scary look.

CHAPTER 29

Special Effects

Special effects are probably the most important aspect of filmmaking that needs to be storyboarded. Effects can be extremely complicated, mixing many different elements into the same scene or shot, and they can be quite pricey to produce. For these reasons, storyboards are needed to plan out every portion of every effects shot so that there are fewer problems and fewer expensive reshoots.

Effects companies need storyboards before they can accurately budget and schedule a production. A script alone does not specify what is needed. While many production teams bid out effects without production boards, the bids will probably be like comparing apples and oranges. The bids will also be high, since the effects houses have to cover all possibilities.

We've all heard of effects companies that start a project expecting to do 250 shots and then end up doing more than 500. This is due to incomplete planning on production's part. Unfortunately, schedules do not always allow enough time for proper planning.

Figure 29.1 *Cousin Kevin* storyboard by Charles Chiodo.

Whether miniatures or computer graphics are used for an effect, they will be designed and built in different ways, depending on the needs of the shots as shown by the storyboards. For example, if a submarine is shown shooting a torpedo, the torpedo needs to be designed into the model, whether it's built as a miniature or a computer-generated (CG) model. It's cheaper to build in these extra elements during the initial design and modeling than to rebuild one. If the torpedoes are not needed, there is no reason to incur the extra expense to incorporate them. While this is a simplistic example, it gets the idea across.

Some effects blend live action and miniatures or computer graphics. It is very expensive to have a full live-action crew just standing around while the director tries to figure out how to shoot elements of an effect. Complicated shots should be worked out with storyboards first. Storyboards prepare crews for what they will need and also allow potential problems to be handled before they occur.

An example of how storyboards help design an effect can be illustrated with a sequence from *seaQuest DSV*. This bizarre scene had the ship going up against Neptune, the god of the sea. The underwater backgrounds and the ship would all be done by computer graphics. The Neptune character would be an actor on a stage against a blue screen.

The blue screen is used to digitally remove a background from around a character; thus allowing a new background to be placed behind the actor. The shots where the ship, background, and Neptune were all inter-

acting had to be meticulously planned so it would all work. Here is a brief rundown of what happened.

I met with the director, Casey Rohrs, to get his take on the script and what he wanted to see. I helped design the layout of the scene by suggesting extreme and exciting camera angles. I took his notes and started boarding out the scene.

I talked with the head of the effects department at Amblin Imaging about what was needed for the scene. I was in Florida and he was in California. We determined what had to be shot within certain parameters to make the shots work without resorting to *rotoscoping*, which is a technique of altering an image frame by frame either to remove or to alter something that is in the way or shouldn't be seen. Rotoscoping is very expensive and time consuming, so we were trying to design the shots so that each element could be digitally composited with one another easily.

Some shots were easy. In the first few boards, you see the background, the ship, and Neptune. In those first few shots, nothing in the foreground moves in front of Neptune. This was an easy effect. The computer graphics made the background and the ship. The live-action footage of Neptune was simply placed into the image. The storyboards were important here to make sure that the placement of each character was correct and that both the live-action crew and Amblin Imaging knew what to shoot and create for their portion of each shot.

The tricky shots were when the ship crossed in front of Neptune, and he was supposed to reach for the ship. Those shots had three planes of images to combine. The

Figure 29.2 Storyboard showing characters approaching a castle. The side note indicates that the castle is actually a miniature close to the camera, which only appears to be sitting on the hill. As long as the characters don't walk so high up the hill that they disappear behind the castle, the effect will work.

Figure 29.3 *seaQuest DSV* board helps to lay out the effects (which elements are live and which are computer graphics) and shows the CG ship in the foreground and Poseidon reaching for it. We made sure not to have his hand cross in front of the ship, which would have meant expensive rotoscoping around his fingers. Board by Mark Simon. (© by Universal City Studios, Inc. Courtesy of MCA Publishing Rights, a Division of MCA, Inc.)

Figure 29.4 Final composited frame from *seaQuest DSV*. (© by Universal City Studios, Inc. Courtesy of MCA Publishing Rights, a Division of MCA, Inc.)

Figure 29.5 Model of the *seaQuest* used for reference when storyboarding. The same model was used for reference in the green screen shoot.

background plate was developed on the computer. (A *plate* is a portion of an image to be composited with other elements, or plates, to make the final image.) The next plate was of Neptune reaching forward trying to grasp the *seaQuest*. The top plate was of the ship trying to escape.

Amblin Imaging had to render the ship with a transparent background to place it on top of the live-action element and the background plate. One thing we had to watch for in shooting was to avoid having Neptune's hand cross in front of the ship. If his fingers crossed in front of the ship while the rest of Neptune was behind the ship, the fingers would have needed to have been rotoscoped, and the budget didn't allow for that.

In the preproduction meeting with these storyboards, items like this were brought up and added to the boards so that the crew knew the parameters. The actor was also shown the boards so that he knew how his actions fit into the composited scene. After studying these boards, Amblin Imaging asked that we provide a model in the shots representing the size of the ship that the actor could reach for. Luckily the retail kit models available at Kmart were the perfect scale, and that's what we used.

As you can see, the boards served as an invaluable tool in this sequence. Problems were circumvented,

shots were made more exciting, the shot was made on budget, and crews in different states were able to work efficiently together. This is the magic of storyboards.

Effects can also be entirely live action. Let's say you have a scene where the script calls for a bridge to explode, with stuntmen flying off of it. The unit production manager (UPM) needs to know how much money and time to budget for an effect such as this. The practical effects supervisor and the stunt coordinator may be asked about the cost and time needed, but without storyboards a precise estimate would be difficult to give. A director may want multiple camera angles, other actions leading up to the big explosion, a truck to flip and then explode, helicopters flying around, or any number of options.

Storyboards determine the exact look the production needs to get, and with them the effects supervisor and the stunt coordinator can properly plan and budget; thus, the UPM can schedule the effect and stunt accurately. These same storyboards allow the live effects team to design and build the proper FX equipment, the camera crew to properly prep, the props guys to know what they have to provide, the assistant director (AD) to plan for all the extras and background talent, and the rest of the crew to preplan accurately for the scene.

Some effects may be an in-camera effect of a combination of live action and foreground miniature work, such as a high shot of two men walking up to a giant castle. The men and the ground around them may be the only life-size elements in the picture. The castle may be a miniature placed closer to the camera so that it appears very large in comparison to the men.

If both elements are in focus and the life-size actors do not move behind the miniature, the shot will look real. Storyboards are the best way to previsualize what shots are needed and how to produce them. Having each shot ready on time also saves valuable production time.

Many times storyboard artists are developing the elements of an effects shot with the director and/or effects supervisor. In these cases, make sure all relevant information about each shot is marked and listed on the boards to inform the rest of the crew. If a character needs to be shot on green screen, make a note of it. If there is to be a matte line along a part of a location, highlight it. If there are many elements to composite in a shot, list them. Any information given to you on how a shot will be produced should be included in the boards that are to be shared with the rest of the crew.

In listing the proper order in which elements need to be composited, always start with the background layer furthest from camera as layer 1. The higher the number, the closer an element is to the camera. We count layers this way because of the way we composite images, much like classic hand-drawn animation. You lay the background layer in first; then you add other layers on top.

Figure 29.7 Perspective view of the layers in a shot. The layer farthest back is the sky, which is layer 1. The dust is layer 6.

Figure 29.6 Practical bullet hits need to be prepped by the practical effects team. Boards will show them how many camera shots need the hits. Boards by Josh Hayes.

Higher layer number
when closer to camera

Furthest back layer is layer 1

					Source Name
👁	6		▷	■	📷 Camera 1
👁	5		▷	■	🎞 Landing Dust...
👁	4		▷	■	🎞 Jeep 3 with ...
👁	3		▷	■	🎞 Volcano text...
👁	2		▷	■	🎞 Eruption 2.tif
👁	1		▷	■	🎞 **Sky.tif**

Figure 29.8 The list of layers shown in the composition in Figure 29.7.

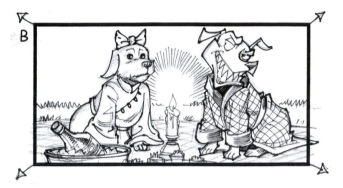

Figure 29.10 Part of the boarding process may be determining how effects such as this combination of live action and animation might be produced in *Son of the Mask*. Storyboard by Tim Burgard. (Copyright MMV, New Line Productions, Inc. All rights reserved. Courtesy of New Line Productions, Inc.)

There is an old Hollywood adage, "Fix it in post (production)." These days, with the latest in computers and special effects wizardry, anything can be fixed. However, those fixes come at a cost. It's expensive. Properly storyboarding, planning, and shooting the elements of an effects shot is always faster and less expensive that "fixing it in post."

There are many different types of effects that may be boarded. Some are quite intense and others are quite simple, but even the simplest ones need to be planned. A special effect that the prop master can take care of, such as an earring falling off an actress on cue, may not be difficult. But many times such things are not written into a script and the prop master may not be prepared for it without storyboards telling him about it.

A director may come up with situations to enhance a scene. He will tell his vision to the storyboard artist, who in turn illustrates it for the crew. Many crew heads have been thankful for storyboards when they see something they did not previously realize they needed to prepare for.

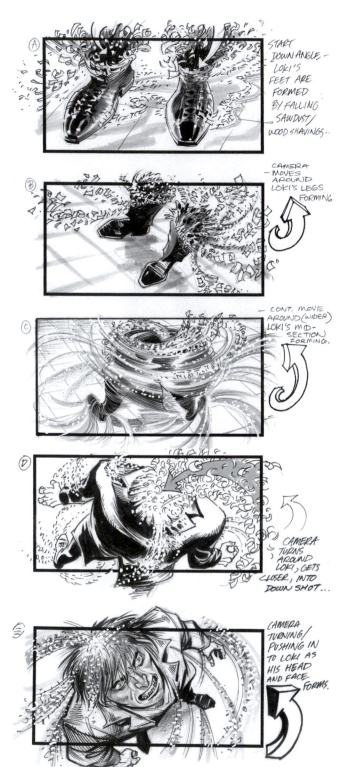

Figure 29.9 Camera moves, compositing, CG, and practical effects in this scene from *Son of the Mask*. Storyboards by Tim Burgard. (Courtesy of Newline. All rights reserved.)

CHAPTER 30

Conceptual Illustration

Storyboard artists often serve the role of conceptual artist on projects. Conceptual art illustrates the designer's vision for the director and producer to agree upon. This may include rendering set ideas, enhancements to locations, character designs, wardrobe, props, and more. On feature films this position is often called *production illustrator*.

Since a storyboard artist is generally the only crew person specifically hired simply to draw, the job of illustrating ideas naturally falls to him. Once an idea has

Figure 30.1 Concept art for the animation series *Creepers*. Art by Travis Blaise of Animatics & Storyboards, Inc. (© 2006, Lyons Entertainment, Inc.)

been agreed upon and approved, the accepted rendering is often used to design and build the final product.

The drawings are given to the producer and director to approve. The production designer gives the illustration to the art director, who makes notes on them regarding construction materials, swing flats (parts of the set that can be removed for access by the camera), colors, and any changes.

Then the drawings are given to the set designer, who draws blueprints of the set or location, which tells the rest of the crew all the construction details, size, color, placement, and so on. The blueprints and the conceptual art are then passed on to construction. The blueprints inform construction how to build the set, and the conceptual illustrations show them how the completed set or location should look.

On the series *seaQuest DSV*, I started as their storyboard artist about a month before production began. Directors do not usually start preproduction on TV shows until about a week before shooting begins (two weeks if it's a two-hour pilot). This left a lot of time for me to work directly with the production designer, Vaughan Edwards.

Vaughan would give me thumbnails of his ideas for the sets. I would then sketch them. He would make notes and I would do the finals. He would then take the final art to the producer to get approvals before blueprints were drawn. I drew from verbal descriptions, sketches, and blueprints (sometimes sets are designed without illustrations first, so I would sketch the sets

using the finished plans as reference). I also sketched ideas for wardrobe and props.

After the director came onboard, I started working with him on storyboarding specific scenes. There were times when the director had an idea to enhance a location and what he wanted to see. The designer and I would both sit down with the director and come up with

Figure 30.2 Concept art for second-season premiere of *seaQuest DSV*. This set was never built due to script changes. The tower in the background existed at the location. Production Designer: Vaughan Edwards. Artist: Mark Simon. (© by Universal City Studios, Inc. Courtesy of MCA Publishing Rights, a Division of MCA, Inc.)

Figure 30.3 From left to right, alien creature illustration, which was then turned into a crew shirt. The metal skull concept was used to reveal a character as an android. The futuristic helicopter was used in backgrounds. All images designed and used on *seaQuest DSV*. Artist: Mark Simon. (© by Universal City Studios, Inc. Courtesy of MCA Publishing Rights, a Division of MCA, Inc.)

ideas. I would then illustrate what we had discussed, and the designer would get clearance to proceed.

To illustrate how a special effect should be included in existing footage, you can mock up the final look on a location photo or on an actual frame from the footage or do an illustration. Illustrating and compositing can be done by hand or in the computer. Digital still frames can be exported from existing footage using nonlinear editing programs such as Avid, Final Cut Pro, and Adobe Premiere.

Using Photoshop, various images can be manipulated very quickly and easily. You can digitally add elements into the frames, or you can draw the elements on paper, scan them, and then composite the elements together. You can also composite all the elements together and add motion within After Effects to produce an animatic.

Alan Lee was called on in the *Lord of the Rings* trilogy to draw the town of Edoras in *The Two Towers* film. To get approval from the studio for the costs of building the town in a desolate location, director Peter Jackson had Lee sketch the town on tracing paper over a location photo.

The concept art often guides matte painters and effects studios in what they need to produce. It also helps them budget and schedule their work. Larger effects studios will provide their own concept art on some productions. They, too, will work with the production designer to keep the look of the film consistent.

On commercials, a storyboard artist may work from general ideas as often as from a finished script. These boards set the tone of the commercial. The illustrations conceptualize not only the look of the set and locations, but the camera angles and lighting as well. These are then shown to the client for approval. Presentation boards are described in detail in Chapter 11, Presentation Boards versus Production Boards.

The Web allows artists to digitally paint with perfect textures and colors. On a recent conceptual illustration job, a client wanted specific Sherwin-Williams colors for the set. I didn't have color chips, so I went online and captured the paint chip color from the Sherwin-Williams web site, which I then painted with in Photoshop. The client also wanted a specific granite countertop. I found a sample of the granite online, captured it, and used the exact texture in my illustration. The client got exactly what had been requested.

Conceptual illustration not only covers drawings of sets, but also of creatures, props, costumes, and vehicles. Anything that needs to be designed, built, changed, enhanced, or created needs to be illustrated first.

Famous artists whose artistic styles films like to rely on are sometimes called on to illustrate or paint production art. H. R. Giger was hired to create the biomechanical designs he's so well known from the *Alien* movies.

Even Salvador Dali was called on by Disney for the *Destino* animated short. His paintings were not of spe-

Figure 30.4 Elements of existing sets and props were composited together with photos of a host for a presentational piece of art. A number of the characters in the illustration are photos of action figures. Illustration by Mark Simon.

Figure 30.5 Set illustration for a Ford commercial. Design by Mark Dillon. Illustration by Mark Simon. Painted with digital color chips from the Sherwin-Williams website.

cific designs or characters, but they were used as visual guides to inspire the staff artists.

Another recent example is Disney's *Hercules*, whose conceptual illustrator and production designer was British cartoonist Gerald Scarfe. Scarfe is well known for his political cartoons in the *Sunday London Times*. He also worked on *Pink Floyd's The Wall*. One of the natural elements in Scarfe's art is serpentine curls, which was heavily used in *Hercules* to give it a distinctive look.

Syd Mead is a famous visual futurist who got his start designing cars at Ford. He is responsible for the conceptual art for such movies as *Blade Runner, Mission to Mars* (V'ger in) *Star Trek: the Motion Picture, TRON,* and *2010: The Odyssey Continues*. His work designing futuristic cars, products, and living conditions have been sought after by Hollywood executives.

Originally, Syd Mead was designing just the high-tech vehicles for *Blade Runner*. When the director, Ridley Scott, saw the background vignettes in the drawings, Syd was asked to create ideas for the street sets. Syd's next assignment was visualizing all of the hardware accessories in the densely detailed movie.

Alan Lee and John Howe were hired to work on the *Lord of the Rings* movie trilogy as concept designers because of their previous work illustrating the book trilogy. Their existing knowledge of the fantasy work made them invaluable. They had spent a decade delving into the look of the books before starting on the movies. Their work is seen in the look of the environments as well as of the costuming and props. Grant Major, the production designer, oversaw and guided all of the design to keep one consistent look in the movie.

Figure 30.6 Pitch board for a 4D theme-park movie designed by Renaissance Entertainment for Busch Entertainment. Collage style presentation art by Mike Conrad of Radical Concepts, Inc.

Concept art is often used for theme-park attractions and shows, themed parties and events, and more. There is no specific format. Each client wants and needs different things.

Conceptual artists may have different titles on projects, depending on what type of project it is and what their overall contribution is. On animations, the main conceptual artist is usually the production designer. On films he may be the production illustrator, illustrator, or storyboard artist.

Many production designers do their own beautiful illustrations, like the great Ray Harryhausen of *Jason and the Argonauts* fame. Whatever your title may be, the purpose of your work is to design and inspire. Even on the lowest-budget productions, great illustrations may lead to phenomenal-looking sets.

CHAPTER 31

Computers and Software

Computers are being used more and more in producing storyboards. Artists are using computers to enhance their art, and non-artists are using them as production support.

Figure 31.1 Digital storyboards by John Ryan for Stone Mountain Park, painted in Painter.

For people who can't draw, there are some software packages for developing storyboards. Most of the images in these programs are rather stiff compared to custom, hand-drawn boards, but they are quick and easy to master.

Three-dimensional rendering programs can render beautiful boards of logos, flying objects, and so on, and they may be great for what you need. But they will take much longer and cost you much more than developing ideas with a pencil and paper. If you are putting together a high-budget presentation, you may want your final art to have the crisp output from an expensive 3D system, but even then you should develop your initial ideas quickly and cheaply by hand with storyboards and then have them rendered from a computer.

PowerProduction Software offers three versions of their digital storyboard software, Storyboard Quick and Storyboard Artist, from basic print to full-motion graphics. The software offers a large library of characters, props, and sets and allows you to draw your own. The script can be imported with audio, timed on a timeline, and printed on a custom-designed form.

BoardMaster also has a large collection of clip art and allows you to use and draw your own art. You can arrange your boards, print them, add sound, export to an HTML page, and run a simple animatic in this program.

There are disadvantages to computer-generated storyboards because they tend to look stiff. You are also not able to be as visually flexible in what you can portray as an artist drawing freehand. There are only so many positions and expressions of each character or item in program catalogs, and, aside from drawing a new image and importing it into the program, you are stuck with somewhat limited images.

Computer programs are also not as interactive as a storyboard artist who can offer ideas and clarify what is wanted. As fast as computers are, they are not as fast as a good storyboard artist. If you can't draw, these programs may work very well for you.

Video game designers will sometimes forgo traditional storyboards and work out action sequences in animatic form using their existing CG assets.

Although video game boards and animatics can be generated with digital assets in any CG program, there are only a few CG programs designed specifically for boards, such as FrameForge 3D Studio and StoryViz. They were designed with cinematographers in mind.

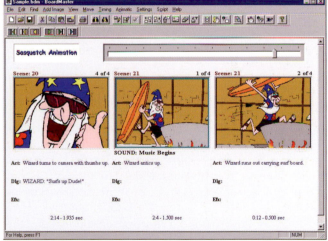

Figure 31.2 Storyboard Quick and BoardMaster screen captures.

Figure 31.3 Color style boards using CG assets from *Stranglehold* cinematic by Janimation, Inc.

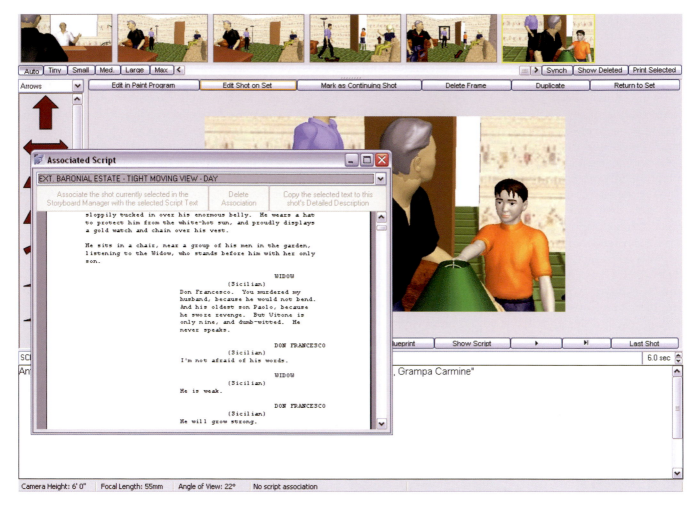

Figure 31.4 FrameForge script link.

Some members of ASC, the American Society of Cinematographers, had been getting frustrated because they feel they can't film what's drawn on classic boards due to real-life limitations. In the CG world, reality can be replicated and can show exactly what is shootable.

Like walking around a location or soundstage, the 3D environment allows directors and directors of photography (DPs) to experiment and walk around a set virtually. Plus it accurately demonstrates depth of field.

Since it is a digital process, FrameForge will import and link to scripts. It will automatically generate blank sets for every unique location.

The program is also designed to work easily with non-CG people. If you drag a character over a chair, the characters pose changes to a sitting position, which you can edit as you need. If you have a character reach for a gun, the gun will attach to the hand.

FrameForge 3D Studio will also print storyboards with a blueprint of camera setups on the page. It will allow you to preview the boards as a slide show, as a Flash slide show, or as HTML pages with links.

You may want to use your computer to help you with your conceptual illustrations. It can be time consuming to illustrate a set and make it dimensionally correct in perspective. However, you can use CG programs such as SketchUp to speed up the process.

With SketchUp, you can quickly build a 3D mock-up of a set, move around in 3D space, and determine the best angle for your illustration. You can export a finished rendering or print a hidden-line removal drawing and add your finishing details while lightboxing the print (tracing over it with a lightbox). For more on this, see Chapter 30, Conceptual Illustration.

Artists who use the computer to enhance their art need a few important pieces of equipment. There's the

Figure 31.5 StoryViz screen capture.

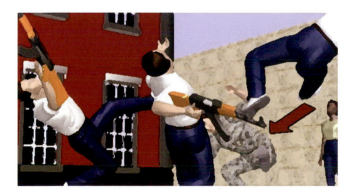

Figure 31.6 Storyboard by Ignacio Sardinas using FrameForge 3D Studio.

computer, of course, and you can never have too much memory or a large enough hard drive. Large monitors are a must; you have to see what you're working on without squinting or your eyes will get too tired. A graphics pad is imperative. They make graphics programs much more like working on paper. Try the different sizes before you plunk down your cash. The 6″ × 8″ tablets seem to be the most popular. The 12″ tablets make you move your arm around too much, and the 4″ tablets don't offer as much detail.

Tablet monitors, such as the Wacom Cintiq, and portable tablet PCs allow artists to draw directly on the screen. This speeds up the digital process immensely. It also allows artists to use drawing tools they are

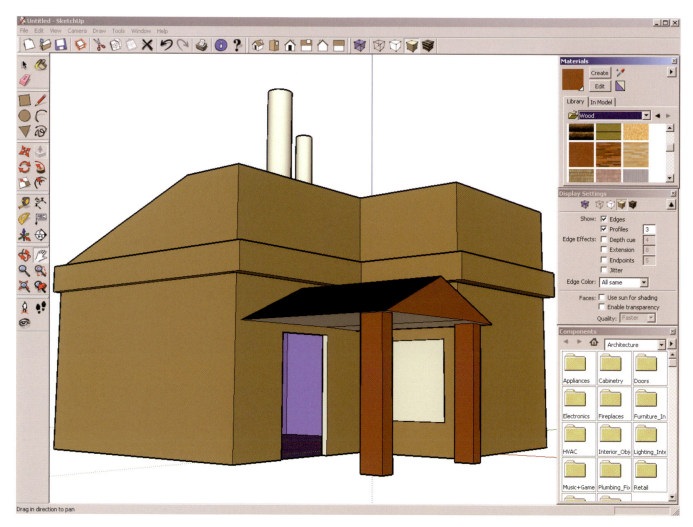

Figure 31.7 Screen capture of SketchUp, a very fast and simple 3D tool for set design and concept art. Fly around a rough version of a set, print it out, and lightbox over the print to draw your rendering in dimensionally correct perspective.

familiar with, such as straightedges and curves and templates, which cannot be practically used with a mouse or regular graphics tablets. The tablet PCs are particularly helpful if you work on location.

You can't do much of anything without a scanner. If you need to do a lot of scanning, be aware that low-cost scanners are extremely slow and give you limited abilities to adjust your scanned image. It is usually best to scan directly from within Adobe Photoshop. If your scanner is Twain compliant, it will show up under the File drop-down menu listed under Import. More and more artists have portable scanners that they take with them on location. They can scan their boards on location for digital coloring or printing while on the job.

And don't forget a good printer. No matter how good you can make your images, without being able to print them well, they won't look good. Try to find a laser printer with at least 600 dpi that will run heavy paper (Hewlett-Packard printers are great with heavy paper). Color printers are getting better all the time, so shop and compare. Inkjet printers are cheaper to buy, but the supplies cost more in the long run. Most inkjet inks are also not waterproof, so they don't work well for mailers. Laser and solid ink printers cost more to purchase but usually print faster and cost less per page, and the results are waterproof.

The most important piece of all is obviously the software. Many artists use paint programs to color their

Figure 31.9 Wacom Cintiq graphics tablet monitor. Drawing on the computer is now even easier than drawing on paper.

Figure 31.8 Wacom graphics tablets are a must for any digital artist.

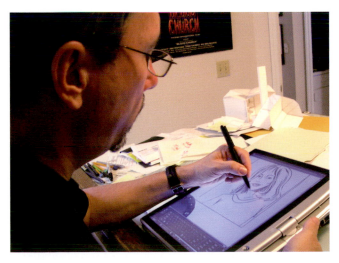

Figure 31.10 Mike Conrad of Radical Concepts, Inc., sketching on a Toshiba tablet laptop computer. He's using Autodesk SketchBook Pro software.

Figure 31.11 High-end scanners have better software for controlling the quality of your scans.

Figure 31.12 Twain-compliant scanners can be used within Adobe Photoshop under the File drop-down menu and are listed under Import.

boards. The most popular paint program is Adobe Photoshop. It's the graphics industry standard. Corel Painter also works very well.

Mirage is a combination paint and compositing program. It features a plug-in called Boardomatic. You can draw your boards and continue in the same composition through animation and compositing. Boardomatic features a thumbnail page (or series of them) where you can quickly lay out your scenes. Then you can transfer your sketches into a project in any order. In your project you can redraw, paint, and animate your images on a timeline using as many layers as you wish. Boardomatic also gives you a customizable template for printing, pans, and more. The printing allows you to add text, your contact information, and numbering.

Cleaning up stray lines, coloring an image, compositing, warping a portion of an image, and blurring the background are all easy and look impressive with these programs.

Adding professional text to a storyboard frame is easy in any paint program or in the vector layout programs Adobe Illustrator and CorelDRAW.

Adobe Photoshop, starting with version CS2, allows artists to quickly use the perspective tool to clone and paint in perspective. This is helpful when you have to extend an illustration or location photo in perspective.

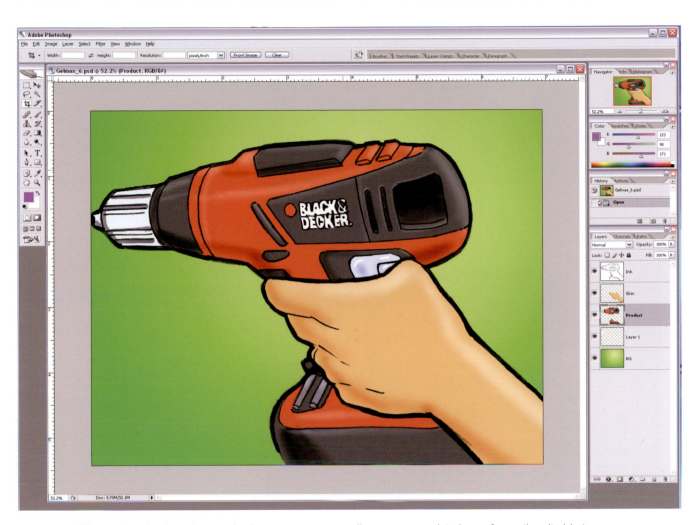

Figure 31.13 Photoshop and other paint programs allow you to work in layers for easily editable images.

Figure 31.14 The Boardomatic plug-in for Mirage allows you to quickly lay out your thumbnail sketches. These sketches are then imported into a timeline in any order you wish.

1. Interactive workspace
2. Main Panel provides all standard brush, masking, and fill tools.
3. Color Controls and Mixer, similar to an artist's palette
4. Fully configurable and customizable natural-media brushes
5. Timeline and Layer Control
6. Digital Light Table, for in-betweening
7. Mirage FX Stack, including blurs, particles, lights, and keying
8. Element Controls, for customized scripting

Figure 31.15 Mirage compositing workspace and controls.

Figure 31.16 CorelDRAW is a great, fast, and inexpensive layout program for designing your own storyboard forms, logos, and page layouts.

Figure 31.17 Adobe Photoshop's Vanishing Point tool allows artists to extend, paint, and clone photos and artwork in proper perspective.

Moving images are also manipulated with computers to make animatics, animation, and special effects. After Effects is the most common software for compositing moving images. Shake and Mirage are also popular. You can produce simple pan-and-scan animatics, and you can produce feature film effects with it. You can also print frames from your composites to serve as storyboards.

Computers are also incredibly helpful in supporting your business. Besides word processing, which makes updating résumés a breeze, you can track your billing, balance your checkbook, lay out your own storyboard forms, design your advertising, and more. If you need to copy your gray-tone boards on a black-and-white copier, just scan and print your boards. Scanning breaks the image into tiny dots that copiers can reproduce, whereas gray markers normally look like black smudges when copied.

A 300-dpi printer will copy better than higher-resolution printers, because the dots will be larger. You can also manually adjust the size of the dots with the Halftone Filter in Photoshop. Halftone is the process of breaking an image into easily reproducible dots, like photos in a newspaper. In Photoshop you can find

Figure 31.18 Jeep animatic frame by BBDO Detroit by Mark Simon
of Animatics & Storyboards, Inc. Composited in After Effects.
(Complements of DaimlerChrysler Corporation.)

Halftone Patterns under the Filter drop-down menu and inside the Sketch selection.

Digital delivery is now the standard. Burning CDs of images and e-mailing images is a daily occurrence. For large projects, it is often helpful to have an FTP site (File Transfer Protocol) for clients to download large files. E-mail systems can easily be overloaded when a number of graphics are sent at once, since many have a 10-MB limit.

PDF files are universal files that can contain images, text, audio, video, and more. They can be read on PCs and Macs. Adobe Acrobat Pro builds PDF files within the program, or you can print your layouts from any other program and set your print dialogue box to PDF.

PDF files are faster and easier for clients to print multipage storyboards. Clients only need the free Adobe Acrobat Reader to read the files. It may be found at www.Adobe.com. Photoshop will also open individual pages from a PDF file. This allows you to make use of elements and graphics from PDF files delivered by clients.

Figure 31.19 In Photoshop, find the Halftone Pattern effect under the Filter drop-down menu in the Sketch selection.

Figure 31.20 Gray colors do not reproduce well on black-and-white copiers. You can use a 300-dpi print from a scan to convert your gray tone to dots, which will reproduce better on a copier. The image on the left is the original by Peter Ivanoff. The center image is how a black-and-white copier is likely to make copies. The image on the right is broken into a halftone for quality copying on most copiers.

Figure 31.21 PDF files allow clients to view and print their entire storyboard from one file.

USB jump drives are one of the best additions for saving and moving files. They work equally well in all PCs and Macs, with no additional drivers needed. Always carry one with you on a job for accepting and delivering images.

Artists and nonartists can benefit from using computers as storyboard support, but computers can't replace the creative mind in the development of a well-designed scene. Computers are only tools, but they can be very powerful tools.

Figure 31.22 USB jump drives facilitate the movement of large files quickly between computers.

Tricks of the Trade

As in every industry, there are tricks that the pros use to help them get their work done quickly and with quality. Everyone works differently and with different tools, so some of these tips won't pertain to you. Make use of the tricks that work within your style and with what you have available to you.

Quick Drawing

- *Tracing reference photos.* Why waste the time it takes to draw a detailed background if you have a photo of that background you can trace over.
- *Tracing your own art.* There's no need to redraw something you've already drawn once.
- *Digital copying.* You can copy elements from one panel and paste them into another panel within programs such as Adobe Photoshop and Corel Painter.
- *Non-repro blue pencils.* Light blue pencil lines are usually not picked up by copy machines. You can quickly rough in the shapes in your storyboards with a blue pencil and go directly to your cleaned-up drawings without having to worry about lightboxing or erasing your layout lines.
- *Light tables.* Use a light table to make tracing your roughs and photos easier.
- *False light tables.* If you don't have a light table available, place a lamp under a glass table. You can also tape your art to a window. This is helpful when you're on location and just need to quickly lightbox something.
- *Perspective.* Layout the rough shape of a location or set in a 3D program, such as SketchUp, without worrying about details. Determine the camera angle and lens in 3D, and print a hidden line removal outline of the image. Lightbox the image, and fill in proper detail with pencil and ink or digitally. This is the quickest way to do an architectural illustration in perspective that is dimensionally correct.
- *Pencil holders.* Simple spring devices from the larger art stores hold your pencils and pens within reach on angled surfaces.
- *Adjustable ship curves.* Easier, cheaper, and faster to use for drawing curves than a large assortment of French curves.
- *Portable drafting table.* Carry a portable drafting board on location. The slight incline of the board is easier to draw on than a flat or textured table when you work on location. These are available at most art supply stores for around $50.

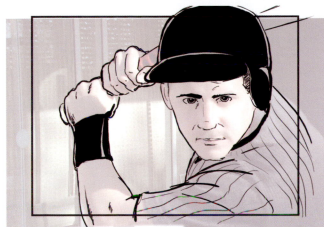

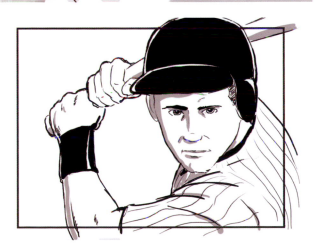

Figure 32.1 Use a photo of a specific pose and digitally trace it. A photo was imported into Photoshop and the transparency was reduced to 28 percent. The board was drawn with a graphics tablet on another layer, and then the photo layer was turned off. Tone was added on an additional layer below the line drawing to color under the lines.

Figure 32.2 Adjustable curves: The *top* unit is for freeform curves. The *middle* two are for even curves. The *bottom* is a classic rigid French Curve.

Figure 32.3 A pencil holder allows you to keep pencils within easy reach on angled drafting and animation tables.

- *Drafting tape.* It has less tack than regular tape and will come off your drawings without tearing them.
- *Post-Its.* Various kinds of sticky note paper can be used instead of drafting dots to hold your paper still.
- *Digital drawing.* Scan your thumbnails into a computer and do your final art on another level, or do your rough drawings digitally on one level

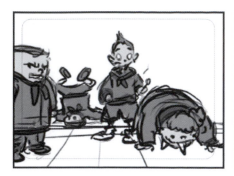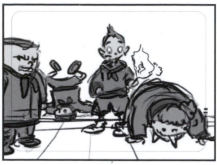

Figure 32.4 Elements digitally copied from one frame to another. The *second* frame only adds a flame. The *third* frame adds foreground legs and turning heads on two characters. Everything else is digitally copied from the first frame.

Figure 32.5 A portable drafting table is made especially for working comfortably on location.

and final art on another level. Instead of erasing, you just turn off the thumbnail layer.

- *Digital drawing in layers*. By keeping different elements of your boards on different layers, resizing, editing, and reframing are made much faster. Keep characters on one level, backgrounds on another, and color on layers under your lines. Client changes are easier to deal with when you keep your art in layers.

Pencils

- *Soft leads*. The softer the lead, the better and darker it reproduces. Just beware that soft leads also smear more easily.
- *Mechanicals*. Mechanical pencils never need sharpening.

- *Non-repro blue*. Drawing thumbnails with a non-repro blue pencil keeps you from having to erase your roughs from under your finishes. Non-repro blue will not scan or copy on black-and-white copiers and scanners.
- *Pencil extenders*. These make your short pencils last longer and easier to use.

Camera Depth

- *Digital blurring*. Use a computer paint program to blur part of an image to accurately portray lens depth.
- *Use of light and dark*. Dark recedes.

Inking and Copying

- *Copiers*. Copying pencil drawings acts like inking, giving you clean crisp lines that won't smear under most color markers. Scanning and printing to laser printers (not inkjets) works the same way.
- *Copies*. Duplicate repetitive frames instead of redrawing them.
- *Feeders*. Don't run original pencil art through feeders on most copiers. Most feeders drag the paper and will smear your art. Make one master set of copies and run the master copies through the feeder for mass production.
- *Script*. Reduce and tape the cut-up script onto your boards instead of rewriting it onto your boards.
- *Script 2*. Digitally cut the text out of the word processor document and paste it into your digital boards.
- *Straightedge*. Use a straightedge with an inking edge (a raised edge) to avoid having the ink bleed under the edge.

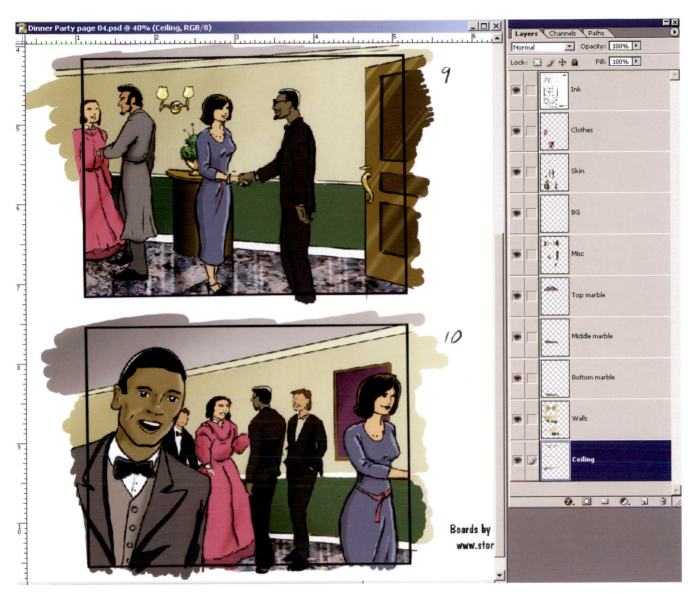

Figure 32.6 Digitally colored storyboards. Notice the 10 layers of colors for easy coloring and adjusting. Storyboards by Mark Simon of Animatics & Storyboards, Inc., for a television series proposal.

Computers

- *Cleanup*. You can scan in your rough sketches and clean them up in Adobe Photoshop. This allows you to digitally color and manipulate your art. You can also layer images over different backgrounds without redrawing the backgrounds each time. Other bitmap software used for digital coloring and manipulating includes Corel Paint and Mirage.

- *Layering*. Again Photoshop, Corel Paint, and Mirage are used a lot to layer new characters over the same backgrounds. After Effects and Mirage are also used to animate layers for animatics.

- *Halftone*. Scan images with tones and print them out. This breaks the image into tiny dots, like a newspaper photo, that copiers can reproduce better than a solid gray, and a 600-dpi copy is better than a 1,200-dpi one.

- *Lettering*. Signage and logos look nicer when done with a computer. Lettering in perspective is much better and more accurate when done with software instead of by hand.

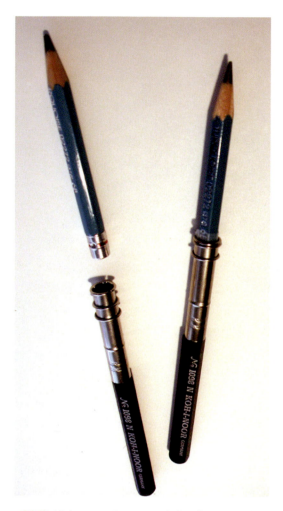

Figure 32.7 Make your short pencils last longer and easier to use with extenders.

Figure 32.8 The blurred background helps add the look of depth to storyboards. To save time, I used a photo of my family room and blurred it for the background instead of drawing a detailed background.

Figure 32.9 A copy of the script is taped below the storyboard panels to save the time of rewriting it.

- *Graphics tablets.* Drawing with a pen device rather than a mouse is a must. Wacom has tablets that better approximate the feel of drawing on paper.
- *Screen tablets.* Use a tablet PC or a Wacom Cintiq tablet for drawing. This allows you to draw directly on the screen.
- *USB jump drives.* Carry USB jump drives with you. Then you can always carry your digital forms, files, and résumés too, and you can copy client files, reference images, and logos while on location.
- *E-mail.* You can e-mail important files, résumés, and forms to yourself so that you can always retrieve them for work, no matter where you are.
- *CD-ROM.* Carry a CD with JPG, DOC, PSD, and PDF files of your forms when you travel. These

are the most common file types you are most likely to find on others' computers.
- *Scenes.* When drawing digital boards, it helps to print the pages as you go. Lay the pages around you so that you can visually reference the entire scene as you work.
- *Textures.* Paint with textures to give your work a feel of depth. Textures can be warped in perspective as well.

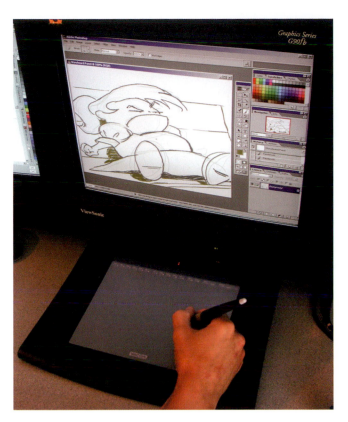

Figure 32.10 Wacom graphics tablets are much easier to draw and edit with than a mouse.

Figure 32.11 Author Mark Simon boarding on his Wacom Cintiq tablet monitor.

- *Screen capture*. Use the Print Screen key on your PC to copy the image of your desktop and paste it into any graphics program.
- *Internet colors*. Use the Internet to capture digitally perfect colors or textures for clients when you are coloring digitally.

Cameras

- *Reference*. We all need references to draw from at times.
- *Organization*. Keep your reference images from different projects together so that they are always easy to find. Keep wood textures in one folder, cars in another, and so on.
- *Digital camera*. This has the great advantage of instant usability of the photos. They can be manipulated for any use. A 3-megapixel camera is fine for most uses; 6-megapixel files will print as large as a poster. Cameras which use AA batteries are best because those are the easiest to buy on the road when you need them.

- *Memory*. Carry extra memory cards so that you don't get caught short.
- *Batteries*. Use rechargeable batteries. You will go through a lot of them with digital cameras, and rechargeables save money in the long run. Always carry extras.
- *Phones*. If you need a reference photo while away from your studio, just pull out your phone. Even if you don't have the service to e-mail it to yourself, you can use the screen on your phone.
- *Camcorder*. The last camera I use is a camcorder. When I'm trying to capture something that's in motion, sometimes the best way to do it is to frame-by-frame advance a video of the motion. I then pause the tape on the frame I want to draw. It is also helpful for studying motion.

Mirrors

- Use yourself as a reference.
- Using two mirrors angled toward each other allows you to see your own profile and back.

Wide-Angle Shots

- *Door peephole*. Look at your reference through a wide-angle door lens and you get a totally

Figure 32.12 Logos and lettering look better when done on the computer. Storyboards by Mark Simon of Animatics & Storyboards, Inc.

Figure 32.13 The PrintScrn key on your PC copies the image of your desktop, which can then be pasted into any graphics program.

different perspective of an object. This works great when you're trying to get an idea of how a miniature (like a submarine or spaceship) would look up close if it were life size.

Erasers

- *Electric erasers*. It still amazes me how many people don't know about electric erasers. They are superfast for erasing small and large areas. They also work great for making reflection lines in glass and water renderings.
- *Kneaded erasers*. They don't crumble and make a mess like other erasers. They work extremely well on soft pencil leads.

Figure 32.14 On a recent conceptual illustration job, a client wanted specific Sherwin-Williams colors for the set. I didn't have color chips, so I went online and captured the paint chip color from the Sherwin-Williams web site, which I painted with in Photoshop. The client also wanted a specific granite countertop. I found a sample online, captured it, and used the exact texture in my illustration. The client got exactly what they wanted.

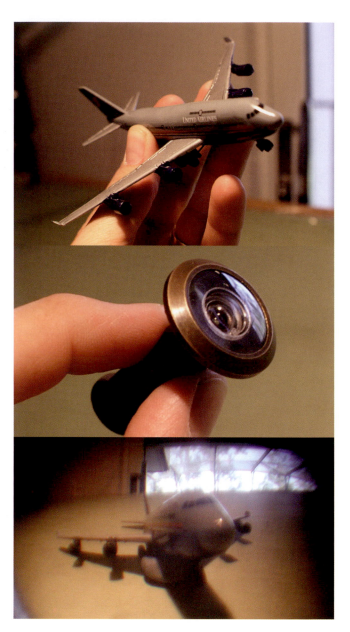

Figure 32.15 For quick photo reference when you don't have your camera with you, use your cell phone.

Revisions

- *Keep your originals.* Clients often call back with changes after delivery. It's easier and faster to make changes if you still have the pencil originals. If clients ask for the originals, tell them you prefer to hold onto them in case they request revisions.
- *Draw only with pencil.* It's easier to erase a pencil line for a revision than it is to white-out an inked line or start over.
- *Lightbox.* If you inked your boards, lightbox the areas of the panels that didn't change, to save time.

Figure 32.16 A toy airplane looks much larger when viewed through a door viewer.

- *Paste revisions over originals.* Use a glue stick or spray adhesive to adhere new panels over the old ones. Animation boards often have sticky notes stuck over just a portion of a panel that needs to be revised.
- *Post-It notes.* For quick revisions on a board, especially in a presentation, paste a sticky note over the panel and sketch your changes.
- *Digital.* Digital art is the easiest to make revisions on, especially if you designed the art in layers.

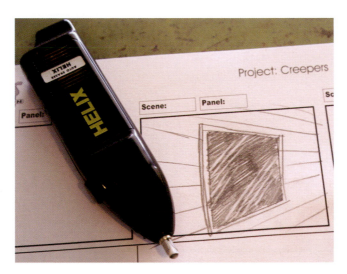

Figure 32.17 Cordless electric erasers are great for erasing thin lines in large dark areas.

Figure 32.18 Quick storyboard revisions can be made on a sticky note placed over the original panel.

Approvals

- *Fax*. Sending a fax to a client for notes and approvals can save you precious time. If you're going to fax roughs, don't do much of your work with a blue pencil—it can't be easily copied or faxed.
- *Faxing blue pencil*. Scan images with non-repro blue pencil marks on a color scanner. Using the Levels command (in Photoshop), darken the lines and lighten the paper background. Convert the image to grayscale and adjust the levels again if necessary.
- *Meetings*. Always try to get approvals before finishing your work. This will make your changes easier and waste less of your time.

- *Thumbnails*. Rough sketches with a client help limit miscommunication and speed every project along.

Animation Boards

- *Lettering*. Those who hate lettering can copy the script, cut out sections of the dialogue, and tape them on your boards instead of writing out the entire script by hand.
- *Moves*. Show multiple extremes of simple moves in one frame, such as an arm starting in a lower position and moving to a higher position.
- *Character motion*. If only one character moves in a scene, draw all the characters in the first panel

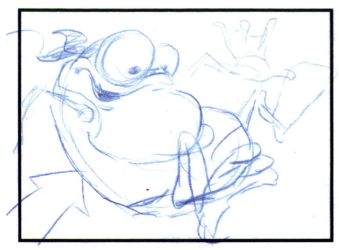

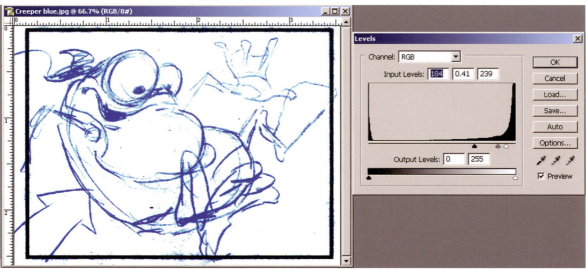

Figure 32.19 In order to fax your non-repro blue pencil art to clients, scan pages with the blue pencil marks on a color scanner. Storyboard by Mark Simon.

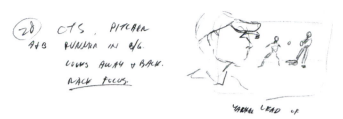

Figure 32.20 Rough thumbnails sketched while the director was talking in order to get a quick approval. Thumbnails by Mark Simon of Animatics & Storyboards, Inc.

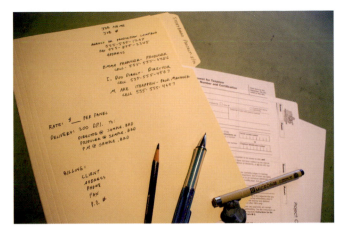

Figure 32.22 Mock-up of a folder prepared for a new project. Print on the cover all the contact and project information for quick reference as you work.

and then just draw outlines of the stationary figures. This helps bring the animators' attention to the character to be animated.

Organization

- *Files.* Make a manila folder for each job, and keep all art, scripts, and reference images in it.
- *Job info.* Write all relevant job info on the outside of the folder for quick reference. This includes billing info, job name, contacts, phone numbers, and e-mail addresses.
- *Numbering.* Number your pages as you draw. It's very easy to accidentally shuffle pages, and it can be time consuming to put them back in the right order on large projects.

General Business

- *Expenses.* Keep track of all your business expenses: advertising, printing, copies, movie rentals, books, and so on. They are a tax write-off.
- *Vendors.* Know where important vendors are before you need them, such as late-night copy

stores and weekend and late-night drop-off points for overnight deliveries.
- *Communications.* Have your own fax machine and e-mail for sending and receiving images to and from clients.
- *Invoicing.* Invoice clients as soon as the job is complete. The longer you wait, the longer it takes to get paid.

There is no such thing as cheating when you're producing storyboards. Do whatever it takes to give your director the images she needs. Storyboards are not art that will be sold for its own merit. It's important that you deliver quality boards in a timely manner. The less time it takes you to do tedious tasks or to redraw the same image over and over, the more time you'll have to improve the layout, story, and quality of your art.

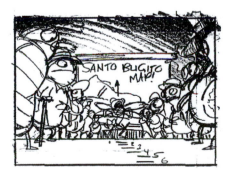

Figure 32.21 The first frame shows the main character, background, and background characters. The two following frames show only the action of the main character, so as not to be confusing; the S/A note indicates that the background keeps the same action.

Presentation and Delivery

There are many suitable ways to present your boards to your clients, as long as they're neat, clean, professional, and on time. You can buy booklets of storyboard forms, but it is usually best to design your own form on the computer or to use forms provided by production. Forms are included in this book that can be copied for use or serve as a template for designing your own. You need to determine how you like to work best, and find out from the client how they prefer the boards to be presented.

Figure 33.1 Many art stores sell storyboard booklets that look like this. They are not practical for professional use.

Most storyboard artists use their own layouts. This allows them to print them at will and include their contact information on each page.

Many storyboard forms that art stores carry are not practical to use. The following are some of the problems with art store storyboard forms.

- They're expensive.
- They're not usually the letter or legal size preferred by clients.
- Black negative areas on forms are not production, reproduction, or artist friendly.
- Rounded edges featured on many preprinted forms are frowned on in the industry.
- Text areas are usually not large enough or laid out the way production prefers.
- Artist contact info is not included.

You should use a form that allows plenty of room for notes. Even if you do not write notes on the storyboards, your client probably will.

Most clients now prefer digital delivery of their storyboards. Most can be delivered via e-mail, though large projects are often delivered on disk. Digital boards allow clients to lay out and print them in any way and at any size they want. Artists who scan their work for clients make clients' jobs easier. Clients are then more likely to return with more work. JPG images are generally the best format for delivery because the quality is high and the file size is small. JPG files also work equally well on Macs and PCs.

Digital delivery of thumbnails and roughs for approval are best kept as files that are around 650 to 750 pixels wide. This allows you to embed the image in the body of your e-mail (instead of making it an attachment because many clients lack graphics software to easily view images) and will print the images within a page without cutting off parts of the images.

Scanned work needs to be high-enough resolution that the client can enlarge and print the images without a loss of detail, yet small enough to be easily e-mailed, if that is their preference. Artists should also take care to adjust the settings of their scans so that the white paper background is actually white and not gray.

Proper naming of your digital files is important for your own organization as well as for ease of clients use. The biggest problem with naming happens when artists name their files something like Spot1Final.jpg. If the client requests a change, it then becomes Spot1FinalNew.jpg. What happens if the client makes more changes? Which is the latest version? What if you have more than nine scans? Following simple

organization and naming conventions will make everything clearer.

Start by setting up multiple directories for your projects. Let's say you are working with client X, drawing storyboards for two spots for their Lizard Lips product. Set up a master directory called *Client_LizardLips*. For your own organization, this directory should be in the same directory as your other storyboard projects. You can have main directories called *Photos, Storyboard Forms, Storyboard Projects, Cartoons, Logos*, and so on. Organize this according to your own workflow.

Make two directories inside of your *Client X_LizardLips* directory. They should be called *LizardLips_Spot01* and *LizardLips_Spot02*, or use the title of each spot in your naming convention. All of your boards for Spot 01 can go into that directory, or, depending on your workflow, you can subdivide that directory further into *Spot01_Roughs, Spot01_B&W*, and *Spot01_Color*.

Name all files so that they stay in the proper order and it is clear as to what they are. Naming conventions, such as Spot01_Panel01.jpg, are very good. This numbering procedure keeps all the files in proper order. If you just number them with single digits, such as 1, 2, 3, 4, 5, 6, 7, 8, 9, 10, and 11, the computer will automatically store them in the following order: 1, 10, 11, 2, 3, 4, 5, 6, 7, 8, 9. Always use two digits when you have up to 99 images (01, 02, 03, . . .) and three digits when you have more than 100 images (001, 002, 003, . . .), and your computer will always display them in the proper order.

Each file needs the name of the spot as well, such as *Spot1_panel01.jpg* and *Spot2_panel01.jpg*. When you e-mail a client all the panels for every spot, you don't want two files named *panel01*.

One problem with not using dates in your file names occurs when your client has the files you e-mailed to them in different e-mails and saved in different places—they won't know which is the most recent file. When clients make changes, simply add the date to the end of your file name: *Spot01_Panel01_rev10-15-06.jpg*. This will always make it clear which is the most recent file. If a client adds a panel in between panels 1 and 2, then the new panel would be named *Spot01_Panel01A.jpg*.

When you are ready to deliver the final scanned art to your client, you can either make a CD with the directories containing the final images or e-mail them the individual files.

When e-mailing files, send a few files at a time in multiple e-mails to keep down the size of attached files; if the client can accept zipped files, use them. Also

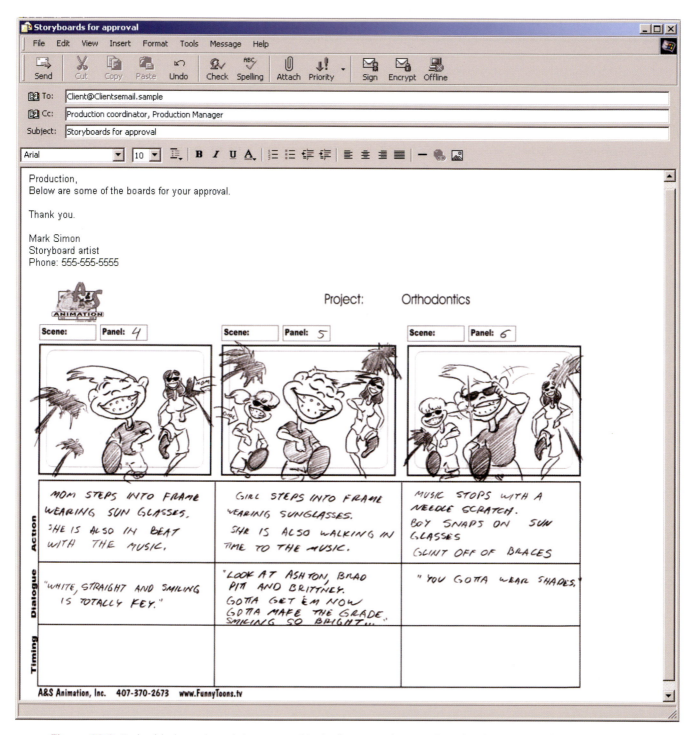

Figure 33.2 Embedded storyboards in an e-mail is the fastest and easiest form for clients to quickly view and print.

Figure 33.3 Poor, low-res scan on the *left*, with a gray background, uneven color, and poor contrast on the lines. The scan on the *right* is at a higher resolution and has been adjusted to have a white background and dark, clear lines.

Lizard Lips spot 01, panel 01.jpg
Lizard Lips spot 01, panel 02.jpg
Lizard Lips spot 01, panel 03.jpg
Lizard Lips spot 01, panel 04.jpg
Lizard Lips spot 01, panel 05.jpg
Lizard Lips spot 01, panel 06.jpg
Lizard Lips spot 01, panel 07.jpg
Lizard Lips spot 01, panel 08.jpg
Lizard Lips spot 01, panel 09.jpg
Lizard Lips spot 01, panel 10.jpg
Lizard Lips spot 01, panel 11.jpg
Lizard Lips spot 01, panel 12.jpg
Lizard Lips spot 02, panel 01.jpg
Lizard Lips spot 02, panel 02.jpg
Lizard Lips spot 02, panel 03.jpg
Lizard Lips spot 02, panel 04.jpg
Lizard Lips spot 02, panel 05.jpg
Lizard Lips spot 02, panel 06.jpg
Lizard Lips spot 02, panel 07.jpg
Lizard Lips spot 02, panel 08.jpg
Lizard Lips spot 02, panel 09.jpg
Lizard Lips spot 02, panel 10.jpg
Lizard Lips spot 02, panel 11.jpg
Lizard Lips spot 02, panel 12.jpg

Figure 33.4 Example of proper naming structure for files of multiple spots.

inform the client of how many e-mails to expect so that they know when they have received everything.

Ask clients if they would prefer to have their storyboards scanned per page or separated into individual frames. Some clients prefer to receive both pages and panels. The needs of each project will be different.

When clients prefer full page scans, you may also want to make a PDF file containing all the pages. This allows the client to easily print all of the storyboards at once, instead of having to open each individual file to print them one at a time. With Adobe Acrobat Pro software, it is easy and fast to make PDF files. Simply select "Create PDF from multiple files" and select the scanned files you wish to include.

Some clients prefer to have storyboards mounted. I charge for the added time and expense, plus 10 to 30 percent markup for the supplies. The supplies would be invoiced under Applicable Expenses or Reimbursable Expenses. If storyboards are mounted, they are difficult to copy en masse, so don't mount originals. Always give your clients an extra set of unmounted storyboards that they can run through a copier.

Each page of your storyboards should have the following five specific pieces of information.

1. Include the project name on every sheet. Both you and the production company are likely to be working on more than one project at a time, so you don't want to confuse boards for different projects.

Figure 33.5 Import all the scans into one PDF file for easy printing and delivery.

2. Put your name on every board.
3. Include your phone number on each sheet. This makes every page an advertisement for you.
4. Be sure every page is numbered. Even though each panel is marked, it is easier to quickly put storyboards in order by using the page numbers.
5. Include the scene number on every page. The scene number is crucial to the production for

reference to the script. Some scripts are not broken into scenes, however, so numbers are not always necessary.

Another element of your presentation is how you finish off your boards. Are you giving your client rough-pencil, finished-pencil, gray-tone, or color boards? This is up to you and your client. High-budget projects like

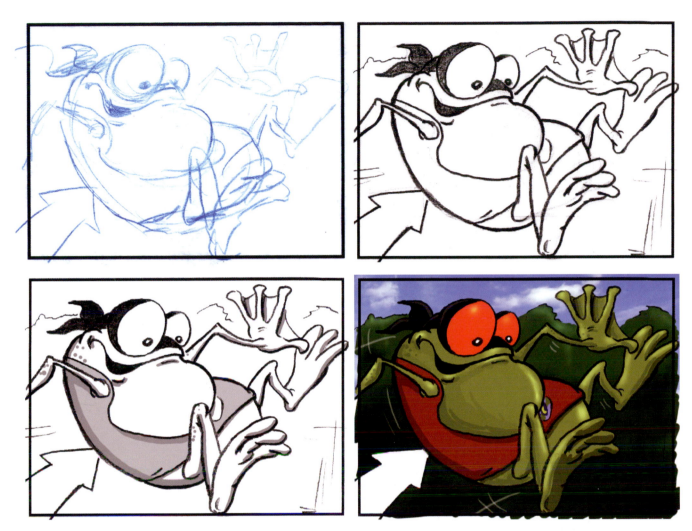

Figure 33.6 Phases of and options for storyboards. Non-repro blue rough, final pencil, tone, and color. Storyboard by Mark Simon of Animatics & Storyboards, Inc.

to have at least gray-tone boards, if not full color. If you have a lot of panels to draw in a short period of time, you probably won't be able to give them color boards, since they take so much longer to draw.

Make sure you and your client are clear about what they expect you to deliver before you get started. You should charge more for tone boards than for B&W and more for color than for tone.

When snail-mailing completed art to a client, include a stiffener in the envelope to keep your work flat and safe. Never fold deliverable art.

Deliver your invoice with your finishes if possible. Try to get clients to sign one copy of the invoice, which you keep, and leave a second copy with them. This can be helpful if there's any confusion later about your billing. You may need to give the clients' accountant a copy of the invoice as well.

The way you present your finished boards is the last thing clients will remember about you. The happier they are with your final delivery, the more likely they are to call you again.

PART THREE

THE BUSINESS OF STORYBOARDING

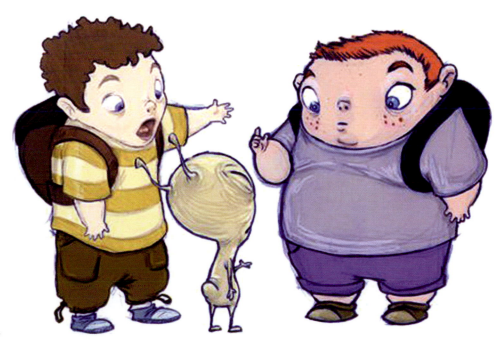

Storyboard by Travis Blaise.

CHAPTER 34

Résumés

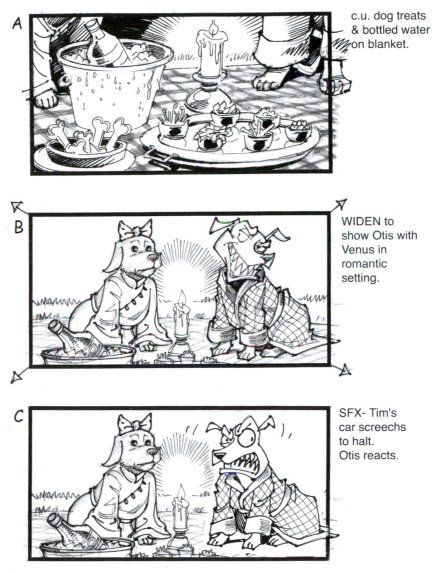

A — c.u. dog treats & bottled water on blanket.

B — WIDEN to show Otis with Venus in romantic setting.

C — SFX- Tim's car screechs to halt. Otis reacts.

Figure 34.1 High-profile projects look great on résumés and increase your chances of getting more work. *Son of the Mask* storyboards by Tim Burgard. (© MMV, New Line Productions, Inc. All rights reserved. Courtesy of New Line Productions, Inc.)

Your résumé is likely to be the first impression prospective clients will get about you and your work. You never get a second chance to make a first impression. The contents and organization suggested here for your résumé in the entertainment industry are likely to be quite different from the way you learned to create a résumé in school. What you don't say about yourself is as important as what you do say and how you say it. The likelihood of your getting a call for work from your résumé is highly dependent on a number of things.

First of all, you need to make sure your résumé contains nothing that does not relate to the job for which you're applying. Items such as age, height, hobbies, and marital status should never be on a résumé. You don't want to look like an amateur. For better or worse, impressions have a lot to do with whether or not you get hired. Why take a chance that something on your résumé might leave a negative impression?

Age is an issue best not brought up. If you're young, an employer might think you don't have enough experience. If you are older, they might feel a job is not challenging enough for you. Don't let age become an issue. Information on your résumé may indicate your age, and you need to be aware of it. If you list education at all (not a necessity in this industry), any graduation date is nearly as telling as your birth date. Projects with dates from decades ago are a dead giveaway to range of age. Dates lead to assumptions of age.

Your purpose is to get a job with your résumé, not in spite of it. What follows are do's and don'ts for résumés and short explanations of each.

◆ Eighteen Common Résumé Mistakes

1. *Listing unrelated job positions.* You may have been a headwaiter, but that has no relevance to your ability to be a storyboard artist. If you were a set PA (production assistant) and feel you need to show knowledge of the industry, you can include some backup information in a secondary section of your résumé, such as Related Information or Related Experience.

2. *Including age or reference dates.* Dates are never helpful. Employers will immediately figure your age, and that may work for or against you. Job dates are also problematic. Generally they are misleading, and someone may look at scattered dates and wonder why you didn't work very long at any one job or why you had so long off between projects. Without reference dates, these issues never come up.

The length of time on a job can also work against you. For instance, I did the storyboards, illustration, and some logo design on the movie *The Waterboy*, which was the number one movie of the 1998 fall season. Most people probably assume I worked on it for three to five months; their minds fill in the perfect amount of time. Actually, I only worked on it for three days. If I put that amount of time on my résumé, it would only work against me. It should be a positive. It only took me three days to complete the work and get approvals.

3. *Including unrelated personal information.* Height or race has nothing to do with your abilities. Your professional qualifications should be the only criteria for whether or not you get an interview.

4. *Using the term "Objective".* Professionals don't have an objective, they offer a service now. Use of that term shows you are fresh out of school and have no experience to offer them. Place your job title boldly at the top so that there is no question as to what you will provide an employer.

5. *Explaining a position instead of using the job title.* Anyone in a position of hiring you knows what the job is. Explaining it gives the impression you have no idea what you are doing. Any explanations should be for duties you performed beyond your job title.

6. *Putting your name and title in lowercase or a small font.* Résumés have to stand out and demand the attention of an employer. If your title is hard to see immediately, it could easily be overlooked and discarded. Lowercase fonts have the tendency to give the impression of being meek.

7. *Listing unrelated hobbies.* No one cares what your hobbies are unless they relate directly to your job function. If you spend weekends drawing caricatures at the local fair, that's relevant to being a storyboard artist. If you like to play racquetball, that's not relevant.

8. *Having too many pages.* The only people who should have more than one page are those with a tremendous background. You will have no reason to use more than one page for your résumé during your first few years in the business. If you're just trying to fill up space, it will look like it. Employers are not easily fooled. You also don't need to list every job you've ever had; list only those that are the most relevant and impressive, not most recent.

9. *Not listing relevant information.* Give yourself every chance you can. If you have relevant skills that others don't, employers need to know about it. If you are bilingual, list it. If you've won relevant awards, list them.

10. *Listing reasons for leaving jobs.* Any reason for leaving jobs just sounds like you're making excuses. In

this industry, every job ends; it's expected and never questioned unless you bring it up. Having an excuse makes it look like you were fired.

11. *Putting education at the top.* Whatever is at the top of your résumé is most important. Experience should be most important. Putting education first says you have no experience.

12. *Listing only education from a highly regarded source.* Education is never as important as experience. (I can say this because I have both.) Education rarely means anything in this field. Certain producers do tend to hire from their alma maters, so education may be helpful. But it is best kept to a minimum or at least at the end of your résumé.

13. *Making updates or corrections by hand.* This is incredibly amateurish and tells an employer he is not worth your time to print a new résumé. With computers, this should never be an issue. E-mail yourself a copy of your résumé so that you always have access to it.

14. *Using overly detailed descriptions and sentences.* A résumé should be short and to the point. A glance should tell an employer everything she needs to know. A glance is often all your résumé will get.

15. *Supplying reference letters before being asked for them.* Cold-call résumés with reference letters are too bulky to look at and make the applicant look desperate. Since this industry does thrive on contacts, you can list the important contacts from each project on your résumé. If the employer recognizes some names, it may help. But keep contacts to names and positions, not comments.

16. *Misspelling the names of the recipient or company.* This shows a lack of regard and professionalism. Call ahead or research on the Internet if you're not sure of a spelling.

17. *Taking credit for more than you should.* If you were just assisting a storyboard artist, don't say you were the storyboard artist. This will always come back to bite you.

18. *Having an unreadable résumé.* Many résumés are almost unreadable because the copies are so bad, the graphics are faxed poorly, or the print is too small. Some may be off-center or have information marked out. This looks amateurish.

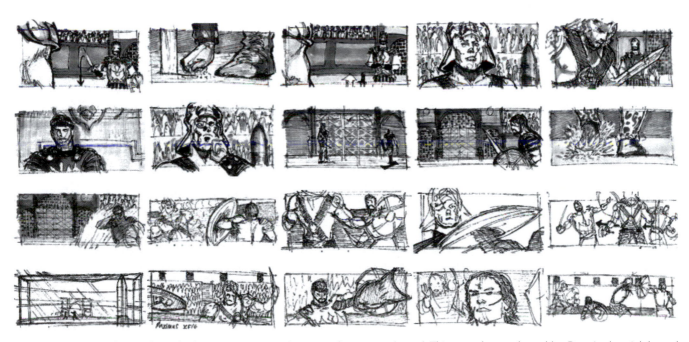

Figure 34.2 Sample storyboards done on your own have no place on a résumé. This sample storyboard by Dan Antkowiak based on the movie *Gladiator* was in his early portfolio, but it was never on his résumé.

Figure 34.3 *Your Resume Sucks!* by Mark Simon, Jeanne Pappas Simon, and Dr. James E. M. Irvine, D.M.

Eight Ways to Enhance Your Résumé

1. Use humor (if you're funny and comfortable with it).
2. Use a single-page presentation.
3. Put your position, name, and phone number in bold at the top.
4. Show experience to back up the position for which you're applying.
5. Include related affiliations (unions, guilds, associations).
6. Include related awards.
7. Have clean and easy-to-read copies.
8. List education only if pertinent and from a highly respected university in the field.

More information on writing résumés that work in the real world can be found in my book *Your Resume Sucks* (www.MarkSimonBooks.com and www.Your ResumeSucks.biz).

CHAPTER 35

Portfolios

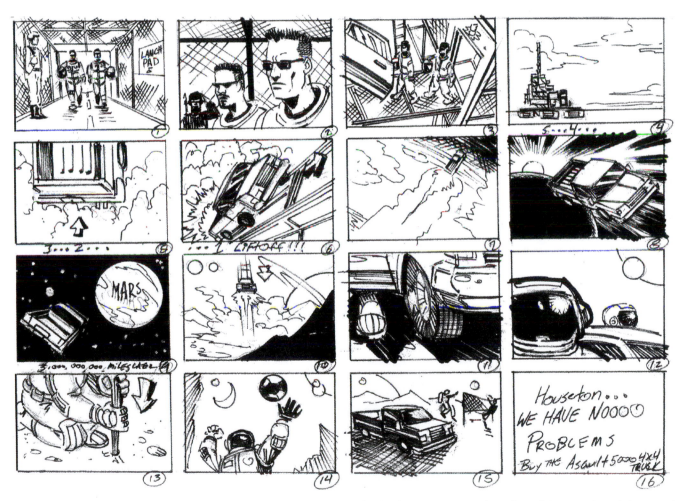

Figure 35.1 It is best to have sketches and storyboard samples, not finished art, in your storyboard portfolio. Storyboards by David Hillman of Hillman Arts.

Storyboard employers will want to see samples of your storyboarding work before you get hired. Everyone knows that production storyboards are not always the nicest-looking artwork and that the quality of the drawings is only a small portion of the importance of good storyboards, but employers will still want to see quality art. Good art is what sells in an interview. You need to present your best stuff.

Experienced storyboard artists need to customize their portfolio for each new client, to match their needs. Make sure you keep copies of every project you do so that you have samples to show.

But what if you don't have any examples to show prospective employers? "How do I get experience without having examples to show that I can storyboard?" you may ask. Here's an easy solution. Don't wait until you are offered a storyboarding job (it may be a looooong wait) to draw storyboards; start drawing them now.

There are four quick and easy ways to build an initial storyboard portfolio before you get hired onto professional projects. These tips were given to me by a storyboarding agent in Los Angeles to help me get started.

1. Write a short action sequence of your own and "board it out" (industry talk meaning to do the storyboards).
2. Take an action sequence from someone else's writing and board it out.
3. Look at an existing project, like your favorite action movie, and draw out a scene.
4. Volunteer to draw the storyboards on a low-budget or student project for free.

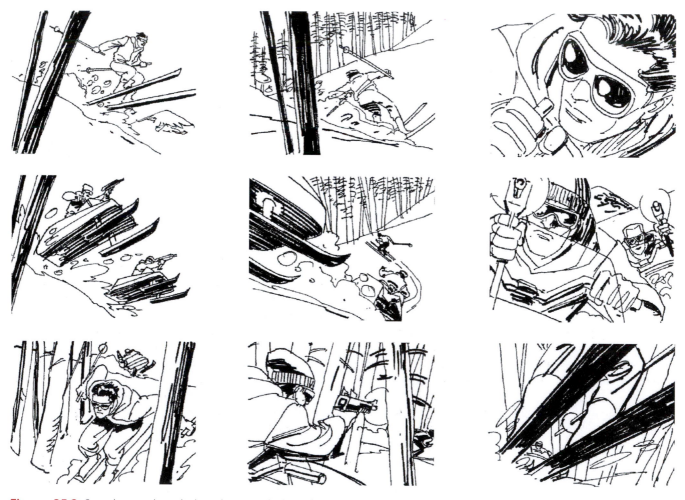

Figure 35.2 Sample storyboards by Alex Saviuk, based on his own action sequence, used to get a job at Animatics & Storyboards, Inc.

Once you put some samples together, you need to get feedback on your portfolio before you start interviewing. When you start showing your boards to people, resist the urge to explain each shot. Your boards should be self-explanatory. If questions arise about what is happening, you should try to figure out how to enhance your boards to make them more understandable.

Remember, it's your job to make the viewer understand your drawings; it's not anyone else's job to read your mind or solve the problems in your art. During production you won't be around to explain your boards to all the crew members working from them. If there is a question about the action in a set of storyboards, then the boards have failed.

There are a few ways to show a portfolio. One of the best is to use the Internet. Have a simple website showing your storyboarding samples, credits, and contact information and any other relevant samples. Regardless of where a client calls from, they can have instant access to your samples online.

You should also have *leave-behinds*. These are single sheets of paper that feature sample sequences and contain all your contact information. This is all that is normally needed and all a client will want to keep.

Make sure every storyboard you work on for clients contains your contact information. There is no better portfolio than the work you've already done. Make sure everyone on the crew of every job will be able to contact you, even if they never met you.

Bulky portfolios are OK but are not always practical. A small collection of letter-size sample sheets are best, and clients can easily file them for future reference.

If you are showing your portfolio around and you notice you have to explain why some boards are not as good as others, get rid of them. You should only show your best. You don't need many to prove your worth. You can get by with as few as three sample sequences, and each sequence can be as short as eight to ten frames. Don't make sample sequences too long; clients and employers want to get through samples quickly.

I recommend drawing a sample "action sequence" rather than static sequences because visually it is the most interesting and will grab people's attention. Try to keep most of your sequences down to 8 to 20 panels. This will make it easy to review a complete scene quickly. Individual drawings out of context, on the other hand, don't get across your ability to tell a story visually.

Any storyboards you draw can be shown as examples of your own work. Be careful presenting any sequences you board out based on projects you didn't work on; you don't want it to look like you're stealing

Figure 35.3 Leave-behind promotional flyer and postcard by storyboard artist Larry Jones.

someone else's professional credit. If it wasn't a commissioned job, it shouldn't go on a résumé. If you work on a job for free, it is considered a commissioned job. Work you aren't paid for shows your skills just as well as compensated work.

Student films are a great training ground. You will get experience drawing boards and working with directors as well. If you're lucky, you may also run into a promising young director who will go on to work on bigger projects and bring you with him. This is how many people's careers develop, by moving up the ladder with friends. Even professionals will often lend a hand to student films during slow times in hopes of making more connections with other professionals and up-and-comers. You never know who you'll meet on a student film, especially in Los Angeles or New York.

Make sure you include sketches and less finished work in your portfolio as well as finished work. Clients

Figure 35.4 Simple portfolio with storyboard samples and leave-behind postcards.

want to see that you can work quickly. Anyone can labor over a piece and make it look good; but in storyboards, time is of the essence.

You should also customize your portfolio, if possible, for each interview. If you're interviewing with a client who does commercials, try to have commercial samples in the front of your portfolio. If you're going to an animation studio, show animation boards. Producers and directors want to see samples of your work that are as close as possible to their current project. It's often a crapshoot, but the more you know going into an interview, the less of a gamble it is.

While knowing what the client is looking for helps, it may not always be enough. I had a potential client once who called and asked for samples of Batman-style storyboards. I sent over sample action sequences from *Spider-Man, Tarzan, McHale's Navy, seaQuest DSV*, and other projects. They called back and asked for other samples that showed Batman. I tried to explain to them that none of my clients had asked for Batman before but that my other boards showed a keen grasp of action and storytelling. This client could not understand that and hired someone else. That's like not being hired because I had never used a certain color in my art. It may not seem fair, but it is how the industry functions sometimes.

Every new project you work on, whether for yourself or for a client, can be a newer, better portfolio piece.

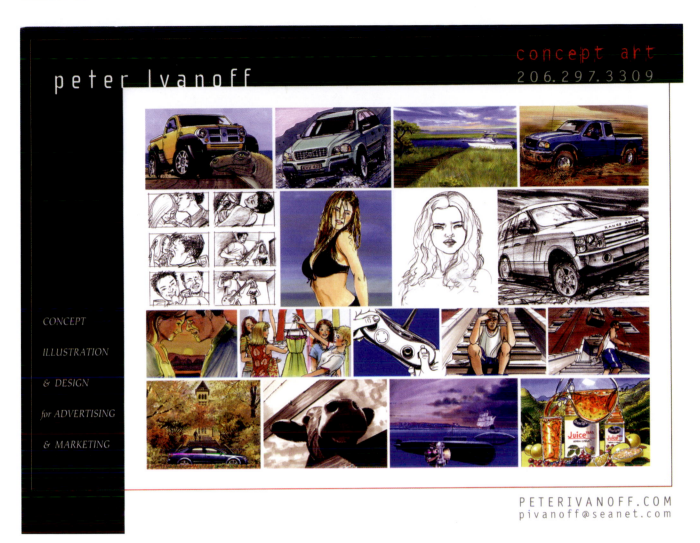

Figure 35.5 Marketing flyer for artist Peter Ivanoff. You should only include samples of styles you like to work in. Showcase your strengths.

CHAPTER 36

Education and Skills

There is no training ground better than experience. One pitfall to avoid is jumping into a project that's over your head and losing potential future business because you didn't know what you were doing. There are very few places that teach live-action storyboarding, and those that do often only offer it sporadically.

Some schools, such as Joe Kubert's World of Cartooning, offer courses in story graphics or sequential illustration. These will teach many storyboarding basics. Most animation schools teach storyboarding to varying extents. Whether you prefer animation or live action, you can benefit from learning animation storyboards.

Figure 36.1 Panels from Alex Saviuk's first comic, *Freedom*. Alex learned sequential illustration at the School of Visual Arts. Comics work partially trained him for storyboards. (© 1977, Alex Saviuk.)

There are other ways to learn storyboarding from different sources, however.

In recent years more live-action production schools have been offering classes on storyboards, though they are still few and far between. Students are partly to blame. Most live-action film students want to be directors and only want to go out there and direct; they don't want to take the time to properly plan a scene. They often don't want to learn about or pay attention to the benefits of preproduction.

Schools are also to blame because they far too often don't explain how important preproduction is to their students. We're missing the chicken and the egg in this equation. Knowledge of storyboarding isn't just important for artists—it's important for all filmmakers.

To save yourself a lot of frustration, you should know how to draw the human form very well. Drawing well is not a necessity for drawing functional boards, but it is important if you want a career in storyboarding. Many directors sketch out their own boards but are not great artists.

Life drawing classes are extremely helpful. Drawing when live models are present is better than drawing from photos. You get a better feel for the roundness of the human body. It is also important to learn the skeletal and muscular systems of the body. By knowing the skeleton, you will learn the limits of how a body can bend. Knowing the muscles allows you to pose your figure and add dimension to it. When you draw a person wearing clothes, the body under the clothes determines how the clothes should fold and drape to look realistic.

If you are not in school, you may be able to find an extension course at a local school or life drawing classes offered by community art stores and associations. Many animation studios offer life drawing classes to their artists.

You can also study life drawing in other ways. You can sketch your family, and you can go to the mall or the zoo and sketch people there. Since storyboards generally portray the human form in motion, you should practice drawing people in action whenever possible. Drawing people while they're moving helps you sketch quickly and capture motion in your art. You can ask your significant other to pose for you. If need be, you can also practice by working from photos in books or magazines. Videos can also work as a reference.

You will also need to have schooling in perspective rendering. Storyboard artists should be able to quickly sketch backgrounds and objects in perspective. As Mark Moore, an Industrial Light and Magic (ILM) illustrator, says, "Try drawing the [Star Trek] U.S.S. Enterprise from every conceivable angle."

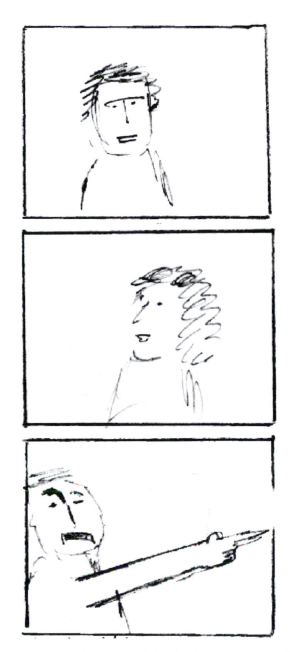

Figure 36.2 Quick storyboard sketches by *seaQuest DSV* director Jesus Trevino.

Nina Elias Bamberger, executive producer of CTW's (Children's Television Network's) *Dragon Tales*, *Big Bag*, and other animations, suggests that watching television and studying animations, both new and old, are two of the best training animation storyboard artists can get. She also suggests that artists produce animatics of their storyboards to see how they work in sequence and whether the visual story is well told.

Figure 36.3 AWN.com has an extensive online list of animation schools and the courses they offer. Some other art and film schools also offer sequential illustration and storyboarding courses.

Software and computers are inexpensive enough these days that producing animatics is fairly easy and economical. Programs such as Adobe After Effects and Mirage are all easy to learn and can be used to produce quality animatics that can play back on a computer.

Besides an education in drawing, I also recommend a few courses in filmmaking, even for animators. Try to get into at least one course that has as much hands-on filmmaking as possible. Not only is it more fun, but you will get a better feel for how to properly build the action in a scene if you are shooting and editing your own shorts. It will also help to have a background, formal or informal, in the history of film. Classic storytelling techniques still work. Steven Spielberg is a master at using classic film techniques in his movies. You will also find that when directors describe a scene they want to shoot, they often refer to other movies or TV shows.

A great way to study filmmaking, special effects design, and the industry as a whole is by viewing special-edition DVDs and "The Making of . . ." videos with audio tracks by the filmmakers. Instead of listening to others describe why they *think* someone designed a shot or a scene a certain way, you can listen to the directors, producers, and designers tell you themselves. Many DVDs offer one or more additional audio tracks that allow the viewers to watch a movie and listen to the filmmakers talk about their films shot by shot. This could very well be the best way to study film and directing.

You should also try to work on a set. Get a job as a set or control room PA (production assistant) on as many shoots as you can. Pay attention to how the director works and how she describes and edits each scene and each shot. Nothing can beat being able to draw upon hands-on experience.

Besides understanding action, understanding the terminology is important. Although you will learn a lot of terms while reading this book, nothing beats working with all the terms in context. If possible, follow a project through the editing stage. (Sit quietly in the back.) Editing is where all the shots start to make sense and where some poorly planned scenes can be salvaged.

When you're ready to start getting your first storyboarding jobs, look to film schools. You can offer your services to student filmmakers at no cost, to give yourself some experience working with directors and to gain some credits. You do not need to be enrolled in a school to help on student films. Many professionals in Los Angeles help out on USC and UCLA student films when work is slow. You never know who you'll meet or what contacts you'll generate.

An education in storyboarding doesn't have to take place at a school, but you can take advantage of a number of opportunities in school. Most of what you learn is up to you to learn on your own, regardless of any formal education. Animation World Network (www.AWN.com) lists more than 900 animation schools that teach storyboarding as classes or as part of their film and animation curriculums.

How I Got Started

I had been art directing for a few of years and I wanted to start storyboarding as well. I had played around with it, but I didn't know the specifics. I went to see a storyboard agent at Storyboards, Inc., in Los Angeles to get some pointers. He was incredibly helpful. He explained how to present my samples and how to charge for doing boards. He looked at some of my work and gave me some suggestions on my live-action boards, such as "Make it look less cartoony."

Many live-action directors specifically request artists whose work is not cartoony. He suggested that for practice I look at a commercial or take a scene from a feature film and storyboard it. He told me to make sure that the scene had action in it. He then said he would be happy to look at my work again. I took him up on his offer. I boarded out several scenes from movies and commercials. I also made up my own short action sequences to draw. Every week I went back to show him more samples. After about a month he liked what he saw, and he liked my persistence. He began placing me on commercials, starting with a Honda spot.

Once I felt strongly about my boards, I approached the executive producer on an HBO series, *1st & 10*, where I was working as construction coordinator. I showed him my work, the practice boards I had done for the agent, and told him

Figure 37.1 Storyboard by Mark Simon of Animatics & Storyboards, Inc. for an animation short proposal.

I would love to do any boards that the show might need. He asked to keep a few samples (always be ready to leave samples).

About three weeks later, he called me on the set and asked if I was interested in boarding some scenes for an upcoming episode. I was at his office in a flash. He showed me the script and said that it lacked the scariness that it needed and asked if I could make it more frightening and still have some humor in it.

Without really knowing how to fulfill his request, I said, "Sure," and thought I would figure it out later. He told me that the director didn't know about the boards I was about to draw and he wanted to keep it that way. He asked me what I would charge. I told him a certain dollar amount per panel, a rate much cheaper than the norm. He responded, "Since this is one of your first jobs storyboarding, I'll make you a deal. I'll give you half of that. If the director likes them and decides to use them, I'll give you twice what you asked for." Even though that may have sounded like a scam, I trusted him and agreed to the deal.

That night I asked my fiancée, now my wife, Jeanne, to help me figure out how to make those scenes scary. We watched a couple of horror movies on video (in the days before DVD) to learn how specific shots added tension. We then rewrote the action of the scenes. From our rewrites I sat down and started boarding them out. I tried to take into account all of the cinematic tricks of the trade: extreme close-ups, figures hidden in the dark,

letting the audience see something that the onscreen characters don't; shock, and surprise.

I met with the executive producer twice during my drawing of the boards, and he gave me a number of great suggestions based on what I presented him. The project ended up being just more than 70 panels. The following week he gave a copy of the boards to the director. The director loved them and used a lot of our ideas in the shooting a few weeks later. The executive producer made good on his word and paid me double what I had originally asked. The best part of all was that I now had experience at a great professional job as a storyboard artist on a popular television series.

The best way for you to get started is the same way I did. Draw samples boards. They could be based on a TV show, commercial, or movie or from a book, play, or even your own story. Think visually about your scenes, and ask for opinions from someone who would know about good storyboards. Not only is this good practice, but you are proving to potential clients that you have the drive necessary to follow through on any boarding project.

If someone gives you advice and asks to see samples as you improve, make sure you do. It shows you listen, learn, and will complete assignments. You could offer free storyboards to student filmmakers. This will give you practice working with directors and start your portfolio. Telling someone you can draw storyboards isn't good enough; you have to prove it with samples.

Figure 37.2 TiVo commercial board by Mark Simon of Animatics & Storyboards, Inc.

Who Hires Storyboard Artists?

If you want to draw boards for a living, you need to know who to approach for work. Not every business of the types listed next will use boards, but many of them will. Some don't want to spend the money, some do roughs themselves, others have no idea how helpful boards really are, and some make great use of storyboards. You should let them all know what you offer, either for that one time or for the many times when they do need boards.

There are more storyboarding opportunities available than most people realize. Table 38.1 should provide you with enough information to find storyboard clients in most cities.

Figure 38.1 Commercial storyboard by German artist Ovi Hondru.

Table 38.1 Types of Storyboard Clients

1. Advertising agencies	14. Producers
2. Commercial production houses	15. Directors
3. Industrial production houses	16. Production managers
4. Documentary filmmakers	17. Laser show design houses
5. Live-event designers	18. Television series
6. Convention services	19. Music videos
7. Cel animation houses	20. Special effects studios
8. Animatics houses	21. Stunt coordinators
9. Computer animation houses	22. Theme parks
10. Film production companies	23. Gaming and interactive companies
11. Local affiliate stations	24. In-house marketing division of a large corporation
12. Art Directors	25. Web design companies
13. Previz studios	

Let's look briefly at why each of these potential clients might need boards.

◗ Advertising Agencies

Ad agencies need boards to show clients what proposed commercials will look like for their approval, before shooting. They also will use them as guidelines for bids from production companies. Creative directors and art buyers are the people in agencies who call on storyboard artists. They may need simple sketches or elaborate color renderings.

◗ Commercial Production Houses

Once the production house gets the job from a client or an ad agency, the director will often want his own shooting boards instead of using the agency boards. These will be much more action detailed than the agency boards, and the director will probably add his own visual signature.

Commercials have the highest budget per second of airtime, and they probably use boards more than any other type of production, with the exception of animation. Because the images fly by so fast, they need to be very organized to make sure that the idea is properly presented. There may be anywhere from 8 to 45 panels for a 30-second spot.

◗ Industrial Production Houses

The ultra-low budgets of industrial films make preproduction planning a must. Again, the boards would be used to present the idea to the client. It also helps the crew be much more efficient. These days a lot of postproduction effects and computer graphics are used to enhance the look of these productions, and storyboards help develop each.

◗ Documentary Filmmakers

Documentary filmmakers will use boards not only to present to a client, but to get financing. When boards are used, they will generally be few, due to budget limitations. At times a documentary needs to recreate some event in great detail. Boards may be used to work out the details.

◗ Live-event Designers

Like most of us, these designers have bosses that have to approve things. Your boards are what they would use to get that approval, whether from the city, the client, the amusement park, or whomever. Boards are also often used along with the designs to help in the bidding. The boards may also show what the people attending an event would see. Many times, they will need only one

Figure 38.2 Agency presentation boards drawn by Alex Saviuk and colored by Mark Simon of Animatics & Storyboards, Inc.

Figure 38.3 Themed-party design illustration by Mark Simon of Animatics & Storyboards, Inc. Design by Mark Wells of Hello, Florida, Inc.

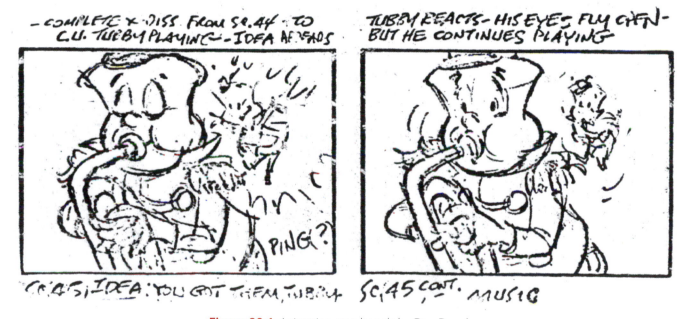

Figure 38.4 Animation storyboards by Dan Danglo.

or two color illustrations of an event to get the idea across in a presentation.

▶ Convention Services

Convention services have basically the same need as event designers. Boards will be more like production drawings, showing the layouts of the facility and how the convention traffic will flow.

▶ Animation Houses

Animation is boarded out completely for every shot. The animators use boards as a blueprint from which to do their work. Each storyboard panel should represent the key frames. (A *key frame* is each portion of a motion of a character or an object in the animation.)

Animation boards show not only the action but also the acting. Anywhere from 120 to 600 panels may be needed for a seven-minute animation. Classic cel

animation will often cast storyboard artists whose artistic style matches the look of the show.

◗ Animatics Houses

A classic animatic was basically a video storyboard, or a freeze-frame style of animation shot to illustrate an expensive commercial or interactive show or to determine pacing and shot needs for a production. The actual animatic is usually highly rendered in full color, with some camera moves introduced. Images may be static or include morphing and limited animation. Some productions will produce animatics in CG. Boards will be used to determine the full-color renderings and how camera moves will work.

A client may spend anywhere from $3,000 to as much as $30,000 to $50,000 to have an animatic produced to test the concept for a commercial or TV pilot. As high as this testing cost may seem, it's a bargain compared to wasting many times that or more shooting a million-dollar concept that may not work.

Expensive game shows may have an animatic made instead of spending more than $100,000 to build large sets and props for a pilot. The animatics are edited in with whatever live action was shot, such as host wraparounds, and the final product is used for demographic testing. Some animatics are cheaper than others; it depends on the length and complexity of the project. Many animatics are produced using only the storyboard's art.

◗ Computer Animation Houses

Boards illustrate for the client how the project will look before expensive computer time is used. Story, continuity, and acting are also illustrated, just as in classic cel animation. Projects may be commercials, movies, training videos, logos, graphics, station IDs, and more.

◗ Film Production Companies

Feature films use storyboards to work out production problems and to detail special effects and stunt shots. There is generally no need for color except for some conceptual illustrations. What matters most is portraying a visually exciting series of images that will get across the story information to the crew and vendors.

◗ Local Affiliate Stations

Normally local affiliate stations have an art department that handles all their needs. Special reports, news openings, and any show produced from within may need boards. They also produce low-budget commercials that may need boards for approval and shooting.

◗ Art Directors

Many art directors or production designers can't draw or don't have time to draw storyboards on projects. When boards are needed on a project, art directors are

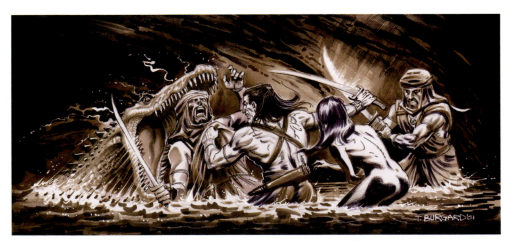

Figure 38.5 Conceptual board by Tim Burgard for the film *Scorpion King*.
(Courtesy of Universal Studios Licensing LLLP.)

often the ones approached to draw them or to find someone who can.

◆ Previz Studios

Previz, or previsualization, refers to the use of computer-generated sequences to replicate soon-to-be-shot live-action sequences. They are the modern-day animatic. Most previz studios work from storyboards provided by a production, but they do have to produce boards on their own at times.

◆ Producers

Producers will use boards to illustrate their vision of what the finished project should look like to show to an investor, a studio, a production crew, or a director. The boards may also be used as part of a pitch to sell an idea. Even when a producer is not working directly with the artist, she will usually be the one to give the final OK on whom to hire.

◆ Directors

Directors will call for boards when they see difficult shots in the schedule. On commercials, directors will often want the agency's boards redone with their exact vision. Some directors have their favorite artists travel with them. They seldom do the hiring themselves. They will ask producers and production managers to hire artists for them.

◆ Production Managers

If producers or directors do not have their own storyboard artists available, they will have the local production manager find one.

◆ Laser Show Design Houses

Laser shows are composed of laser images that are often animated to move in time with music. Those images and how they are manipulated need to be planned out with a set of boards.

◆ Television Series

As in films, if a production has stunts or FX (special effects), producers and directors may want boards to work them out. Sometimes the openings are boarded. I boarded the first opening for Nickelodeon's *Clarissa Explains It All* to provide the technicians, who were doing the camera moves and special effects, with a visual of the creator's idea. Amblin's *seaQuest DSV*, *The Cape*, *Star Trek*, *Babylon 5*, and *The West Wing* all used storyboards for special effects and stunt scenes.

Figure 38.6 Previz frame from *Sky Captain and the World of Tomorrow* by Pixel Liberation Front.
(© 2004 Paramount Pictures. All rights reserved.)

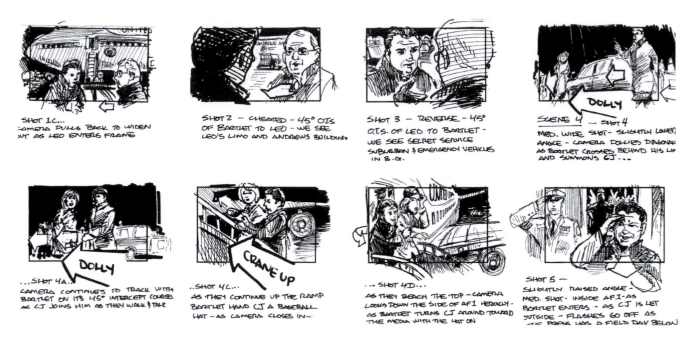

Figure 38.7 *The West Wing* storyboards by Josh Hayes. (Courtesy of Warner Bros.)

◗ Music Videos

Most music videos won't have enough of a budget for boards, but some of the bigger ones do. Those with wild FX and sets may use boards.

◗ Special Effects Houses

Often a production team chooses an effects house before all the boards are done. During production, the effects house will generate many of the boards needed for the shots they have contracted, either as part of their bid or as a way to develop their shots. The effects house may board out their own vision of a shot and send it to the director for approval or notes.

◗ Stunt Coordinators

Generally the production staff provides stunt coordinators with finished boards for bidding and shooting. However, when stunt coordinators aren't given boards and they need to develop boards themselves, you want them to know who to call.

◗ Theme Parks

Theme parks have videos to entertain patrons in their queues. Queues are the long lines patrons hate to stand in while waiting for a ride. These videos are often boarded out. Some theme parks also put on shows for certain times of the year. Universal Studios Florida uses boards for events such as Halloween Horror Nights and the making of their haunted houses.

The boards for a haunted house may demonstrate the perspective of a patron going through it. A new ride may also be storyboarded. The designers may board out the entire experience, from standing in line to sitting on the ride and exiting the retail area, to show the client what they are planning on doing.

◗ Gaming and Interactive Companies

Interactive games and videos are one of the hottest commodities around. They are extremely complex in their design. For each action a player chooses there may be any number of responses the computer will make. Every action needs to be fully planned. Storyboards are perfect for use in planning these actions and reactions.

Figure 38.8 *Zorro* theme-park attraction pitch board for Renaissance Entertainment, by Mike Conrad of Radical Concepts, Inc.

▶ In-house Marketing

Many major companies design and produce all their commercials and marketing videos in-house. Their marketing departments need storyboards for presentations as well as production.

▶ Web Design

Web sites are big multimedia files that need to be organized. Web animations, such as Shockwave, Flash, and GIF, need to be planned and approved just like any other type of animation. It's beneficial to know how these animation programs work in order to properly storyboard for them. Flash, for example, is a popular vector-based, as opposed to pixel-based, animation program that has limitations in order to be efficient. Familiarity with Flash is the only way to know how to storyboard for it.

Figure 38.9 Storyboard panel for the arcade game *Behind Enemy Lines*. (© EPL Productions, Inc.)

CHAPTER 39

Finding a Job

The best way to get a job storyboarding is to have storyboarding samples. How do you get storyboarding experience to get hired as a storyboard artist? Easy. Just do it.

- You can always storyboard your own short scenes.
- Offer to storyboard for students or friends on their projects.
- Storyboard commercials for businesses of friends and family.
- Storyboard scenes from movies (just don't take credit for those you weren't hired to board).

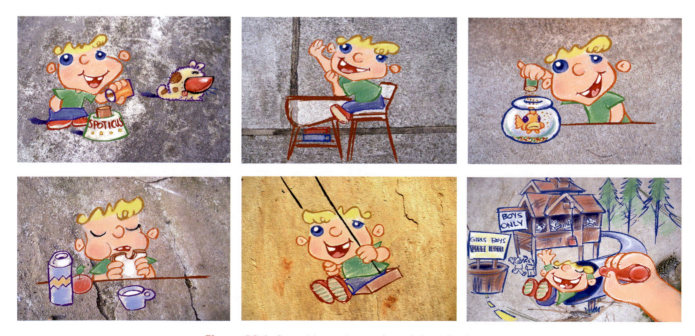

Figure 39.1 *Stone Mountain* storyboards by John Ryan.

Figure 39.2 Dan Antkowiak's storyboards, based on the film *Gladiator,* for story-telling practice. Samples shown in his portfolio but not listed on his résumé.

Beginners will seldom get hired doing storyboards for large agencies, storyboard companies, or animation studios. However, working as an assistant for a storyboard artist is a good way to learn. Internships are another way to get exposure and experience.

Some animation studios have storyboard-cleanup positions available. These artists redraw rough boards sketched out by the main storyboard artist and make the lines neat and clean. The cleanup artist also makes sure the characters are *on model* (look like the character designs).

Look in industry trade magazines for low-budget productions and offer your services for free. You will meet people, show them what you can do, and get experience, and your name will get passed on to other projects. When crew members move on to other projects, you are likely to get a call for a paying gig. Here are some other ideas.

- Try to get knowledgeable people (not family members) to review your boards and listen to what they say.
- Have samples of entire scenes laid out on one or two pages to hand to potential clients. Don't just show sample frames. Single frames don't show story flow; sequences do.
- Send samples to production managers in your area. You can find them through your local film commission or in your local film guide if your city is large enough to have them.
- Market your services to industry professionals with flyers and listings in local film books.
- Ask people you work with what other projects are coming to town and how to contact them.
- Make sure every piece of art you do on a project has your contact information so that you can be contacted later.

- Have a website of samples available to show your work at a moment's notice.

Try to meet people in the industry. Go to industry events. Better yet, offer to help at industry events. Then you get to meet more people, and they will see you are a good worker. People tend to hire people they know. You have to get people to know you and what you can do.

There are five main steps productions use when hiring freelancers.

1. *They hire someone they know and trust.* With tighter schedules, clients need to know that a job will get done right the first time. Often, someone who is reliable will get a job over someone with more talent.
2. *They ask someone they know and trust for someone they know and trust.* If their first choice is not available, clients will ask for a recommendation.
3. *They look through their database of saved portfolios and samples.* Saved portfolios and samples are from those who clients have met and liked or whose samples were considered outstanding enough to hold onto.
4. *They search on the net.* The net makes it fast and easy to research anything. Clients can review samples and credits online and deal with long-distance artists more and more.
5. *They look in the local film guide.* Local artists are often preferred to long-distance ones, but every year more clients are comfortable with working long distance via the net. Storyboard artists in film books are usually those with real credits and industry knowledge.

Notice that none of the five steps mentioned posting an available position. Freelance gigs happen too fast to

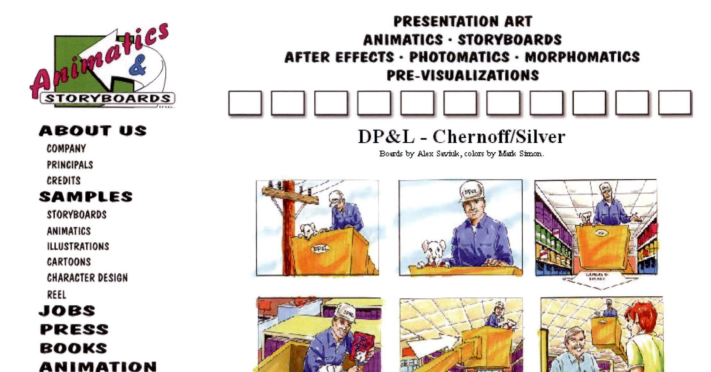

Figure 39.3 Web site sample from Animatics & Storyboards, Inc., that showcases many samples and has contact information; each sample shows an entire sequence. Storyboards by Alex Saviuk and colors by Mark Simon.

post. Most positions are filled in the first two steps. You need to network to get jobs. Sending out blind e-mails will not usually get you a job.

Get involved and get known. Volunteer in industry associations such as Women in Film, ASIFA, American Advertising Federation (and local chapters), and more. This allows potential employers to get to know you and see how you work. Cold-call potential clients. Introduce yourself to new people at industry events and parties.

Send flyers to old, new, and potential clients reminding them of what you do. You want to be the first and last person called for a job.

Do a great job and do it with a great attitude. This is the best guarantee crew members will recommend you on other projects. There is an old business adage that is true, the 80/20 rule, which states that 80 percent of your business will come from 20 percent of your clients.

CHAPTER 40

Prepping for Each Job

When you get a call to work on a project, you want to be prepared when you show up. Proper preparation will save you time and make you look more professional.

First, make sure you and production are clear on when they expect you to be available and that you don't have any scheduling conflicts. As you get busier, this gets trickier.

Figure 40.1 Storyboards by David Hillman of Hillman Arts.

At some point you may ask clients if they have you on a hard booking or a soft booking. A *soft booking* means that they want to know your availability on a certain day but that they know their schedule may change and that they don't want to be liable for your fees if they're not ready. Therefore they would like to be first on your list and to let them know if someone else wants to book you at the same time, and they will deal with the scheduling and booking problem only if a conflict arises. Clients can resolve a conflict by making it a *hard booking*, meaning that they expect you to turn down any other offers during the time they've asked you to work and that they should pay you for your time, even if they're not ready for you.

Once you book the project, it's time to:

- Get all of the clients contact information.
- Determine who is your main contact.
- Determine where are they located.
- Determine who you should bill, and get their address and phone number.
- Determine where they want to meet or when and how a conference call will take place.
- If you are meeting at a hotel or in a secure location, such as a studio back lot, determine who pays for parking and make sure you have clearance to get in.
- Determine, after you meet with the director, if you will you be working on location, at their production offices, or at your own studio.
- Determine if they want B&W production boards, tone, or color renderings.
- Determine how the client would like the work delivered. Will it be digital or hard copy?
- Get e-mail addresses or fax numbers, if necessary, for delivery.
- Ask to have the script and/or previous agency boards (if applicable) forwarded to you before your meeting.

Before you begin, negotiate the following:

- Your rate based on price per drawing or on time.
- What is included in your rate and what isn't; who pays for what expenses.
- If any of the work will be charged as overtime or rush fees.

Before you start the job, do the necessary research:

- Read the script. You need to be prepared when you meet the director.

- Obtain copies of any logos that may be needed.
- Find reference images of items in the script that you may need for drawing (e.g., trains, star of spot, client product).
- Understand the script and research unknown locations, props or words. For example, on a recent commercial job the script called for a woman working in her atelier. I had never heard that word before. A quick search on the Internet and in the dictionary confirmed that an atelier is an artist's studio.

I keep each storyboard project in its own manila folder. I title each one according to the product and job name, and I add the month and date for future reference. Before I go to the job, I place into the folder blank paper, blank storyboard forms, blank invoices (if necessary), a copy of my W9 (if necessary), the script, and reference images I may need.

On the face of the folder I write all the important contact information so that I don't have to search inside the folder for it. I write the job name, all the contact names, phone and fax numbers, and e-mail addresses, production office location, billing information, and delivery specifics, such as scanning resolution for images to be e-mailed.

Before you leave for your meeting, go over the following supplies checklist to make sure you are prepared. Be ready to draw on the premises even if you were told otherwise. Never be caught off guard.

- Folder
- Blank paper

Figure 40.2 Mocked-up folder showing important information which is helpful to have easy access.

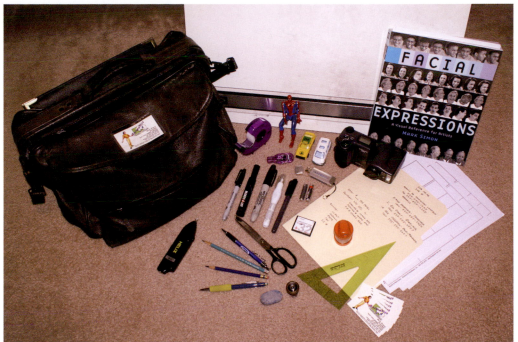

Figure 40.3 Mark Simon's project bag taken on each job. Other items are included as needed per job, such as laptop computer, scanner, and markers.

- Storyboard forms, possibly customized with the project title on each page
- Printed reference images and logos (if necessary)
- Sharpened pencils or mechanical pencils (have a spare)
- Portable pencil sharpener (if needed)
- Miscellaneous art supplies as needed, such as straightedge, scissors, tape, markers
- Extra leads in and for mechanical pencils
- Erasers, kneaded and electric
- Reference toys (Hot Wheel cars, action figures, etc.)
- Digital camera
- Extra batteries for camera

- Extra memory for camera
- Door viewer (see Chapter 32, Tricks of the Trade)
- USB mass storage device
- Blank invoice (if you need to invoice at the end of the day)
- A copy of your W9, a tax form new clients will need each year.
- Business cards
- Portfolio for contacts who have not seen your work
- Relevant reference books

The more prepared you are, the smoother every job will go.

How Productions Work

Every production team, director, and producer will work with storyboard artists differently. It will help you to understand how different situations may work. Here are the basic situations you are most likely to run into.

Commercial Example 1

The production company or advertising agency is bidding on a job for a client. They have an idea and need to present it to the client. They approach you to draw the boards according to their vision. These presentation boards will be larger than most production boards and will likely be in color. The visuals help them sell their concept. You may get the call for this late on a Tuesday, for example, and they are likely to need the art by Friday morning. You should charge by the panel.

Commercial Example 2

An advertising agency has chosen a production company to shoot the commercial for them. They have a set of presentation, or "agency," boards that were used to sell the idea to the client. The director on the project looks at them to get a general idea of what the client is looking for and starts to do her own shot breakdowns. The director sits down with you, her shot list, the agency boards, and reference photos of the locations and explains how her shots differ from the agency boards and what extra shots she wants to see.

If you are working long distance, you will get e-mails of scripts and reference images and you will have a phone conversation with the director about her needs. These will be the director's boards, which are given to the crew and used by production. You will charge by the panel or by the day or the week. Make sure you keep copies for your portfolio.

David Nixon, a commercial director, describes the problems with agency boards:

> A lot of times with agencies they like to do a photo comp board, where they have taken a real life image and they've just adapted it some way. And it doesn't really have much excitement to it other than it's a real life image. But the problem is that it shows no flow.

Figure 41.1 Commercial boards by Ted Slampyak of Storytellers Workshop, Inc.

Action Example 1

The producer brings you in and explains the look he wants on his project. He hands you a script and details a sequence he wants boarded out. You leave and do some thumbnails of what you think the action should look like. You and the producer get together again to go over your ideas and revise and refine them. You finish drawing the final boards on your own, then the producer gives them to his director or uses them to budget the cost of doing that sequence. You will probably charge by the panel, unless it's a long project, in which case you may charge by the day or week. This is exactly how a project at HBO went for me, as detailed in Chapter 36, How I Got Started.

British Commercial Example

Some big British ad agencies have their own storyboard artists on staff. The agencies without staff artists have their creative director farm out the work to the handful of specialist storyboard studios. One of the studio reps takes the brief, which is information needed for the storyboards. An artist at the studio is then given the job. The artists rarely take the meetings themselves.

Most of the work is done by freelancers working within the studios, which are mostly in London. Most of the freelancers work in the studio, with a few working from home. One studio charges for desk space, about £250 a month, which is deducted from the artist's earnings that month. The others offer free space.

Much of the commercial work arrives in the studio from an ad agency at about 4 p.m. and is almost always deadly urgent, usually to be delivered by the next morning.

Action Example 2

The director of a project calls you in to help with some action sequences. She has a clear-cut idea of how she wants it to look. The two of you flesh out her idea in thumbnails; at the same time you are offering her advice on the flow of the scene. She OKs your thumbnails as you discuss each shot. During your meeting the director may show you sample clips from movies she is emulating. You go away for a few days and finish the boards. You charge by the board on a short project or charge for your time on a longer one.

Graphics Logo Animation Example

A computer graphics company has a project to produce for a client. Time on the computer system is very expensive, so to flesh out what the client wants they ask you to sit in on the meetings to board out everything first. If they want to animate a logo, your boards present not only how the shots should look but also how all of the elements work together. The computer graphics company shows these boards to the client for approval. Once everyone agrees on the look, the computer artists can start laying out the needed elements. You have given the graphics company a direction to go without needlessly and expensively spending excess time on expensive CGI (computer graphics) equipment. You charge your client per panel.

Animation Example

You are working on a short animation. You're hired for a flat fee for the episode you're doing. The episode is 11 minutes long and should take you about three weeks. The production company sends you the script, the forms to draw on, sometimes the rough audio of the actors, and any visual references you need.

Props, characters, and backgrounds are generally designed before you get the board. You do your own shot breakdowns. You will send your roughs to the storyboard supervisor, who makes sure there is consistent story-telling among all the storyboard artists, who will make notes and tell you what to change. You need to send in the final boards by the deadline given to you.

On the Nickelodeon animation series *The Brothers Flub*, we were able to work from the voice-over recordings. A number of the sequences were recorded with different attitudes than we had imagined from the script, which of course made a difference in the visuals. We never received any director's notes or talked with a director. Our artist on that project was chosen because his style matched the style of the cartoon.

◗ Production Example 1

You are in the art department, in any position, of a project that needs boards. You are the only one in the department experienced at drawing boards. You get the job, but there is a very good chance you will not get paid extra, unless you draw the storyboards outside your time at work (they are already paying you for your time during the day, regardless of how you use the time). In any case, your portfolio now has another new piece. They own the art.

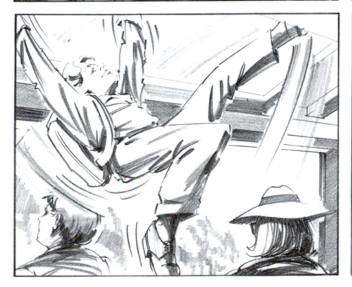

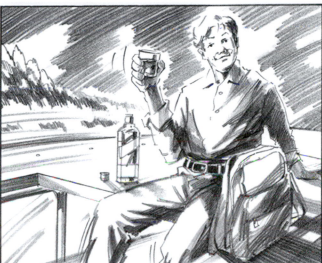

Figure 41.2 Commercial storyboards by British artist Kevin Scully.

▶ Production Example 2

You are a staff member on a series. You are the story-board artist. You also do the *conceptuals*—concept illustrations of sets and locations. The show schedule dictates that a new show is to be shot every seven days. That means you have seven days of prep for the next show. It takes a day or two of prep for the location scouts to find possible locations, and the script is being revised at the same time.

You go with the director, producer, production designer, and others to see each location. You go over possible scenes with the director at each location, and you take reference photos for your boards. By the fourth day of prep the director knows what he wants and you sit down and take notes. This is the same time the production designer has thumbnail sketches for the sets for that show and wants you to render them.

You need to juggle both jobs and get them done quickly. The boards are rough but accurate. You need to finish the scenes that will shoot first in the schedule. You finish the last scenes two days into shooting.

It is now time to start scouting locations for the next episode with the next director. This will go on for about

Figure 41.3 Liberty Safe logo frame storyboarded by Dan Antkowiak of Animatics & Storyboards, Inc.

nine months, the average run of a television show's season. You are being paid by the week, and the production owns the original art you draw as well as all rights to it. This is work for hire; you are an employee. Check with the production coordinator and make sure that you are on the crew list and that they have all of your correct information.

The crew list is used to assemble the credits and is the way its members can reach you for other projects. This is how my stint as the storyboard artist on Amblin's *seaQuest DSV* went. I worked for nine months on the show and drew everything from boards to new ships to props and wardrobe. We had a different director every week, and I learned different things from each and every one of them.

Feature Example

You are hired onto a feature film that is shooting on location. The production will fly you to a location and put you up in a hotel with the rest of the crew. You are on a weekly five-day rate but rarely leave to go home on the weekends. You are paid a per diem for every day you are away from home, usually between $25 and $50 a day, depending on the city you are in. You hang out with the director on location scouts and in his office. You will get reference images of vehicles in the movie from the transportation department and reference photos, plans, and drawings of sets and locations from the art department.

Figure 41.4 *The Brothers Flub* storyboards by Wolverton of Animatics & Storyboards, Inc. (© Sunbow Entertainment.)

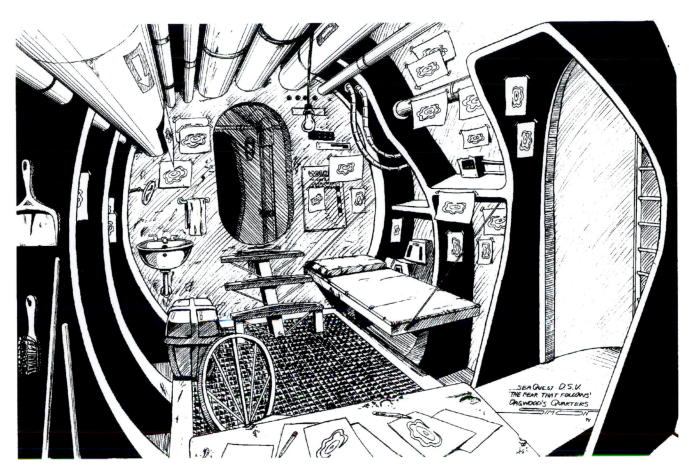

Figure 41.5 Dagwood's quarters in *seaQuest DSV*. Set design and placement of props on walls and table for the episode "The Fear That Follows." Dagwood was drawing images that he covered his walls with. This was a redress of a hallway set. Production designer: Vaughan Edwards. Artist: Mark Simon. (© by Universal City Studios, Inc. Courtesy of MCA Publishing Rights, A Division of MCA.)

The director will have headshots of all the actors hanging on the wall in his office. You will storyboard all the stunt and special effects scenes first, because those have to be planned early. Then you will work with the director on boarding fancy camera shots and difficult scenes until the production budget no longer wants to pay for you. You could work there from a few weeks to many months. Big movies may have a number of story artists working together. Don't be surprised when your five-week contract turns into 12 weeks of boarding.

Figure 41.6 Alex Saviuk of Animatics & Storyboards, Inc., did the boards for the movie *Hoot*. Alex is based in Daytona, Florida, and the movie shot in Ft. Lauderdale. Production reimbursed him for his mileage getting to the production, put him up in a hotel, and paid him a living expense per diem on top of his weekly salary.

CHAPTER 42

What Producers Look For

There are a number of things a good producer will look at when hiring a storyboard artist. The way you present yourself and your work, your ability to visually tell an exciting story, your experience, and your knowledge of the industry all play a part.

Producers usually hire storyboard artists with whom they have had good experiences. If they need to look for someone new they will ask their friends in the industry for referrals. A good reputation is the best advertising you can have.

When interviewing, the first thing that will catch a producer's eye while looking at your work is not necessarily the most important—the quality of your art. Before others can tell whether you understand storytelling, direction, and editing, they will see how well you draw.

You can't deny that good art alone can attract someone to your abilities. But if you lack the ability to work with a director or don't know how to move a story along, you won't last long as a storyboard artist. However, with presentation boards, unlike production boards, the quality of the art, layout, and design are what producers value. Agencies working on large accounts, especially car accounts, like really tight concept pitch boards.

When working with production boards, producers understand that with the tight time constraints of production, you won't be drawing a Mona Lisa for every frame. Storyboards tend to look rather rough during production. Be this as it may, producers still want to see quality work in your interview. The thinking here is that the better you are when you have some time to draw, the better your quick sketches will be.

Your polished boards should still reflect the style of your quick boards; in other words, don't spend a week detailing five panels for your portfolio when your boards will never look anything close to that. Show a sampling of your tight boards and your quick boards.

Good professional credits go a long way in this industry. If you apply for a job and you have a top credit to your name, you stand a good chance of beating out someone who might draw better than you do but who has fewer big credits. Having good credits lets people assume that you have the knowledge and experience from that project, which may benefit their project.

Film and TV are artistic mediums of motion. Good storyboards need to portray that motion as well as possible. When someone is reading through storyboards, she should be taken on a visual trip through the story. A good story artist knows how

Figure 42.1 Presentation boards by German artist Ovi Hondru.

Figure 42.2 Ford truck pitch board by Peter Ivanoff.

Figure 42.3 Action storyboard by Dan Antkowiak of Animatics & Storyboards, Inc.

to portray a moving camera and how to show actions that take more than one drawing to represent. You should draw as many panels as it takes to demonstrate what is happening.

Don't be afraid to draw more panels. Motion in your art can be portrayed with the quality of the drawing itself, but it can be better understood with directional arrows. The arrows can tell the viewer what is moving and if it's moving within the frame, through the frame, or directly at camera. Arrows are fully discussed later in this book.

The professionalism you show both in the interview and on the job means a great deal. This has nothing to do with the way you dress on the job, since we all tend

to wear shorts or jeans. *Professionalism* refers to the way you handle yourself when dealing with production, such as whether you offer constructive suggestions and get along with directors, and how you present your artwork. In the interview that means having a neat and clean portfolio with professional-looking storyboards in it, not a bunch of sketches thrown into a zippered bag and strewn across a desk.

The way you present your business knowledge is important too. If you go into an interview and have no idea what to charge for your services, you will look like an amateur. If you state how you like to work and what your rate per panel or per week is, chances are you will get it. I am very seldom asked to cut my rate.

You will also need to be able to speak intelligently about what you do. Producers may ask about how you work, your experience in dealing with special effects, or about other aspects of your past projects. Your answers will tell her whether you have enough knowledge of storyboarding to help the production.

Television director Jesus Trevino agrees that production experience is beneficial. He adds:

> Be familiar with the lenses. I think something like that can be very helpful to a storyboard artist because, ultimately, after the storyboard is done, someone is going to have to translate that into lens sizes and camera position and make it happen.

However, he does add this caution:

> I think that a storyboard artist needs to be sensitive interpersonally to making the director feel comfortable about his participation. I think the worst thing a storyboard artist can do is to come in and start telling him how to shoot the sequence.

In animation, producers look for many of the same aspects that live-action producers look for in storyboard artists. But with their art, the artists also need to be able to act as if they are the actor in a scene. Nina Elias Bamberger, producer for Children's Television Workshop (CTW), says:

> I look for creativity. I don't really care if the characters are drawn perfectly, but you have to be able to really read the emotion in their faces. I look for movement in the storyboards. I look for if they know when to hit a close-up if something is emotional, how to show humor, and how to keep the story moving.

It's also important to take criticism well. Remember, your job is to capture the director's vision, not to push your own vision. Producers want to work with

artists who are easy to work with and who are noncombative. When you deliver your boards, they should be presented nicely, on clean, unwrinkled paper, scanned and adjusted so that the background color is white, not gray.

The most important but often overlooked aspect of boards is how well they communicate an overall series of events or actions. This may be overlooked because it takes viewing the overall work, not just the individual panels. Your drawings need to tell a visual, moving story in such a way that any crew member will understand what is happening. A good producer will look at your storyboards to see if they do this.

Knowledge of the industry, integrity, and good storytelling will help you more in becoming a successful storyboard artist than the quality of your art.

Figure 42.4 *Santo Bugito* storyboards by Klasky Csupo. Acting, instead of action, is represented here. Many animation studios want to see quality acting in sample boards. (© Klasky Csupo.)

CHAPTER 43

Pricing

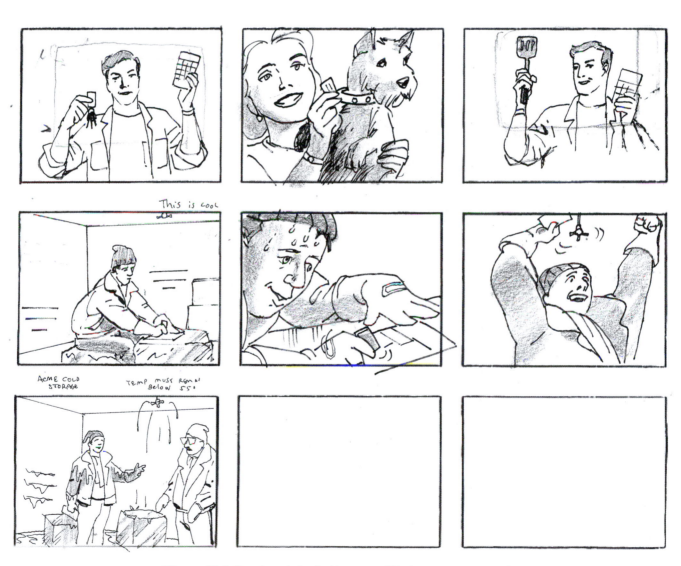

Figure 43.1 Storyboards by Bo Hampton. Billed out as seven panels.

Artists, like many other professionals, often undervalue their work and seldom know enough about rights and licensing. This is not a good situation, for two reasons: (1) You may deserve a better income if you know how to price your work; (2) you can keep yourself from getting in trouble by not accidentally using or selling art or trademarked characters that someone else owns.

There are five principal ways to charge for storyboarding.

1. By the panel
2. By the hour
3. By the day
4. By the week
5. By the job, flat rate

If you are charging by the panel, you need to make clear how the number of panels is determined. There is no need to charge for the time you spend in meetings when you charge per panel. I count the total panels as follows:

- The total count of finished boards delivered to production, plus:
- The number of boards changed by production, usually because of new concepts and through no fault of mine.
- If there is a change in the boards because I misunderstood the direction, there will be no charge for the change.
- I also charge for applicable and preapproved expenses, such as parking fees for meetings.

Here is how I state it:

I charge $ ____ per panel. If you decide to change some panels because you come up with another or better idea, I charge for the new ones as well. If I have to redo one because I misunderstood, there will be no extra charge.

I will show you the thumbnails first to make sure that they are what you want. If I have to pay for parking or incur any expenses, such as supplies to mount your boards, I will ask that you reimburse me for them. Expenses may also include mileage if I have to drive somewhere to look at sets or locations. I don't charge for mileage to get to meetings.

I feel this is quite fair, and they always do too. By taking care of all this business up front, there are no questions or problems.

When working on an hourly rate, most artists charge a minimum half-day, or four hours. This is because even if you only work for one hour, you have lost at least a half-day of work for another potential client who may want you for a full day.

Many artists find that they make more money charging by the panel. It also allows them to work on more than one project at a time. The faster you are, the more money per day you can make. This pricing also allows clients to control costs.

However, some clients prefer to hire artists per day, which is sometimes an easier way to budget. Productions usually can't predict the number of boards a spot will need until the artist has gotten all of his notes from the director; thus, budgeting a daily rate can be more accurate, assuming production has budgeted for enough days. If a director has one or two revisions the following day, however, a daily rate can cost much more than a panel rate. When charging hourly or day rates, meeting and approval time is included.

To determine pricing rates, ask either a storyboard artist, someone in production familiar with storyboards, or a storyboard agent. There are very few of these agents, and they are listed in the *LA 411*, the Los Angeles production directory. Rates are also listed in the *Handbook of Pricing and Ethical Guidelines*, 11th ed. (published by the Graphic Artists Guild; see Part Seven, Appendices, Reference Books). This is a great resource for pricing, industry standards, and sample contracts.

The rates you can charge will vary according to what city you work in—New York area work would be billable at a higher rate than in Omaha, Nebraska; your expertise; and the budget for the project. Low-budget productions pay the least and high-budget commercials pay the most. General rates do not reflect certain considerations, such as overtime and out-of-town work, and every negotiation is different when taking all the factors involved into account.

As stated earlier, certain expenses are reimbursable. Clients should be made aware beforehand if there may be any expenses that they will have to reimburse. On large projects you may want to write a letter, known as a *deal memo*, that breaks down fees and probable expenses. If the client agrees to the terms, ask him to sign a copy. Agreements such as this are seldom needed or used in storyboarding. Nevertheless, reimbursable expenses may include:

- Models
- References books or magazines
- Reference props
- Location or model photos (film and processing)
- Travel and lodging to distant locations, not local meetings

Figure 43.2 The Graphic Artists Guild *Handbook of Pricing and Ethical Guidelines,* 11th ed. (see www.GAG.org).

- Special matting materials
- Parking

Working as a local means that you are working for a production on location and are to provide for your own transportation, housing, and meals. Many production people like to work as a local in more than one city to increase their chances of getting work.

If a production pays to bring you out to a location or distant city where you do not work as a local, they will pay for airfare (or mileage), hotel expenses, and a vehicle if necessary. They will also pay you a per diem,

a cash amount per day, while you are on location to reimburse you for food and miscellaneous living expenses. Per diems generally range from $25 per day to $55 per day, depending on the city.

Per-panel rates for storyboard artists generally range from $20 to $50 per 3″ × 4″ B&W panel. For larger sizes, tone, and color, the rates are higher. Storyboard artists rarely charge by the hour. When they do, the fees range from about $50 to $150 per hour.

Daily rates for storyboard artists are in the range of $500 to $750 per day in large markets for the top artists. Smaller markets may only afford $200 to $450 per day. Daily rates come up when an artist has to work onsite for only a few days. In this situation, you are likely to be considered an employee rather than an independent contractor, and taxes should be deducted from your check.

Weekly rates vary greatly within each market and with each individual's experience. A storyboard artist is likely to make between $750 and $2,500 per week. Again, you are likely to be considered an employee in this situation. When you are on a weekly salary, the production usually provides you with office space and all supplies. You should not have any financial burden at all for supplies, copies, or references. If you do, you should be reimbursed.

Make sure you do research on rates before you interview with production. Early in my storyboarding career I interviewed in Miami for doing the storyboards on *Ace Ventura,* starring Jim Carrey. They seemed to like my work and asked my rate. I really wanted the credit, so I gave them a fairly low rate, not knowing what they were used to. They actually grimaced and said, "Ooh. We thought you had more experience than you obviously do. We need someone with experience." They figured that since I didn't ask for enough money, I didn't know enough to help them—and I didn't get the job.

Generally speaking, the highest rates are paid in Los Angeles, New York, and Chicago. The smaller the market you're in, the less you will be able to charge because smaller markets often cost less to live in and production budgets tend to be lower. Try to be aware of what a client can afford and charge accordingly. If you don't know, ask them. They may actually tell you what they can afford.

In Britain, they also tend to bill by panel, by hour, or by day. Complexity of the storyboard frames does affect the per-panel cost, but the average for simple black-and-white drawings are £10 to £15 each. For larger color renderings, around 8″ × 10″, the rate could be £60 to £70 each. A normal daily rate for someone

Figure 43.3 Comp storyboard by British artist Kevin Scully.

working at a steady speed is between £300 and £350. A normal hourly rate is from £30 to £40. The illustration studios then add their markup to the total when billing their clients.

Rush fees can be charged when a client's schedule demands that artists work through the night, on holidays, or over a weekend. Rush fees are determined by how much of the work needs to be done after normal business hours. The fees range from 20 percent to 100 percent more.

Most productions will not pay rush fees for weekend work unless it's their project that causes you to work a sixth or seventh day. Make sure that discussions about rush fees occur before you start drawing. It's amazing how often a supposedly tight deadline will losen up when rush fees are mentioned.

Each city and each country will have its own slightly different rates. Larger cities and production communities tend to have higher rates due to higher living costs and depth of experience of the artists.

Estimating

Quite often one of the first questions I get from a potential new client is "What will it cost to storyboard this project?" or "How many panels does it take to storyboard a commercial?" My response is "I don't know." This may sound weird coming from someone of experience, but it's true. Every project has its own needs and every director has his own visual style. Without going over the script with the director there is no way to estimate the number of storyboard panels it will take.

More and more commercials pay per panel when they hire storyboard artists. Some still pay by the day. Per-panel fees guarantee production that artists will not run up the bill by drawing slowly and that they can save money if they only need a few drawings. It also protects the artist if the client keeps adding more panels.

If the client is paying a day rate, the number of panels needed is relevant to how long it will take to complete. Even then, commercial creative people are known for changing their minds, creating the need for multiple versions of spots that have to be boarded over several days.

I can go through a script and quickly estimate how many panels it would take according to my vision, but the director may have a completely different vision. I have worked on 30-second commercials that needed only four panels, and I've worked on 30-second spots that needed more than 45 panels. The final number could be anywhere in between.

A director who envisions a project with fast cuts and editing will need more panels drawn than a director who sees a project with a nice, slow pace. As the storyboard artists, that is not our decision.

On the Universal Pictures feature *McHale's Navy*, starring Tom Arnold, I was hired to storyboard the second-unit boat chase. The sequence in the script was only about three lines long. However, Glenn Wilder, the second-unit director, had a number of large ideas as to how to play out the action beyond what was written in the script. By the time we were done, those three lines had turned into 101 storyboard panels. There is no way I could have estimated that.

There are other times when a client calls and says they have a spot that will need about eight panels. Make sure, before you start on the boards, that the client understands that the actual number of production boards may be different when you finish going over notes with the director.

Experience has shown that client estimates of the number of storyboard panels needed is often off by a factor of 2 or 3, meaning that if they think it will only be 8 panels, it might easily be at least 16. The best way to handle this situation is to

Figure 44.1 Storyboard artist Peter Ivanoff did not know how many panels this Armour spot would need until after he got his notes from the creative director. His own vision of the script might have been different.

have the meeting with the director and then tell the producer how many panels were requested by the director and to get her approval before proceeding.

It is easier to estimate days because most production boards for commercials can be done in one or two days per spot. I've done as many as five simple spots in a day, and I've had some complicated spots that take two days each. What can't be estimated is how often a client will change their mind during preproduction, causing boards to be redrawn over a number of days.

Feature films are the hardest to estimate, especially without a script. Clients will always say, "This is a pretty simple series of scenes. It will be easy. What do you think?" Never fall into this trap. The last time a client told me that, I read scenes with a cast of thousands with lots of action. Always read the script and hopefully talk with a director before giving any sort of estimate of time.

I've worked on movies for one week, and I've worked on movies for months. What makes the biggest difference in time has been either the needs of the movie or the budget amount for storyboards. Usually production only has a limited budget for a storyboard artist and you have to do what you can within that time period.

For example, the director of the movie *Dexter*'s pilot (see Figure 44.2) needed only one sequence boarded, and I was hired on a day rate for the project. I drove from Orlando to Miami, met with the director, and drew the boards while he left on a location scout. I met up with him that afternoon, got approvals on my boards, and drove back to Orlando that night, billing production for one day plus mileage for the out-of-town trip.

Again, estimating how many panels or scenes you can do in a particular period of time is difficult. Some directors like to walk locations with artists, and location scouts can take a lot of time. Some directors know exactly what they want and can get their information to you quickly, while others don't start thinking of their shots until you show up and may be constantly interrupted by a thousand production issues that need their attention. In other words, your time is not decided by you.

When a production has a limited amount of time budgeted, start by storyboarding the special effects and stunt scenes. These are the most important for production because they are needed for bidding, budgeting, and scheduling. If time permits, you can move to special camera moves and then general storytelling. Explain this concept to potential clients, and you will set their mind at ease.

Animation is a little different. Since every scene is storyboarded, there is less variance in what it will take. For animation series, you never charge by the panel. For freelancers, it's almost always a flat rate per episode. Staff storyboard artists get paid weekly.

Animated series will have a budget for boards, and it's OK for you to ask what that is. They will always request your weekly or flat rate first because they would like to pay less than their budget, to pad for overages. Your best bet is to know the industry standards for the type of show, the length of show, and the location in which you live.

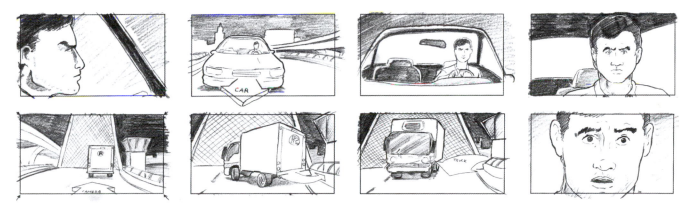

Figure 44.2 Boards for the Showtime movie/pilot *Dexter*, by Mark Simon of Animatics & Storyboards, Inc.

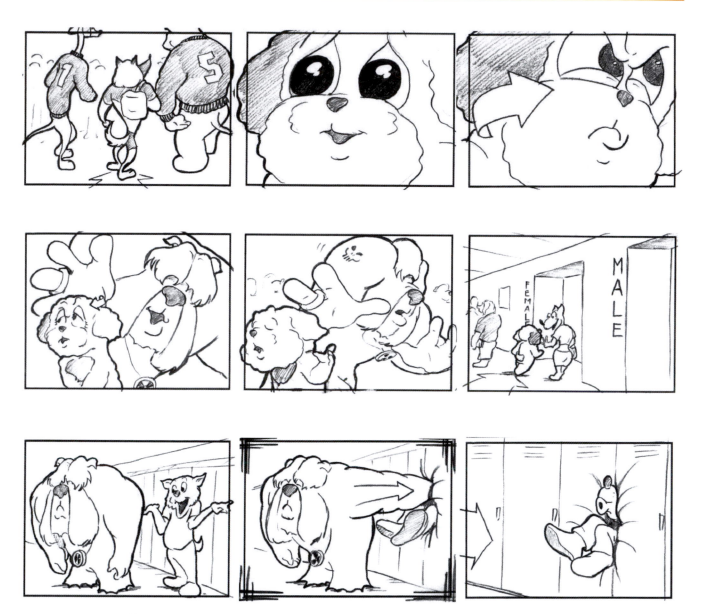

Figure 44.3 *Howl High* storyboards by Mark Simon for A&S Animation, Inc. Animations pay either flat rates or weekly rates for storyboarding.

The boards for the 7-minute short, shown in Figure 44.3, took a week and a half to complete. Be sure to accurately estimate how long it will take you to draw a project to determine a fair rate.

The best and most honest response is to give clients a large range once you know the parameters and to briefly explain why you can't make a clear estimate. Those with experience will understand, and those without will keep asking you to make a tighter estimate. Wait until you've talked with the director before you give any estimates and you will always protect yourself.

CHAPTER 45

Billing Practices

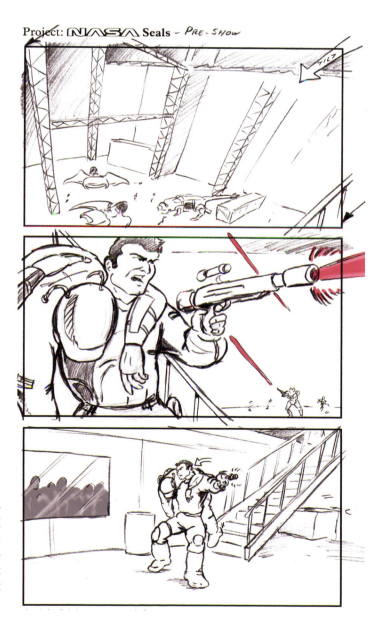

Figure 45.1 *NASA Seals* story-boards by Mark Simon for DAVE School Productions. I invoice all my clients promptly on completion to speed up the payment process and to make sure I don't forget to invoice them.

The best way to avoid billing problems is to be very clear upfront about costs. Talk to the person who approves your invoice before you begin the job, usually the production manager or producer. If there are rush fees because of a tight turnaround, make sure they are disclosed before starting. Be clear about who handles potential expenses such as travel, per diem (if on a distant location), parking, and freight.

The worst thing an artist can do is not to invoice a client immediately. By not sending an invoice as soon as you are done, you could forget to send the invoice later, or the production could shut down with no one left to pay you. The longer you wait to invoice, the longer it will take to get paid.

Production offices are often put together just for a particular production. Commercials may hire freelancers on location and open an office for the length of the shoot, following which all go their separate ways. If you don't give them an invoice immediately, you may not be able to find them later. Movies are the same way. Many features are set up as independent companies. Those companies function only as long as the production lasts.

When you are working on location, bring blank invoices with you. Fill out and hand in your invoice at the end of the job before you leave. If you are being paid for your time and you're not a corporation, you will fill out a time card which someone from the production staff will provide. Many commercials will cut a check while you wait.

If you are working on a payroll, or need to fill out a time card, make sure you do it at the end of the day or the end of the workweek. Delays in filling out these forms beg for mistakes and always cause delays in getting paid.

When working from your own studio, make sure you find out who to send your invoice to. Also ask how they prefer to receive it. Some clients will not pay invoices unless they have the original. Others will pay from faxes or e-mails. Always confirm that they have received your invoice. E-mails often don't make it, and faxes are often misplaced. It's better to discover they didn't get your invoice right away than to wait 30 days and then find out they never knew you sent it.

Always fill out your invoice with the client's name, address, and phone number. This helps them and you. If you need to call on an overdue invoice, all the info you need is right there. Also include a purchase order (PO) number if the client has one for you as well as a job number. Commercial houses often have multiple jobs going at the same time, and job numbers allow them to allocate costs to the proper job. When there is

Figure 45.2 The top part of your invoice needs to have your information and all the client's information, including job numbers, PO numbers, and an invoice number.

no job number, ask what the job name is. Always include a description of the job and what you provided on the invoice.

Be prepared to give each project a copy of a W9 form. It's easiest just to carry copies of one with you. If you are a corporation, no taxes will be taken out of your check. Many companies will deduct taxes from free-lancers' checks due to their tax liability and because of labor laws that determine when people are considered employees and not freelancers.

If a client asks you to discount your price, the best way to handle it is to invoice for your normal amount and show the discount at the end. That way they will always see your true fees. Clients have short memories and will always remember the lowest amount you charged and will assume that the low rate is your normal rate.

Never be embarrassed to invoice clients, as some artists are. You are providing a service for a fee, and clients expect to pay for it. It is up to you to track your invoices and call clients when payments fail to arrive within 30 days. When payments are late, phone the accounts payable person and nicely ask about your payment.

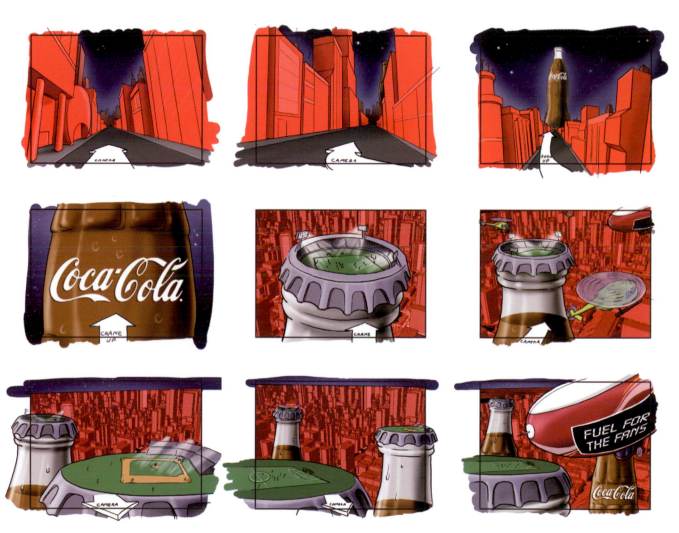

Figure 45.3 Coke presentation boards by Mark Simon of Animatics & Storyboards, Inc. Creative by Keyframe.

CHAPTER 46

Licensing

A licensing agreement is written permission the artist gives to a client for a specific use for a specified length of time of any creative work for a predetermined price. Just because companies are paying for your art doesn't necessarily mean that they own it. Because of the nature of the development of storyboards, clients almost always own all rights (see later). Artists have historically sold all rights for preproduction work.

When I am working as an independent contractor, I state upfront, and confirm on my invoice, that the fees I charge are for preproduction purposes only. I give clients one copy of my invoice, and I have them sign and return a second copy for my records.

WIDEN to show Otis with Venus in romantic setting.

SFX- Tim's car screechs to halt. Otis reacts.

Figure 46.1 Although Tim Burgard did these boards for New Line Cinema's *Son of the Mask*, he has no rights to them. New Line can do anything they want with the art and the designs. (© MMV, New Line Productions, Inc. All rights reserved. Courtesy of New Line Productions, Inc.)

Figure 46.2 Conceptual set design by Mark Simon of Animatics & Storyboards, Inc. I still own the design.
No one can use this set design without paying my company a license fee for its use.
This drawing cannot be used in any marketing without a separate license fee.

You should limit the rights to your art as much as possible, and you should retain ownership of the original artwork. The illustration industry standard is for art to be returned to the artist within 30 days of its use. Production moves so fast that it's easy to lose track of your art. Always try to keep your own copies of your boards while you're working.

Because storyboards are part of a collective work, they are generally considered to be work-for-hire, and the rights belong to the producing company when there is no contract stating otherwise. The characters, the story, and the look are all owned by the production house, and the storyboard artist is simply manipulating these elements. Thus, although it's original art, it's not an original concept that the artist can own.

Although it is the industry standard for all the rights to be sold for preproduction art, it's not always necessary. You can state upfront that the price you are quoting is for preproduction purposes only, that the original art and any other rights belong to you. In other words, your drawings could not be used in advertising or in a book without your getting paid for them. Some companies will object. It will be up to you whether it's worthwhile to fight for additional rights.

You have to weigh the risk of upsetting or losing a client if they feel strongly about owning all the rights. It's not worth a big fight and losing a client. You are not likely to lose any future fees on production storyboards, since they are so specific for each project and have little use outside of preproduction. Even if your storyboards are used as an extra on a DVD, you benefit. That's a free ad for your abilities.

Whether or not you have a legal right to your artwork will depend on your legal relationship with the company for which you are doing the boards. It is important to know the differences between being an independent contractor, an employee, and under a work-for-hire agreement. The Graphic Artists Guild is unalterably opposed to the use of work-for-hire agreements, under which the artist is treated as an employee for copyright purposes only and receives no employee benefits.

If you are an employee, you are given a place to work and you are told when and where to work. Employees must be covered by the employer's worker's compensation insurance. This is required by law. Should you be injured on the job, you can file claims for medical costs and disabilities. The employer must also withhold

taxes from your checks. In this event the employer owns all rights to the work.

When you are an independent contractor or free-lancer, you determine your own working conditions and you are responsible for self-employment taxes. You may also have your own employer identification number. The employee/independent contractor laws are vague at best. Having a signed agreement to determine license ownership of any non–work-for-hire artwork is recommended.

Many production companies prefer to treat people who should be considered employees as independent contractors because it saves them a lot of money in taxes. (Employees increase their labor budget line by around 24 percent.)

Under a work-for-hire agreement, the copyright law gives the initial copyright to the artist's employer. Even in the absence of a written agreement or oral contract, the work-made-for-hire law may apply. The copyright law states:

> In the case of a work made for hire, the employer or other person for whom the work was prepared is considered the author (the word "author" has a broad meaning in the copyright law and can include "artist") for purposes of this title (the author is the initial copyright owner), and, unless the parties have expressly agreed otherwise in a written instrument signed by them (the employer or the person for whom the work was prepared) owns all of the rights comprised in the copyright.

Figure 46.3 Dan Antkowiak sculpted this maquette while working at my studio, Animatics & Storyboards, Inc. Because he worked for me, the art he produced while at work is legal property of Animatics & Storyboards, Inc.

There are two situations within the copyright law in which the term *work made for hire* exists.

1. "a work is prepared by an employee within the scope of his or her employment."
2. "a work specially ordered or commissioned for use as a contribution to a collective work, as a part of a motion picture or other audiovisual work, as a translation, as a supplementary work, as a compilation, as an instructional text, as a test, as answer material for a test, or as an atlas, if the parties expressly agree in a written instrument signed by them that the work shall be considered a work made for hire."

The written agreement just mentioned is only valid if it is signed by both parties prior to the time that creation of the work begins. A work-made-for-hire agreement cannot be entered into after a work has been started.

Some companies, such as *Playboy* in past years, attach a work-made-for-hire statement on the back of checks giving the company all rights to the art when the check is endorsed. These work-for-hire statements must be signed in order for the check to be cashed. This is *not* a valid contract, as proven by the *Playboy Enterprises Inc. vs. Dumas* case in California, because the contract on the back of the check was not signed before the work began.

For any works of art in which you retain the rights, it is a good idea to include a copyright statement on each page of your drawings. It is not necessary, however, since the requirement to inscribe the notice ended in 1988, but you have more rights when the copyright statement is present. Copyright is given from the moment of creation.

There is a push in the government to overturn part of the copyright law in the form of orphaned-works legislation, which states that if someone cannot find the owner of the art, that person can legally use the art. There are no restrictions on how hard someone looks for the creator. This means someone could just say she looked for you and use your art. If the legislation passes, your only compensation would be up to the fair market value, with no legal fees reimbursed or fines levied. In other words, there would be no incentive to actually find you. It is up to all of us artists to let our government know how devastating this legislation could be to artists.

The following is the description written by the Copyright Office at the Library of Congress regarding the form of copyright notice on visually perceptible copies (graphic artwork).

Figure 46.4 Copyright website at www.copyright.gov. Information, registration, laws, and publications can be found here.

A copyright notice will help ensure that you can easily be found. The notice for visually perceptible copies should contain the following three elements:

- The symbol © (the letter C in a circle), or the word "Copyright," or the abbreviation "Copr."; and
- The year of first publication of the work. In the case of compilations or derivative works incorporating previously published material, the year date of first publication of the compilation or derived work is sufficient. The year date may be omitted where a pictorial, graphic, or sculptural work, with accompanying textual matter, if any, is reproduced in or on greeting cards, postcards, stationery, jewelry, dolls, toys, or any useful articles; and
- The name of the owner of copyright in the work, or an abbreviation by which the name can be recognized, or a generally known alternative designation of the owner (for example, © 1982 John Doe).

For more information and copyright forms, you can call 202-479.700 or write to: Register of Copyrights, Copyright Office, Library of Congress, Washington, DC 20559. For registration of graphic art, ask for Form VA.

The Copyright Act of 1976, which became effective January 1, 1978, gives the limits of copyrights as protection for artists and authors. This act states that any work of art is protected at the moment of its inception. The lack of a copyright notice does not negate your rights to a work of art. The only problem with not having the copyright notice on your work is that it becomes vulnerable to supposedly "innocent" copyright infringers who may claim they didn't know the work was protected. Since 1988, this is less of a worry. Legal registration of copyright allows artists to sue infringers for penalties in addition to market value.

Since storyboards are so specific in their purpose and quite often are nothing more than quick sketches, licensing rights are not usually an issue. You need to make that determination for yourself. It is a good idea to start retaining rights to your personal art as a matter of setting a precedent. As you sell more original art (not storyboards), it may become more valuable, and the sooner you claim a stake in your work, the easier it will be to make use of that value.

Trade Practices

The following list presents storyboard trade practices that are commonly accepted as standards in the illustration industry. There are differences for storyboards specifically, but it's good for artists to know these general trade practices. Most of the list that follows is from the Graphic Artists Guild's *Handbook of Pricing and Ethical Guidelines*, 9th ed.

1. The intended use of the art must be clearly stated in a contract, purchase order, or letter of agreement stating the price and terms of sale. This is seldom done with long-term clients prior to starting a job but should always be stated on the invoice.

2. Artists historically have sold all rights for preproduction work. Since this work is very product specific, frames are almost never reusable. The higher fees available for this work have justified the loss of rights, although many art directors will return artwork for an artist's self-promotional use. Storyboards, however, have very little, if any, use after production is done.

3. If artwork is to be used for anything other than its original purpose, the price is usually negotiated as soon as possible. The secondary use of an illustration may be of greater value than the primary use. Although there is no set formula for reuse fees, current surveys indicate that artists add a reuse fee ranging from 25 to 75 percent of the fee that would have been charged had the illustration originally been commissioned for the anticipated usage. This is seldom an issue with loose production boards, because they have little secondary value, and it's never an issue if you're an employee.

4. Illustrators should negotiate reuse arrangements with the original commissioning party with speed, efficiency, and all due respect to the client's position.

5. Return of original artwork to the artist is automatic unless otherwise negotiated.

6. Historically, artists have charged higher fees for rush work than those listed previously, often by an additional 50 percent.

7. If a job is cancelled through no fault of the artist's, historically a cancellation fee is often charged. Depending on the stage at which the job is terminated, the fee has covered all work done, including research time, sketches, billable expenses, and compensation for lost opportunities resulting from an artist's refusing other offers to make time available for a specific commission. In addition, clients

Figure 47.1 Digital art has no originals to be delivered to clients, so returning artwork is seldom an issue these days. Pencil art by Alex Saviuk, digital colors by Mark Simon of Animatics & Storyboards, Inc.

Figure 47.2 Notes and script on this job came late, but the deadline didn't change. This forced artist Dan Antkowiak of Animatics & Storyboards, Inc., to work nights and through a weekend to finish the job. A rush fee was charged for the late hours and weekend work.

who put commissions "on hold" or withhold approval for commissions for longer than 30 days usually secure the assignment by paying a deposit. Only large agencies will typically consider a deposit.

8. Historically, a rejection fee has been agreed on if the assignment is terminated because the preliminary or finished work is found not to be reasonable or satisfactory. The rejection fee for finished work has often been upwards of 50 percent of the full price, depending on the reason for rejection and the complexity of the job. When the job is rejected at the sketch stage, current surveys indicate that a fee of 30 to 60 percent of the original price is customary. This fee may be less for quick, rough sketches and more for highly rendered, time-consuming work. Rejection fees are for finished illustration, not storyboards.

9. Artists considering working on speculation ("spec") often assume all risks and should take these into consideration when offered such arrangements. Spec usually means "for free" unless the spec art helps

sell the project it's attached to. All such arrangements need to be in writing prior to the commencement of work.

10. The Graphic Artists Guild is unalterably opposed to the use of work-for-hire contracts, in which authorship and all rights that go with it are transferred to the commissioning party and the independent artist is treated as an employee for copyright purposes only. The independent artist receives no employee benefits and loses the right to claim ownership or profit from future use of the work forever. Storyboards, however, are considered work-for-hire due to their collaborative nature. They are not just the artist's creation.

11. Preapproved expenses, such as unusual props, costumes, model fees, travel costs, parking, production costs, and consultation time, should be billed to the client separately. An expense estimate should be included in the original written agreement. (I recently needed to go into a themed facility for research on a project and my client agreed to pay for the cost of my going in.)

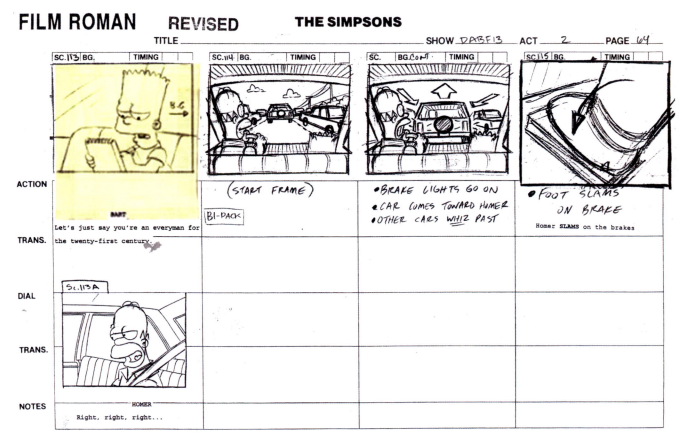

Figure 47.3 Notice the dialogue and action written under the frames. Dialogue is necessary to know where in the action the characters are speaking. (*The Simpsons* storyboards™ and © Twentieth Century Fox Film Corporation. All rights reserved.)

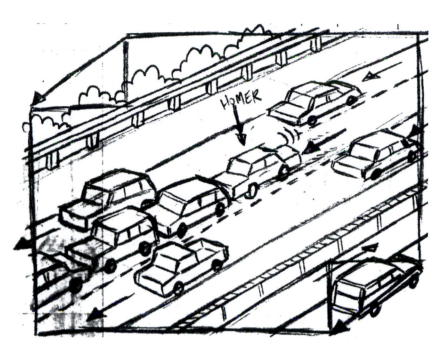

Figure 47.4 The note on this board makes it clear which car is Homer's. (*The Simpsons* storyboard courtesy of Twentieth Century Fox Television.)

12. Animation producers want to see the entire script written under the storyboards so that they and the animators can easily follow what is happening in the story.

13. Write any camera notes or effects on or under animation boards. Animation boards are the blueprint for the entire project and often also act as translators when projects are animated overseas.

14. Checks for long-term jobs usually get sent every one or two weeks; freelance projects pay within 30 days. If you don't get a check after 35 days, call accounting to make sure they received your invoice.

Format

Boards are usually drawn in one of three standard ratios, or screen formats. A *ratio* is the relative proportion of the screen width to the screen height for a particular format. The three formats are Television, 35 mm feature film and HDTV (high-definition TV and 35 mm film are the same size), and 70 mm feature film. The HDTV widescreen format has the 16:9 ratio of 35 mm, which will allow feature films to be shown properly on widescreen TVs and in the letterbox format on standard TVs.

The ratio for standard TV is 4:3 (4 units wide by 3 units high), for 35 mm features it's 16:9, and for 70 mm, or *anamorphic*, it's approximately 2.35:1. Anamorphic is an extremely wide shot that is compressed by a lens on the camera to fit onto a 35 mm film frame. An anamorphic lens on the projector widens the shot back to its intended width on the viewing screen.

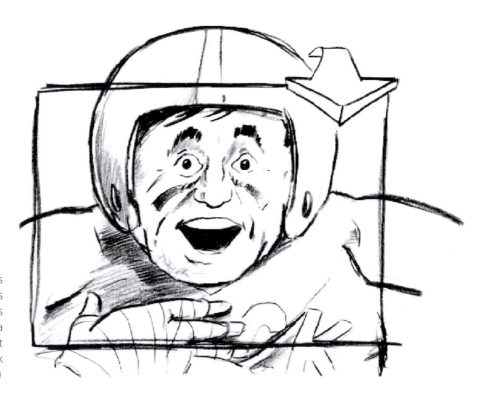

Figure 48.1 The character was drawn first and the framing was then sketched over it. Artists don't need to be confined to a box when they draw if they don't want to be. Storyboard by Mark Simon. (© 4 friends Productions.)

Storyboard Ratios

- Television = 4:3, or 1.33:1
- 35 mm film/HDTV = 16:9, or 1.85:1
- Standard wide screen in Europe = 1.66:1
- Anamorphic = 2.35:1
- 70 mm film = 2.2:1

The following are the standard frame sizes for television storyboards.

- Miniboards—less than $2\frac{3}{4} \times 3\frac{3}{4}$
- Telepads:
 - $2\frac{3}{4} \times 3\frac{3}{4}$ (I usually use $3'' \times 4''$)
 - 4×5
 - 5×7
 - 8×10
 - 9×12

The standard animation frame sizes for TV are:

- $2\frac{3}{4} \times 3\frac{3}{4}$
- $3\frac{1}{8} \times 4\frac{1}{4}$

The standard frame sizes for films are:

- 2×5
- 4×10
- 8×20

These sizes are just for reference. Any size you and the client agree to is fine as long as the ratios are correct for the format of the project. I tend to use $3'' \times 4''$ boards for my television work. They stack vertically three to a page, leaving room for my logo on top and production notes to one side.

Clients usually prefer simple rectangular boxes for storyboard panels. While rounded corners may seem more pleasing to some, they are frowned on in the industry. One reason is to make sure all storyboards match in shape when more than one artist works on a project. Another reason is that when a client cuts out the storyboard panels to paste up on a colored layout board, the rounded corners are needlessly time consuming to cut out.

Following are samples of proper storyboard frame ratios. You can find, and copy, full-page storyboard

Figure 48.2 The most common formats for boards for TV, 35 mm/HDTV, and 70 mm widescreen.

forms in Part Seven, Appendices, Forms. Some artists prefer not to use forms at all; they simply draw the illustration and then draw the frame over it, cropping the image where they feel it works best.

It is very easy to design your own forms in Adobe Illustrator, CorelDraw, or Adobe Photoshop. Computerized storyboard programs, such as FrameForge 3D, Storyboard Artist, and Mirage's Boardomatic, also allow you to customize your forms. This will save you money and allow you to put your contact information on every page.

Agents and Artist Representives

Are agents or artist representatives necessary? Yes and no. Part of the answer depends on the city where you live and work. Another part of the answer is how well you're able to market yourself to new productions. Some artists don't want to worry about looking for work and prefer to let a representative handle that for them.

Los Angeles is basically the only city in the United States, and London in the United Kingdom, that has agents specifically for storyboard artists—because they are two of the few cities with enough production being developed that agents are able to place enough clients to make a living.

So if you don't live in Los Angeles or London, agents generally won't do you much good. A few other large cities may have art representatives that take on storyboard clients as well as other industry positions. Ask a few production agents listed in your local film book or art guide whom you should talk to.

So you live in or move to Los Angeles or London and you're trying to decide whether or not to get an agent. How do you get one? What are the benefits? How much will it cost you? Getting an agent isn't easy if you don't have much experience.

For an agent to want to represent a client (the artist), that client has to be an easy sell to productions. Some agents are willing to take on an inexperienced artist and help train him or her. That's what happened with me. I found an agent who helped me over a period of about four months to develop my style and build a portfolio. Once my work became saleable, he started sending me out to productions.

To attract an agent, you need to present one with your current résumé and samples of your storyboards. A good agent will know immediately if they can sell you or not. Always call before you send samples, and make sure never to send originals. Different agents handle seeing potential new clients in different ways.

There are five main benefits to having an agent.

1. *Marketing*. Good agents know how and where to market to potential productions. Agents will generally pick up the marketing costs for their clients' work, although some split the printing costs for sample sheets. They should already have a good client base.

Figure 49.1 Capital One commercial storyboards by Josh Hayes. He prefers to work through Storyboards, Inc., as his reps. He feels it's easier for him.

2. *Quality.* Productions know that agents prescreen artists for knowledge and ability. When a production calls an agent, they know any artist sent to them is bound to be good. You don't have to worry about selling yourself to productions; the agent has already done that for you.

3. *Opportunity.* Your agent should have more contacts in the industry than you do and thus, potentially,

Figure 49.2 *Scorpion King* storyboards by Tim Burgard. Tim is represented by Storyboards, Inc. (Courtesy of Universal Studios Licensing LLLP.)

can bring you more work than you could have gotten on your own. As an added benefit, when a production wants another specific artist and that artist is busy, your name will likely be on the list as another choice.

4. *Negotiating.* Few artists enjoy negotiating rates and terms, although all of them should know how. An agent will handle negotiating your fee—probably for more than you could have—and for the terms of your employment and how you'll get paid. All you have to do is show up and do a great job.

5. *Consistent work.* A good agent can be marketing you while you're busy on a production. This means more money-earning days for you.

An agent will generally take as a commission between 15 and 30 percent of what the production pays for your position. While that may seem like a lot, a good agent should be able to keep you busier and get you more money than you would have been able to get on your own, so your net income should be higher when using an agent.

In any contract you sign with an agent to represent you, probably the main item you need to be clear on is whether you are in an exclusive or a nonexclusive contract. *Exclusive* means that the agent takes a percentage of every project you work on, whether she found you the job or not.

Some exclusive contracts make the exclusivity apply only to representation, not to all the work you do. Nonexclusive means that the agent takes a percentage of only the projects she finds or negotiates for you and that you are free to be represented by others at the same time and/or find your own work.

Artist reps are seldom called on for storyboard artists. The main reason is that storyboard art is a specialized field and productions will generally look only in trade film books or ask colleagues for experienced storyboard artists. While artist reps handle very talented artists, a good artist does not necessarily make a good storyboard artist.

Some artists are excellent at marketing themselves and can keep a steady flow of work coming through the door. If you can do this, you may not need an agent. Others won't have the option of getting an agent due to where they live or their lack of production experience.

CHAPTER 50

Unions

There are two different unions in the states that cover storyboard artists, one for live-action and the other for animation. The live-action union is IATSE (International Alliance of Theatrical Stage Employees), Local 790, which covers entertainment industry illustrators and matte artists. (They do not have a web site. For information, you can call 818-784-6555.) The animation union is The Animation Guild, otherwise known as Affiliated Optical Electronic and Graphic Arts, Local 839 of IATSE (www.AnimationGuild.org).

Being that they are both IATSE unions, most of the benefits are the same. Through the union, you can get heath coverage, 401 K plans, and investment options. The union also sets salary minimums. These minimums are merely a

Figure 50.1 The Animation Guild website at www.animationguild.org. You can find contracts, benefits, and signatory studios online.

Figure 50.2 To work on the large Hollywood movies, you need to be in the union. *Son of the Mask* boards by union member Tim Burgard. (© MMV, New Line Productions, Inc. All rights reserved. Courtesy of New Line Productions, Inc.)

starting point for rate negotiations. Experienced artists always get well above minimum. The union contract also sets forth basic working conditions and overtime rates. The union also offers classes and support for its members.

To join the Animation Guild, you simply need to get hired at a union shop. The studio will send the union a letter stating that they have hired you. Soon you will receive a letter about the union, along with a schedule of dues and initiation fees.

The trick to getting hired is having the right talent at the right time and proving it to the right people. Pay attention to what the shops are asking and looking for, and show it to them.

Local 790 prefers that productions hire only current union members, to keep their members working. The union will offer a roster of available workers, but each shop may find staff any way they wish.

So how do you get a union job without being in the union already? You can be grandfathered in if you are on a nonunion project that becomes signatory. A union show can hire you if there are no other union artists available, and you can join at that time.

Signatory companies, those that have signed union contracts, can only hire union workers for staff and free-lance positions. To work on big-budget films, you generally have to be a member of the union.

CHAPTER 51

Business Aspects

Storyboarding is fun. Storyboarding is an essential part of the entertainment industry. Storyboarding is also a business. Like all businesses, it has to be handled professionally. The business of storyboarding is no different than any other business, except you may enjoy it more. If you are the one hiring storyboard artists, understand that it's their livelihood and they deserve to make a living at it.

Figure 51.1 *Tugger, The Little Jeep Who Wanted to Fly* storyboards by Woody Woodman.

To thoroughly go over every aspect of business would take an entire text, not to mention several college courses. So if you haven't already, I recommend taking business, marketing, and accounting courses. Even so, I will briefly highlight the main business aspects of storyboarding for a living.

◆ Marketing

Make sure you know how to advertise what you do to potential clients. You may be the best in the world, but if no one knows you, it won't do you any good. You can get around knowing marketing if you have a good agent or work full time at a production or animation studio. When you market to clients, show them sequence samples, not individual pieces of art. Clients need to see visual story flow. They also want to know about your experience.

◆ Résumé and Portfolio

Résumés and portfolios were discussed in Chapters 34 and 35, respectively. Once you get an interview, you need to be able to prove what you can do. What you show is what the client will expect, for good or for bad. If you show some messy samples and have excuses for it, your client will expect to receive messy work and hear excuses for it.

Figure 51.2 Animatics & Storyboards, Inc., flyers, which are mailed as reminders to existing clients and inspiration for potential clients.

Figure 51.3 Portfolios should be letter-size for easy filing by clients. They can be simple and should always include your contact information on every page.

▶ Professional

Present yourself just like any other successful business. Have a good letterhead and business cards. Everything you present to your clients should be neat, clean, and professional. Be on time, every time. Scans should be crisp, with white backgrounds. Make your clients' job easy.

▶ Credit

Make sure you get proper screen credit and that you are on the production crew list. Most productions have a crew list, detailing every crew member's name, position, and phone number. This serves as a great reference for anyone trying to find crew people they have previously worked with. If you are listed in the crew list, you have a good chance of getting your proper screen credit.

Many television shows don't have enough time to run a full credit list, so most storyboard artists don't see their names onscreen. Most feature films should list every crew member.

▶ Attitude

Present yourself properly in an interview and during a job. There is no need for a suit and tie—ever. Dress is usually casual in this industry, but at least be neat and clean. This may seem like a no-brainer, but I have seen many an artist show up looking pretty "nasty."

When you're working with a production, show up on time and be a benefit to the process. Don't be combative about the art or the idea. The goal is to capture what the director wants to see and to offer suggestions.

▶ Pricing

Know what your art is worth. The two main questions you'll be asked before starting a job are "What's your availability?" and "What's your rate?" There are many ways to price storyboards for different projects, as described in Chapter 43. Know them. Pricing too high may knock you out of the race, and pricing too low may make you seem like an amateur (it happened to me once)—not to mention making it hard to make a living. If you're going to charge for expenses, make that clear to the client upfront. No one likes surprises on the invoice.

▶ Trade Practices

Make sure you know what is expected of you and the client knows what your terms are. Before you start, establish with your client when a project is due, when you should get paid, where you're expected to be and when, when you may need any information from them to get started, how they want the boards delivered, when changes are billed extra, and what expenses you expect.

▶ Delivery

Make sure you deliver when you say you will deliver. If you realize you can't make your original goal, let the client know as soon as possible. There is no excuse for delivering a job late and not forewarning anyone.

When delivering digital art, try to send the files to more than one person at a time, as a safety precaution. Always call the client to let them know when you send the files so that they can look for them. That way they know you've done your job and will call you if they don't see the files in a reasonable amount of time. Try to make sure clients have received your work before you leave the office and become unreachable.

▶ Billing

Bill a client exactly what you said you would, in a professional manner. Make up or buy good invoices and

Figure 51.5 Storyboard by German artist Ovi Hondru.

Figure 51.4 Know when production sketches are enough, and know when clients want and need tight comp work. Production boards by Bo Hampton.

keep track of them. You can use a computer program, such as Quicken or QuickBooks Pro, to generate your invoices for you. Make up your own invoice using a spreadsheet program or word processor, or have some forms printed with your logo. A printed invoice says a lot to your client about how professional you are.

Many clients take their time in paying invoices. You need to develop a good system for tracking who has paid you and who hasn't. You may want to put a line on your invoice that states "Amount due/payable within 30 days or late charges will apply."

♦ Accounting

You need to keep track of your income and expenses. Expenses are the cost not only of your paper but also of your drafting table, your accountant, marketing, the

portion of your dwelling that you use for business (including rent, mortgage, utilities, phone, etc.), health insurance, investments, utilities, movie rentals, industry magazines, and more.

Make sure you have enough money to cover downtimes in the industry (it's feast or famine). Plan for your own retirement. Every penny you can write off of your taxes is extra money that stays in your pocket. Find a savvy accountant to help you set up a system.

♦ More Marketing

Don't wait until you're finished with one project before you start looking for another, or you'll end up with a lot of downtime between projects. The best marketing is always out there working for you, like listing yourself in local trades and local film books.

Web sites that come up high on search engines also work very well. Make sure your contact information is on everything you give to every client. Make it easy for people to find you. The more you do, the more you're likely to get.

♦ Be Cordial

Make sure your client enjoyed working with you. The old 80/20 adage is true: You'll make 80 percent of your income from 20 percent of your clients. In other words, returning clients are where the bread and butter is.

The more you act like a business, the more clients respect you and will be willing to pay for your time and effort. You can have fun and take your business seriously at the same time.

PART FOUR

INTERVIEWS

SFX: Footsteps, squeak of seat

Man (quietly): "Go Magic. This is good."

AVO: "Orlando Magic fans have a very high C Level."

AVO: "C for Commitment. That's why everything has to be just right."

AVO: "We understand. Mostly."

Man: "Guys, I found one."

Lights go off. Man: "Guys?"

AVO: "What's your C Level?"

Orlando Magic commercial boards by Mark Simon of Animatics & Storyboards, Inc. The production company was Convergence.

CHAPTER 52

Alex Saviuk, Storyboard and Comic Book Artist

Alex Saviuk is a comic book artist veteran of over 30 years. He illustrated *The Web of Spider-Man* for more than seven years. He has also illustrated such classic comic books as *Superman*, *Flash*, *Green Lantern*, *Aquaman*, *Ironman*, *X-Files*, *Hawkman*, *Spirit*, *Phantom*, and more. He is the artist for the comic strip *Feast of the Seven*

Figure 52.1 Alex Saviuk.

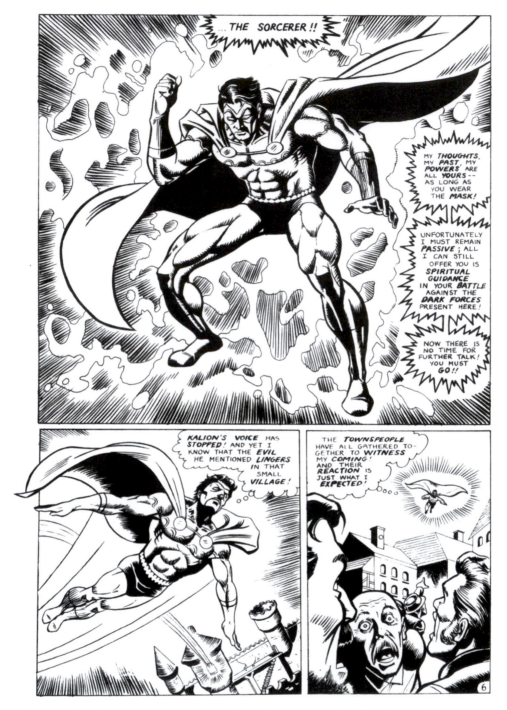

Figure 52.2 A page from Alex's independent comic book, *Freedom*, which helped him land his first job at Marvel.

Fishes and the *Spider-Man* comic in the newspaper. He's a favored guest at comic conventions around the United States as well as in my home and studio.

At the time this was written, Alex has been drawing for my studio, Animatics & Storyboards, Inc., for more than eight years. He's not only talented but unbelievably nice.

MS: How did you get started doing storyboards?
AS: I got started doing storyboards when I was working in comics back in the late 1970s and a guy that was inking one of my stories turned out to be living in the same town as me in Long Island. It turned out he was working at Benton and Bowles, an ad agency in New York. He was working as a full-

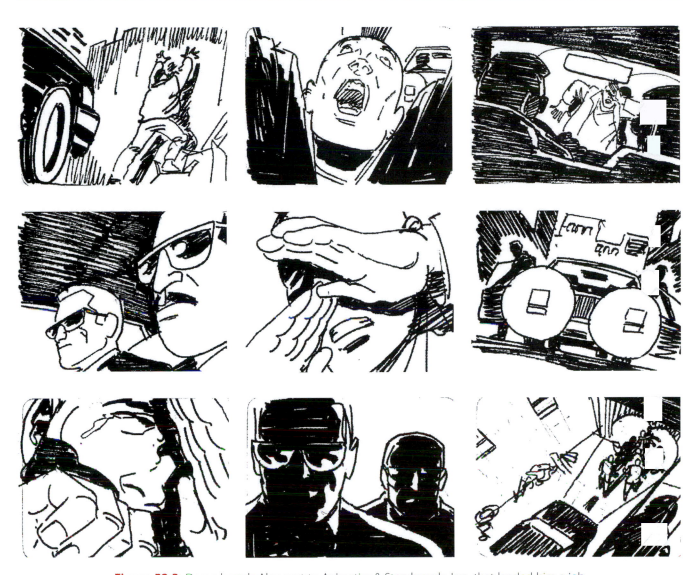

Figure 52.3 Demo boards Alex sent to Animatics & Storyboards, Inc., that landed him a job.

time storyboard and concept artist there during the week and at nights he was freelancing doing comics. He had asked me if I'd ever be interested in assisting him with storyboard jobs because sometimes he got much more than he could handle over a weekend. He called me up and I spent an entire weekend at his house in his studio and doing pencils, and he'd be doing finishes and colors. I saw what kind of money there was to be made doing storyboards versus doing comics, so I got pretty intrigued by it. I started putting some samples together and started going to some of the agencies on my own.

MS: How did we end up working together?

AS: After I had moved to Florida in 1992, comics were at a real high point. Their royalties were running rampant in terms of pay scales for the artists. I was working for Marvel Comics at that time, doing very, very well. I had my own *Spider-Man* comic book on a monthly basis, and royalty checks were coming in that were equal to working an entire month on the book. I just literally let storyboarding go after I had left New York. That was from 1992 until 1997, or 1998. I was working in comics and all of a sudden they were cutting back. I found myself not working for Marvel anymore, not getting freelance work in comics.

I remembered buying a book as I was looking around for clues on storyboarding. It was *The Artist's & Graphic Designer's Market 1997*. That was the year that the book had an article about you. You talked about storyboarding and that you lived in Orlando. I figured, what the heck, I'm going to give it

a shot. I sent you a FedEx package of some glossy color presentation boards.

MS: Yes, if I remember right, I called you and asked you for some quick-sketch samples, which is what most of my clients prefer. I always want to see what an artist can do when they have to work quickly. And I think you turned that around in like a day or two. And you sent me a couple of pages of new quick-sketch samples—exactly what I had asked for.

I get a lot of calls from storyboard artists, and they send samples. If I see some talent, like I did in you, I'll tell them what I'd like to see before we can move forward, and I never hear back from them. So, not only was your work great looking, you actually did what I asked for, got back to me quickly. You beat out 99.9 percent of the other people just because of your follow-through. So not only did you have the talent, I knew that you had the work ethic I need in my artists, and that sold me instantly on you.

AS: Oh well, thanks! I appreciate that. Actually, in terms of the work ethic, one of the things I've always prided myself on is my professionalism. Whatever it was I got my hands involved in is a commercial art form, and you have a deadline. I take pride in the fact that I've always been able to work very well with people, and if they needed something done at a particular time I got it done. And to be effective enough, especially in storyboarding, you don't have to have the prettiest-looking artwork, so to speak, but it has to visually convey the message. If you can do that, then you should be able to get some work.

MS: How did comic book work prep you for doing storyboards?

AS: The whole thing about comic book work is that you can take words, whether they be a written descriptive or a vocal directive from an art director, he will describe to you what he wants, and then you take your own notes and try to give him what he wants visually on paper. Or you can take the written words in a script, which 9 times out of 10 is what you're going to be getting from an art director anyway.

If you're doing some kind of an action sequence, sometimes the art director is looking for you, as the artist, whether it be comic books or storyboards, to be able to take those particular words and turn them into something that is pretty dynamic and exciting. And so whether you're talking about commercial advertising or even comics, a lot of it is based on your own visual

experience and having watched television and film. So, literally, if you can glean off something you have seen in the past and put it down on paper and enhance it with something new that you can come up with, then you can come up with a really effective scene over the course of those two pages, and that is what the writer wants.

MS: When you're working, how do you like to work? Do you blue-line first? Do you work straight with pen? How do you work?

AS: When I started doing them in New York City, everybody there, if they were finishing in black and white, they used ink. Nobody did boards in pencil and just turned them in. If you were doing color, you needed your ink to hold the marker color that you were putting down. After working with you and finding out that you can take a nice pencil board and just keep it as clean as possible and then go ahead and just Xerox it, and then color the copy if you need color. You're maintaining a certain organic quality to the look of the art, which I think makes it look a lot more spontaneous and a lot fresher. So now I'd just as soon light-blue-pencil a layout first, which will not reproduce on a Xerox machine. Although you have to watch how heavy-handed you get with your blue-line pencil. As long as your lines are pretty light and you just pencil on top of them, you can make a nice, clean copy for presentation purposes, and you can do some nice work that way, by just keeping it as fresh as possible with a pencil look.

MS: Do you do any of your work on computers?

AS: I hate to say it, I don't do much more than scan my art in and adjust it. If I'm doing pencil, I can bump up the contrast, I can use some of the tools in there to clean up some line work, but basically I would say that's it. As far as color goes, I know that the computer is a great tool for color, but I still just work with markers.

MS: What supplies do you like to work with— what pens, what pencils, what markers?

AS: For a blue pencil I use the Col-erase medium blue pencil. I also use a mechanical pencil. I don't use the fancy $25 mechanical pencil. I'll go to Wal-Mart and buy three mechanical pencils for $5 or something and just use a 2B lead, which is not too soft, not too hard, but it will give you a good line, specifically for reproduction on a Xerox machine. I still draw the *Spider-Man* Sunday newspaper strip, and lately I haven't even been lightboxing those pages. I've just

been doing blue pencil straight on the board and going in with my 2B mechanical pencil and just drawing right on top of it.

Over the years I found that I've been using Chartpak markers. I enjoy the colors, I enjoy working with them. However, as time has gone by I've found that the smells, the turpentine or petroleum-based odors coming from those markers, are just enough to give you a big headache by the time you finish up a job. So I've switched my tools over to using the Prismacolors, which I believe are more alcohol based, and they still have a bit of an odor but they're not as strong as the Chartpak.

MS: What was your favorite storyboard project?

AS: I would have to try and look at that twofold: doing storyboards for advertising and doing them for film. If I could pinpoint one advertising job that was one of my favorites, coming from your studio was this little six- or eight-panel piece, which, for lack of anything else, we called Sam Spade. It was done in black-and-white line, and I colored it in a sort of sepia tone just to maintain some sort of film noire feel from the forties. And there was only one little panel on the back end of it where the product that we were trying

to deal with was on a computer screen in full color; everything else was done in this particular sepia tone. For as small as that job was, it had to be one of my favorites. In terms of film, the one that I worked on this year was a movie called *Lonely Hearts*, filmed here in Florida in Jacksonville. And the actors were John Travolta, James Gandolfini, and Selma Hayek.

The director's name was Todd Robinson, and he was noted for having written a film called *White Squall*, which was produced in the late '90s. Todd was the kind of director who was very passionate about what he was visualizing. He'd be walking around from point A to point B around the large office, just walking around showing camera angles, where he wants things done. That was a great experience, working with him, because I was literally feeding off that energy. One of the things I enjoy working in films is the fact that, first and foremost, instead of being in your own lonely studio, which is what I got accustomed to for the last 30 years, you find that you're all of a sudden thrown into this mix of people who are all focused on one objective, to make this movie the best possible film, regardless of what the budget is. And being surrounded by people who seem so energetic and supercharged, it was a pleasure to get

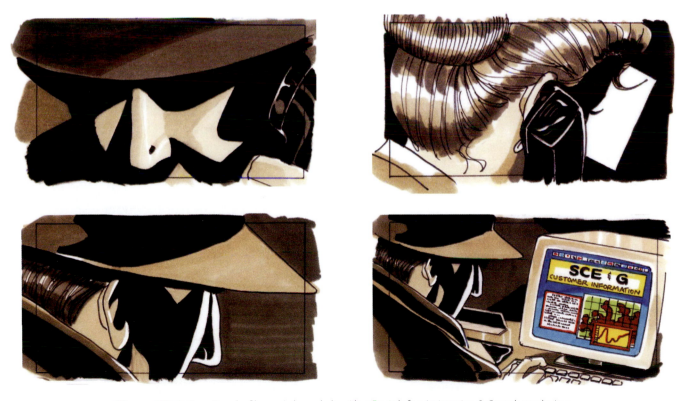

Figure 52.4 Sam Spade film noir boards by Alex Saviuk for Animatics & Storyboards, Inc.

up in the morning and look forward to going to work.

MS: Do you have any good war stories?

AS: Yes, I was working in Louisiana and the heat was terrible, and the movie *The Reaping* also got affected by hurricane Katrina at the end of summer 2005. The hurricane forced the production to evacuate from Louisiana to Austin, Texas, for about a week until power and conditions came back for them to be able to start working again. They had just started shooting as of August 15, 2005, and two weeks into the shooting schedule there was no power and some of the sets were almost completely wiped out and they had to wait for the water tables to go down because they were in the swamps. There was one particular set in New Orleans that was literally completely wiped out by the hurricane.

MS: How did they evacuate you guys?

AS: It's amazing when you've got a movie studio like Warner Brothers, who can make a phone call and charter a plane from the local, small Baton Rouge airport and be able to literally take 200+ people from a production site and put everybody on a plane and fly them out to Austin, Texas, and put us up in a wonderful Omni hotel. We stayed there for an entire week and just waited out Katrina.

MS: Have you ever worked any really crazy hours?

AS: The craziest job that I ever worked on was about 20 years ago. I got a freelance job to do for Benton and Bowles in New York City. They called me up on a weekday afternoon; it must have been 3:00 or 4:00 in the afternoon. They asked me if I could head into New York City for an after-dinner meeting. I got in there around 6:30 pm and I left the meeting by about 8:30, going home with 25 panels to do, 5″ × 7″ in full color, for a spot that they needed at 10:00 in the morning. I got home around 9:30 and it was about 10:00 by the time I got started, and I managed to get those 25 panels done at about 5:00 in the morning. I didn't get to sleep, but I did get to lay down and nap for about an hour, got up, took a shower, and headed into New York City via mass transit, because to travel in there by car at that hour would have been suicide. I was there for that 10:00 am meeting and I stuck around for a while and at around 12:00 to 12:30 they came out and said, "There are no changes to be done at the moment,

but there is going to be an addition to that particular job. And we'd like you to go ahead and work on it, but we won't have any particulars until 3:00 in the afternoon. If you want to lay down in one of our offices to take a bit of a nap, go ahead."

I took a nap, and they got me up at 3:00 and then I ended up staying the entire night, from 3:00 that afternoon to the following morning, when the creative director came in and said, "Gee, you're here bright and early. What happened?" And I told him that the art directors kept me there the entire evening because they kept coming up with new ideas and asking me to draw them. By the time I finished the job, I ended up doing only about 60 or 70 panels, but they paid me a fortune to do that work over the course of that 36-hour period where I didn't have a chance to sleep. They called up a limousine service to drive me back home. That was probably one of the worst but also one of the most lucrative experiences I've ever had in my life.

MS: What tricks of the trade do you have?

AS: I remember there was an old adage that Wally Wood, a famous cartoonist, had for everybody that was getting into the comic book business. I believe that it went something like this: "Never draw what you can copy, never copy what you can trace, never trace what you can lay down with a photograph." So if you think of it in those terms, use whatever reference you can find. If you need a car, you can trace it and put it into your storyboard.

MS: What is the hardest part of storyboarding?

AS: Two things: the first one being that the hardest part could be not having enough time to do something and still always meeting those deadlines. The other part is dealing with writers and even with directors. The fact is that they have their particular impression of what it is that they want you to convey, and you have to figure out what that is.

MS: What's your education?

AS: Primarily I am self-taught. I've been drawing a lot since I was a little kid. However, I did start college for pre-med. I started off and did about 2½ years of biology and math and chemistry and all that, and then I decided that I was going to become an artist as a career. I transferred over to the School of Visual Arts in New York City. I would say one of my biggest influences on my storytelling career and ability was working with and taking a class with a gentleman

named Will Eisner, who created a character called *The Spirit*, back in the 1940s. It was a newspaper strip, and in comic book circles he is considered one of the founding fathers in the comic book industry in terms of storytelling. Even though I had a certain sense of how I would tell a story, by taking that particular course with him for a year or two, I learned more from him than I learned from anybody else. I was also lucky enough to work with him last year on his last comic book before he passed away.

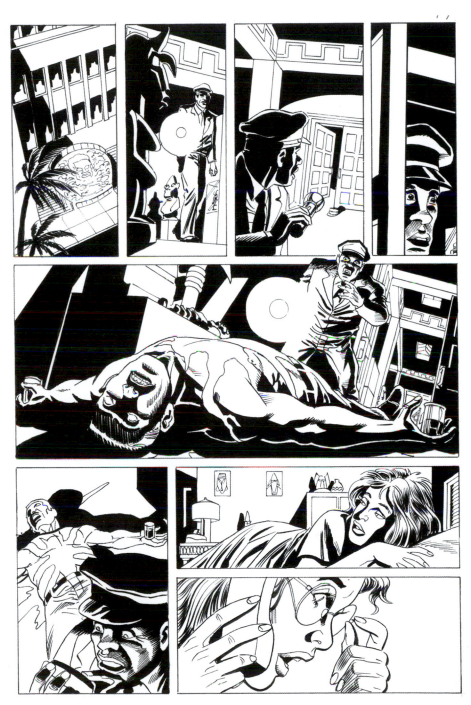

Figure 52.5 *The Phantom* comic page by Alex Saviuk. Published by Frew Publications Pty. Ltd. (The Phantom, © King Features Syndicate Inc, New York.)

Figure 52.6 *Full Flame* storyboard by Alex Saviuk of Animatics & Storyboards, Inc.

MS: So the education that you have, how has it been important to you?

AS: When it comes to education, I know some people think, "Why do I need this, why do I need that?" Every course of study that you take has its particular place. Having to take courses in anatomy, in illustration and composition, in color use and theory, are vital in order for you to keep going in your art career.

MS: Let's talk about speed: How many panels on average do you do? And how many have you been able to do?

AS: I recall over this one weekend they asked me to do an overtime situation. Normally you would have a weekend off when you're doing storyboarding for a film, especially if you're on vacation, but I had to storyboard a scene. I ended up doing 14 eight-panel pages over the course of two days, so I did 112 panels in about 18 hours over two days. I was probably doing then about eight panels in an hour.

MS: What about average numbers on a day, for black and white and for color?

AS: I would say on the average you would want to do at least three B&W panels in an hour, so if you've got an eight-hour day, there should be no reason why you shouldn't be able to do 24 black and whites in a day, 20 minutes a panel. As far as color goes, I find that it takes me longer to color a panel than it does to draw it.

It is hard for me to actually pinpoint how long it takes me to do a color board. If I'm doing 3″ × 4″ color panels, maybe I can do two in an hour, sometimes three. Usually I do the black-and-white artwork first, so I know how long that takes. Then I go ahead and form an assembly line of a coloring process where, if I'm doing a spot that has 12–15 panels in it and I have to deal with flesh tones, I'll lay all my sheets out on my drawing table. I'll just go in there and put in my first layer of flesh tones on all the faces, and then I'll go in there with my shadow, contrasting flesh tone color, and I'll go in there and put the shading in.

I'll just go ahead and take every color that I think is going to remain constant within that job and I'll just lay in all those colors. So if there is a character that has a blue shirt on, I'll lay that blue shirt in for the entire board; same thing if he's wearing brown pants.

MS: It may be hard for you to pinpoint time, but it's easy for me to say what a great time this has been. Thanks.

Mark Moore, Vice President and Senior Executive in Charge of Production at ILM and Former Storyboard Artist

Mark's credits as a storyboard artist include, among others, *The Hulk, Jurassic Park 3, Sleepy Hollow, Mighty Joe Young, Jumanji, A.I. Artificial Intelligence, Harry Potter and the Chamber of Secrets, Dragonheart, In the Mouth of Madness,* and *Star Trek Generations*.

MS: How did you get started storyboarding, Mark?

MM: I started in fine art, then graphic design, some architecture, then finally industrial design.

MS: What supplies do you use?

MM: I use Col-erase light blue pencils to begin with.

MS: Do you prefer finishes in pencils or inks?

MM: I prefer pencil, because of the constant revisions.

MS: What kinds of projects do you usually work on?

MM: Feature film special effects.

MS: What do you think are the most important qualities for a storyboard artist to have?

MM: The ability to draw *everything* in perspective and to draw quickly.

MS: How do you prefer to work with directors?

MM: I usually work by fax, which allows quick feedback time.

MS: Any good war stories?

MM: Try drawing the *USS Enterprise* from every conceivable angle!

MS: What sorts of references do you use?

MM: Usually model kits—looking through a wide-angle door lens.

MS: What books do you recommend to other artists?

MM: *The Art of Star Wars, Empire,* and *Jedi. The Making of Jurassic Park. How to Draw Comics the Marvel Way.*

MS: Do you use computers to assist you? Which programs do you use?

MM: Adobe Photoshop.

MS: Any helpful hints or tricks of the trade?

MM: Scanning rough sketches in, then cleaning them up in Adobe Photoshop.

MS: How do you like to work, thumbnails to sketches, blue pencil, etc.?

MM: Blue pencil first, then Berol 314, copy, then Berol Prismacolor markers, Prismacolor white pencil, and a little white-out.

Sean Cushing, Executive Producer at Pixel Liberation Front and Previz Specialist

Pixel Liberation Front is a previz and visual effects studio located in Venice, California. Founded in 1995, PLF pioneered the process of previsualization—recreating the physical production environment in 3D and animating the principal action of a sequence will in advance of shooting. In addition to previsualization, PLF has created and composited final 3D elements for feature films, television commercials, games, and music videos. Some of their credits include *Superman Returns*, *Zathura*, *Matrix Revolutions*, *The Ring*, *Sky Captain and the World of Tomorrow*, *The Brothers Grimm*, *Blade: Trinity*, *Van Helsing*, *The Bourne Supremacy*, *Elf*, *Pirates of the Caribbean*, and *I, Robot*, among others.

Figure 54.1 Sean Cushing.

MS: Good morning, Sean. How did Pixel Liberation Front get started?

CS: It started in New York back in '95 as a small shop focusing on any sort of animation. Basically it did commercial work for the most part. The owner of the company, Colin Green, worked initially out of the Berkshire Motion Picture Corp with Douglas Trumbal and did work on *Judge Dredd*. That was probably his first work in previz. Then he came out here in '97 to work on *Starship Troopers* doing previz. So that was pretty much the big launch.

MS: So how did the company move from New York to Los Angeles?

CS: *Starship Troopers* was based out here, and Colin realized that we needed to move out here if we wanted to compete for feature work.

MS: Unlike storyboards, when you only have to work with the director, with previz you have to work with the DP and others. Who else do you collaborate with, and in what way?

CS: Primarily we are under the visual effects umbrella. We work mostly with the visual effects supervisor. There have been shows where we have interfaced directly with the storyboard artist, which has been fun, but for the most part it's the visual effects supervisor and then the director in terms of the hierarchy of who we deal with.

MS: Do you set up calling out lenses as a part of previz on most of your projects?

CS: Yeah, a lot of the feature films require that we do some of the technical planning for them, so at that point all of the information gets passed to whatever department requires it. On certain shows we interface a lot with the stunt coordinator, and on other shows it's with the DP; on some shows it's with the video effects department. It just depends on what the shows needs are.

MS: Are storyboards usually done before you guys come in?

CS: It depends on the show, but they are primarily done first, and then we get them and we don't really interact so much with the storyboard artist. But on recent shows we've been working side by side with them, as they're being creative, which has been fun and really collaborative. We go through a lot of iterations quickly. And once the storyboard artist lays it out, it usually just stays in 3D. It's always a great launching point for us to do the work once it's been boarded.

MS: Do you use the storyboards to set up your budgets and estimates on time?

CS: Yes, totally. It's much more difficult to estimate how long or how complex a sequence is going to be if you don't have boards. You usually go by the number of shots, so having boards is helpful. We've done sequences without boards, and unless you have the director closely interacting with you it's very difficult to pull it off.

MS: Are all the boards you work with mostly hand-drawn? Have you worked with digital boards?

CS: Absolutely—they're all hand-drawn. I really haven't seen anybody do digital storyboards yet.

MS: When you're delivering assets both during production and at the end, in what format are you delivering? Printed CG boards? DVDs?

CS: There's a whole slew of things that we deliver. There's DVDs that have quick times for the production and the executives and editorial to view and work with. And there's 3D scenes in Maya and/or XSI that we deliver to the visual effects vendors. And then there're set diagrams for production.

Figure 54.2 Pixel Liberation Front logo.

MS: So they can import the 3D scenes into their systems?

CS: Yeah, they can continue to work directly from work we've done. That's what has worked best for us. We can hand off a scene, and their artist can continue to work from our scene 'cause we've already got the camera approved and the overall blocking approved, then they just want to refine it. It's not successful if they have to go through and completely reengineer the scene or start from scratch and try to match it—then there's some time that has been wasted. We try to make our scenes as clean as possible so that someone can just inherit it and continue to work from it. Then there're diagrams that we hand out to whatever crew needs it. If the DP wants the location of the camera, we provide start frame, end frame, overview camera, and various camera data so that they understand what the set up

is. The grips enjoy getting the diagrams just to get a sense of where to start.

MS: What software do you use?

CS: Softimage, Print 3D, XSI, Adobe After Effects for compositing for basic 2D work, then just basic Photoshop for all the textures.

MS: What different sorts of information are you giving production?

CS: It depends on the shoot. For instance, it could be basic camera data, such as how high the camera is, what the lenses are, or the degree of the tilts and pans. It could be as complex as motion control data that the motion control operators import directly into their rigs. Green screen stage planning, how big the green screen is, what you see, what's practical, what CG, and how it lines up. If there's a car chase, how fast the

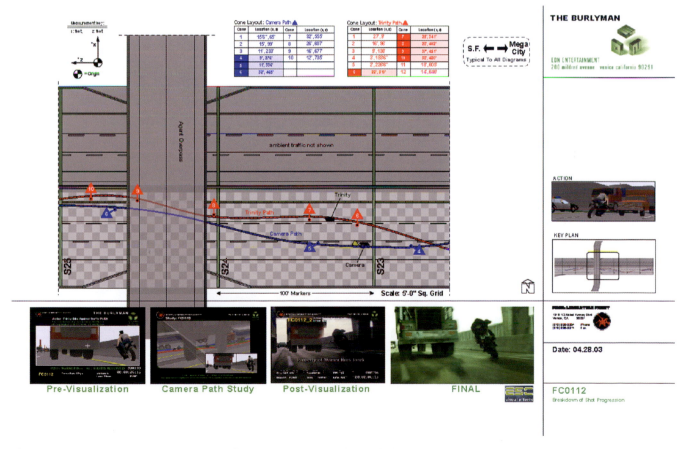

Figure 54.3 Breakdown and shot progress from *The Matrix*. Previz by Pixel Liberation Front. (© Warner Bros, all rights reserved. Images courtesy of Pixel Liberation Front.)

cars are moving, how fast the camera car is moving, how high the camera is in the camera car.

MS: Give me an idea of timelines for working on previz for projects such as *Superman Returns*. I know they're still shooting that movie. Are you still working on it?

CS: Yes, we're still on it. In fact it's been 12 months pretty much to the day. On big shows like that we have at least a small crew on through production to do technical planning and do any tweaks that they have. There are revisions that we're currently working on, but for the most part it's technical planning once production starts.

MS: How big are your crews?

CS: *Superman* is the biggest job that we've done so far that I'm aware of, and there were eight people here at our studio initially and in the low teens in Australia with the production.

MS: How do you make up for the time difference between here and Australia?

CS: We always send guys to where the production is. We never do a satellite setup. We tried it once and it didn't work very well. You have to have a humongous infrastructure to really pull it off. And even then it's difficult. It's imperative that the production allow us to go with the FX department or the director so that we can interface with databases. We have a full team down there, and we work with an Australian company for some of the staffing. We have a crew of about five or six guys down there now.

MS: What about *Zathura* or *Blade: Trinity*?

CS: On *Zathura*, we worked over at Sony because they shot here locally, which is cool. During the motion control shoot we had a team up in Van Nuys at the motion control stage. We move around where we're required. That was a team of four artists originally and then three at the motion control stage. It depends. On bigger shows we're looking at four to seven artists and on smaller shows like *Blade* usually around two artists. It really depends on the needs of production.

Figure 54.4 *Matrix Revolutions* previz and matching final shot. Final effects by ESC Visual Effects.
(© Warner Bros. All rights reserved. Images courtesy of Pixel Liberation Front.)

MS: Give me an idea of workflow on a project. How do you work with clients, and what input do you get from them?

CS: Let me use *Zathura* as an example. We get the script and then the first pass of storyboards, and we discuss what the needs are with the special effects supervisors, Joe Bower in this case. Then we go through and estimate how many sequences they want us to work on and how long that will take. Let's say there are three sequences. We usually have a lead artist and a few senior artists and a few junior artists. The lead artist determines who works on what sequence. We edit together the previz and do a rough pass and determine which shots are working and which aren't. We go back and do revisions and show the director, get the notes from the director, implement those notes, and do that process until the VFX supervisor and director are satisfied that the shots are ready for the shoot. Then we go through and do techno-planning for whatever shots they want. If they want all of them, we'll go through and do diagrams and layouts for each shot. Usually it's whichever shots are the most complex.

MS: How often do you guys end up doing the final effects in house?

CS: That's a recent development over the last couple of years. We're starting to do more and more finished work. We're not looking to become an enormous shop, but more and more clients have asked us, "Can you go ahead and do this sequence?" In *Superman Returns* we're doing some finish work. We're on a show called *Stay Alive*, where we're the only effects vendor. We've got about 100 shots. Kent Seki, our creative director, is the visual effects supervisor. That's a big deal for us. There's a lot of movies that are low end, with only about 30 to 50 shots in terms of VFX budgets. That's a good fit for us. Bigger movies with 900 shots sometimes have a sequence that has 15 shots in a stand-alone environment, which is something that we would go after. In the past it's paid dividends not to be a big shop, so we're not competing with the other vendors on the show. We're just doing previz. We're basically a resource for the entire production.

MS: What do you guys look for in previz artists?

CS: We look for somebody who is good with cameras, which is a rarity. I know some people say that they can do cameras because cameras are part of the software package. As far as creating cinematic cameras that will make it to the screen, it is a rare skill. It takes time to really hone that ability. That's what's fun about working with storyboard artists because that's their primary focus and we can talk the same language and get the best shots out of the process. We also look for generalists, people who are comfortable modeling, texturing, animating, rendering in some cases, low-grade compositing, people who can take on the entire process and don't specialize so much. In unique instances we'll bring on a character animator if it's intensive work, but for the most part we want someone who can take over a shot and be responsible for it.

MS: Do you care if they know your software?

CS: We prefer that they know XSI. The user base is obviously a smaller market in terms of the number of artists. But that number is changing. We're finding more young artists who are knowledgeable about XSI. There're artists working here now who were initially Maya artists who have trained to use XSI.

MS: When artists bring in stuff, do you want to see it on DVD or tape?

CS: DVD primarily. The other issue is a good attitude. Previz is rare in visual effects, in that you actually interface with the director and effects supervisor directly. There's no intermediary. They are usually over your shoulder or in a review and you have to talk about the work you've done. You need people who have social skills and can work in a group atmosphere and get along with everybody. I find that someone with a good attitude will usually win out over someone who may be super skilled at something. You can accommodate some deficiencies in skill set and they'll learn if they have a good attitude. We'd rather have fun working with somebody.

MS: Does education make a difference to you?

CS: Not so much. I've found a lot of our core staff are architects. I was a product designer. But we've had just as much success with someone who's never gone to college and has just done 3D his whole life, as we have with someone who's had three years of post-grad work in architecture. I've found that more experienced artists can do a better job in that. But for previz, if you've got the skills, I think it can be independent of what your schooling was.

MS: What do you recommend for artists who want to get into previz work?

CS: Well, storyboarding obviously helps. Anybody who is a storyboard artist and migrates into 3D will be an excellent previz artist. He is conscious of cameras and how shots work together.

I think another flaw in people who just do finished work is that they just focus on the shot; they don't think about how all these shots fit together to tell the story or make a compelling action sequence. If storyboard artists want to start learning 3D, that's a good path. If you want to be a previz artist, you really have to focus on previz and doing all of the things necessary to create the sequence. We get a lot of reels of guys who are just character animators who don't have much experience modeling or texturing or some guys who just rig. We want someone who can do it all and is comfortable doing everything, maybe not to a finished level, but can be competent in all aspects of 3D. More and more I'm starting to see artists in college from the Academy of Art or Full Sail or wherever who focus on previz as their thesis or as their primary focus through school and will come out with a previz reel. That's cool.

MS: You can thank DVDs for that.

CS: Exactly. People are learning what it is. Their stuff isn't polished, but it's great previz. That was a good comment about DVDs. Study them. There's previz all over them in action movies and special editions.

MS: How many people do you have working here?

CS: There are seven core staff and about 20 to 25 people. And we have a team in Australia and a team over at Sony and the team here.

MS: Where do you see previz going?

CS: Hard to say. I feel like the future of it is going to be driven more into finished work. Where and when you hand a file off to vendors will be a little bit more difficult to define in terms of how far you can take something quickly and hand it off. How much look development and animation development you do in the previz stage versus handing it off to a vendor to do. If you can do the work expeditiously in previz while you have the director and the visual

Figure 54.5 The Pixel Liberation Front studio in Venice, California.

effects supervisor and production designer around, it makes sense.

Real-time previz is going to be the next thing, where you can just create the environment and quickly do cameras without having to do nuanced animation where you have to go in and touch the characters or environment or cameras and basically fly through like a game. The director can pick out whatever's happening and capture that and then go through the next shot. I think real-time previz is probably the Holy Grail that we're all working toward, where you don't have to sit and capture.

MS: Thanks, Sean, for letting me capture your thoughts.

Josh Hayes, Director, Producer, Storyboard Artist, and Art Director

Josh Hayes has more than 15 years' experience in the worlds of marketing, advertising, media, and entertainment. He is the founder of Stormship Studios, an award-wining Boston-based print and multimedia design studio. As an art director and

Figure 55.1 Josh Hayes.

creative consultant he has worked with Warner Brothers, Walt Disney, Twentieth Century Fox, Columbia/TriStar, IBM and many others. Through joint ventures with various production companies and ad agencies he has helped develop promotional projects and media launches for the syndicated releases of the television series *Mad About You, The Nanny, ER,* and *Friends* as well as promos for *Fox Football,* the *X-Files,* and various Disney projects.

As an LA-based storyboard artist, Josh shares a close working relationship with many of the top directors in the industry, such as Lasse Hallstrom, Scott Hicks, Francois Girard, Rob Reiner, Michael Bay, Kinka Usher, Kevin Smith, Simon West, Jonathan Darby, Gary Fleder, Tommy Schlamme, Paris Barclay, Leslie Dektor, Jonathan David, and even Joe Pitka (once). Over the past 12 years he's storyboarded more than 2,500 commercials for clients such as Intel, Budweiser, Levis, Coke, Lexus, MasterCard, Ford, AT&T, Nike, Jack in the Box, Kellogg's, and American Express. He has also boarded numerous music videos and television shows, including episodes of *Clubhouse, The Bernie Mac Show, The West Wing, The X-Files, ER, Saving Grace,* and *Mad TV* and two full seasons of the ABC Superman series *Lois and Clark.* He has worked on films such as *Alex and Emma, Slow Burn, Cats and Dogs, Kiss the Girls,* and *Hush.*

Josh's storyboard work is represented by Storyboards, Inc., who introduced us for this interview.

MS: What kind of storyboards do you normally do?

JH: I work mostly on commercials, but I've also done five studio features and numerous television series.

MS: You've done a couple of hot television series too, like *Lois and Clark.*

JH: That's where I started, with *Lois and Clark.* Most TV shows don't need storyboards, but if they're using special effects or big action sequences then they'll lower themselves to doing so.

MS: How did you get started doing storyboards?

JH: I moved out to L.A. and I was an illustrator and graphic designer. I had my own studio in Boston, but I fell in love with a woman who was coming out here, a woman I'm still married to, and I didn't know exactly what to do. I had done some agency boards before, but I got hooked up on a movie called *Manasaurus* as an actor. I auditioned for a part as an actor but had on my acting resume that I did storyboards. They asked if I want to storyboard a movie, and I said OK. I worked on it for two months, got all the books I could find at the time on storyboarding, which in 1993 were not very many. *Shot by Shot* was the only book that really told me anything. It's a great book. I basically figured it out on my own. I worked two months for free, and they used the money to get some financing for the film, and I used it to get an agent. So that's how I got my first start in the business.

MS: When you are working, do you have a preference of styles? Some people start with blue-line, others like black line and lightbox. How do you like to work?

JH: I always work in either non-repro blue or purple. I did purple for a while because it was easier to see, but then it's harder to erase, so I went back to blue. So I start blue-lining and then I go work in pen and ink primarily. I do pencil occasionally, but mostly pen and ink. White-out is my friend.

MS: Do you do much work in Photoshop?

JH: Because everything is pretty much done over the Internet now, I scan everything and doctor things in Photoshop. I do all of my cutting and pasting now electronically, and any modifications I need to make I'll do in Photoshop.

MS: What about coloring? Do you scan your marker colors, or do you use Photoshop or some combo?

JH: I'm a recent convert to Photoshop. I've done color in Illustrator before and traditional with markers. In the last couple of months I've been completely going Photoshop.

MS: I find it slower than marker. What about you?

JH: It's a lot slower than marker. One of the first questions someone who doesn't know storyboarding will ask is "Aren't you going to be replaced by a computer?" And I say, "Not right away," because I can easily crank out a couple of spots a day or an action sequence in a day and I can add in, based on reference photos, the specific vehicles they need and the location that they're doing. And when you see something computer generated it seems a little more finished, and I think people get a little more nervous about that than a sketch. A sketch still leaves possibilities. But it would take weeks to program that into a computer. The advantage of the computer,

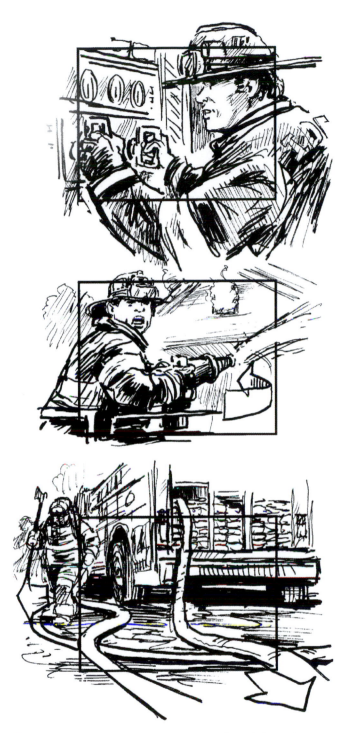

Figure 55.2 *Close to Home* TV series storyboards by Josh Hayes. (Courtesy of Warner Bros.)

though, is once it's in there it's a lot easier to edit than your own work. That's why I find when I work in color, if I lay things out properly in the various layers, changing anything is a lot easier.

MS: Do you mean clients actually change their mind?

JH: Ha, ha! Shockingly enough. TBS is doing a thing where they are talking about studying humor, and TBS is the place to go for great humor, which I boarded. They have a research lab to study humor, all fictitious. Originally I had John Cleese in a suit and the technicians and scientists in lab coats. I had to redo all the John Cleese drawings because they decided they wanted him in a lab coat, and I'm thinking, "Can't you use your imagination? But it's your money. OK. If you want to pay me to do that, fine and dandy."

MS: What was your favorite project?

JS: My favorite recent project was the *Project Green Light* feature last fall: *Feast*. That was a lot of fun. It was the first-time director, and the whole process was interesting. I like working with first-time directors and sort of helping them get their footing, and the circus/zoo atmosphere of having it videotaped just added a different layer to things. It was sort of funny to watch the combination of the creative process and reality TV.

MS: What's the best advice you can give to a new storyboard artist?

JH: Outside of the basics of "draw well," if you're going to draw anything well, draw people well. Other things can be forgiven. The big thing for me is that storyboarding is a business and you really need to treat it that way. Customer service is crucial. Part of the reason I work as much as I do is because, very early on, mainly because of my background owning my own design studio and having clients, I knew that how I treated them was at least as important as my work itself, if not more. That's served me well. I get a lot of repeat business, a lot of word-of-mouth business because of that. As a storyboard artist your job is not only to serve the director, but to also serve the producer and production managers and make their jobs easier. I develop formats for my storyboards that can easily go into production books. I often will find out from a production manager exactly what they need and I will do it for them, as opposed to them having to do it themselves.

MS: When you're working with directors, do you have a preference on how you work with them?

JH: Yes. Basically I bring a sketchpad and pen and I sit down with them, and as we're talking I do thumbnails while we're speaking. That's the way I

Figure 55.3 Action storyboards by Josh Hayes.

prefer to work. Most of the directors I work with choose me mainly because I watch a lot of movies and TV and will throw in ideas. Not all directors want that, but it seems to me that the ones that I work with, I'll say, "What about this shot instead?" They'll think about it and either tell me to stick it in my ear or they'll go along with the idea, or it will inspire a new idea from them. Being interactive is the part I really like. The creative brainstorming session in the beginning is the most fun.

MS: Do you ever go out on location?

JH: All the time. Oftentimes people will apologize for bringing me into a small space with little light. I've actually storyboarded in limousines, helicopters, on a boat. A couple of years ago I was hit by a car. I'm left-handed and I shattered my left shoulder. I used to have a huge kit, and in that kit I had everything I would ever need, like reference books. It weighed 35 or 40 pounds. After I broke my shoulder I got leaner and meaner and carried just the basics of what I needed and found I never needed anything more. I still carry a few reference books, but they fit in an easy over-the-shoulder satchel. A lot of guys now are bringing their own laptops and scanners with them, especially guys that are doing agency boards, because they really need to do that. I haven't done that yet just because I don't want to be that accessible. I like working at my own studio.

MS: What was the weirdest thing or the weirdest scene you had to storyboard?

JH: For the *Project Green Light* movie *Feast*, it was a horror film, and there are these creatures that are attacking these poor people who are in a bar. Basically, they're sort of held up in this bar during this one night with these creatures outside. If they step outside they're toast. And the creatures start infiltrating the bar. One of them is a small preteen beast and it finds a moose head on the wall and starts to have sex with it. I had to draw that. So that was pretty unusual.

MS: You got to love this industry.

JH: Yeah. And I did a lot of the Capital One commercials that have the Visigoths doing various things. So I had Visigoths running through malls and that sort of thing.

MS: Now, I'm assuming you're still working with an agent because you're represented by Storyboards, Inc. Do you also have clients of your own? Or do you do everything through them?

MS: When you're working with them, how does it work? Do they call you directly? How do you let them know what your schedule is?

JH: I check in with them daily. One of the complaints I often have with artists and actors is I never believe that it's up to my agent to get me a job, so I'm very proactive with my agent. I work with them in my own promotion. I keep in touch with them. I've sent things out to various big directors that I wanted to work with and let them know about that. Basically, daily I'll check in to see what my schedule is. The commercial world is a very good way to build up a client base very quickly. It's not as rewarding as working in film or television. TV for me is sort of halfway between. It doesn't take as long as a feature, and some of the shows I've worked on I'm very proud of because I love the shows and it's fun to get to be on the set and watch what's being done. They pay usually as well as commercials, but it's a shorter gig. In the commercial world it's very migratory. Producers are all hired guns usually, so if you do well by a director, the producer will remember you and the production manager will remember you as they go to other locations, and they'll bring you in.

MS: Give me an example of a schedule on a project.

JH: I will usually have a meeting with a director. If it's a director I've worked with a lot, sometimes those meetings will happen over the phone. But usually, for my comfort and the director's comfort, I like to be face to face and get a feel for them. On a commercial, you're usually working on multiple commercials. Rarely is it just one. I'll go and meet and sketch out the various spots for the director. Same thing for television. Features, you're usually meeting several times, you're just attacking a scene at a time or pieces of a scene. I'll do thumbnails for them right then and there and get a basic feel: "Is it like this?" "Yeah, it's basically like this."

I'll then go back to my studio and draw them out. I'll blue-line them first and ink them in. I lay out my pages in Quark Xpress, where I have a header at the top that tells people what the project is, who the agency is or the studio is, and who the director is and the production company. And one other thing I do at the bottom, which was not intended to be promotional but has worked out well for that, is my contact information, including my phone number, Storyboard, Inc.'s phone number, the date that the boards were generated, and the page number. That

Figure 55.4 Capital One commercial storyboard by Josh Hayes.

JH: I do everything through Storyboards, Inc. I have a good relationship with them. It a lot easier for me. Occasionally I'll take a job on the side, but very rarely.

has actually worked out very well, because lots of times those storyboards will go into a production book. And if somebody's picking up another production, oftentimes they'll look at the production beforehand, especially in a commercial production house, and they'll see who did the boards. And if they liked the boards, they'll call me directly. That works out pretty well.

Speed is of the utmost importance. That was the hardest thing for me to learn as a storyboard artist. I came from an illustration background and I used to do editorial illustration, so making things nice and beautiful, taking your time to do real research, you often don't have that luxury in storyboarding. On an average day I'll do somewhere between 15 and 50 frames.

MS: Black and white? Color?

JH: Black and white. And I work relatively small. I started by making big panels and got progressively smaller and smaller. Filling a larger box takes time.

MS: What's the time frame generally on a project for you? When you get a phone call, how long do you have before they want you there starting?

JH: With any luck it's at least the day before. And when you start getting busier and busier, people will start trying to book you in advance. I still get phone calls when I don't think I'm working that day and at 10:00 and Storyboards, Inc., calls, asking if I could be somewhere at 11:00. It is very fluid. I often work on weekends.

Somebody asked me once what storyboarding was like, and I said it's sort of like being a bartender and a fireman. The bartender part is that you're often with the inner sanctum of the director, in his private place, so you get to hear the good, the bad, and the ugly of how they're doing with regard to the production. Do they have a good handle on it? Are they nervous? Do they like the material, hate the material? And they'll often talk to you because it's that sort of intimacy. It's like a fireman because I have to be ready to go anywhere, anytime.

One thing that really bums me out about being a storyboard artist is that you don't get the opportunity to talk to other artists. I'm grateful for jobs where they need multiple artists. Through my agent we would introduce ourselves to the newbies by getting together once a month to get pizza and beer at our agent's office and sort of talk about things. But my big thing is how do you as a storyboard artist handle certain things, what gear do you use, what do you carry in your kit? Because all of us have certain things that we do well and things that we don't know, and

it's so great to get the chance to see somebody else solve the problems.

MS: What kind of inks do you use? Which white-out do you use? Do you use white-out pens?

JH: I use the Liquid Paper correction pen. Liquid Paper is the best one because you can actually draw over it. You have to use Sharpie pens at that point because other things will smudge. The other thing is the mini-correction pens. That's what I actually carry in my kit because they take up less space, but I use big ones at home. With regard to pens, I'm afraid to actually tell you anything that I'm using because invariably when I fall in love with a pen, it disappears.

MS: Oh, I hate that!

JH: Yeah. The mainstays are—I like the Rapidographs and the 01 setting, so that's my smallest tip. Then I use the Pilot Fine Liner as my mid weight, and then I use the Papermate Flair pen because it's got sort of a soft tip—that's my wider tip. Then I carry the markers that have the brush tips so that I could get thicker and thinner lines as I need them right from that. I carry the fatter Sharpies with me too and the

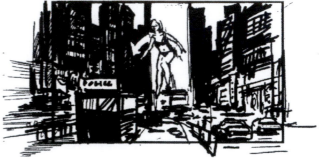

Figure 55.5 Storyboard by Josh Hayes.

razor Sharpies as well. The reason I use pen and ink was from the old days of fax machines; it translated a lot better than pencil did. That's how I got into that generally. I also like the boldness of it, and it sets my work a little bit apart from most of the artists.

MS: What's the hardest part about storyboarding for you?

JH: Seeing the image. In my 12 years as a storyboard artist there have been two days in particular that I just couldn't do the job because I couldn't see it. I ultimately finished the job, but what should have taken me three or four hours had taken me 10 or 12 because I just couldn't see the picture in my head. There are days when I feel like I'm painting with a ham. And sometimes you've got those days.

MS: Compare for me how important you feel the quality of art is versus the quality of telling a good story.

JH: I would have to say, as an artist, story is most important to me. But the practical reality of my experience in the world is getting it down, and getting it on time is the most important, image as opposed to story, and it doesn't have to be that good. You just have to be able to tell what it is, which doesn't always appeal to me. The most panels I've ever done in a day was for Dodge. It was a series of truck commercials. I had to do four spots in eight hours. It was something like a 150 images, and I did them in less than eight hours, so I was flying—and I never want to do that again. That was a clear case of just getting it down on paper. You could really tell what they were and some of the panels were actually quite nice, but most of them were just basic.

MS: Isn't it amazing, though, how you can get into a rhythm on those?

JH: Yes, exactly. What's also funny is that technology has allowed us to do certain things. I did

a color job and I was chosen because they wanted something really cinematic. But the time frame was so short that I ended up doing the drawings and the coloring was done by an artist in Spain. I would do the under drawings and e-mail them to him, because basically they were nine hours ahead. So at my 11:00 or 12:00 at night I would e-mail him the batch of work. I would go to sleep, I would wake up in the morning at 9:00 or 10:00 my time, and the boards would come back to me in color. And then I would tweak them and mess around with them, add my little personal touch, and then send them off to the client.

MS: What's your education?

JH: I have a Bachelors of Fine Arts in Illustration from the Massachusetts College of Art in Boston.

MS: How important is that to what you're doing now?

JH: Technically, not important at all. You don't need to be a schooled artist to be a storyboard artist. You need to draw well, you need to understand storytelling, and you need to know how to work with people. Art school for me really helped me explore different avenues creatively that I don't think I would have found on my own or not as quickly on my own. In that respect it was useful. Most of my skills are skills I've already learned in the field anyway as a designer and that sort of thing. I don't think it's a prerequisite for working as an artist.

MS: Have you ever even been asked whether you have an education?

JH: Never. One of the things that's helpful about being an artist as opposed to a CPA or a doctor is that no one has ever asked to see my diploma. They always ask to see my portfolio.

MS: And what we see here looks great. Thanks.

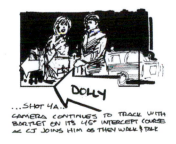
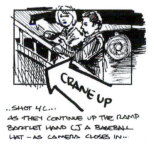
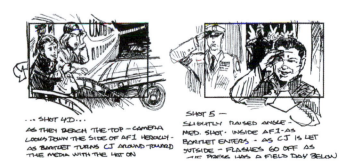

Figure 55.6 *The West Wing* storyboards by Josh Hayes.

CHAPTER 56

Tim Burgard, Storyboard Artist

Figure 56.1 Tim Burgard.

Tim Burgard is an illustrator/cartoonist. He specializes in drawing storyboards in a comic book style that comes out of working in comic books and animation jobs. He graduated from the Art Center College of Design in Pasadena in his home state of California. He learned useful things there, but in no job interview has he ever been asked whether he had a degree. He still has a child-hood love for dinosaurs and monsters that has taken him far ("Follow your bliss").

His years as a fencing instructor at Renaissance Pleasure Faires can also be considered a growth experi-ence. He's a member of two trade unions: the National Cartoonist Society and the Comic Art Professional Society (he is a past president). Tim's tried standup comedy, because an art career wasn't hard enough to make a living at. His feature film credits as a storyboard artist include *Terminator 2, Bewitched, The Day After Tomorrow, Scorpion King, Ali, Swordfish, The Patriot, Small Soldiers, Batman and Robin, Mars Attacks!*, and many others.

MS: How did you get started doing storyboards?

TB: Storyboards are sort of related to comic book stuff, and I sort of got into storyboards through animation through comic books. I first did some comic books for DC and Marvel, and one of my first jobs was assisting a fellow named Rick Hoberg, who was doing work for DC Comics. It's sort of funny, because there was a mentoring thing going on and Rick had had his own mentors too, and it's basically hiring people who you recognize have a little bit of talent and hiring them as assistants to help you speed things along. I got into animation through him by cleaning up his animation storyboards, by taking his blue-line roughs and making them a little bit more on model, more photocopy ready. You start working over enough storyboards, you start picking up how it's done.

MS: So what was your break into doing features?

TB: My very first job was a film called *The Class of 1999*, which at the time was supposed to take place in the future, and it was sort of a *Terminator* rip-off.

MS: So how did you end up landing that movie?

TB: Actually, at that time I was a freelance animation storyboard artist, and one of the freelancers I worked with, named Bud Lewis, had gotten me in touch with my first agent, Philip Mattel. And at that time it was a little easier to get movies that were non-union, direct-to-video kind of things. I did a bunch of

small non-union things, and some of them were bigger, like *Super Mario Brothers*, which started non-union and then was picked up by Disney. And I ended up working in North Carolina for a month, which was my first time working outside of the LA area.

As you pick up things, you start getting more and more references, people that have worked with you and like you, that kind of thing. The big turning point I guess would have to be *Stargate*, not only because that has been pretty good on my résumé, but it turned union. I had put in 30 days and it turned union after I had actually been working on it, which made me union eligible. And after that point I could work on any union film. So I started working a lot more on bigger pictures after that.

MS: So are you working on mostly features now? Or are you jumping back and forth with commercials? What are you keeping busy with?

TB: I do a lot of commercials. I tend to prefer movies because it's a little easier on my personal life. You put in the time for the movie, you know, the 9-to-5 kind of thing. But commercials are pretty much there all year round, and movies aren't technically seasonal but tend to be more seasonal.

MS: Are you still doing work outside of storyboarding?

TB: Oh yeah! I recently started doing a few more comic book projects, and about six months ago I worked on another animation project. There's a whole different culture in the animation business than when I was in it. They used to rely a lot on freelancers, and now they can get talent pretty cheap, so they want everything done in-house.

MS: Were you doing design or boarding on the animation?

TB: I did boarding this last time, but when I was in animation I used to do everything. I used to do character design, prop design, development artwork, and of course the storyboarding.

MS: I saw some of the stuff you did, like the Warner theme-park illustration. Do you get into a lot of illustrations, whether it's architectural or previz or set design?

TB: I do the occasional set design type of thing, but that is usually because quite often they put storyboard artists in with the art department, and if

Figure 56.2 Comic book page by Tim Burgard.

they don't have anything for you right there to work on as far as a storyboard goes, you're another pair of hands. I've done stuff for *The Patriot* and other films, like *The Scorpion King*—things like prop illustrations, backgrounds, and set illustration. That's not what they primarily hire me for. I'm capable of it, but I

don't particularly like it either, because I kind of like the storytelling side of it. Key frames are fine, larger illustrations just depicting one scene, not necessarily as a continuity thing. And you get to be a little more illustrative there and I pull out my color markers and whatever. I'm doing a lot more coloring in Photoshop

Figure 56.3 Theme-park illustration by Tim Burgard.

these days, but it's the same thing. I get to go in and do more developed artwork. That's always fun.

MS: What is the process of your work? Do you work in blue-line, ink, pencil?

TB: This may sound like a copout, but it honestly depends on the production and the director. Some directors don't require much as far as illustration; what they're more concerned about is speed. And there have been times where I would work on just a thumbnail size in pencil and that would be enough. It's all they want as long as it's clear and concise and they see inscriptions off to the side and they know what it is and they're happy with that. And other cases, where I'm given a little bit more time, I get more illustrational.

And a nice technique that I have used in the past is if I do thumbnails that I am pretty happy with, I'll blow them up on the copier. Or these days I might blow them up in the computer. And I would use them for a basic drawing on the lightbox. That's helpful too. If the director has seen the thumbnails and has

approved the thumbnails, then they're ready to go. Why redraw everything? So that speeds things up. But there are always changes. I'm working right now on *Underdog*, and the director literally drew all the storyboards himself. But he did them in very light pencil, and he did them very fast, so there're all kinds of drawing glitches and a couple of perspective problems. But in general he did a fairly good job.

MS: Do you find when a director boards out his own stuff that you have less input?

TB: There are some directors who know exactly what they want, and if I have a question about something and I don't understand what he's doing, then that might lead to a discussion. If it's very straightforward, then he knows what he wants and I'm not going to try and argue him out of it. And there are some directors that are very specific about certain points, but you have to put in continuity with the scene, so I have to fill in the gaps.

I work that way with Roland Emmerich quite a lot. He knows certain scenes he really wants and I just

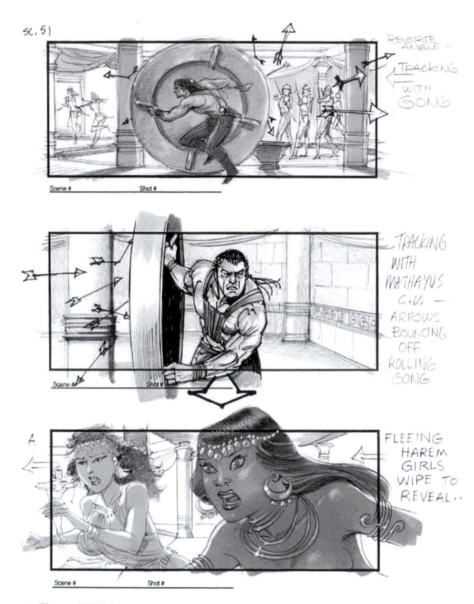

Figure 56.4 Scorpion King storyboards by Tim Burgard. (Courtesy of Universal Studios Licensing LLP. © 2001 Universal Studios.)

supply coverage, so it bridges everything. And with him working with screen direction and everything else, that gives him a basic working board. And that tends to be what a lot of directors like—having a backup to whatever they want to cover on the day of shoot. If I give them a particular setup, it's only one setup. There are probably dozens of different ways to cover it, but that one works, and so they always have something that works.

MS: What was your favorite project that you've worked on?

TB: I have to break that down into two things. One would be the project that I had most fun on while I was there, and the other would be projects that I think turned out the best, and those are totally different things. I had a lot of fun working in Australia recently working on *Son of the Mask*, which was a horrible movie! And I not only did storyboarding there but I did design work that actually showed up onscreen. They made statues and stuff based on my artwork. And it's really great seeing that up there. And you can print this, and I hope the director forgives me for it, but I had a blast working

SC.139
ext.Betty's
backyard

A

c.u. dog treats
& bottled water
on blanket.

B

WIDEN to
show Otis with
Venus in
romantic
setting.

C

SFX- Tim's
car screechs
to halt.
Otis reacts.

Figure 56.5 *Son of the Mask* boards by Tim Burgard. (© MMV, New Line Productions, Inc. All rights reserved. Courtesy of New Line Productions, Inc.)

there. It was one of those fun times, and I got to go see Australia.

Some movies where I didn't have a particularly good time, but I think turned out really well, are *Ali* and *Terminator 2*. And I guess sort of in the middle there is *The Patriot*, I guess. It turned out very well. I had a good time working on it, and it was a period piece, so I did people shooting muskets and playing with swords in costume, riding horses. And those movies don't come around that often.

MS: What is the best advice you can give new storyboard artists wanting to get into the industry?

TB: First of all, if I thought they had the talent, one of the things I would tell them is if they don't have representation I think they should get it. It's very, very tough if you're trying to break into it. And you have to have a lot of luck if you're trying to do it by yourself. It has happened. I know people who have done it, but somebody either has to champion you or really want to work with you, and maybe you can get your foot in the door that way. But it took a while for me to do it, and it took a lot of working on commercials and working on low-budget stuff, TV things, kind of at the edges and making contacts. The more people you know who recognize your talent, the

better chances you have of not only getting in the business, but staying in the business.

MS: How do you work with directors?

TB: Probably the best thing to do is to try and listen. I've almost gotten in trouble a couple of times by coming up with the ideas before I totally realized that the person really wanted to tell me his ideas. But if you want to talk about tricks or toys, it does really help to communicate visually with the director while you're there. Always have a pencil and paper and sketch something really quick if there is any kind of a discrepancy. Sometimes you're like a kid with the director, and he'll pull out a pencil too and start drawing with you. So, I communicate with people.

A director I really like right now, Dean Parisot, whom I worked with on *Fun with Dick and Jane,* we kind of communicate that way, half verbal, half drawing. He'll constantly apologize for not being able to draw well, but it helps me get into what he wants. Simple diagrams and elevations helps me get into what he wants very quickly. And I can do the same thing for him. And that is sort of what thumbnails are, very quick thumbnails—just to show him that I think I know what he's talking about.

MS: What was the weirdest or funniest scene you've ever had to board?

TB: Oh, that's easy. I worked on *Swordfish,* and the director at that time was negotiating with Halle Berry about a nude shot. At this time I was working on an elaborate chase scene that they were trying to see if they could do it on the Universal lot rather than on location. I get this call to go in and meet with the director. And what he wanted me to do was board the titty shots, because they were going to have a meeting with Halle Berry's representatives about how much coverage she was going to have, how long the titty shot is going to last, what angle we are going to be shooting at. It's kind of funny because I had pictures of Halle Berry but none of her breasts, and I had to sort of imagine them. And I could have been cruel and I could have been overindulgent, but I had to try and be restrained there. But later on I made cartoons for the crew and I let loose a little bit. But that's actually the weirdest storyboard I actually worked on.

MS: Give me an idea of what a typical schedule is during the day or during the week when you're working on a big project.

TB: Typical is changing. Typical used to be that I'd get on a movie and there would be someplace set up in some office for me to show up everyday. And I would be available for the director when he wanted to meet with me, and in the meantime I would work on whatever scene I was given. These days, a lot of times I'm working for companies that don't have office space for me, and they're just as happy having me work from home, like I am right now, and I'll set up a time to meet with the director to go over new stuff. I send in a lot of my stuff over the Internet, especially with commercials these days. I will work with companies on the other side of the country, and I'll go with the flow a little bit more and set up an FTP site, as opposed to sending everything as attachments on e-mails, which can be kind of a drag and a long process.

MS: Do you rough out big scenes first and then go back and fill in detail, or do you do each panel completely before you move on?

TB: I tend to rough things out, like I told you before about doing thumbnails. A lot of times I will just sit down and work from the script, or at meetings with the director I'll do thumbnails. I'll get all that done and then I'll blow them up. And I'll essentially clean up the drawings that way. I try to work fast when it comes to the storytelling because it has to flow, one scene has to go into the other. I tend to do the camera thinking kind of fast. When it comes down to doing the clean up, that's the fun stuff. That I can do fairly quickly, too.

MS: What kinds of supplies do you use? What kinds of pencils, what kinds of pens?

TB: I tend to be working mostly with F pencils. The actual brand doesn't matter to me so much, but the actual hardness does. F is not too hard; I can keep a point on it. Some people like a more painterly approach with their pencil and maybe work with a softer pencil. But the HB and F are about what I really like. F is a little bit harder than HB. And I do work a lot with Col-erase blue. There is just something about the feel of it, there is something satisfying about it. And, like Prismacolor, the lead is a little bit hard, so it's more controllable. I just like the look of it. And as far as other stuff, when I want to get into a little bit darker things, I work a lot with Sharpies. I tend to like the ultrafine points especially. I really love the Tria Letraset Illustrator black. It has a brush pen on the back and a regular felt-tip pen on the front, and the ink is the darkest black ink out there, other than Ad Marker superblack. Lately I've been doing stuff with those Tombo brush pens.

6 Amazons fighting guards in front of palace gates

AMAZONS AND ISIS NOTICES SOMETHING (MORE GUARDS)

O.T.S. AMAZONS,— more guards pour out of gates

Figure 56.6 *Scorpion King* storyboards by Tim Burgard. (Courtesy of Universal Studios Licensing LLLP. © Universal Studios.)

MS: You mentioned earlier that you're now getting into doing some coloring in Photoshop.

TB: Yeah. I used to be a marker guy, and there's something still visceral and fun about doing that. But I've been going from doing markers to doing markers and then scanning them and adding to it in Photoshop. And then I'm saying, "OK, well, other than the texture, what am I getting from the Ad Marker thing?" And I'm spending time in Photoshop anyway; I can probably get this coloring in there. And you're working in levels, so I can just go ahead and try things. And if I don't like it, I can just erase it. You can't do that with markers. If I threw a marker on something and I didn't like it, I'm screwed. I'd have to redo it or I'd have to live with it.

MS: What's the hardest part about story-boarding?

CAMERA TURNS AROUND LOKI, GETS CLOSER, INTO DOWN SHOT...

CAMERA TURNING/ PUSHING IN TO LOKI AS HIS HEAD AND FACE FORMS.

Figure 56.7 *Son of the Mask* storyboards by Tim Burgard. (© MMV, New Line Productions, Inc. All rights reserved. Courtesy of New Line Productions, Inc.)

TB: It could be time management, especially if you're freelance. For instance, I'm working on this one job now, and there are some difficult things about it and I'm not going through it as fast as I think I can. I'm on the honor system working here by myself and I have to produce. I have to put this stuff out even though it is taking me longer than it normally would. It's very detailed oriented. And dealing with that and driving to places and my personal life, you know—all of that together, time management is the hardest part of it. Job security might also be the other hard part. I forget about this because I've lived as a freelancer for such a long time. But you don't know how long you're going to be on a job when you get it. And sometimes I make decisions based on how long I think a job is going to last because I like to keep a steady

stream of work coming, but that really depends on what's out there.

MS: Compare for me your feelings on the quality of art and the quality of story.

TB: Personally I wouldn't feel right not doing the best drawing job I can on the work. But there are a lot of successful storyboard artists out there who are just strong story people, and they get their message across but they aren't necessarily the strongest draftsmen out there. So I would say that understanding story, understanding camera are the main things.

MS: What's your education?

TB: I have a Bachelor of Fine Arts from the Art Center College of Design in Pasadena, and I'm sure

you've heard this, but B.F.A. means B.F.D. You know, it's my life experience and where my interests have taken me that are the most important things. But I guess some things . . . like I really learned how to do markers and understand some other basic drawing things from classes I had at Art Center, so I think I owe them a bit for that.

MS: Have you ever even been asked about your education when you're going into a project?

TB: No, not at all. It's nowhere on my résumé. I include it on bios and stuff, but that's just because I've done it and I paid the tuition and I may as well get something out of it.

MS: What should someone look for in a college if they want to be a storyboard artist?

TB: For storyboarding they should look for something that has a film department because they're going to have to understand film storytelling. It's good to be able to draw people and cars and trucks and whatever. It actually helps to have a visual library in your head so that you can draw an approximation of almost anything without looking at reference. But you really need to know storytelling, especially when the director talks to you. He's talking to you in the language of film. He's going to be mentioning that you have a long lens shot here and you need to know what he's talking about, like if there's a dolly shot and you're going to be following him or if it is a crane shot. You have to understand all of that to be effective in this job. A little film history is pretty good, just to understand what good filmmaking is.

MS: Besides books and Google searches, are there any other type of reference sources you use?

TB: A lot of times you're provided with reference for a show; you should even ask for it. A lot of times those are the things that are picked by the production designer or the director. Say he's got an old-style fire truck; then it's better to use that than something you found somewhere else, like a brand spanking-new one. Other than what you need for quick jobs and such, you do actually use whatever the production company has for the reference.

MS: And you've given us a lot with your time and experience, too. Thanks.

CHAPTER 57

Woody Woodman, Animated Feature Film Storyboard Artist

Figure 57.1 Woody Woodman.

Woody Woodman is a professional storyteller and illustrator, trained in storyboarding at Disney, who is passionate about his craft. His credits on Disney animated feature films include *Mulan, Tarzan, The Emperor's New Groove, Lilo & Stitch, Treasure Planet,* and *Brother Bear.* Woody left Disney to create and develop a property called *Tugger, The Little Jeep Who Wanted to Fly,* a CGI animated film. He developed the characters and wrote, storyboarded, and directed the film.

At the time of this interview, Woody was developing original content for the studio Project Firefly and heading up story on a feature film out of Korea.

MS: How did you get started at Disney?

WW: I was a Ringling School of Art and Design graduate in Sarasota, Florida. I got a bachelor's in illustration, but I knew nothing about animation. Disney was hiring for *Mulan,* and the entry level was cleanup animation. So when I got there and they explained to me what I would be doing in cleanup, I just knew I made a big mistake and that I did not fit into that at all. But I did it and I stuck it out because of Chris Sanders and Dean DeBlois (directors of *Lilo & Stitch*). They were working on *Mulan* at the time and the walls were covered with their storyboards, and I realized that's what I needed to be doing, telling a story with my pictures. And so I worked very hard to break that glass ceiling out of cleanup and into story. It required a lot of banging on doors and meeting with directors and story people and doing a lot of story tests so you could put work in front of them, get input, and learn. It was still impossible—you just couldn't be seen.

MS: Did Disney give you these story tests?

WW: There were about three or four scenarios they had you work with: an old lady crossing the road, character 1 finds or discovers something and they have to do something with it. Character 1 comes over a hill and sees another character in the middle of something and then they have to deal with that situation. So they were very simple premises they gave you to work with and your job was basically to tell them a story with that basic scenario. That was a very difficult time; there really wasn't the right opportunity. Being in Orlando, they were looking at Orlando to be a self-sufficient studio, so the timing was right. They were developing *Brother Bear* and they were looking for a story team, and they could not bring anyone from California to Orlando—nobody wanted to go. The artists looked at Orlando as a one-shot deal, and

if they came out for a show they would be stranded here. Or if they left California, they might not get picked up for another show in California. So no one would come to Orlando.

So, anyway, they gave me an opportunity. They had a story review that had about 25 applicants. I got selected based on my test and was sent to California for six months to work on *Treasure Planet.* That was the first film I did, and so I learned a great deal. That's how I got into story. I went back to Orlando to work on *Brother Bear,* and that was it.

MS: What are the good and bad parts of boarding on a Disney feature?

WW: The good: You have all kinds of facilities and money and access to material and wonderful, talented people. You're completely surrounded by really talented people. Some of the bad things are more the structure in which they tell stories. They had at the time an executive branch who really were not storytellers, so you were always working on a story you didn't believe in or you thought wasn't going in the right direction. It was very difficult working in that sort of bureaucracy.

The other thing is, because it was so big and they had so many talented people, if you wanted to move ahead, it was very difficult in a big studio because you had to prove yourself. Sometimes to get ahead you had to back stab your fellow story people, and that was not a great environment to be in as well. It was very competitive. When you're working on a show and when the show starts to finish, you then had to be put on another show. Story is a little bit different that way than regular animators or cleanup people or effects or background or layout. Those other departments, a lot of time, stayed with production, and they would just move on to the next show. There is some degree of competitiveness in those fields as well. But in story, when you were on a show there was no guarantee that you would have a job after that show.

MS: When you were working story on *Brother Bear,* how long were you on that project?

WW: Just over a year.

MS: How many story artists were on that with you?

WW: That was a fun one. When I came on to *Bears* (the original title of *Brother Bear*), there were 13 story artists, and that's a lot.

MS: Did Aaron Blaise, one of the directors, do a lot of boards too?

WW: Yes, he did a great deal. He and Bob Walker, the codirector, were very active in the whole process. Whenever we sat down, because they were artists, if they didn't like a shot they would do a quick thumbnail and they could give you immediate notes. But going back to a big studio and that method, having thirteen story artists with thirteen different opinions and your two directors and a producer and also executives who would come in on meetings, and then if you brought writers in, that became a monster to get anything done. I do believe in having a single central person that really is the storyteller. Then the story team can come on and help visualize it. In most cases, story teams work better in groups of five. Any more than that and it starts to get a little convoluted and hard to keep continuity in the sequences and in the story meetings.

MS: Did you pitch your own sequences?

WW: Yes. You do pitch your own material. You would meet in story meetings with everybody if it was something to do with affecting the story or developing a sequence. When scenes were basically approved, which means we all agreed on it, a writer might have done a pass or not, and then the director would go to issue you (the story artist) your scenes. You would meet individually first, you and the directors and possibly a producer. They would talk about what needs to happen in the scene. If you were given pages, you would go through them for any changes and then you would do your first pass. Your first pass would be rough, but you would then pitch that back to the directors.

During that first pass—again, in a very small group it works better that way—you can all look at it visually and say; "I like this. This is working very well. Now flesh it out a bit more," and we would take any notes we had at that meeting. In the second pass you would then be pitching to the story team, potentially more people if executives wanted to sit in on the pitch. That way, now everybody can put their opinions back in and either tear it apart or strengthen it, hopefully. That's the process of doing the work and then getting up there and pitching it. So you get a sense of the timing and pacing of the scene.

Ultimately, when the scene is approved and everyone thought it was hunky dory, we would then bring the editorial people in and you would do an editorial pitch. Again, they are really looking at the pacing and the timing so that they editorially get a sense of the timing of the scene.

MS: I know in television animation, storyboard artists are often cast according to their ability to draw a specific style as well as their ability to tell a story. But in features I know that there is redesigning going on through the entire preproduction process. Is it important at all to be or try to draw on character in feature films?

WW: It is nowhere near what TV is. When they select their story team they will look at portfolios. They will usually look for a couple of things. They do want experienced people. The more experience they have from working on various shows, the producers know the artist can work well: They can take notes, they can turn things around quickly, and they're pretty confident in their job. But they're also looking for personalities. They usually want to cast a story team like you would cast anything, like a character cast for a sitcom. You want some "gag" guys; you want some people who could come up with some funny stuff. They want to have some dramatic people that can deal with the chase scene or an action scene, some crazy exploding planet or forest fire. They want people that can handle the touchy-feely tender moments, so if you need to jerk some tears from the audience you want to have somebody who can do that. And they want someone who can handle songs.

Certainly at Disney we do a lot of musical stuff, so we want someone who can handle working real abstract, sometimes without dialogue, and just working to music, having a sense of that kind of timing and that kind of abstract surreal visual stuff as well. So they get themselves a good cast. It's not that important to be on model. Any of the shows I worked on for features and story at Disney, no one really cared that from sequence to sequence the character looked the same. Every artist had his own kind of shorthand of the character so that some of the features would be recognizable, but I never saw anyone say, "Take that back, it's not on model."

MS: What are you boarding now?

WW: Actually, I'm boarding on a film. I don't know if I can release the name or not. I'll just say that it's a Korean project. It's an old, old story, a Chinese story, and I'm developing the story with the director. He lives in Korea and I'm here in the states and I'm boarding it. I'm head of story on that project, and

that's what keeps me busy most of the day and into the night.

MS: What's your process of working visually? Do you work blue-line, marker, or pen?

WW: I like working direct. I don't like anything to do with a blue pencil or pencils. That's just me. I like to work with a pen. To me I like to work direct so that it's more about whatever I'm thinking; the line gets down exactly what I'm thinking so that it has some expression. That's why cleanup animation was never my point because I didn't care about the volumes; I didn't care about being on model and all that. That's why I really chose to get into story, certainly at feature, because it allows me to draw very loose and expressive. So I work with a pen directly, and I'll use a Prismacolor pencil that is black.

At feature animation you do your rough pass very scribbly and very quick. Then when they want to do the story reel, they'll want to do a cleanup pass on the boards to show that it's not just a bunch of scribbly doodles. We would spend more time and really punch up the boards. I might put down some pastels if the scene required it and needed some subtlety, and I would spend more time on the drawings. Even then I pretty much work with a Prismacolor pencil or put down a little tone with my pastel.

MS: Would you lightbox it or redraw it completely?

Figure 57.2 *Tugger* storyboard of Shorty by Woody Woodman.

WW: I don't like lightbox at all, I really don't. This is just me personally. I don't know how layout guys can do that. When I was in cleanup it always bothered me to look through the drawing because there was a disconnect. Usually my brain is spending more time looking through to the underneath drawing instead of drawing the drawing on top. You know, sometimes you get that trace feel. It looks okay through the lightbox because, again, the drawing underneath had all the expression, and all the emotion is coming through, and you are putting another line or a darker line on top, and then you turn off the lightbox and it's, like, "Eeww! What happened? I've lost all my feeling.

MS: What kind of pens do you prefer?

WW: Oh, my gosh. Right now I have a Pilot Razor Point; it's an extra fine felt tip. Then I have another one that's a little fatter if I want a fatter line. And, I usually use a Prismacolor pencil because they're relatively available. My favorite pen of all time, because it was cheap and worked great, was a Schaeffer. The worst thing that happens when I fall in love with a pen or the ink or whatever tool you're drawing with, is when the company goes out of business or it becomes harder to get—you end up having to stockpile all those materials.

MS: Do you work digitally at all?

WW: Well, I am starting to a little bit. I'm trying to break in, but I really do like drawing on paper, the texture of the paper. I like the process, that's why I got into drawing. For me, I didn't like looking at the monitor, I didn't like drawing with the mouse. Now I've been learning it on the job and doing more of that sort of stuff. I'll do the line drawing freehand and scan it in to do the color digitally and that works really well.

MS: What was your favorite project in story?

WW: *Tugger* was my favorite and, of course, my most painful project, because it was taken away. In the beginning that really was the thing I always wanted to do, and why I wanted to get into story in the first place was to tell a story. Having the opportunity to create your own story and really tell a very personal story, something you feel passionate about, is the best. *Tugger* was a very personal story because I always wanted to tell a story about a chief. I'm an ex-Marine—the experience of drill instructors and combat. *Tugger* was a character (it was after the

Figure 57.3 *Tugger* concept art by Woody Woodman.

war), but I had a lot of those characters, and a lot of those characters were me and my life and my grandparents. It was very fun because I got to do everything. I got to develop the characters, develop the story, write the script and the storyboard for the entire film. That was great!

MS: What's the best advice you can give to a budding artist trying to break into story?

WW: One of the things is to really enjoy drawing. If they don't like drawing, then it's going to be a lot of work for them and they are not going to enjoy it. They should look at real life more than anything else. I tell people all the time, go out to the malls and restaurants and wherever they go and observe life, and then you draw it. Because it's your ability to observe real life and then put it in a drawing, an illustration, so that it's clear for someone else. So all those things from your real life you have to understand, and as a storyboard artist you have to be able to draw these things. I always say that if you are going to get into storyboarding, you have to be able to draw from real life.

It isn't like illustration, where you draw what you see in front of you. You draw the story. That's the difference. In storyboarding you have to draw the story, what's going on. People like Rockwell were able to do that, draw in such a way you could tell what was going on. You knew what happened just before that moment and you know what will happen next.

So when I start to break down my sequence—I will always break it down. I will break the sequence down to its basic components. I will find my major events,

and I will ask myself the same questions that I ask myself of the story. I say, "Who wants what in this scene? What happens if they don't get it? What's at stake? What are the obstacles?" If I understand that, the basic idea of the sequence, then in my drawings I will know what I'm moving into. I always tell people: Think before you draw. Think about what you're drawing. Think about what you're trying to tell. Answer a lot of questions to yourself before you get into the drawing. Then when you start thumbnailing you'll have a very clear idea of what you're searching for.

MS: How do you prefer to work with directors? Do you have specific things you like to do to get into their head?

WW: Ultimately, if you come on a new project, I would love the director to pitch me the story. If you can understand how the director is seeing the story and if the director understands the story, what he wants out of this story out of his characters, then you can relate to it.

MS: Can you briefly step through your process of developing story treatment and pitch?

WW: I think when you get into any story, you want to know who the story is about and what the characters are about. I think the character always drives the story. People always attach themselves to the character. They see themselves in the character, or they want to be like that character. I want to establish all the things about that character that will drive the story: What does the character want? What stands

Figure 57.4 *Tugger* beat board by Woody Woodman.

against him? What are his obstacles? What happens if he doesn't get it? What's at stake? And, of course, I might set up a villain or an antagonist or a situation that makes it impossible for him to get what he wants.

Those things will then give me my components and drive my story. If I understand my characters and I understand the cast and the chemistry of the cast, then I can start developing the story. Basically the beat board finds those basic events in the story that then can be put in a visual way to pitch it to somebody, whether it's an investor or a story person that's coming on the story team. I will then go in and write a real clear treatment of the story. Now that it's in written form, you can pass it to people, whether it's the future screenplay writers, an investor, or a story person. I like going from beat board to treatment to script because now I know my story—beginning, middle, and end. I have a good idea of what kind of business is going to happen in the sequences. Some dialogue is in there to get the tone and to get what's going on. It makes storyboarding easier.

So now I'm ready to begin my storyboarding phase. I'll take every sequence and treat it like I did the basic beat board. I will go in, break down the sequence, ask myself who wants what and what's at stake, and I'll start thumbnailing. I'll start coming up with doodles

that will illustrate my idea. Once I get the storyboards locked down, then we're ready to actually cut it into a reel and add sound effects and dialogue. You're really starting to build the movie at that point. That's really the process I like to use.

MS: You talked about beat boards and storyboards. What's the difference between them and process boards and color keys?

WW: Beat boards, to me, are more illustrative. I will draw a drawing that will communicate sometimes many ideas in that drawing, like I would do a children's book. The old guys at Disney would treat it like a children's book so that someone could—without even a pitch—could look at it and tell the story. They know the characters, they can see what's going on, they can see the humor, they can see the drama in the drawings.

Those drawings are very crucial to find those basic beats and then illustrate them. I think they're more effective when they're color—if I can indicate an art direction that's great. If not, I just want the story to be told. I want it to carry some emotion. It's a tone. If that moment's supposed to be sad, it has to be felt. I think color is a strong tool. I like the beat boards to be colorful and to be entertaining. That's the purpose of a beat board.

NOW!!!

.. TO BARBIQUE MY—

STEAMMM...

BANG!!

Figure 57.5 *Tugger* continuity (production) boards by Woody Woodman.

When you start doing the process boards, to me they're like a beat board, but color's not an issue. It's more about looking at the story boards and illustrations so that they're clear and I'm now starting to work out staging. I'm now going to limit the information per panel. I'm going to find those big, big images that will help to sell any given sequence. I could take process boards and I could cut it together, and the story gets another step clearer in terms of how you are setting things up. It's just beginning to get fleshed out.

When I get into my continuity boards, like for a story reel, then I'm really paying more attention to screen direction, to continuity in my cuts, so that everything transitions smoothly to the next drawing. I'm starting to get closer to making the film. It becomes more subtle and more details are piling on. So you can see from beat board process to continuity boards it's getting clearly fleshed out. I am adding details.

MS: So the last one is color keys?

WW: Color keys are a visual description of the movie in terms of its color and tone. I'm still looking at the movie's story sense. Usually you will have a very talented colorist that will understand the attributes of color. He'll understand how to work color together and he'll look at the story. He'll say, at this moment he's happy and joyful, so he'll work out a color palette for that moment. They do what we do in storyboarding in color. They'll get a color scheme for the entire movie; the entire movie will be bathed in gold and orange.

But at moments of the story it could be dramatically different: This moment will be real dark and gray and lack any color because he's lost his greatest point there in drama. I'll take the audience down visually with the color. Then I can dramatically raise him up, like I did in *Tugger*'s case, when he lost everything. He was bathed in blue; it was a very sad moment. There were hints of some gold when he would look outside at what was going on without him. I want to use color to visually show that, to tap into the audience emotionally. I'm not telling them anything verbally. I will do it with music, color, and the drawings.

With the color boards, I want to look at that like I do the continuity boards. I want to look at the entire movie in one stroke. Then I'll break down my sequences, like I would with the beat boards, to a color per sequence, a tone. Within that tone, there might be three or four colors that fit into an entire

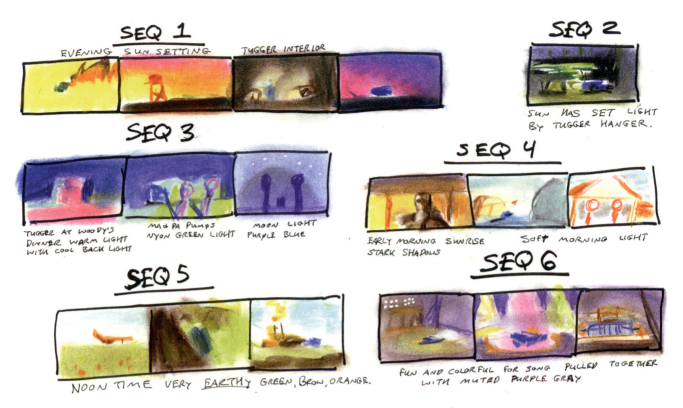

Figure 57.6 *Tugger* color keys by Woody Woodman.

movie scheme. In *Murder on the Orient Express*, the movie was black and red. The entire movie was black and red. The set designers and everyone that made that movie kept that in mind.

MS: When you're looking at a blank piece of paper, how do you motivate yourself and get into a scene?

WW: Good question! Every artist has his method. It usually starts with straightening bookshelves. (laughs) Really, I've heard that of many people, and I'm no different. Production managers don't want to hear that; they want to see you sit down at your desk and want you to work. Story artists don't usually work that way. You have a deadline, which is good. If artists didn't have deadlines they would get nothing done. When you begin, you look at the white piece of paper. There is a process that I use and I'll share.

I will have met with the director and hopefully I will have gotten a good idea of what he wants, and I have to excite myself. If I'm already excited and I already have some ideas, I'll immediately sit down and start doodling or just drawing things. If I don't know where to start, for example, this case with the Korean project, I'm not from China and I don't know what

these places look like; I'm from Michigan and Florida. So I would look at movies or illustration books that can give me some imagery.

Sometimes if you don't know where you're going creatively, you can't just dive into it, you know? You have to do some research, some legwork. I know I want to procrastinate; I want to fuss and think about it. So when I'm walking around or straightening bookshelves, I'm already thinking about my scenes. I run it through my head. I think everyone goes through that process.

With *Tugger* I would go to the airfield, I would take photographs, get reference, do drawings, just smell the place—oil and dirt and that kind of thing. Being around the environment in which I'm going to work is a great way to procrastinate. Yet you're still focused on taking in the material to do your sequence. At some point I want to start drawing. If I still can't get motivated to draw, then I want to write my sequence. Even if I'm given pages, I will write my sequence. Sometimes, in the wee hours of the morning, when you're working all night against a deadline, you can tap into things you can't sometimes at an office, in a cubicle.

I know a lot of people who like to wear headphones and play music. That motivates them and

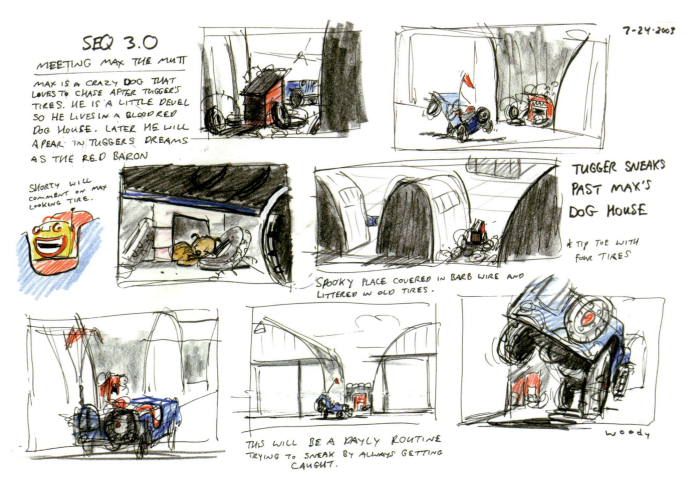

Figure 57.7 *Tugger* process boards by Woody Woodman.

that's fine. I don't typically. If I really know my scene and I'm having fun, sometimes I'll put on some music because I thoroughly understand my sequence. But in the beginning, when you're looking at that blank piece of paper, I can see why someone would put on some music that inspires them. And if it's a musical sequence, I will, because the musical notes will give you some inspiration and break down your sequence. But in most cases I don't. I don't listen to music; I don't listen to anything. I won't typically work with the TV or music on because I'm not internally thinking about the story. I want the story to come from internally. I usually turn things off so that I can just focus on what I need to do.

MS: Most storyboard artists have their own stories. How do you sell your original ideas?

WW: At some point you have to take a risk. If you want to go to a TV studio or whomever you're

pitching it to, set up a meeting and pitch it. You may have some kind of nondisclosure agreement, but they usually won't sign that. They may ask you to sign a submissions release form to protect their company. If you're willing to take that risk, and you seldom have the choice if you want to sell your show, your story should be presented in a way that can be understood. This is going back to the beat board. You have clear images of what your characters are, have a story. That's the way I like to pitch the story. I like to tell the story, because people, no matter how old they are, love to be told a story.

Some people will go with one image, a poster or something, and pitch the story. Me personally, I love to tell a story. If the story pitch is too long or has too many details, they will be bored and confused. The art of storytelling is always underestimated. If you go into a pitch, you should know your material very well. You shouldn't read it off a piece of paper. You're

going to be nervous, so prepare or practice, pitch it to your family or friends, get very comfortable with getting up and pitching the story.

When you walk into your executive room, you need to be well prepared. You should have your materials in front of you to clearly illustrate your story ideas. What you choose to leave behind is up to you, and it's nice to leave something behind. Anything you leave behind can be in the hands and eyes of people at that studio. They may like the character design or something on that image that sparks an interest. It's not an easy business.

MS: Speaking of learning about the process, have you ever been asked if you have an education?

WW: No. I don't think they care. The people in the educational industry care. But when productions are putting together a story team, they want experience. They want to look at your portfolio. They may be looking at style and they'll look at your credits: "You worked with this person or that director." They can pick up the phone and ask the director what they thought of Woody. Is he good? Did he help you? Is he a jerk? How is his personality? Those are crucial to getting picked up on a film.

The guy in Korea, he just looked at my work and some credits so that he got a sense of, oh, he worked for Disney, so that carries some clout and gets you picked up on a show. Your work usually gets you picked up on a show. It's not how many degrees you have or how many books you've read.

What I tell everyone is: Create projects for yourself, story tests. Give yourself realistic deadlines and work through that process, the process of being issued, going through all that procrastination and all that development and boarding them and then presenting it to someone. Getting familiar and getting confident in that process is what's going to save your butt, because if you ever get a job, whether it's in TV or feature, and you show up to work, they're going to treat you as an industry professional and say, "Here's your sequence." So you better be ready to do it. If you do well, your reputation will precede you' a poor reputation will precede you. That's in any job: If you do a good job, they will remember you and usually call you back.

MS: I'm sure you'll always be called back. Thank you very much for your time.

CHAPTER 58

Lyle Grant, Commercial Storyboard Artist

Lyle Grant was born in Thunder Bay, Ontario, in 1965. He graduated from the Alberta College of Art and Design in Calgary, Alberta, in 1989 and then spent six years as a freelance illustrator, followed by six years as an art director. He moved

Figure 58.1 Lyle Grant.

to Los Angeles in 2001. Having worked once through Storyboards, Inc., almost 10 years earlier, he dropped off his portfolio. Fortunately, they had called him back by the time he drove home.

Some of the world-class accounts he's been lucky to work on since 2001 include Mattel, Hot Wheels, Land Rover, Toyota, Miller Genuine Draft, Sony, Cadillac, Microsoft, Old Navy, Scrabble, Jaguar, Volkswagen, Red Lobster, Activision, IKEA, Sears, Lincoln, and Jack in the Box. He lives in Santa Monica with his wife and 1.5 children.

MS: Lyle, good to meet you. What kind of boards do you draw?

LG: I almost exclusively do advertising boards, and actually today I'm working on some Mattel Hot Wheels boards down in Irvine.

MS: When you say you do advertising, do you mean agency boards or production boards?

LG: Agency boards. I periodically do production work, but it's pretty infrequent for me.

MS: Do you do more black-and-white or color work?

LG: Well, it's seems like in the last couple of years it's gotten down to being a little bit more black-and-white work. And I don't know if it's just that companies are making their money go further, trying to sort of spread it out, or what. I still do half black and white and half color.

Figure 58.2 Agency board by Lyle Grant.

MS: Let's talk about your process when you're drawing boards. Do you start with regular pencil? Do you blue-line or lightbox?

LG: I guess when I first started working down here when I got out of college, back in 1989, I started using pencils, and I would draw it or trace it and lightbox it on Letraset paper with markers. But when I moved out here a few years ago, there was a big break when I wasn't actually doing storyboarding. I was working as an advertising art director. So when I moved here it was kind of like a fresh start and back to storyboard illustrating. All the people here blue-line, and for me to sort of seamlessly slip into the process, I just did whatever they were doing. It seemed like everyone I was working with blue-lined for their rough work and then traced over on tracing paper in black with black Prismacolor. And then they would photocopy it and add color with markers, but that's totally old-world technology now. Now almost everybody I work with exclusively works digitally for the color portion.

MS: Are you doing any Photoshop coloring?

LG: Yeah, I do. I still haul all my old markers and dyes around. It's about 50 pounds worth of stuff, but I never use them. I also have a shoulder bag with my laptop and my scanner and my Wacom tablet, and that is what I use exclusively now.

MS: Do you find doing the coloring in Photoshop is slower than doing the marker, or is it faster?

LG: I think at first it was slower. But I think that now, it's probably about the same amount of time. I think that I probably could get a better result faster if I did it in markers. And that's just me, personally.

MS: Not really. Every artist I've asked has said markers are faster!

LG: Yeah, I think it really is. And I don't know exactly what it is, because you're pulling caps off and on, blobbing dye on to cotton and tissues, and stuff like that.

MS: I think we're not being as accurate.

LG: That's exactly what it is. You don't have to lasso tool anything, and maybe you don't work into those edges quite as tightly. I have seen people working quite loosely on their digital coloring, and the effect is very similar to using paper and inks and markers, and it's similar looking and it's quick and it's got that layered look to it. But the style that I

Figure 58.3 Agency boards colored digitally by Lyle Grant.

probably work in is a little bit slower, depending on what I'm doing. But I think that the end result is—I think that nowadays the computers have made it so that people's expectations are higher in terms of being able to make alterations or to change things. It can be so much quicker on the computer not having to patch stuff or cut stuff out.

MS: The big question almost all artists like to ask other artists is what types of supplies they use? What types of pencils, what types of pens do you use? Besides Photoshop, what types of software do you use?

LG: Besides Photoshop, coming from an art directing background, I am familiar with Quark Xpress, which is a page layout program. I'm pretty adept at Adobe Illustrator, which I use for vector graphics. And it's really great for type treatments and logos and stuff like that, stuff that you're really going to want to scale in different applications. The Adobe Create Suite is the bundle of software that I use. I use Streamline once in a while. I sort of go back and forth on paper. I sometimes use tracing paper. But I guess, depending on my mood or the drawing, if I'm working on something with a lot of detail, I like

really, really smooth paper called Canson Calque Tracing Paper. I also like the Seth Cole medium tracing paper. It is a good, solid basic tracing paper. For pencils I use Prismacolors. Sometimes I don't have enough time to retrace something and I do my blue-lines reasonably tight with Prismacolor violet blue. I sometimes can scan that, and I can work my levels and I can darken it, and I can pump up the contrast and darken it, and then I don't have to trace over it again with black. But if I'm going to tidy it up, I just use Prismacolor black over the top of that as a second tracing.

I know some guys who do a lot of production work, they work in ink because they can get a nicer, high-contrast finish. But I just work mostly in Photoshop. And I find that with the Internet, people don't really fax anymore, so those things don't tend to be an issue as much. People just e-mail PDFs and people can see them on their screens or people can print them out, as opposed to photocopying things.

MS: I'm looking at some of your samples here from Storyboards, Inc., and I see a lot of vehicles, which are the bane of a lot of artists' existence. So what's your secret for drawing great cars?

Figure 58.4 Storyboard by Lyle Grant.

LG: That's funny. I was just working with another artist here yesterday and he was just saying how he had to work on some vehicles this weekend and I could tell he really didn't want to. I think with cars, it's just that some people don't really like laying down a really good perspective construction drawing underneath, and I think that might be part of the problem. I think you need a really good under-standing of basic perspective drawing. I think a lot of artists draw the human form and organically draw everything, so they don't ever really concentrate on those kinds of forms. I think it presents challenges, and I think aptitude and interest go hand in hand. So if you don't like drawing cars, you're not going to do it very well and you're not going to do it very often, and you're going to like it even less. Myself, I do actually like cars, so I do like drawing them. There's a lot of car accounts in L.A., for some. It's like half my work.

MS: What's been your favorite project that you've worked on?

LG: It's hard to pick one single commercial, but I really do like working on the Hot Wheels stuff. A couple of years ago there were some Hot Wheels RC toys and they were called Hot Poppers or something. It was a series of commercials that never actually made it to production, with this little doll that rode in all their RC cars. So it was this human head on this little doll's body and in these RC cars, all bouncing around, and I worked on it for probably around a couple of months—a couple days here, a week there. The ideas that the writer and the art director had come up with and the situations were quite funny and they were fun to draw. Kids' toys and stuff tend to be pretty fun.

Conversely, I've worked on some food stuff where it was literally a sequence where a hand came in and dunked a triangular-shaped taco chip into a bowl of salsa and then went to this mouth. And I was, like,"Man, I cannot believe that I actually have to board this." It was ridiculous and, really, it was pretty elaborately colored, and I was, like, "Man, this is so, so tiring." And it was just six frames. But it was boring, just coloring that same bowl of salsa in all six frames.

MS: When you were working on those commercial projects, are you charging by the panel, by the day, or by the week?

LG: You know, it kind of depends on the region. I know when I work for places on the East Coast, especially New York, it's a frame rate, but here (in California) it's a day rate.

MS: What is a day there, 8 or 10 hours?

LG: Well, I'm kind of a little bit generous with that. Depending on whether I think I worked really fast that day or if I think I just poked around. For me I'd let it go to like 9 working hours before I charged overtime. Sometimes 10 if I was really slow at something or having a tough time. But generally it's based on an 8-hour day.

MS: What about when clients work you through the night (which I'm sure never happens to you)?

LG: My wife always asks, "Are you the only guy who does this?" And I'm, like, "No. Everybody in this business works overnight. It's just the way it goes." It's like delivering the royal mail or something; it's just got to be done. But after 8 hours it's time and a half. The day rate can be broken down to an hourly rate. At night I would just charge overtime rate, which is time and half.

MS: What's the best advice you can give a new artist who wants to get into the field?

LG: I think the best thing is: steal. I like to watch what other people are doing. You always find some technique that somebody else is doing that you can borrow that will help you save time. You can see the way they draw one thing that is a weak spot in your

Figure 58.5 Storyboards by Lyle Grant.

repertoire, and you'll go, "Wow! I like the way that person has simplified that. I can really see how that works now." I don't mind borrowing. And think it's the type of industry that is about time and money and it's about getting the job done. I've learned a lot from other artists working here. That is why I like to work with other artists, because you get to see how they do stuff, and it can really help.

MS: Are multiple guys called out at once on certain projects?

LG: Yeah. Like today, there's a few of us working on basically the same series of spots, the same pitch. But we're all working on different commercials, and I think we're all working for different art directors, too.

MS: And you're on location?

LG: Yeah. I would say that split is at least 50/50 working at home or on location. But I think that work is slowly but surely working toward people just staying at home, working in their studios and using the Internet and the telephone to keep in contact.

MS: With the boards that you do for agencies, you're working with art directors and creative directors and not directors, correct?

LG: Yeah.

MS: So how do you work out the shots with them? Do you have any tricks to get into their heads? Or do they give you thumbnails? Give me an idea as to how you go about working with them.

LG: That really runs the gamut, because some art directors are really, really specific, and they give you thumbnails with the script and tons of reference and scrap. And you get a really good idea right out of the blocks as to what they want in each frame. It's like you're transcribing their shorthand. So I think that that can be quite easy. Then the other end of the spectrum is the art director who might give you a feel for something like "Here's the kind of photography we're going to use, and here's the script—read through it." They might say, "Try and do this in 10 frames or 6 frames."

MS: What size do you normally do your finished boards?

LG: I do all different sizes. I would say that the ones that I'm working on today are 5–7/8″ × 4¼″, and that is my normal frame size for doing advertising boards. I've worked on a couple little film pitches, and I used the widescreen aspect ratio and the frames are about 6″ long. A big-size frame for me would be 7″ wide by 5″ high. That is the largest I'd do a storyboard frame, depending on how tight time is and how many frames they want. I've got small ones that I usually use just for thumbnails that are 2″ × 3″. You can still tell the story in real tiny, little frames.

MS: Do you get into doing animatic illustration?

LG: Yeah. I'm actually going to be doing some animatic stuff this weekend. I worked on some animatic stuff about a month ago for an agency called Secret Weapon, and they do all the commercials for Activision. I was working on some spots for a video game called *Gun*, which plays off of the *Deadwood* theme. They were pretty fun, and they were pretty different than some of the other animatic stuff I've done.

MS: So what's been the weirdest thing you've had to board?

LG: The boards were for medical sales seminars. They were choreographing these medical sales seminars. They had a motivational speaker out onstage, and there was music and dancing and I think they had a live African drum team and also in-audience interviews and stuff. It was kind of a crazy thing to storyboard. It was extremely intricate choreographing of all these different elements onstage. The woman, who shall remain nameless, from some agency in New York gave me the direction for this over her cell phone while she was riding the train home.

MS: How did you end up getting associated with Storyboards, Inc.?

LG: When I was working as an art director back in Canada, in 1992, a production company came to shoot the Albertville Olympics commercials. So they came there to shoot them, and the director who was working on the project needed to get some boards done after he did his location scouting and hunted me down. I don't know who referred him to me, but I did some boards for him and he was, like, "You should come down to California and work. There's tons of boarding down there and there's lots of work. He kind of put the bug in my ear, and I was, like, "Yeah. I should go down there and do that."

Then I actually did come down here in about 1996 and showed my portfolio to Storyboards, Inc., and they weren't really interested. The reason that was given was that that they weren't that busy and they didn't need to add anybody. But in my mind that meant that if the work was better, they would have replaced someone on the crew with me. So I assumed that meant that the level of work wasn't good enough. So I went back about four years ago, when 9/11 happened. It didn't seem like a good time to go to New York, so we stayed here. And I went and saw them again, and they got me working right away.

MS: Do you work on getting your own work and do your own marketing?

LG: I don't. I think that there are people who are good at all aspects of being small businessmen, and I'm definitely not one of those people. I find it tiring enough just to do the drawing.

MS: Do you need to be part of a union?

LG: Not to do this kind of work.

MS: Give me an idea of your typical schedule. I know there's no real typical day, but tell me how you work your day, how long you work with directors versus how long you spend drawing and how many days a week you're working on things.

LG: We don't have any extended family here, so I'd say that right now my focus has been on work. I'm pretty much available all the time. I have my cell phone on me all the time, and I'm working this weekend. I tend to stay pretty busy, and I think for the next little while that's the plan, to keep my head down and work. Generally I work five days a week plus. I just sort of take as much work as I'm given, and I don't turn work down very often. It makes it complicated if you want to make plans outside of work. But normally I'd say my day gets going around 9 or 10 AM, depending on when and where I have to be, and will usually go until 7 or 8 PM. I bet that four or five nights a month I'm up until about 3:00 or 4:00 in the morning or work all night.

MS: What do you feel is the hardest part about storyboarding?

LG: I've had hard jobs, like when I was an art director I thought it was a demanding job. But I would say that this is probably the hardest job that I've ever done. I've done manual labor and all kinds of jobs, but I think that the level of intensity, sitting down and drawing all day, is quite mentally demanding, and I think that maybe people don't understand how demanding it is. I remember when I first started working doing storyboarding again and I worked three days in a row, long days, like 10-hour days or something, and I was so tired after that. I was so tired of drawing and thinking about drawing, I was amazed at how exhausting it was. I think that is a bit of a misconception: It's a talent. But I don't think it's so much talent as it's just desire and lots of hard work.

MS: What's your education?

LG: I have a four-year college education from the Alberta College of Art and Design up in Calgary, Alberta, Canada.

MS: Is your formal education important to what you do?

LG: Not at all. Well, I shouldn't say that. I think what I got was a really good basic aesthetic education, a really good understanding of commercial art and all the commercial arts: illustration and design and designing with type and using photography. And I think that all that was really important. Those are really good things to have in the bag coming into this industry. I don't think you have to have the art education, but I think it's one of those things like if you want to learn how to play the piano it's probably a good idea to go take some piano lessons.

MS: Have you ever even been asked if you have an education?

LG: No. Never. I think when I was working as an art director, that maybe played a bit more of a role when I got my first job as an art director. But other than that, once you're in the door, all they want to look at is your work. Really, it's just the product, and so nobody cares if you've got a sheepskin in your closet or hanging above your desk.

MS: Any other thoughts about storyboarding?

LG: It's an interesting job. I like it because it is a nice balance between being artistic and a trade. It's a trade because it's a skill set that everybody has, and you use the same tools and you just go out and do the job and you don't have to worry about inventing a reason to be. There's just this industry that exists that you're supplying a need to, and I kind of like that. It kind of takes some of the artistic pressure off. But there's still those times when you're working on a frame and, when you finish, you really like the way it turned out. It's just a storyboard frame, but there might be something about the way you captured something that you kind of enjoy.

MS: Well, I enjoyed your interview. Thanks.

Figure 58.6 Storyboards by Lyle Grant.

CHAPTER 59

Jeff Dates, Creative Director at Janimation

Janimation is a Dallas-based animation studio providing high-end game cinematics, feature film animation, commercials, and visual effects. Some of their credits include *Spy Kids 2*, *Spy Kids 3*, *Area 51*, and *Stranglehold* game trailers for Midway and the Chick-Fil-A cow commercials and calendars.

Figure 59.1 Jeff Dates.

MS: Last night I pulled up the trailer for *Stranglehold*. That rocks. It looks really great. What did you do on it?

JD: Basically I directed the cinematic for Janimation. My responsibility was to interact with our client, Midway, and make sure we were satisfying their needs for what they were wanting to promote. It was designed to be the title launch—meaning, they were announcing they were going to start the game and it was with John Woo. Woo didn't have a lot of input into the shots, other than he sort of blessed our shots. So everything we did went through him to make sure he liked it, but we didn't get a lot of feedback from him. But that's part of how it is. He's working more with the game elements. Midway came to us wanting us to do a launch and get people excited about the title. I've been such a big John Woo fan for as long as I can remember. We filmed a bunch of guys here acting out famous trademark John Woo scenes, and we cut it together to make the animatic for the trailer. It was sent to Midway, and Woo would comment on that, whether he wants this or that shot and if he liked it.

MS: Prior to your shooting your guys acting this out, did you storyboard it?

JD: Mostly we just shot a bunch of sequences, not knowing what we wanted to do. It was just a different approach. We could have storyboarded the whole thing. We just shot a bunch of stuff and cut it together. So we basically had a live version of the entire trailer cut together with DV footage. We just ran around the studio with handguns and ran around acting the fool. It allowed us to play with timings and

motion a lot faster than if we had done storyboards, which we do a lot. We wanted to just jump right in and have everything timed out, since we had a tight production schedule on this. We wanted to know how long it took for him to draw his gun or to kick open a door. We needed motion feedback as quickly as possible. Filming in DV was the fastest. We could actually get timing immediately, so we could get it all worked out.

MS: Let's talk about other games where you did storyboards.

JD: *Area 51* and *The Suffering*, both used extensive storyboarding. More thumbnailing on *Area 51*. For us storyboarding is a luxury if we have time to explore. In *Area 51* we did really quick storyboards, where it was thumbnailed out and sort of worked through. We never polished the storyboard to the next level because of our schedule. We would thumbnail them out and get them working and scan the thumbnails into the edit and cut it together to see the sequences we like. Then we go in and actually previz those storyboards in the computers really

Figure 59.3 Stills from DV reference video for *Stranglehold* animation.

Figure 59.2 *Stranglehold* video game cinematic frame by Janimation.

quickly with cylinders and spheres. We'd model these little sets and build it out quickly. The *I-Ninja* trailer we did a little more polished storyboarding. For us it's a luxury.

When you're in a real short turnaround, sometimes, for us, it's just better to jump in with both feet and work it out in previz. Some of the stuff that's not immediately apparent in storyboarding is how a camera is going to react and the timing of an action. If someone's delivering a line of dialogue or someone is going to walk across frame, timing that out in storyboards is kind of an ambiguous thing. You sort of do it and hope in animation that you gave yourself enough time. We're trying to lock the edit for our side as soon as possible. Doing it in previz we can see exactly how long it all takes a character to do his actions.

MS: Do you show your thumbnail boards to your clients, such as on *Area 51?*

JD: We did an animatic. Our storyboards were cut together with rough audio. These thumbnails were drawn with Sharpies. They were just iterations of iteration. The artists would be drawing while we were in a brainstorming section. Then we would take the ones we liked and would tack them onto a cork board. Then you break it all down—6″ × 6″ boards. They were able to be tacked up and taken down and order of sequences changed. Then would all be scanned in and cut together. And that first wave was shown to the client as a progression. That way if there was something they didn't like, they could raise the flag. Usually they would say OK and wait to see the next level.

Unless there are polished storyboards, sometimes it's hard for clients to visualize exactly what's going on, especially as rough as ours were. The boards were more of a communication tool for our team, not so much for our clients. We used the next stage to really flesh it out for the clients so that they could see the monsters and camera moves. Ideally we would love to have polished storyboards and cut out the elements and have multiplaning and fly around and experiment a lot more on the front side.

With the shorter turnarounds on these productions we'd rather spend our time on the back end, especially with how heavy some of the productions get. Try to get it in there and previz it in the editing while we're already using the previz elements, handing it off to the modelers so they know what the set is, since we've already prevized it and they can start building it out.

We've already prevized the cameras, so they're already working with the actual camera. It totally depends on the production.

MS: When you're roughing these out, is it you and the designers doing the boards?

JD: Our artists are all multitalented. So they are designers, storyboard artists, compositors. We have our main art director, Mark Moore. He is a dedicated storyboard artist and concept artist and designer. He was here and was doing storyboards. And we had a couple of our other artists assisting him as well.

MS: Are many of your projects the same as the John Woo piece, where you weren't given much direction?

JD: Each production is a little different. The *I-Ninja* trailer we did was completely concepted on our side. *The Suffering* one was completely concepted by the client. It depends on where you are in production. Some developers have very concrete ideas of what they want, and we just execute it. Others would have no idea and just want to see cool stuff, and we do that as well.

MS: Does it help to know anything about the game when you're working on it?

JD: Yeah. Absolutely. We learn as much about the game as we can. They usually don't have a game we can play at that point. *I-Ninja*, they had a bunch of game footage, so they gave us hours of their testing the game engine. So you could see the little guy running through the game engine so that you could get a feel for the levels. But we couldn't actually play the game. In fact we haven't played any of these because they've all been in development. We talk to the producer and we talk to the creative team and if we can get assets from their animators, we do. For *The Suffering* we got a lot of their monster assets and sort of uprezzed them for the production.

MS: You do lots of different things: shorts, gaming, commercials, and feature work. Are there any differences in the way you board for gaming versus any other sort of production?

JD: No. Storyboarding is storyboarding. It all comes down to cinematography and choreography of the action and where the viewer's eye is going to be led, how you're going to tell the story visually. The

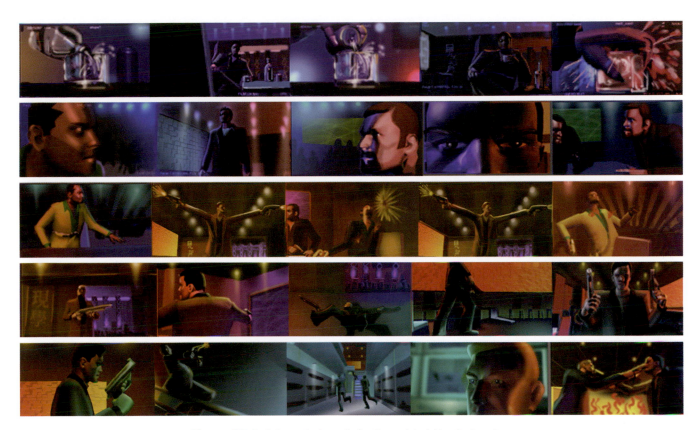

Figure 59.4 Color style boards for *Stranglehold* by Janimation.

rules are the same whether you're doing a 30-second commercial or a two-hour film. Mark Moore just storyboarded pretty much the entire production for the new *Texas Chainsaw Massacre* film, the prequel. He did something like over 500 boards for their sequences. The rules are exactly the same. You're just working out the action.

I guess it depends on the purpose of the boards. If you're doing a full CG production, the storyboards are, at least how we use them, they're sort of shorthand, so we can get into the computer as fast as possible. Since we're all digital and not using any live-action elements, we want to get into the computer as fast as possible so that you can start seeing what's happening. But in live-action stuff, there's no need to go into the computer, and storyboards are a lot more vital. But again, it's a luxury. If it was up to me my productions would have extensive storyboards brought into very elaborate animatics until it was rock solid.

There's the *Blind Fury* animated DVD that takes place in the timeline between the first Riddick film

and the big *Chronicles of Riddick* movie. They have an animatic on there that basically is verbatim the animation of the show. You could tell they did real extensive storyboards and they cut those storyboards into multiplane animatic and did this really elaborate animatic. I think that's the ideal way of doing it if you have that luxury of time. But if you have a 12-week production, how many weeks of storyboarding are you going to deal with? We just try to gobble up as much time for production as we can.

MS: Do you have any storyboarding tricks of the trade?

JD: Draw fast. Once you get on the computer you can copy and paste quite a bit. The way that we work is that we will thumbnail or rough them out, with the director there, real fast. He's talking to you like a storyteller. He's telling you what's happening. We have a bunch of guys at the table drawing what he's saying as fast as they can, and someone else is pinning those drawings up on a board. It's an incredibly fluid process. At any point you can back

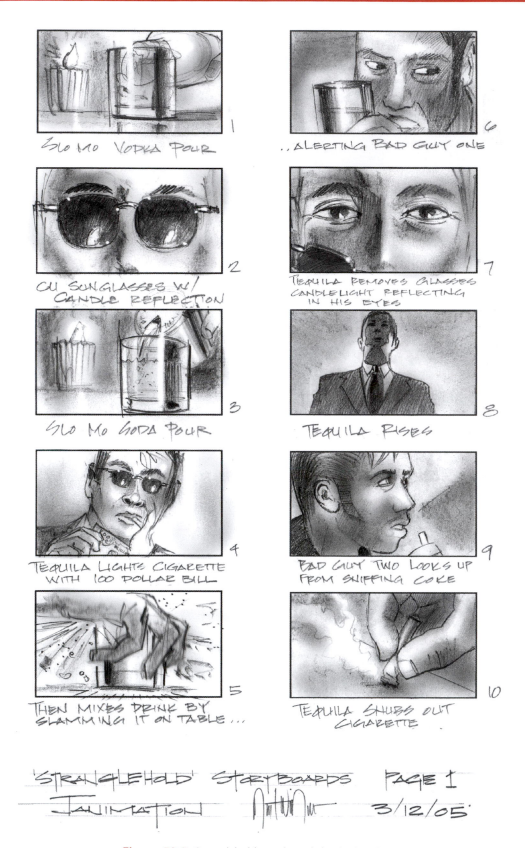

Figure 59.5 *Stranglehold* storyboards by Janimation.

up and say, "No, no! Let's change this." And you rip them down and you put up other ones. They're drawn real fast, with Sharpies or whatever, just to get the point across.

Once we have a first pass of that and we read through it and you like it, then you go back and you refine those storyboards and you make them tighter and more descriptive. Then you scan all those in and you cut it together. And sometimes it even goes back to another round of storyboards. It's just trying to get that storytelling flow working out.

MS: Any last comments for storyboard artists?

JD: You have to have an understanding of camerawork. Make sure that whoever comes behind you can read them and can interpret them correctly. I think storyboard artists themselves need to be kick-ass artists and have a good understanding of what visually you are trying to accomplish.

MS: Great advice, and that's a wrap. Thanks for your time, Jeff.

EXERCISES

The following exercises work great both in a classroom environment and for individuals wanting to build and enhance their portfolios. Some exercises are simple descriptions of actions. Others are setups designed to allow you to create your own actions and build your own story. Some are scripts, with and without shot breakdowns provided.

There are two ways to work with each of these exercises. You can work on it alone, do your own breakdowns, and storyboard it as if you were the director and storyboard artist. You can also, and I recommend this, let someone else direct an exercise for you to storyboard. This is the best way to gain experience on how to work with directors. Working with someone else to illustrate his or her vision is a different experience. Try this experiment with someone who knows how to direct, and it will be more beneficial for you. If you have a friend who also wants to learn storyboarding, you can direct each other.

Here are the biggest things to watch for in your storyboards exercises.

- Show proper screen direction.
- Illustrate enough panels to properly show the action in each scene.
- Vary your shots between close, medium, and wide shots.
- Allow your audience to see the spatial relationships among your characters in a wide shot.
- Don't use any fancy camera shots unless they are motivated.
- Don't be limited by the stories and scripts. As director you can make it as big as you want.
- Design exciting shots and angles.

Teachers, when you go over your students' storyboards, try reading through the boards and giving notes while projecting the boards so that everyone can learn from each other's work.

Artists, for practice try pitching your boards to friends. Pitching repeatedly also allows you to get a good feeling for any deficiencies in your boards. If there are any questions about your boards, go back and try to make them clearer, and then try your pitch again.

Good luck, and keep on drawing!

Exercise 1: Dogfight

Two flying planes, or flying vehicles, are having a dogfight. They are diving through canyons during the fight. As the front-running vehicle is hit and blows up, parts of it fly at, and past the camera, to scare the audience. Show the winning pilot's reaction.

How do you shoot this to enhance the feel of speed and peril in the fight? If it's a personal battle between the pilots, show their reactions during the fight. There are a number of opportunities for extreme close-ups to help tell this story.

Feel free to use toys, photos, illustrations, or other references when drawing your flying vehicles. You can use the references shown on the following figures or find some of your own.

Figure 60.1 Reference images of the F/A-18A jet plane.

Figure 60.2 Reference images of various propeller fighter planes.

Figure 60.3 Reference images of the B2 bomber.

Exercise 2: High Fall

A robot walks along a high balcony, or into a glass elevator, inside or outside of a hotel. A dark and mysterious figure follows and approaches the robot without his knowing it. All of a sudden, the robot is hit, or is thrown over the edge of the balcony, or through the glass wall of the elevator. He either grabs something on the way down or lands on something.

If you want this scene to be exciting, add reactions from bystanders and mysterious figure. If you want this scene also to be funny, have the robot look up, or sit up and say something corny like, "You can't keep a good robot down."

You have the opportunity here to design some exciting camera angles of the robot falling toward or away from camera.

- Determine how to make the mysterious figure mysterious.
- Are there any cutaways that would help tell your story?
- What else can you add to make this more interesting?

The sample images that follow can be used for reference, or you can design something completely different.

Figure 61.1 Sample hotel elevators.

Figure 61.2 Sample elevator interior.

Exercise 3: Outlines

What follows are some rough guidelines to get you started in developing your own short story or sequence. These outlines are meant to inspire creative story thinking. Add any amount of humor, angst, horror, drama, and action you want to make each sequence entertaining. You could storyboard the same outline many times and tell a different version each time.

The sequences here can be boarded as live action or animation, your choice. The biggest thing to remember is to have a good, solid ending, and enough shots to effectively tell your story.

1. A young boy has to climb a hill to find or rescue something. Is it urgent? Is it funny? What's his motivation to complete his task? What impedes his way? Is he reluctant? Does he have help? What is the item he searches for at the top?

2. We are at an adult baseball league game. The players are in various degrees of physical fitness. It's an intense competition and we're at the end of the game. What happens? Is there a personal battle between some players? Is there a distraction in the stands? Is there a home run, a strikeout, a base hit, a big play? What is the purpose of the scene? What is your ending?

3. Someone is sneaking into a dark house. They seem to be looking for something. Something surprising happens. Is it a funny surprise? Is it scary? Is there a series of events that lead to something bigger? Does the person find something, or does something find them?

4. A person parachutes out of an airplane. Does the person freefall for a while? Does the chute open right away? Does the character have a problem while falling? Do birds attack her or is she being shot at? Is the landing easy or rough? This is a great opportunity to use dynamic angles to show the person's decent.

5. A dog is chasing a cat through a department store. What funny and exciting elements can you add to the chase? What sequence of events can you design that build off of one another as they wreak havoc in the store? Are people also chasing them? Is it a mindless chase, or is the cat smart enough to make the dog cause more damage?

Exercise 4: Special Effects Matte Shots

Storyboards for special effects shots need more information than normal storyboards to be helpful to production. To be most effective, they need to have the effects broken down in each panel. Matte lines should be marked, CG images noted, live-action plates noted, green-screen or blue-screen elements noted, and any other elements noted that are important for production to know. You should also list the order of your composited layers (see Chapter 29, Special Effects).

On a real job, if you are not certain about how an effect should be achieved, don't make up notes. However, there are times when the special effects supervisor and director are involved with determining how certain shots should be produced. Make sure all the information you get from them is included on your boards so that they get communicated to the rest of production.

The example shown in Figure 63.1 is from an episode of *seaQuest DSV*. The *seaQuest* ship was in a battle against Neptune. We had a live-action actor playing Neptune, and he was interacting with the ship. Under the storyboard panel, notice how I broke down the elements of the shot for the crew.

Matte lines are the lines between live action and CG or miniature elements. For set extensions, this is the line where they connect. In a storyboard, it's important to show the matte line so that production knows which elements need to be produced and which elements are live action.

Storyboard and break down the following effects shots.

1. *Location enhancement*. Add a CG high-tech addition to an existing building in your area. Take some reference photos to work from. In your board, have a live-action element pass in front of your CG element, and have a CG vehicle pass behind your building.

 - Where are your matte lines?
 - Is there a camera move in the shot?
 - What is your background plate?
 - Do you have people walking by in the foreground? How will you film them if they need to pass in front of CG elements?
 - In what order are your elements composited?

2. *Futuristic traffic*. Design or find designs of futuristic vehicles. Find a street or highway location in your area. Your scene needs to show someone trying to cross this busy road. The person is live action, but all the vehicles are CG. Design three shots from different camera angles to show the actor trying to cross the road.

- You can have more than one layer of CG vehicles. Vehicles in front of your actor are on a different layer than those behind your actor.
- Is your actor shot on the background plate or on a green screen? Green screen is really only needed when CG elements have to be composited behind the actor. (Note: Use a portable green or blue screen on location. That way the camera lens, camera angle, and lighting all perfectly match the location footage. It's also cheaper, since you don't have to rent and light a green screen on a stage.)
- Do your vehicles go behind other elements in your background plate?
- In what order are your elements composited?

3. *Destruction*. Plan three to five shots of a monster in a downtown area. It's throwing cars all around, into buildings, onto people, out of frame, and toward the camera. You design the type of monster and exactly what the action is.

- Do you show people in peril?
- Are there CG set extensions?
- Is the monster a live-action outfit, live-action on blue screen, or CG?
- Is the monster supposed to be huge? If so, make sure your shots look up to emphasize its height.
- Are the vehicles being thrown around live-action effects, CG, or a combination of both?
- How are you going to show the destruction? Set pieces? Practical effects? CG? Miniatures? A combination of effects?
- Are any people shot on blue screen?
- Are virtual actors needed?
- Where are your matte lines?
- In what order are your elements composited?

There is no one right answer, but there are lots of wrong ones. Work with experienced people to help determine the best ways to shoot your concepts.

Figure 63.1 One of the Neptune storyboards and a still frame from *seaQuest DSV*.

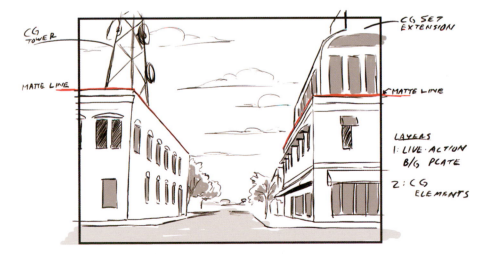

Figure 63.2 Storyboard showing matte lines.

Exercise 5: TV Western

You will board out Scenes 1 to 5. Scenes 1, 3, and 5 take place in a Western town. Scenes 2 and 4 are in a movie theater. The character sitting in the movie theater imagines himself as one of the Western characters in the movie he's watching and sees himself on the screen. Your boards must show how the shots should be edited between the Western scenes and the theater scenes to be the most fluid and effective. It is also important to show why and how the lead character in the Western all of a sudden looks like our movie-watcher.

Your boards should be around 38 panels long for these five scenes. This is not to say that you have to have exactly 38 drawings, but it is to let you know that if you have only drawn 20, you have left out a lot of visual information. Illustrating some motions may also take more than one panel to draw. For example, in Scene 1 the shot of the saloon doors and Lash flying through them and toward the camera should be at least three panels. Everyone's boarded version will be a little different. There is no one right answer.

An example set of boards is provided for these scenes. You should refrain from looking at them until you've tried to board the sequence on your own.

Now Showing

Written by Jenni Gold (All rights reserved.)

Note: All scenes are color except those designated as black and white by B&W.

```
1      EXT. WESTERN SALOON—NIGHT—B&W                    1

       The swinging doors of the saloon fly open as LASH, a
       handsome cowboy, falls into the street. He is
       pursued by a drunken desperado named LUTHER. The
       townspeople anticipate the upcoming violence. Luther
       towers over Lash.

                         LUTHER
               Get up, you yellow-belly son of
               a sow.

       Lash wipes the blood off of his mouth and slowly
       gets up.
```

> LASH
> Look, Luther, I don't need no trouble
> here.
>
> LUTHER
> Well, you got trouble mister.
>
> LASH
> Just take yo-self on home and sleep
> off the whiskey before I have to hurt
> you.
>
> LUTHER
> I'm gonna show you a world of hurt.
> Now, draw.

The steely eyes of the weathered desperado squint. A hand twitches as it hovers over a six-shooter.

2 INT. MOVIE THEATER—DAY 2

A man's hand slowly reaches into a bag of popcorn. Although LARRY MILLS is transfixed by the action on the silver screen, he manages to get the popcorn into his mouth. Larry is wearing a long-sleeved white shirt, with a bow tie loosely hanging around his collar.

3 EXT. WESTERN STREET—NIGHT—B&W 3

Lash and Luther study each other as they await the optimum moment to reach for their guns.

4 INT. MOVIE THEATER—DAY 4

Larry stares at the screen.

> LASH (O.S.)
> I don't think you wanna do this,
> Luther.

Larry's lip movements are synchronous with Lash's off-screen dialogue.

5 EXT. WESTERN STREET—NIGHT—B&W 5

(Now Larry Mills, the audience spectator, becomes Lash, the character, and is dressed in Lash's clothes.)

Hiding on a nearby hotel's roof, there is a COWBOY aiming a rifle directly at Lash/Larry. Luther draws his gun first, but Lash/Larry is quicker. Shots RING out. Luther keels over and lies motionless in the dusty street. The cowboy on the roof cocks his weapon. Instinctively, Lash/Larry ducks and spins around toward the hotel. The cowboy on the roof narrowly misses his target, thus allowing Lash/Larry a chance to shoot back. Lash/Larry fires and the cowboy falls to the ground in a twisted heap. Lash/Larry picks his hat up, shakes off the dust, and walks to the saloon and enters.

DISSOLVE TO:

Director's Notes

"The character in the movie theater, Larry, makes faces while watching the movie, mimicking the characters on the screen. Larry is alone in the theater, and the shots should have a lonely feeling to them. When Larry steps into Lash's part in the movie, his actions should be over-amplified. Make sure that you show a few close shots of Lash before Larry steps into his role. The first shot of Larry as Lash should be a close-up so that the viewing audience realizes what has happened. This transformation should take place right after a close-up of Larry in the theater.

"The horse should be tan, with some mottling in its coat. The drunken cowboy, Luther, is wearing a stupid-looking floppy hat that is sitting far back on his head of receding hair. The hat has a wide brim that is flipped up in front. Luther's gun belt is worn loose and low. Luther also has a scruffy mustache and beard. Lash, the hero, is very clean, except for the dirt on him from his fall into the street; he is clean-cut and his gun is chrome. There should be at least one good close-up of the chrome gun. He is NOT wearing fringe, but his outfit is slick. Lash's outfit is white and tan, to contrast with Luther's darker clothes. The townspeople come out of the saloon to watch what is happening. There should be no less than 12 extras.

"The cowboy who gets shot on the roof needs to land on something that is breakaway, made to easily break into pieces, and can hide a stunt pad inside or beneath it. The stunt pad is to protect the actor from the high fall."

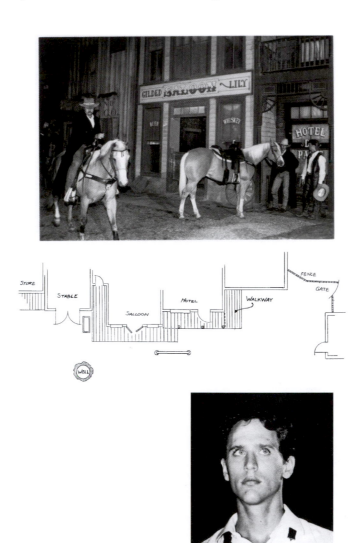

Figure 64.1 Western location on the back lot at Universal Studios Escape in Florida. The bottom image is our star, Larry.

Shot-by-Shot Description

SCENE 1

Start on a shot of the saloon doors filling the frame. Lash comes flying out of the saloon and right into the camera lens. As his face fills the frame we cut to the reverse angle to see a close-up of the back of Lash's head as he flies away from the camera and onto the road.

Medium shot of Lash on the ground as he looks over his left shoulder back toward the saloon.

Low angle looking up at a medium shot of Luther coming out of saloon. Luther stops in the doorway, with his hands on the swinging doors.

Wide shot of the townspeople gathering in the street.

Camera is low behind Lash.

Over-the-shoulder (OTS) of Luther approaching Lash. Tilt up on Luther as he approaches, and keep Lash's head and right shoulder in frame.

Luther's point-of-view (POV) of Lash getting up. This is a medium shot looking down at Lash and tilting up with him as he stands. Lash is wiping blood off his mouth as he stands.

Head on close-up (CU) of Luther.

Medium-close shot of Lash, Luther's POV. Lash is pointing at Luther.

Extreme close-up of Luther's eyes.

Close-up of Luther's right hand twitching over his gun.

SCENE 2

Close-up of a man's hand slowly reaching into a bag of popcorn. This is a matching cut from Luther's hand over his gun. (Both hands are placed the same way in the shots: same size, same position.)

Medium close-up of Larry watching a movie screen as his hand moves up into frame with popcorn in it. We are in front of Larry and he is looking just off camera left at a screen we can't see.

SCENE 3

Camera is looking over Luther's left shoulder in a medium-full shot (head to knees) of Lash. Camera slowly moves clockwise around the men until the shot is looking over Lash's shoulder looking at Luther.

Close-up of Lash looking from camera left to camera right as he starts his next line. Camera is just off to Lash's right.

SCENE 4

Close-up of Larry as he lip-syncs with Lash. Shot is framed exactly like the last one of Lash, except Larry is looking from right to left.

SCENE 5

Close-up of Lash, but now he looks like Larry—and will for the rest of this scene. Shot is framed like the last two, but we are off to Lash/Larry's right and we are a little wider. Lash looks to his right, away from Luther.

Lash's POV of a man on the hotel roof aiming a rifle at Lash.

Wide shot.

Medium shot of Luther drawing his gun.

Wider than a full shot of Lash as he draws and shoots. We are behind Luther and to his left. Luther is in frame on camera right.

Extreme close-up of Lash's gun barrel, with bullet and smoke coming out of it.

Full shot of Luther keeling over and falling toward camera. We cut just as he hits the ground in a puff of dust.

Wide shot of Lash as a bullet hits the ground beside his leg.

Lash's POV of man on the roof cocking his rifle.

Medium shot of Lash dropping to his right side and firing at the man on the roof.

Wide shot of man falling off the roof and landing on some crates below that are in a wagon. The crates crumble as he goes through them, and dust and chicken feathers fly everywhere. We follow the man down as he falls.

Medium shot of Lash. We follow with him as he stands and brushes off the dust. We are looking at him from just off his right.

Three-quarter shot behind Lash as he looks from the two fallen men over to the saloon and he starts walking to the saloon. This is a static shot, a little wider than full.

The following figures show sample storyboards for *Now Showing*.
Boards by Mark Simon and B. C. Woodson.

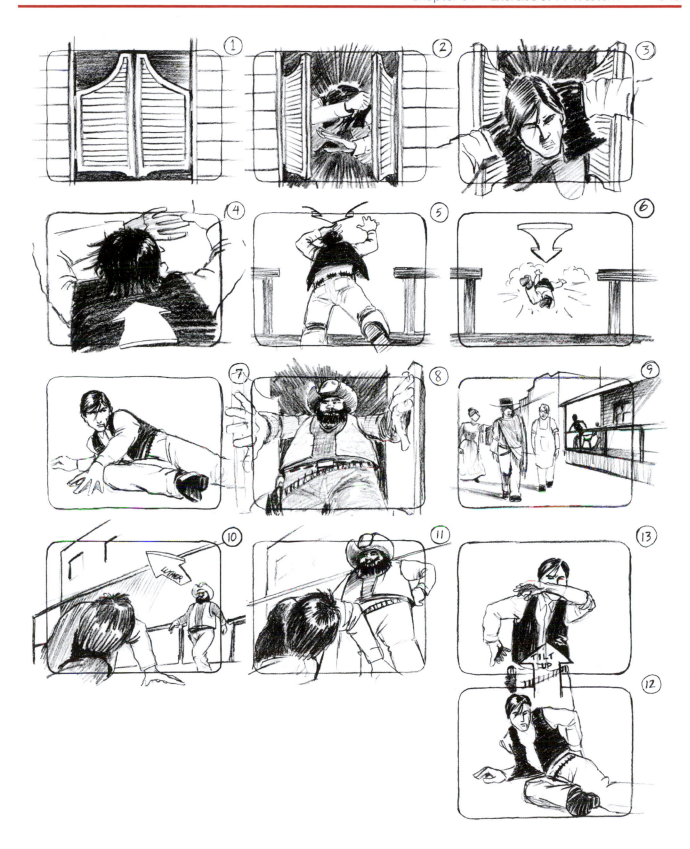

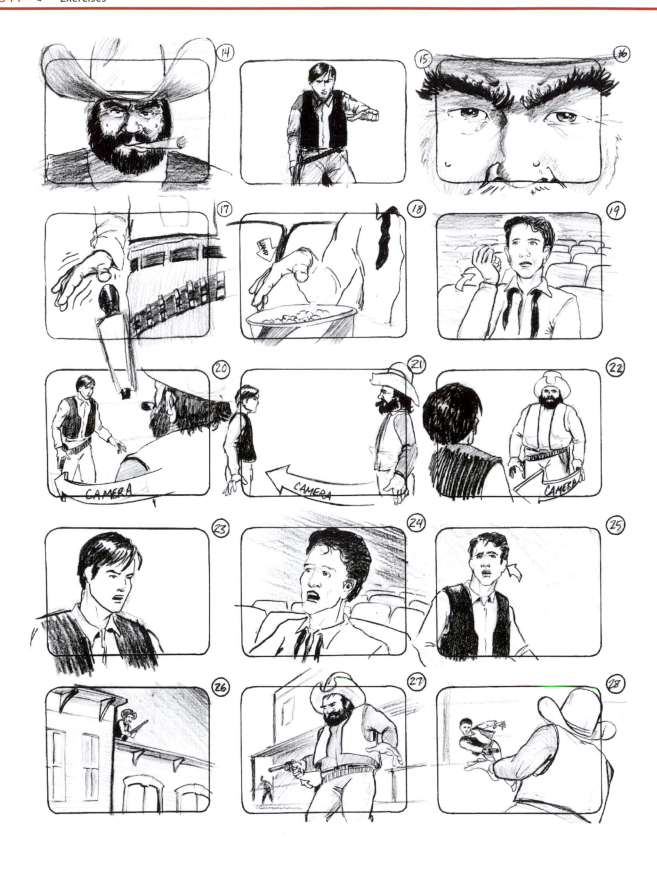

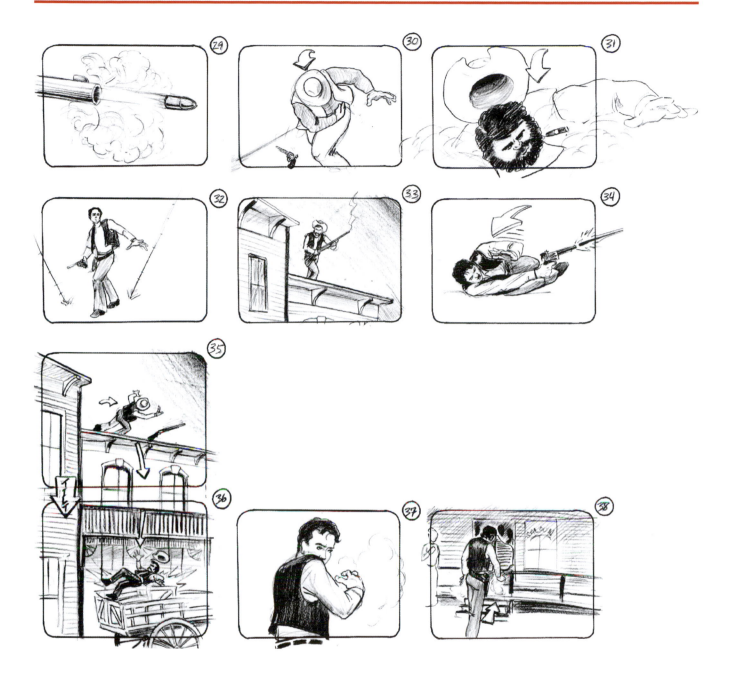

Exercise 6: Commercial

This will be a 30-second commercial. We are going to break this exercise into two parts. Each part of this exercise will use the same commercial. This will give you an idea of what it's like to work with advertising agencies.

In the first part, you will illustrate the commercial as a set of full-color presentation boards. Presentation boards are generally beautifully rendered boards used by advertising agencies to pitch their ideas to a client. You usually only need a few presentation boards per spot (commercial spot), just enough to get the idea across to the client.

In part two, you will illustrate a set of black-and-white production boards. Production boards usually do not need to be in color and portray the commercial spot shot-by-shot the way the director sees it. There will be many more panels in a production board than a presentation board, for every shot and edit in the finished commercial needs to be portrayed.

▶ Part One: Presentation Boards

The first thing you need to do is to figure out how many panels are needed for this spot so that a client can understand it—keep it as short as possible. There are two main reasons why there are fewer panels for presentation boards than for production boards. Presentation boards are more expensive than production boards, and most clients only need (and want) to see a visual outline of the commercial concept.

You can get away with seven to nine panels for these presentation boards. Design them yourself.

Animatics & Storyboards, Inc., Live-Action Spot: 30

Royal's Gym—Written by Jeanne Pappas Simon

VIDEO:	AUDIO:
Medium shot of workout woman.	JEANNE: I don't wear lace. And bows? Definitely not me.
Wide shot of group aerobics.	I do work out, though. I like a no-nonsense, breath-pounding, sweat-dripping workout, and I can get that at Royal's Gym.
Quick shots of weights, stationary bikes, and people running on an indoor track.	They've got free weights, the hot new bikes, and an awesome indoor padded track.
OTS (over-the-shoulder) shot, past woman, of monitors on the wall.	Plus, Royal's has walls and walls of monitors playing the hottest videos from MTV that keep the place jammin'.
Racquetball court.	Oh yeah, I almost forgot . . . they have four racquetball courts.
Close-up of woman.	And mom . . . I never let the boys win.
Logo.	Royal's—the place for a serious workout.

▶ Part Two: Production Boards

When drawing the production boards, you need to work with the director. The director's ideas will always be a bit different from the agency's—it's called creative freedom and job justification. Plus, directors are chosen for their ability to visualize certain types of commercials. Since the publishers of this book couldn't afford to send a director to your house, we'll give you her notes as if she were actually talking to you. This is exactly like a number of the commercials I've worked on.

Take the director's notes, make quick sketches, and then draw the final boards. If this were a real job, you'd get approvals on your rough pencil drawings before you finished the art. You may want to have someone do this for you and give you notes. To make this a realistic test, complete the production boards in one to two days. That's about all you'll get in a real production.

Director's Notes

"To start with, you'll see a couple of photos here that can serve as good reference. The one of the woman's backside gives you an idea of what she'll be wearing in the close-ups when she's talking to camera. Whenever we see her working out, she'll be wearing a sexy half-shirt over it, as in the other photo.

"The photos of the equipment give you an idea of what some of the products look like at Royal's Gym.

We don't have reference of what the bikes look like or the indoor track. Do you have reference of workout bikes?" (Say "yes" and find photo references after the meeting.) "We're going to have a lot of fast edits of different parts of her body cut in with wider shots of the facility. Think of the Bally Fitness Club commercials and you'll get the idea. The camera will be moving on every shot, either as a handheld swish-around or as fast-tracking moves using a dolly.

Figure 65.1 Costume reference for the sexy workout woman.

Figure 65.2 Exercise equipment reference.

"On the first shot I want to start close on the back of her legs, tilting up. Then I want to do the same move on her right arm. I want that shot so that we're seeing the profile of her breast beside her arm. Then when she says, 'Definitely not me,' I want to cut to a headshot, including her shoulders. She should look sexy but tough. Have her wearing a headband like she's been working out a little bit already. This is the only static shot in the spot.

"Now I want a fast move in front of an aerobics class with our talent centered in the front. Have about fifteen women in the class, mirrors all around. Intercut shots of extreme close-ups, like feet hitting the floor in rhythm, a head moving up into frame, quick pan past sexy sweating heads.

"I want to see a move down across a stack of chrome hand weights on their stand. I want to follow a barbell on its upward curve to reveal our woman's half-shirt. I want to see feet spinning rapidly on a stationary bike's pedals, then cut to a quick shot of the camera running up a row of women on the bikes, to make it look like they're pedaling past the camera. Have you ever seen spinning? That's the look I'm shooting for. Cut to a hand pumping in and out of frame, with a sweatband on the wrist—this should be a jerky shot. Go to a close shot of a sweaty forehead, and move down the woman's face to see her breathing hard. Then let's go to a shot down low and have our woman run past the camera and make it look like she's speeding past us on the indoor track.

"Quick pan from left to right across a bank of monitors with music videos on them. Then cut to a quick pan right to left across woman working out. Then another cut to a quick move behind the women as they're moving in rhythm to the music and we see the monitors beyond. Go to a quick shot of our woman's eyes for the 'Oh yeah.' Then let's go to a low shot where a racquetball racket hits a ball up close right into the lens. The racket needs to fill the frame on this shot. Give me a variety of fast shots in a court of a ball hitting the line, a person flying past camera leaping for a shot, two other shots you can make up, and a high shot seeing down in more than one court.

"When we get to 'I never let . . . ,' I want to start on a medium shot 3/4 back view of our woman. She should turn to the camera, and we need to do an extremely fast push into her face, with a very serious look on it. Cut to their logo with a towel thrown into the background. I want to see the towel land on the floor and against the corner, and take up part of the camera left background of the frame. We don't have their logo yet, so just come up with something nice and generic to use in the boards."

Now, remember, all this will be edited into a 30-second spot—Whew! You should end up with around 31 to 34 panels for your production boards.

CHAPTER 66

Exercise 7: Animation and Cartoons

When you storyboard an animated TV episode, you may not get much guidance from a director. The animation script is written with much more detail regarding shots and camera angles than live action, but you probably won't be going over a shot list with a director. You will, most likely, get notes from the storyboard supervisor. Remember to illustrate every little nuance of action or character reaction. Your drawings will probably be sent overseas to be animated. If you don't have an action in your storyboards, it won't show up on the screen.

This script is from an animated pilot I produced called *The Winkles*. Work with the character designs shown here to draw them accurately ("on character"), and try to match the style of the art in your boards. This is very important in animation. One thing you need to know is that Winkles don't walk; they bounce—kind of like kangaroos. I've also included some sample backgrounds. You can use the entire background or just a portion of one for close shots.

All you get here is the script. You do all the breakdowns yourself, but you may want to have someone give you creative notes.

The Winkles—"Material Girl"

Written by Jeanne Pappas Simon
(Copyright 1996, Animatics & Storyboards, Inc.)

```
Fade in:

SEQUENCE 1—EXT YARD

As we open, we are flying behind two Gorks,
delusional ducks who think they're World War II
fighter pilots. They are flying, gliding actually,
holding their arms out from their sides like a kid
does when she pretends to fly. We see below them the
fantastic rolling landscape of their planet, Mirth.

We cut to a low angle looking up at Gork 1.
```

 GORK 1
 Pilot to bombardier, pilot to bom-
 bardier! We have the targets in sight!

Gork 2 is looking down past the camera and is holding out a
blueberry pie in one hand.

 GORK 2
 Roger that, Gorkmeister, blueberry
 bombs loaded and ready to fly.

Down on the ground Walter and Winnie Winkle, no relation, are
playing Nurfletee, a nonsensical game where there are sticks
placed in a circle and you roll an eight-sided die. If you
lose a point you put a stick in your hair. Walter and Winnie
each have two sticks in their hair.

Walter has one eye closed as he concentrates on rolling the
die. Winnie is impatiently waiting for him to do so.

 WINNIE
 Come on Walter, roll your Bink.

Back up in the sky, we are close on Gork 1. Gork 1 yells
excitedly and pumps his left arm as he says it.

 GORK 1
 Targets are in positionnnnn . . . Now!
 Go! Go! Go!

Gork 2 holds the pie up behind his head with both hands. His
posture is bent backward to get the hardest possible throw. As
he throws the pie, his feet fly up and his hands go down
between and beneath his legs.

 GORK 2
 WAHOO!

Walter has wound up . . . hesitates . . . and throws the die. As he
throws it he leans forward with the force of the throw. The
pie from above barely misses him and hits the screen, totally
covering it with blue.

As the blue drips off the screen, we reveal a close-up of Walter,
angry, pumping his fist up in the air, yelling at the Gorks.

 WALTER
 You stupid Gorks.

Cut to close shot of Gork 1 with his head stretched down
looking at Walter. He lifts his head and looks back at Gork 2.

 GORK 1
 Pilot to bombardier. The enemy has
 turned aggressive. Take evasive
 measures.

Medium shot, both Gorks fly in formation and bank off into the
clouds as they glide away.

Winnie shrugs off the attack. Then she turns and hops off toward the fence to fetch the Bink, an eight-sided die.

> WINNIE
> Forget those Gorks, they always miss.
> Come on, let's keep playing. I'll get
> the Bink.

Winnie hops into frame by the fence. She looks down and spots a shiny rock, which looks like a colorful quartz crystal sticking out of a hardened mass of mud. She picks it up, holding it up high, right in front of her face, and looks at it carefully and with a lot of pleasure. As she calls out to Walter behind her, she never stops looking at the rock.

> WINNIE
> Oh, Walter, look at what I've found!
> Isn't it pretty?

Walter comes up behind her. He tries to look over both of her shoulders, popping up over her left, then her right, then her left, and so on, to see the sparkly rock.

> WALTER
> Winnie, lemme see.

Winnie shrugs up her shoulder and tries to keep Walter from getting too close. She now holds the sparkly rock close to her chest with excessive pride.

> WINNIE
> Finders keepers, Walter. You can look,
> but you can't touch.

Walter backs away hurt. He then gets mad, puts his hands on his hips, and lets Winnie have it. As he talks he wags his head from side to side for emphasis.

> WALTER
> Hmph...I don't like you very much. I
> don't wanna hold it. I don't wanna see
> it. I don't wanna play with YOU...

Walter's finger points right at camera, getting very close.

> WALTER
> (cont.)...anymore.

Walter then turns away from us and Winnie, hangs his head low, and slowly walks (not bounces) away. We slowly pull out to reveal Winnie in the foreground looking at her rock, oblivious to Walter or what he just said.

SEQUENCE 2—EXT. STREET

We see an adult Winkle sitting on a park bench, reading his paper. Winnie comes bouncing into frame, stops at his feet, and proudly presents her sparkly rock to him.

 WINNIE
 Look at my very special rock. It's my
 treasure beyond measure.

The adult Winkle smiles and pats Winnie on her head
dismissively.

In the background we see the Gorks approach, unaware that
they're about to walk up on Winnie.

Close on Gorks as they saunter through the frame. Gork 2 stops on
the edge of frame and does a double take, and his head and neck
stretch back to the center of the frame as he excitedly yells . . .

 GORK 2
 Code red! Code red! Enemy at twelve
 o'clock.

Gork 1's head stretches into frame to look, his eyes bug out,
and his mouth hangs open in surprise.

 GORK 1
 Wha??

Medium shot as Winnie bounces up to the Gorks. She stops in
front of them, smiling.

 WINNIE
 Hi!

Close on the two Gorks. Gork 1 has his hands tightly around Gork
2's neck and is vigorously shaking Gork 2's head back and forth.

 GORK 1
 We've been spotted!

Gork 2's eyes are bugging out and his tongue is swinging
around and turning blue.

 GORK 2
 Urp!

Shot of the park. Gork 1 slides his head in from camera right;
he's holding a microphone and is talking to the camera.

 GORK 1
 Houston, we have a problem.

Gork 1 pulls his head back out of frame.

Cut to a 3 shot.

 GORK 1
 Activate Operation Camouflage.

The Gorks quickly duck their heads down into their jackets. Gork
1 remains standing and Gork 2 ends up sitting in the middle.

Winnie is presenting her sparkly rock in her presentation pose with
her eyes closed. She's more interested in voguing than in their
reaction, so she's not paying any attention to what they're doing.

Gork 1's eyes pop up out of his jacket, he looks around, and then slowly brings his entire head up. Winnie is not moving. He leans forward and looks at the rock. He then pulls out a blueberry pie and proudly presents it to Winnie with a mischievous grin. Gork 1 turns to the audience in a close up...

 GORK 1
 (to camera)
 This is too easy.

Once Winnie's sure they're adequately impressed, she turns and bounces away.

 WINNIE
 Okay...Bye bye.

Gork 1 winds up with his pie, ready to throw it at Winnie...

Gork 2 suddenly pops his head up in between them...

Gork 1 lets the pie fly and it hits Gork 2 in the back of the head.

We see Winnie bouncing away into the distance, happy and pie-free.

WINNIE **WALTER**

Figure 66.1 Winnie and Walter Winkle (no relation). If you decide to do these in color, Winnie is green and Walter is yellow. They both have pink hearts. (Designs by Mark Simon. © 2005 Animatics & Storyboards, Inc.)

PILOT GORK

BOMBARDIER GORK

Figure 66.2 Gork 1, pilot, and Gork 2, bombardier. They fly by holding their arms straight to their sides. They are purple, with brown bomber jackets. (Designs by Mark Simon. © 2005 Animatics & Storyboards, Inc.)

ADULT WINKLE

Figure 66.3 Adult Winkle (no relation). He can be any color and just sits on the park bench. (Designs by Mark Simon. © 2005 Animatics & Storyboards, Inc.)

Figure 66.4 Winnie's colorful rock.

Figure 66.5 Backgrounds: The first background is where Winnie and Walter play. The second is where Winnie finds her rock. The third background is where the adult Winkle is sitting. (Art by Mark Simon. © 2005 Animatics & Storyboards, Inc.)

PART SIX

EXPERIMENT

.

A Storyboarding Experiment

Like a director, each storyboard artist brings a unique vision to every story that's told. To emphasize the difference a storyboard artist can make to a project, I asked five artists to board out the same scene; I participated in the experiment too.

Each artist was given the same short scene, as shown shortly. They were all asked to board the scene in a 16 : 9 film ratio format. The number of panels it takes to tell the story, the shot direction, and the style of illustration were up to each artist.

The artists acted as their own directors. They determined each camera angle, each stunt, and each action. Even the layout of the location was up to them. Enjoy the results.

▶ The Experiment's Details

Characters

Bear—A large, brutal man who is used to war. (Think of a 6′8″ Wolverine.) His skin is impervious to bullets. Leading up to this scene, he has been in a number of skirmishes, and his hair and clothes show the result.

Girlfriend—A beautiful, petite woman who sees the gentle man beneath the gruffness.

Attackers—Combination of six trained assassins and warriors in battle armor. There is one commander who shows strength only when surrounded by his troops. He's otherwise a wimp.

Scene

FADE IN.

EXT. ALLEY—DAY

Bull is holding his woman's shoulders tenderly against a wall, with his body protecting her. He gazes into her eyes as a volley of bullets bounce off his back.

　　He turns in a rage, still protecting her body with his. His clothes are shredded by gunfire. He leaps at the small group of attackers and takes out three on his landing.

　　He grabs the barrel of one gun and smashes it into the face (faceplate) of an attacker.

　　He picks up the limp body over his head to throw at the last two attackers. In the background the commander turns and runs away around a corner.

　　The fallen attacker's body is either thrown onto the last two attackers or swung at them like a bat.

 FADE OUT.

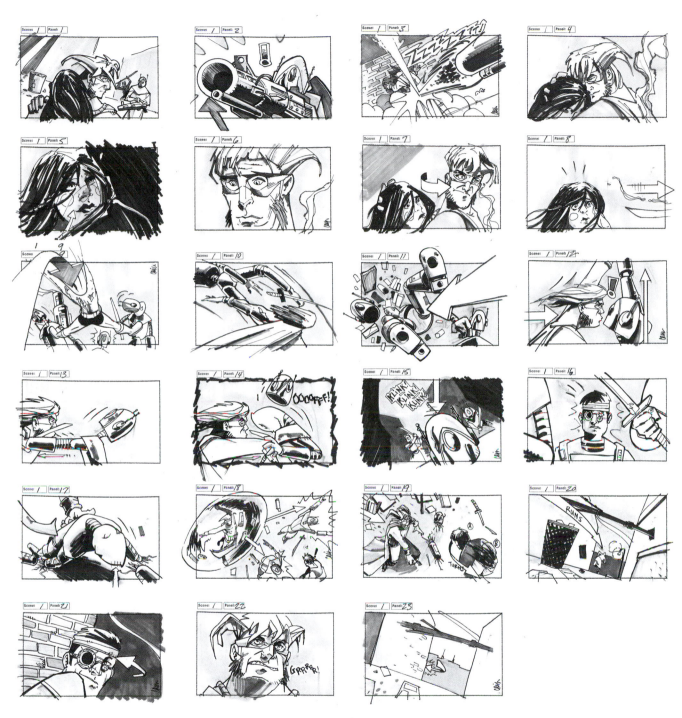

Figure 67.1 Craig Gilmore's experiment.

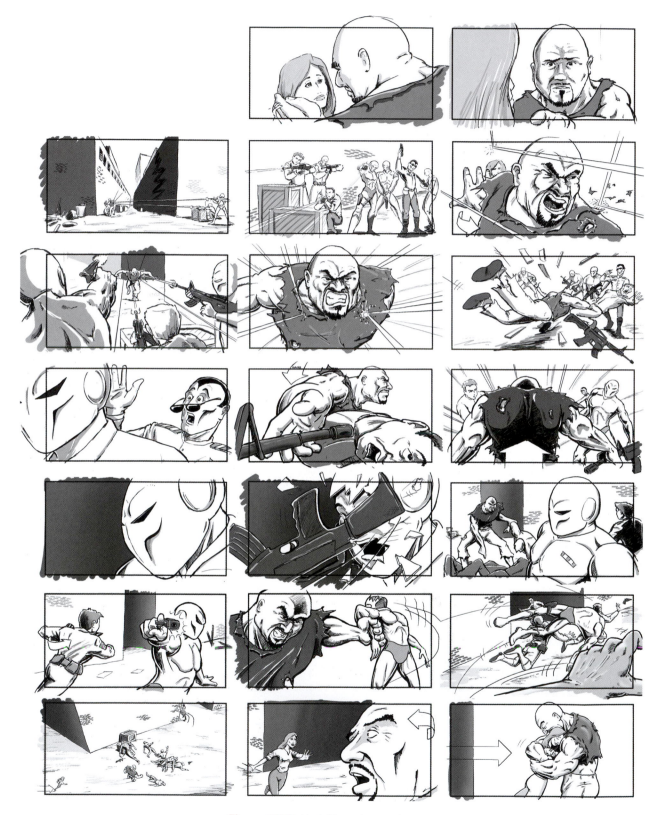

Figure 67.2 Mark Simon's experiment.

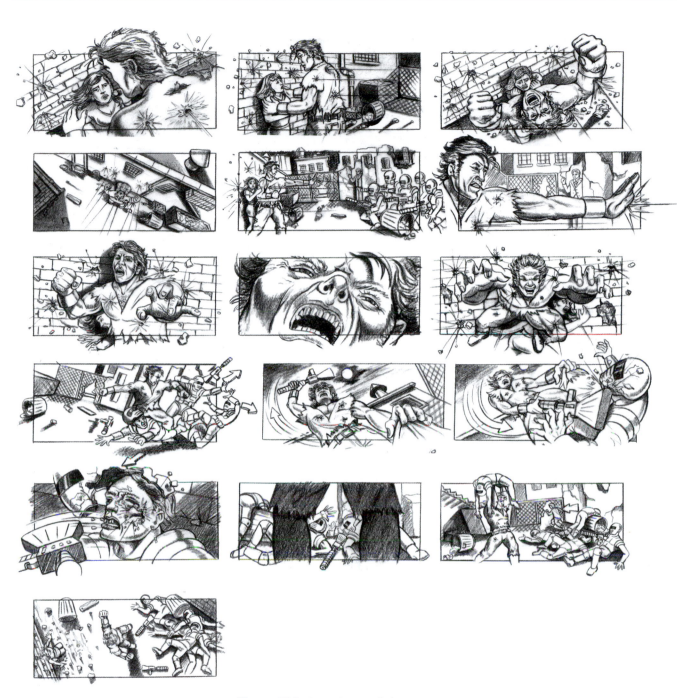

Figure 67.3 Craig Cartwright's experiment.

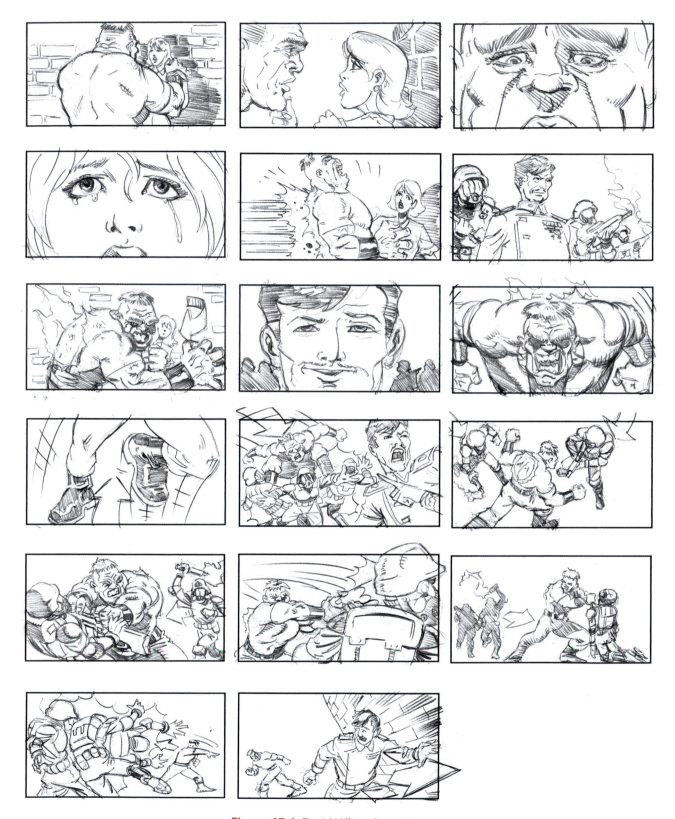

Figure 67.4 David Hillman's experiment.

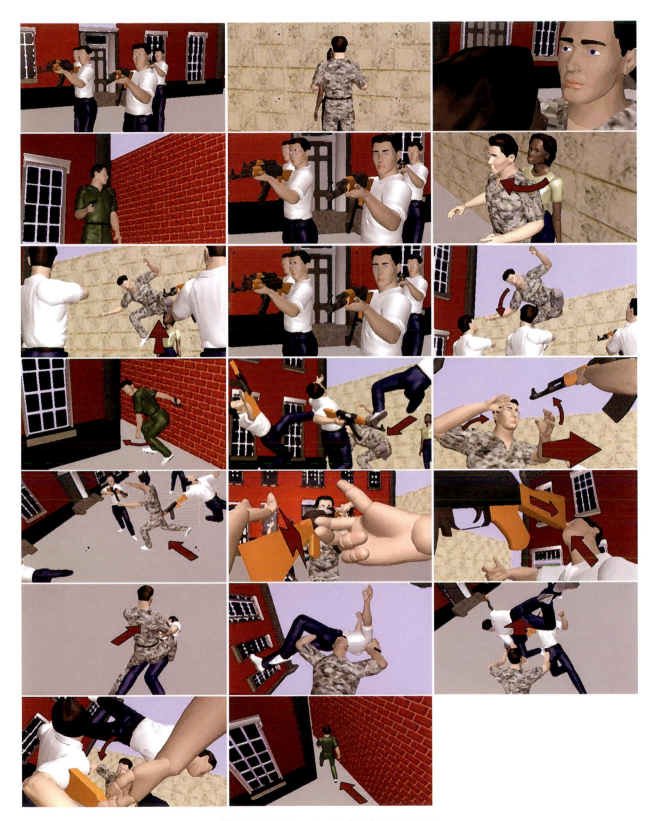

Figure 67.5 Ignacio Sardinas's experiment.

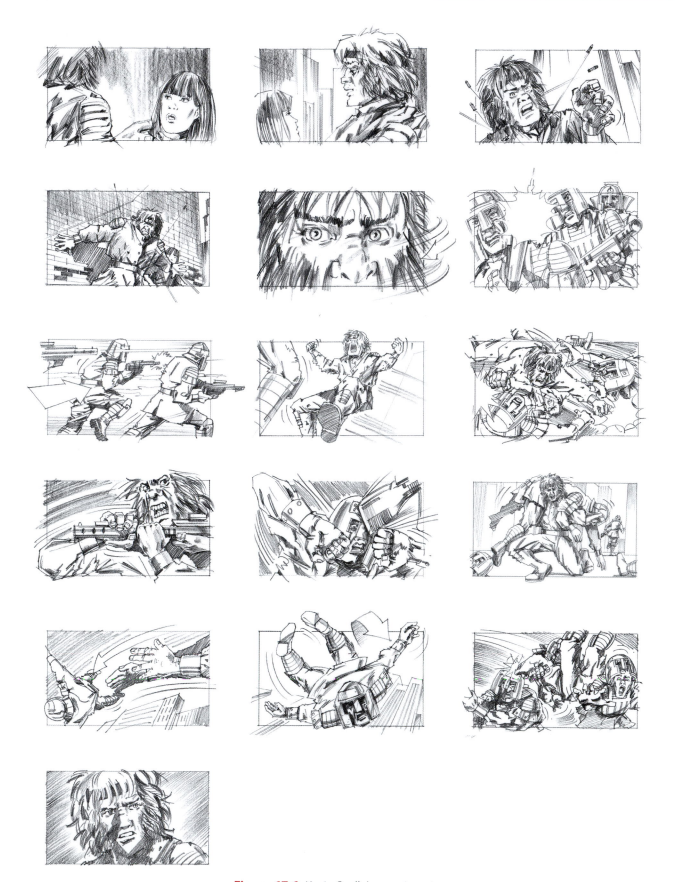

Figure 67.6 Kevin Scully's experiment.

APPENDICES

Forms

You may copy and use the forms in this book for your own purposes. You can also check my web sites at *www.MarkSimonBooks.com* or *www.YourResumeSucks.biz* for any of these digital and/or editable forms available for free on the Web.

Because of the print size in this book, you may need to enlarge the pages a bit so that the forms properly fill your copied page.

Choose the proper storyboard form according to the format you are working in, such as film or high-definition (16 : 9 ratio, widescreen HDTV) or TV (4 : 3). The forms with more than three panels per page are considered quick-layout (thumbnail) pages.

The forms, in order, are:

- Television ratio storyboard form
- Film/HD ratio storyboard form
- Animation/TV storyboard form
- Television thumbnail/layout storyboard form
- Film/HD thumbnail/layout storyboard form
- Storyboard invoice, front and back

Project: Page:

Scene:
Panel:

Scene:
Panel:

Scene:
Panel:

Artist:

Form: TV-Strybrd-3X

Project: Artist: Page:

Scene:
Panel:

Scene:
Panel:

Scene:
Panel:

Form: Film-Strybrd-3X

Project: Scene: Panel:

Artist: Scene: Panel:

Page: Scene: Panel:

Action	Dialogue	Timing

Project:

Artist:

Page:

Scene: Panel:

Scene: Panel:

Scene: Panel:

Scene: Panel:

Scene: Panel:

Scene: Panel:

Project: Artist: Page:

Scene: Panel: Scene: Panel:

Scene: Panel: Scene: Panel:

Scene: Panel: Scene: Panel:

Scene: Panel: Scene: Panel:

Form: Film-Strybrd-8X

STORYBOARD INVOICE

Please make checks out to:

Invoice #

TO:

Date:

Commissioned By:

Assignment Description:

Boards for

	Number	
	Panels	
		Subtotal
	Number	
		Subtotal
	Number	
		Subtotal
		Total Fees

Expenses:
The Client shall reimburse the designer/artist for all expenses.

Photography, location reference	
Models & Props	
Materials & Supplies	
Digital Blurring	
Stats, Proofing & Copies	
Mechanicals	
Client's Alterations	
Toll Telephone	
Transportation & Travel	
Messengers	
Shipping & Insurance	
Other Expenses	
	Subtotal Expenses
Fee	
Expenses	
Payments on Account	
Balance Due	

1 ½% monthly interest due after 30 days. Client responsible for all collection fees.

Rights Transferred:
The designer/artist transfers to the client the following exclusive rights of usage.

Title or Product:

Category of Use:

Medium of Use:

Edition (if book):

Geographic Area:

Time Period:

Any usage rights not exclusively transferred are reserved to the designer. Usage beyond that granted the client herein shall require payment of a mutually agreed upon additional fee subject to all terms

Receiving Party Signature:

Date:

Please Print Name:

Terms:

1: Time for Payment
All invoices are payable within thirty (30) days of receipt. A 1 1/2% monthly service charge is payable on all overdue balances. The grant of any license or right of copyright is conditioned on receipt of full payment.

2: Default in Payment
The client shall assume responsibility for all collection of legal fees necessitated by default in payment.

3: Expenses
The client shall reimburse the designer/artist for all expenses arising from this assignment, including the payment of any sales taxes due on this assignment.

4: Changes
The client shall be responsible for making additional payments for changes requested by the client in original assignment. However, no additional payment shall be made for changes required to conform to the original assignment description. The client shall offer the designer/artist the first opportunity to make any changes.

5: Cancellation
In the event of cancellation of this assignment, ownership of all copyrights and the original artwork shall be retained by the artist, and a cancellation fee for work completed, based on the contract price and expenses already incurred, shall be paid by the client.

6: Ownership and Return of Artwork
The designer/artist retains ownership of all original artwork, whether preliminary or final, and the client shall return such artwork within thirty (30) days of use unless otherwise indicated below:

7: Credit Lines
The designer/artist and any other creators shall receive a credit line with any editorial usage. If similar credit lines are to be given with other types of usage, it must be so indicated here:

8: Releases
The client shall indemnify the designer/artist against all claims and expenses, including reasonable attorney's fees, due to uses for which no release was requested in writing or for uses which exceed authority granted by a release.

9: Modifications
Modifications of the Agreement must be written, except that the invoice may include, and the client shall pay, fees or expenses that were orally authorized in order to progress promptly with the work.

10: Uniform Commercial Code
The above terms incorporate Article 2 of the Uniform Commercial Code.

11: Code of Fair Practice
The client and the designer/artist agree to comply with the provisions of the Code of Fair Practice, a copy of which may be obtained from the Joint Ethics Committee, P.O. Box 179, Grand Central Station, New York, NY, 10017.

12: Arbitration
Any dispute in excess of $2,500 (maximum limit for small claims court) arising out of this Agreement shall be submitted to binding arbitration before the Joint Ethics Committee or a mutually agreed upon Arbitrator pursuant to the rules of the American Arbitration Association. The Arbitrator's award shall be final, and judgement may be entered in any court having jurisdiction thereof. The client shall pay all arbitration and court costs, reasonable attorney's fees and legal interest on any award or judgement in favor of the designer/artist.

Resources

These books will help you with storyboarding in many ways. They will serve as visual references and inspiration and help with knowledge of the entertainment industry and storytelling. This is by no means a complete list, but it is a great start.

"How to Draw" Books

How to Draw Comics the Marvel Way
By Stan Lee and John Buscema
Publisher: Simon & Schuster, 1984
 Wonderful book showing how to draw the human body quickly and in motion. Contains dynamic examples.

Force: The Key to Capturing Life Through Drawing
By Mike Mattesi
Publisher: iUniverse Star, 2004
 Instruction on capturing the human body and animals in motion.

How to Draw Cars the Hot Wheels Way
By Scott Robertson with the Hot Wheels Designers
Publisher: MBI Publishing Company, 2004
 Outrageous car designs and great examples of how to draw cars in perspective.

The Animator's Survival Kit
By Richard Williams
Publisher: Faber and Faber, 2001
 While this is for animators, animation storyboard artists will learn a great deal on how to pose actions.

How to Draw Animation
By Christopher Hart
Publisher: Watson-Guptill, 1997
 Great examples of character design, illustration, and posing for animation storyboard artists.

How to Draw Cartoon Animals
By Christopher Hart
Publisher: Watson-Guptill, 1995
 Helpful reference for drawing cartoon animals.

How to Draw Animals
By Jack Hamm
Publisher: Perigee, 1969
 Clear instructions for drawing animals, with more than 1,000 step-by-step illustrations. Includes skeletal and musculature illustrations.

Creative Marker Techniques: In Combination with Mixed Media
By Yoshiharu Shimizu
Publisher: Graphic-Sha, 1990
 Incredible examples of how to color machinery with markers.

Marker Magic: The Rendering Problem Solver for Designers
By Richard McGarry and Greg Madsen
Publisher: John Wiley & Sons, 1993
 Forty mini-lessons with step-by-step demonstrations.

Photoshop Down & Dirty Tricks
By Scott Kelby
Publisher: New Rider Publishing, 2004
 Great tips and tricks for using Photoshop in real-life situations. Updated for every edition of Photoshop.

Bridgman's Complete Guide to Drawing from Life
By George B. Bridgman
Publisher: Stirling, 1991
 More than 1,000 anatomical drawings with full breakdowns of bones and muscles.

Dynamic Figure Drawing
By Burne Hogarth
Publisher: Watson-Guptill, 1996

Figure Drawing for All It's Worth
By Andrew Loomis
Publisher: Viking Press, 1973
 Recommended by storyboard artist Josh Hayes.

Perspective! For Comic Book Artists
By David Chelsea
Publisher: Watson-Guptill, 1997

Perspective: A Step-by-Step for Mastering Perspective by Using the Grid System
Publisher: DAG Design, 2002
 Includes grids to work with.

"Making of" Books

The Making of Congo: The Movie
By Jody Duncan and Janine Pourroy

Publisher: Ballantine Books, 1995
 Great examples of conceptual art for the movie.

The Making of Judge Dredd
By Jane Killick, David Chute, and Charles M. Lippincott
Publisher: Hyperion, 1995
 Conceptual art and costume design. Large section at the back shows storyboards.

The Making of Jurassic Park
By Don Shay and Jody Duncan
Publisher: Ballantine Books, 1993
 Written by the publisher and editors of *Cinefex*, the finest magazine on the effects industry. The best book of its kind I've found. Great photos and renderings of the concepts, sets, dinosaurs, robots, and more. Also includes the greatest gallery of storyboards (41 pages worth) I have ever seen in a "making of" book. A must-have.

The Making of The Lost World: Jurassic Park
By Jody Duncan
Publisher: Ballantine Books, 1997
 Tons of great conceptual art and storyboards. Has a great sequence of digital storyboards combining the actual footage and hand-drawn dinosaurs.

The Making of Starship Troopers
By Paul M. Sammon
Publisher: Boulevard Books, 1997
 Examples of the director's sketches and real storyboards.

The Making of Waterworld
By Janine Pourroy
Publisher: Boulevard Books, 1995

T2: The Making of Terminator 2: Judgment Day
By Don Shay and Jody Duncan
Publisher: Bantam Books, 1991
 Storyboards, photos, and explanations of the effects.

Toy Story: *The Art and Making of the Animated Film*
By John Lasseter and Steve Daly
Publisher: Hyperion, 1995
 Lots of conceptual art and storyboards.

"Art of" Books

The Art of Robots
By Amid Amidi
Publisher: Chronicle Books, 2004
 Great previz, hand-drawn art of the filmmaking process.

The Art of The Incredibles
By Mark Cotta Vaz

Publisher: Chronicle Books, 2004
 Fantastic art. Shows the incredible 2D talent behind the 3D feature film.

The Art of The Matrix
Publisher: WB Worldwide, 2000
 Amazing amount of art, storyboards, and conceptual illustrations of this amazing film.

Tim Burton's Nightmare Before Christmas: *The Film, the Art, the Vision*
By Frank Thompson
Publisher: Hyperion, 1993

The Art of Anastasia
By Harvey Deneroff
Publisher: HarperCollins, 1997

Disney's Art of Animation
By Bob Thomas
Publisher: Hyperion, 1991

The Art of The Lion King
By Christopher Finch
Publisher: Hyperion, 1994

The Art of Pocahontas
By Stephen Rebello
Publisher: Hyperion, 1995

The Art of The Hunchback of Notre Dame
By Stephen Rebello
Publisher: Hyperion, 1996

The Art of Star Trek
By Judith and Garfield Reeves-Stevens
Publisher: Pocket Books, 1995
 Filled with art, designs, and photos from the original and contemporary series and films.

The Art of Star Wars
By Carol Titelman
Publisher: Ballantine Books, 1979
 Production paintings, storyboards, sets, costumes, and creature sketches. The best of its kind.

The Art of The Empire Strikes Back
By Deborah Call
Publisher: Ballantine Books, 1980
 Production paintings, storyboards, sketches, and more of the sets, creatures, and wardrobe. Awesome book.

The Art of Return of the Jedi
Publisher: Ballantine Books, 1983

Production paintings, sketches, and storyboards of the sets, creatures, and costumes. Incredible.

Indiana Jones and the Temple of Doom: *The Illustrated Screenplay*
Introduction by Steven Spielberg
By Willard Huyck and Gloria Katz
Publisher: Ballantine Books, 1984

Men in Black: *The Script and the Story Behind the Film*
By Barry Sonnenfeld, Ed Solomon, Walter F. Parkes, and Laurie MacDonald
Publisher: Newmarket Press, 1997
 Great drawings of futuristic weapons.

Space Jammin': *Michael and Bugs Hit the Big Screen*
By Charles Carney and Gina Misiroglu
Publisher: Rutledge Hill Press, 1996
 Great art and good simple descriptions of how the animation and live action were produced.

The Prince of Egypt: *A New Vision in Animation*
By Charles Solomon
Publisher: Harry N. Abrams, 1998

Dune: *Official Collector's Edition*
Publisher: Paradise Press, 1984
 Photos of sets, props, and characters.

Dracula: *The Film and the Legend*
Publisher: Newmarket Press, 1992
 Wonderful photos and sketches of the immense sets used in this Academy Award–winning movie. Storyboards and design ideas explained.

Oblagon: *Concepts of Syd Mead*
By Syd Mead
Publisher: Oblagon, 1985
213-850-5225
 Art of this incredible futurist designer. Included are designs for movies such as *Blade Runner* and *2010*. Other books by Syd Mead are available as well.

Batman: *The Official Book of the Movie*
By John Marriott
Publisher: Bantam Books, 1989
 Photos and sketches of the sets, props, and costumes.

Batman Returns: *The Official Movie Book*
By Michael Singer
Publisher: Bantam Books, 1992
 Photos and sketches of the sets, props, and costumes.

Batman Animated
By Paul Dini and Chip Kidd
Publisher: Harper Entertainment, 1998
 Great art, storyboards, character design, and behind-the-scenes stories. One of the best.

Special Effects Books

Industrial Light and Magic: The Art of Special Effects
By Thomas G. Smith
Publisher: Ballantine Books, 1986
 The bible of special effects. Photos, sketches, and storyboards from some of the best FX movies ever made. Possibly the finest FX book ever published. A must-have for your collection.

Creating Special Effects for TV and Films
By Wilke
Publisher: Focal Press, 1977 (available from Tri-Ess Sciences, Inc., Catalogue #BK903)
 A basic, simplified, page-by-page procedure for special effects such as wilting flowers, fires, cobwebs, quicksand, explosions, breakaways, etc. Helpful information for a storyboard artist to know.

Secrets of Hollywood Special Effects
By Robert McCarthy
Available from Tri-Ess Sciences, Catalogue #BK892
All types of effects are covered. This is highly recommended by Tri-Ess Sciences.

How Did They Do It? Computer Illusion in Film and TV
By Christopher W. Baker
Publisher: Marie Butler-Knight, 1994
 If you're going to draw how to do it, you need to know how to do it.

The Screenplay

The Screenplay: A Blend of Film, Form, and Content
By Margaret Mehring
Publisher: Focal Press, 1989
 Recommended text at Ringling School of Art and Design.

The Writer's Journey: Mythic Structure for Storytellers and Screenwriters
By Christopher Vogler
Publisher: Michael Weise Productions, 1998
 Recommended text at Ringling School of Art and Design.

Figure A2.1 *Producing Independent 2D Character Animation* by Mark Simon. Published by Focal Press.

Animation Books

Producing Independent 2D Character Animation
By Mark Simon
Publisher: Focal Press, 2003
 Showcases every step of producing your own animation, from concept through post production and selling your idea. Great interviews with animators, creators, recruiters, executives, directors, and producers. Includes a CD containing sample software and custom animations.

How to Draw Comic Book Heroes and Villains
By Christopher Hart
Publisher: Watson-Guptill, 1995
 Great simple drawing strategies.

Too Funny for Words: Disney's Greatest Sight Gags
By Frank Thomas and Ollie Johnston
Publisher: Abbeville Press, 1987

Disney Animation: The Illusion of Life
By Frank Thomas and Ollie Johnston
Publisher: Abbeville Press, 1984
 One of the bibles about animation.

Disney's Animation Magic
By Don Hahn
Publisher: Disney Press, 1996

Cartoon Animation
By Preston Blair
Publisher: Walter Foster Publishing, 1994
224 pages
This is a great book for beginners from one of the animators of *Fantasia, Pinocchio* and *Bambi*.

The Animation Book
By Kit Laybourne
Publisher: Crown, 1998
A beginners discussion of many different animation techniques.

Makin' Toons
By Allan Neuwirth
Publisher: Allworth Press, 2003
Firsthand accounts and interviews on what it takes to get an animation produced.

Acting for Animators
By Ed Hooks
Publisher: Heinemann Drama, 2003
Analysis of character motivation and expression of emotions and how that translates into better, more believable animated characters.

Online References

Most any image for reference can be found rather quickly on the Internet. Be aware that while you may use any image as a reference, most photos and illustrations are copyrighted, and the images themselves may not be used without permission of the copyright holder.

Many of the following offer video search as well.

- *www.Google.com*—image search
- *www.Yahoo.com*—image and video search
- *www.AOL.com*—picture and video search
- *www.AltaVista.com*—image and video search
- *www.msn.com*—image search
- *www.Toyota.com*—3D fly-arounds of Toyota vehicle interiors and exteriors, including high and low angles.
- *www.GM.com*—360° rotation of vehicle exteriors.
- *www.Ford.com*—360° rotation of vehicle interiors and exteriors.

Figure A2.2 *Facial Expressions* by Mark Simon. Published by Watson-Guptill.

Reference Books

Facial Expressions: A Visual Reference for Artists
By Mark Simon
Publisher: Watson-Guptill, 2005
More than 3,200 photos of over 50 models ages, from 20 to 83, holding a variety of expressions. Also includes galleries of kissing, phonemes, skulls, and hats. No other facial reference comes close to this one. First in a series of photographic expressions books; check www.MarkSimonBooks.com for more.

Animals in Motion
By Eadweard Muybridge
Publisher: Dover, 1957
Great reference of 34 animals walking, jumping, and running; more than 4,000 photos.

Legacy of the Dog
By Yamazaki Kojima
Publisher: Chronicle Books, 1993
Photos of more than 200 breeds.

Dog—The Complete Guide
By Sarah Whitehead

Publisher: Barnes & Noble Books, 2003
 Color photos of more than 120 breeds.

The Human Figure in Motion
By Eadweard Muybridge
Publisher: Dover, 1955
 Great reference of nudes walking, running, jumping, lifting, and so on; more than 4,700 photos.

New Atlas of Human Anatomy
Edited by Thomas O. McCracken
Publisher: Barnes & Noble Books, 1999
 Anatomically correct CG reconstruction of the human anatomy, including bones, muscles, and organs.

Couples, Vols. 1 (*Basic Pose*) and 2 (*Daily Pose*)
By Hisashi Eguchi
Publisher: Bijutsu Shuppan-Sha, 1997
$35.95 each
 Black-and-white photo images of couples in various poses, taken from multiple angles, both clothed and nude. Around 900 images apiece.

The Nautilus Woman
By Ellington Darden, Ph.D.
Publisher: Fireside, 1985
 Photos of women on exercise machines.

Black Belt Karate
By Jordan Roth
Publisher: Charles E. Tuttle, 1974
 Multiangle photos of martial arts poses, hits, kicks, and sparring.

Illustrator's Reference Manual: Nudes
Publisher: Chartwell Books, 1989
 Posed photos taken from a variety of angles.

American Dream Cars
By Mitchel J. Frumkin and Phil Hall
Publisher: Krause, 2002
 Photos of more than 650 show cars and futuristic cars.

Weapons Through the Ages
By William Reid
Publisher: Crescent Books, 1976
 Illustrations and designs of armor and weapons from Neolithic archery to modern tanks.

Ships and the Sea: A Chronological Review
By Duncan Haws
Publisher: Crescent Books, 1975
 Illustrated ships and sailing vessels from the dawn of time until the present day. Every aspect of sailing is explored. Styles, vernacular, and design specs on each ship.

Entourage: A Tracing File for Architecture and Interior Design
By Ernest Burden
Publisher: McGraw-Hill, 2002
 Drawings and photos of people, cars, buildings, and landscaping. Some people and cars are dated to the original edition of the book from the 1970s. Includes a CD-ROM.

Storyboarding and Directing Books

Film Directing Shot by Shot: Visualizing from Concept to Screen
By Steven D. Katz
Publisher: Michael Wiese Productions/Focal Press, 1991
 Great examples of storyboards and how to visually tell a story.

Figure A2.3 *Film Directing: Shot by Shot* by Steven D. Katz, published by Michael Wiese Productions; see www.mwp.com.

Comics and Sequential Art
By Will Eisner
Publisher: Poorhouse Press, 1985
 Based on the popular course Eisner taught at New York's
 School of Visual Arts.

*The Five C's of Cinematography: Motion Picture
Filming Techniques*
By Joseph Mascelli
Publisher: Silman-James Press, 1998
 Recommended by storyboard artist Josh Hayes.

Comps, Storyboards, and Animatics
By James Fogle and Mary Forsell
Publisher: Watson-Guptill, 1989
 Step-by-step techniques for artistic creations.

*Directing for the Stage: A Workshop Guide of 42 Creative
Training Exercises and Projects*
By Terry John Converse
Publisher: Meriwether, 1995
 Recommended by animation director Larry Latham.

Directing Motion Pictures
By Terrence St. John Marner
Publisher: A. S. Barnes, 1972
 Recommended by animation director Larry Latham.

Marketing Books

Your Resume Sucks
Mark Simon, Jeanne Pappas Simon, and Dr. James E. M.
Irvine, D.M.
See www.MarkSimonBooks.com or
www.YourResumeSucks.biz, 2006
 Shows you how most of what you learned about résumés
 is not only worthless, but potentially may also be harmful.
 Told in an entertaining story format and includes examples
 of before and after résumés.

*Selling Your Graphic Design and Illustration: The
Complete Marketing, Business, and Legal Guide*
By Tad Crawford and Arie Kopelman
Publisher: St. Martin's Press, 1981
 Everything you should know about selling rights and
 licenses for artwork, including example contracts and
 pricing guidelines. A must-have if you intend to sell
 artwork.

Artist's and Graphic Designer's Market
By Mary Cox
Publisher: F&W Publications, updated every year.

Figure A2.4 *Your Resume Sucks!* by Mark Simon, Jeanne Pappas Simon, and Dr. James E. M. Irvine, D. M.

Interviews of artists along with thousands of listings of
where to sell your art and for how much. Yours truly was
interviewed in the 1997 edition.

*Graphic Artists Guild Handbook: Pricing
& Ethical Guidelines*
Publisher: Graphic Artists Guild, 2003
 The best pricing and business information book for artists
 I have ever read. Copyright and tax laws, ethical issues,
 business forms, liability, new technology, and more. Order
 from 90 John St., Suite 403, New York, NY 10038 (800-
 878-2753).

Architecture and Interiors Books

*Entourage: A Tracing File for Architecture and Interior
Design Drawing*
By Ernest Burden
Publisher: McGraw-Hill, 1991
 Photos and drawings of people, buildings, cars, animals,
 and plants for reference and tracing. The only drawback is
 that many of the clothing styles are out of date.

Interior Space Designing
By Yasuo Kondo
Publisher: Graphic-Sha, 1989
 Mostly commercial building interiors; great for use as a conceptual reference.

Restaurant Design 2
By Judi Radice
Publisher: Rizzoli International, 1990
 Restaurant interiors for conceptual reference.

Exhibit Design 4
By Robert B. Konikow
Publisher: PBC International, 1990
 Designs of outrageous and large industrial and exhibition hall exhibits. There are six books in this series.

Retail Design
By Rodney Fitch and Lance Knobel
Publisher: Whitney Library of Design, 1990
 Commercial retail design interiors.

Display and Commercial Space Designs (all volumes)
Publisher: Rikuyo-Sha Pub/Nippon Books
 Commercial retail and point-of-purchase display designs. For that matter any book by Nippon Books; all architectural designs are from Japan (213-604-9701).

International Contract Design
By Lewis Blackwell
Publisher: Abbeville Press, 1990
 Some of the most exciting public interiors for offices, stores, restaurants, bars, hotels, museums, and health centers.

The Complete Book of Home Design (rev. ed.)
By Mary Gilliatt
Publisher: Little, Brown, 1989
 Ideas for studies, children's rooms, and all household rooms. Information on changing technology. Space, color, and fabric design.

Rooms by Design
By Gerd Hatje and Herbert Weisskamp
Publisher: Harry N. Abrams, 1989
 Very different types of interior design. Many are very eclectic.

An Illustrated History of Interior Decoration: From Pompeii to Art Nouveau
By Mario Praz
Publisher: Thames and Hudson, 1964, 1982
 Illustrations and paintings through the ages, mostly from 1770 to 1860, from Europe, Russia, and the United States. Many well-known artists are represented. Good source for period props and architecture design.

Homes and Interiors of the 1920s
By Lee Valley
Publisher: Sterling, 1987
 Interior and exterior designs of the 1920s. Illustrations show everything from floor plans to casework and balusters.

American Vernacular Interior Design: 1870–1940
By Jan Jennings and Herbert Gottfried
Publisher: Van Nostrand Reinhold, 1988
 Historic design concepts and sketches of a lot of construction pieces and fixtures. Interior and exterior

designs and vernacular illustrated. Great for period pieces.

Architectural Detailing in Residential Interiors
By Wendy W. Staebler
Publisher: Whitney Library of Design, 1990
 High-quality photos and designs of different residential interiors.

Castles: Their Construction and History
By Sidney Toy
Publisher: Dover, 1985
 Sketches, designs, photos, and vernacular about a number of castles.

Industrial Landscape
By David Plowden
Publisher: W. W. Norton, 1985
 Photos of industrial complexes, interior and exterior, and the surrounding living areas. One of the references for this type of design.

Periodicals

Animation World Network—AWN
Information on the animation industry. Great school and work databases. Daily e-mails available. Monthly magazine available via PDF download from *www.AWN.com*.

Animation Magazine
Monthly magazine can be ordered from: 30941 West Agoura Rd, Suite 102, Westlake Village, CA 91361 (subscription rate: $50 per year); also maintains a large Web presence at *www.AnimationMagazine.net* and daily e-mails are available on request.

Daily Variety
5700 Wilshire Blvd., Los Angeles, CA 90036
800-552-3632 / 310-782-7012; *www.DailyVariety.com*
Listings of features in pre-production and in production around the world appear in every Friday edition. Good for trade information; $329.99 per year for print and online or $259 for print subscription to *Variety.com*

Figure A2.6 Animation World Network online periodical.

Figure A2.7 Cover of an issue of *Animation Magazine*.

Hollywood Reporter
5055 Wilshire Blvd., Los Angeles, CA 90036-4396
213-525-2000; *www.HollywoodReporter.com*
Daily industry trade paper via print and e-mail; $299 for the daily paper and online per year or $19.95 per month for online only. Very good listings of features in production and pre-production and the top crew people. Good for trade information.

Backstage
1515 Broadway, 14th Floor, New York, NY 10036
212-764-7300 / Fax 212-536-5318; *www.BackStage.com*
Published every Friday (subscribe for $195 per year). Deals mainly with New York production in TV, film, and theater. Casting information for crew and talent. Good for trade information.

Art Direction
10 E. 39th St., New York, NY 10016
212-889-6500
Monthly magazine dealing with design for the visual arts. Mostly for print, with some commercial storyboards. Information on new design software and more. Great for keeping up with the latest looks and designs.

Interior Design
44 Cook St., Denver, CO 80206-5800
800-542-8138; *www.interiordesign.net*
Monthly magazine with great photos of residential and commercial design; $95.95 per year when ordered online. Awesome reference material each month.

Cinefex
P.O. Box 20027, Riverside, CA 92516
www.Cinefex.com
Published quarterly; four issues for $32
Simply the finest magazine published for designs and special effects. Photos and descriptions of FX for the latest movies and commercials. The advertisers are the best sources for whom to call or where to get special supplies. A definite must. They supply a list in the back of each issue for ordering back issues.

Post
25 Willowdale Ave., Port Washington, NY 11050-9866
516-767-2500; *www.PostMagazine.com*
Free subscription if you meet the demographic requirements of the publisher.
Monthly magazine dealing with all aspects of postproduction. A lot of information on computer graphics is included in each issue as well as some FX information.

millimeter
Penton Publishing
Subscription Lockbox, P.O. Box 96732, Chicago, IL 60693
www.millimeter.com
Free subscription if you meet the demographic requirements of the publisher.
Monthly magazine dealing with new production and post production techniques.

American Cinematographer
ASC Holding Corp., 1782 N. Orange Dr., Hollywood, CA 90028
213-876-5080; *www.TheASC.com/magazine*
Monthly magazine with articles on every aspect of the industry; $29.95 per year for print or online. Some articles touch on the art fields. All the photos are great references from the top movies.

Resource Guides

LA 411
P.O. Box 480495, Los Angeles, CA 90048
213-460-6304
The best film and video guide for crew and services in Southern California ($55 for 13th edition). Includes production companies and union rules. If you live and work around L.A., get in this book.

Reel Directory
www.ReelDirectory.com
415-531-9760
Northern California's premiere resource guide for film, video, and multimedia; $35 for 2005 edition.

PART EIGHT

Storyboard Samples

Storyboard Samples

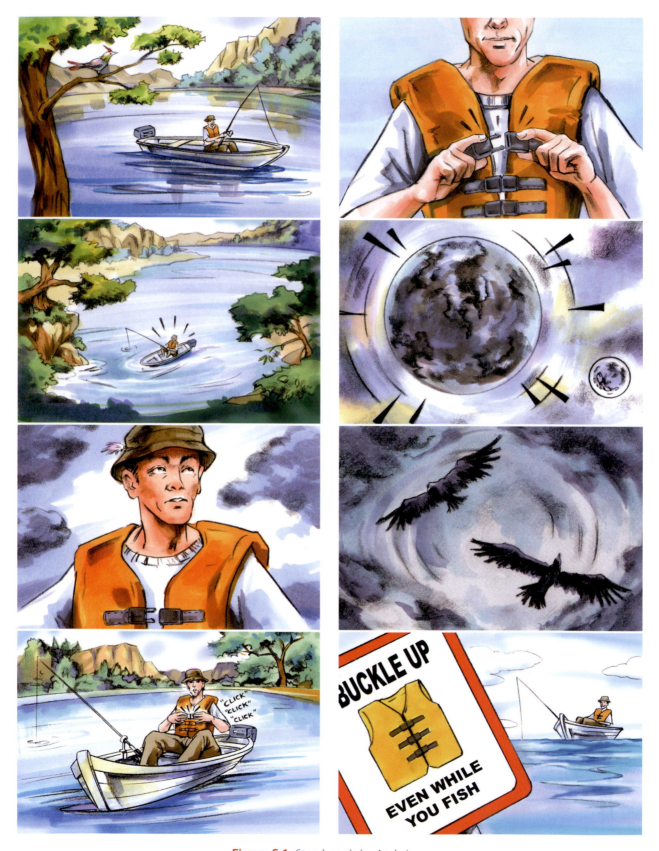

Figure S.1 Storyboards by Andy Lee.

Figure S.2 Film Noir commercial storyboards by Alex Saviuk of Animatics & Storyboards, Inc.

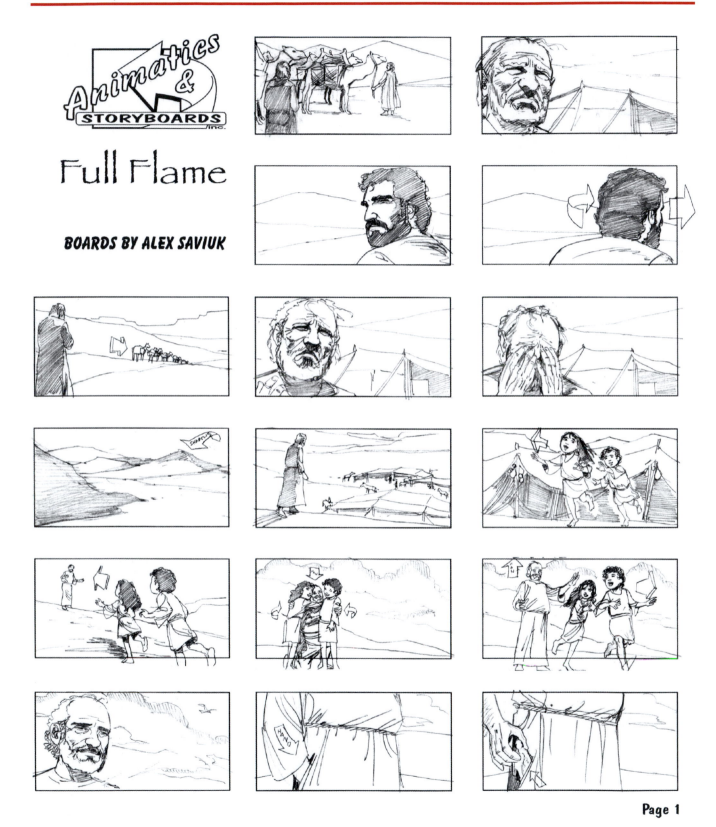

Figure S.3 *Full Flame* storyboards by Alex Saviuk.

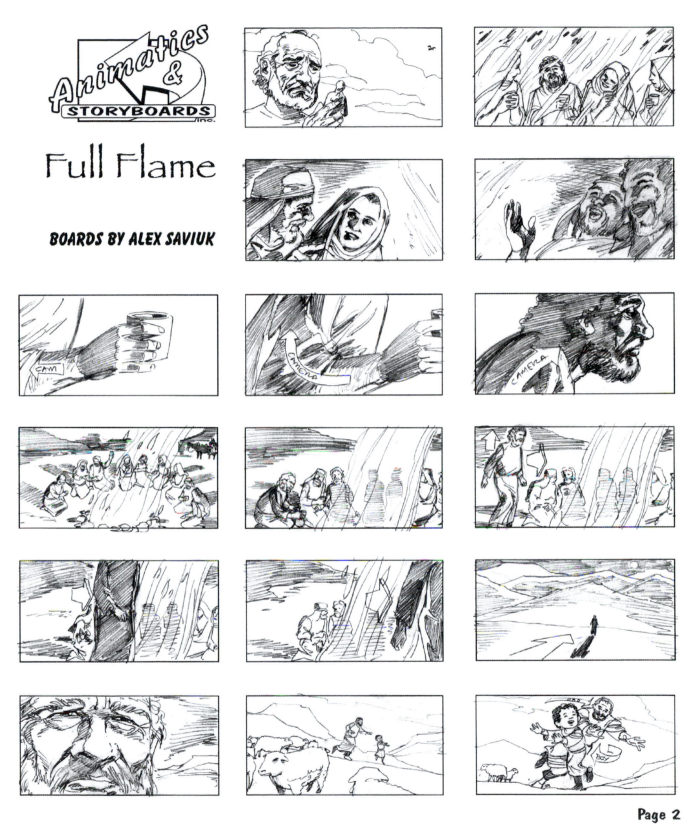

Figure S.4 *Full Flame* storyboards by Alex Saviuk.

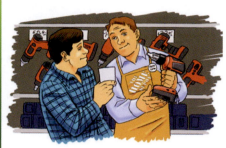

Figure S.5 Commercial storyboard art by Alex Saviuk. Colors by Mark Simon of Animatics & Storyboards, Inc.

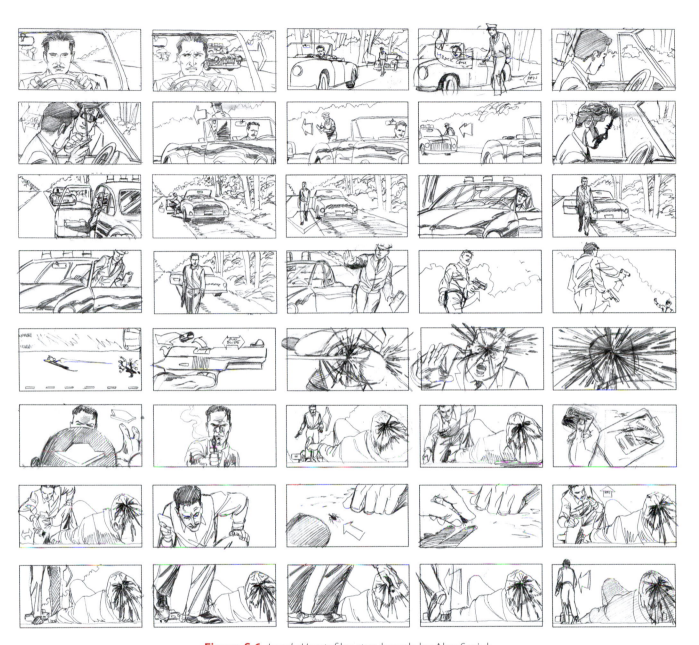

Figure S.6 *Lonely Hearts* film storyboards by Alex Saviuk
of Antimatics & Storyboards, Inc.

Figure S.7 Commercial pitch board art by Alex Saviuk and compositing and color by Mark Simon
of Animatics & Storyboards, Inc.

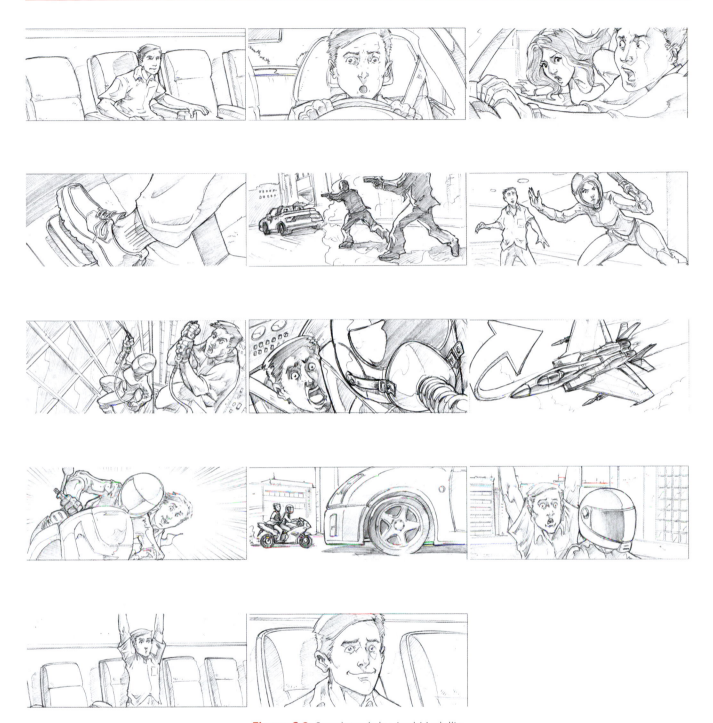

Figure S.8 Storyboards by Axel Medellin.

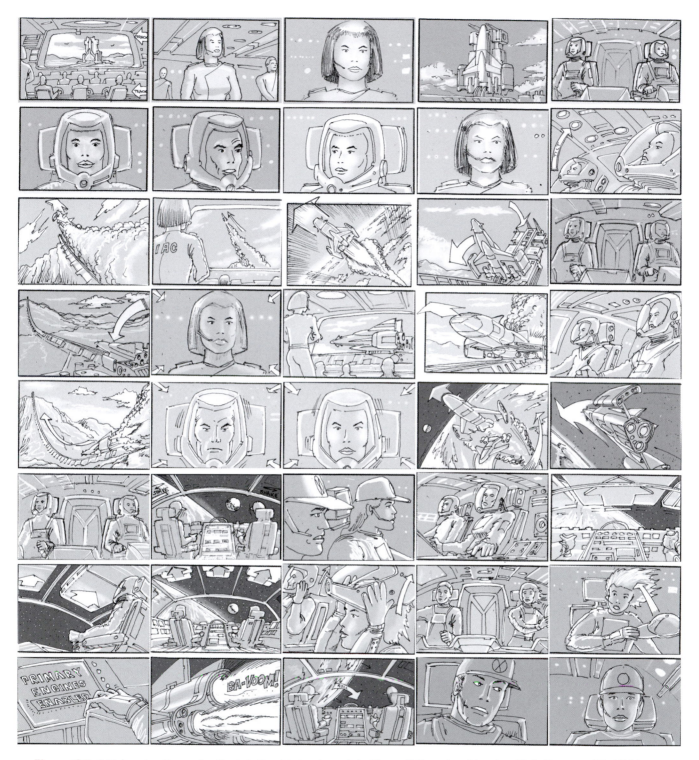

Figure S.9 British animation series *Captain Scarlet* storyboards by Tracey Wilson, Lee Munday, Chris Drew, and Teri Fairhurst.

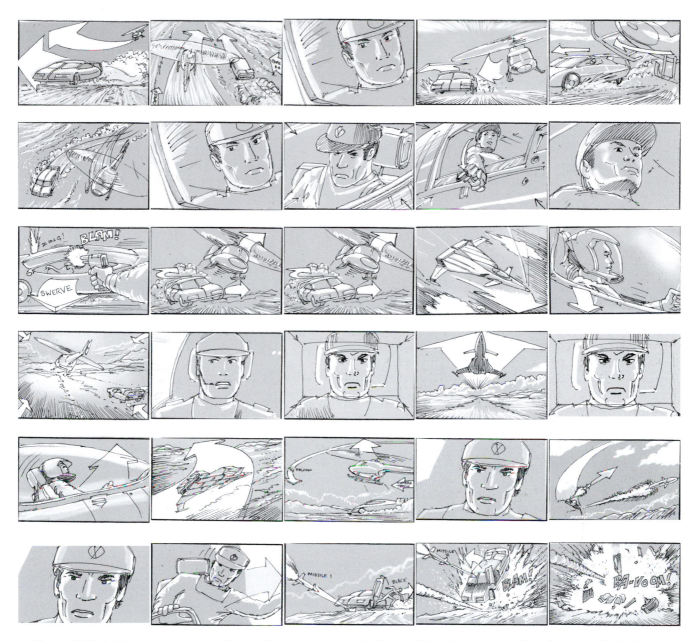

Figure S.10 British animation series *Captain Scarlet* storyboards by Tracey Wilson, Lee Munday, Chris Drew and Teri Fairhurst.

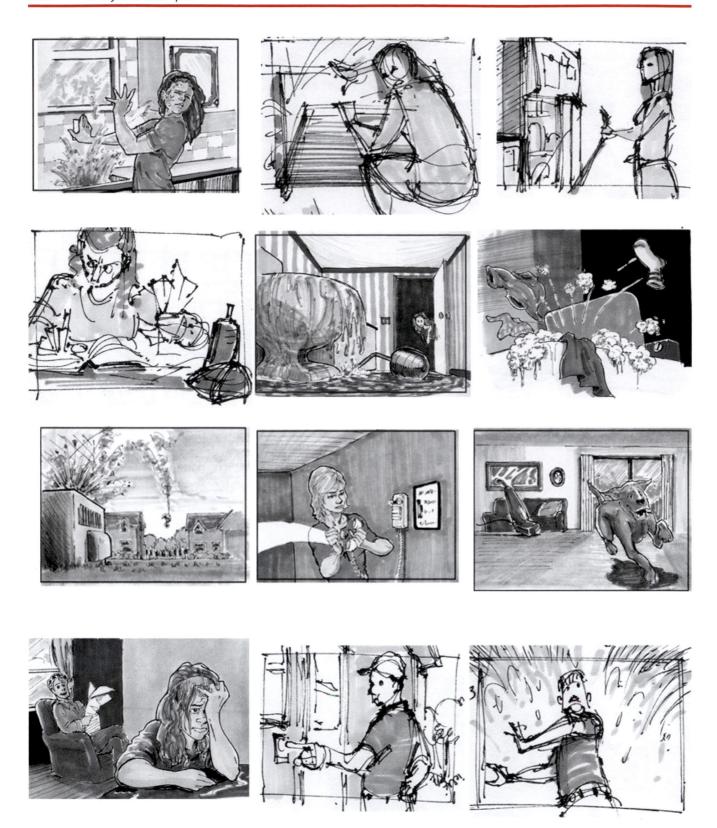

Figure S.11 Thumbnail storyboards by Dan Antkowiak for Animatics & Storyboards, Inc. Notice that some of the panels were already complete and copied from an earlier spot. There was no need to redraw them.

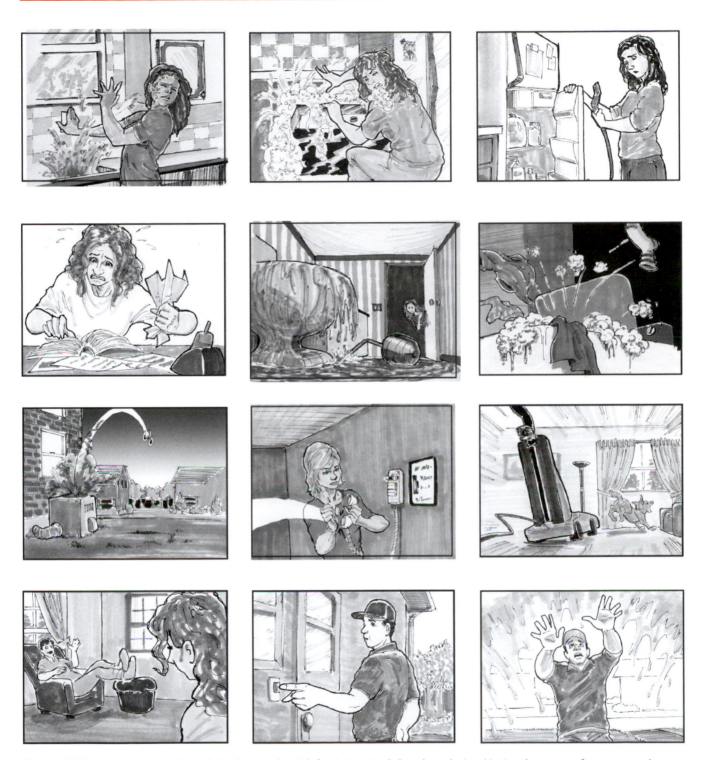

Figure S.12 Completed storyboards by Dan Antkowiak for Animatics & Storyboards, Inc. Notice there are a few camera changes from the thumbnails, requested by the client during approvals.

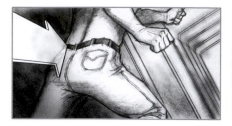

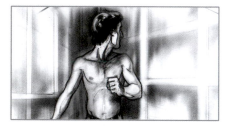

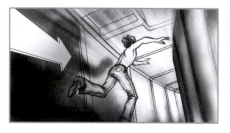

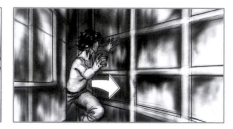

Figure S.13 Storyboards by J Parris.

Figure S.14 Storyboards by David Hillman of Hillman Arts.

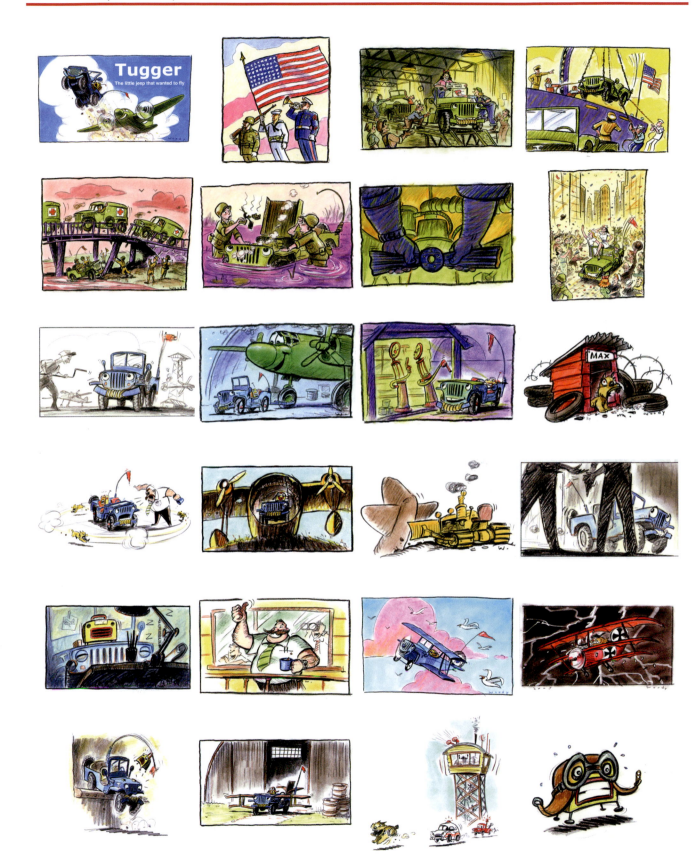

Figure S.15 *Tugger, The Little Jeep Who Wanted to Fly* beat boards by Woody Woodman, co-creator and director.

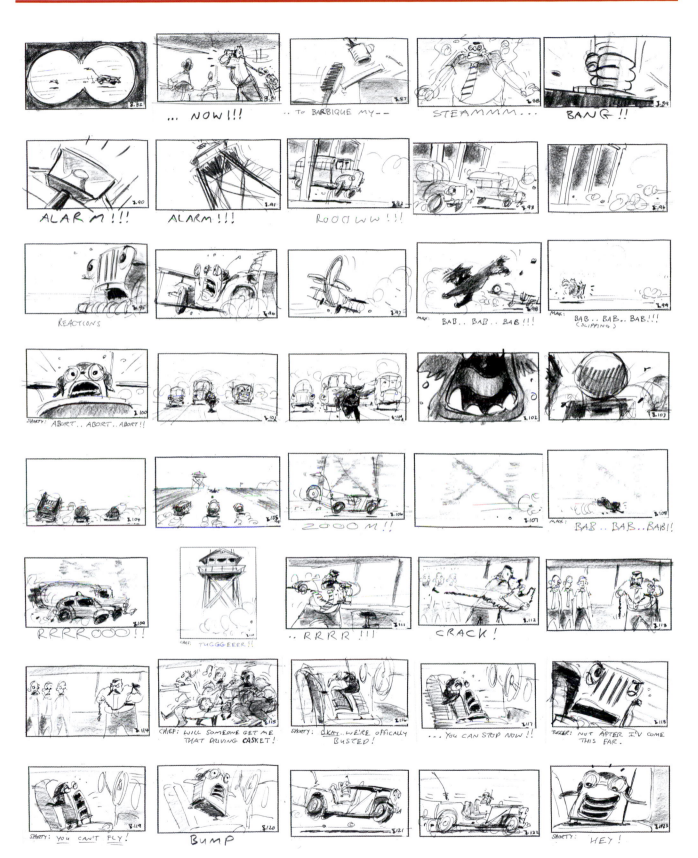

Figure S.16 *Tugger, The Little Jeep Who Wanted to Fly* production boards by Woody Woodman, co-creator and director.

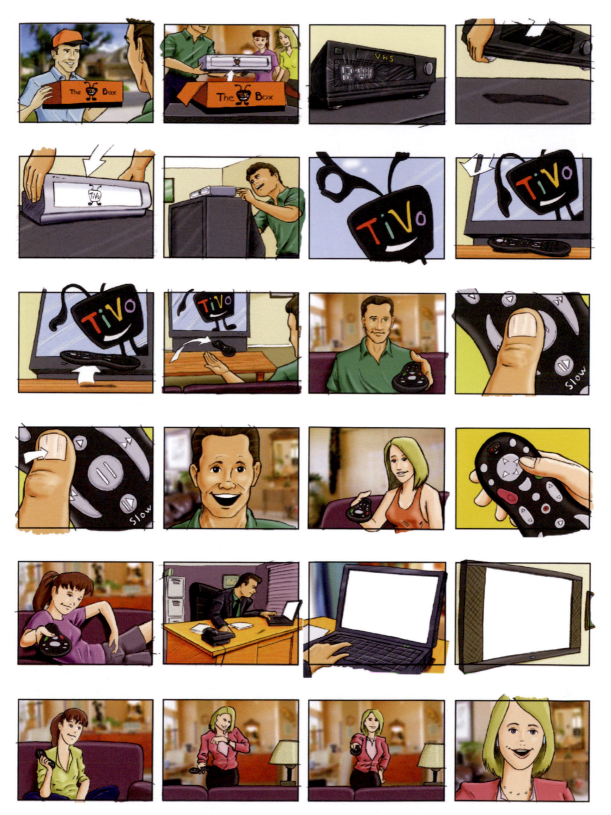

Figure S.17 TiVo agency pitch boards by Mark Simon of Animatics & Storyboards, Inc. The agency filled the blank monitors with their own images for the pitch.

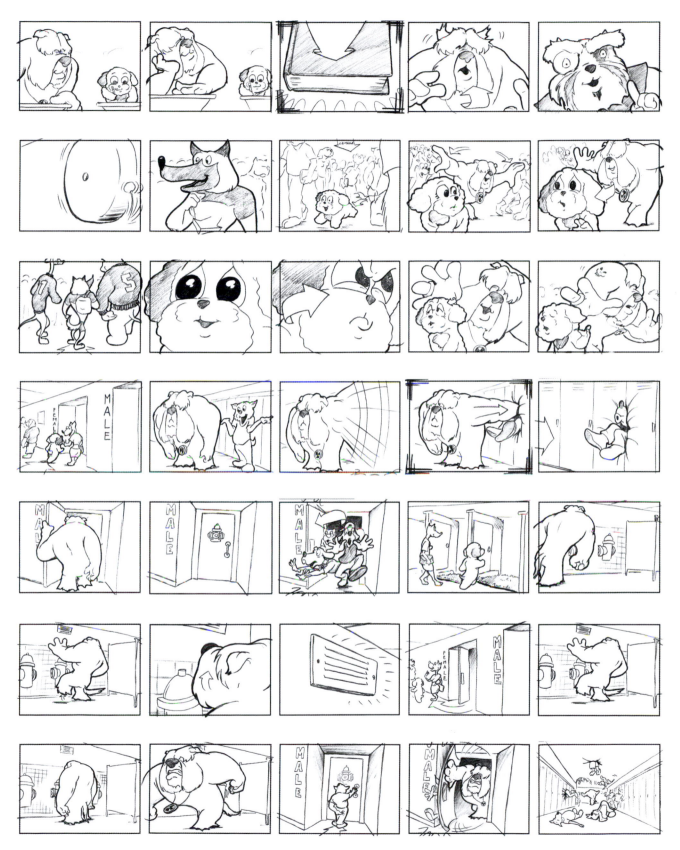

Figure S.18 *Howl High* animation pitch boards by Mark Simon. (© 2006 A&S Animation, Inc.)

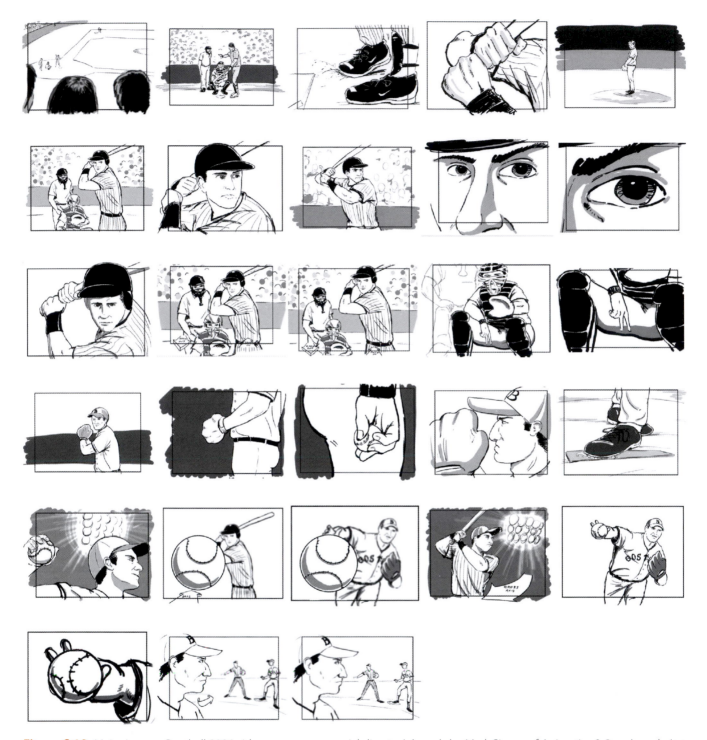

Figure S.19 Major League Baseball 2006 video game commercial director's boards by Mark Simon of Animatics & Storyboards, Inc.

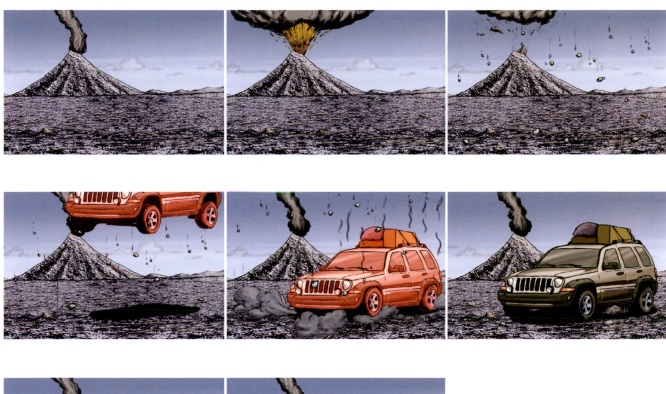

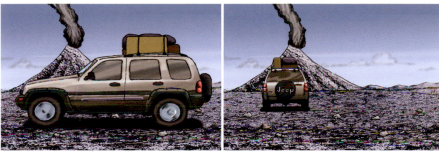

Figure S.20 BBDO Detroit Jeep animatic frames by Mark Simon of Animatics & Storyboards, Inc. Compliments of DaimlerChrysler Corporation.

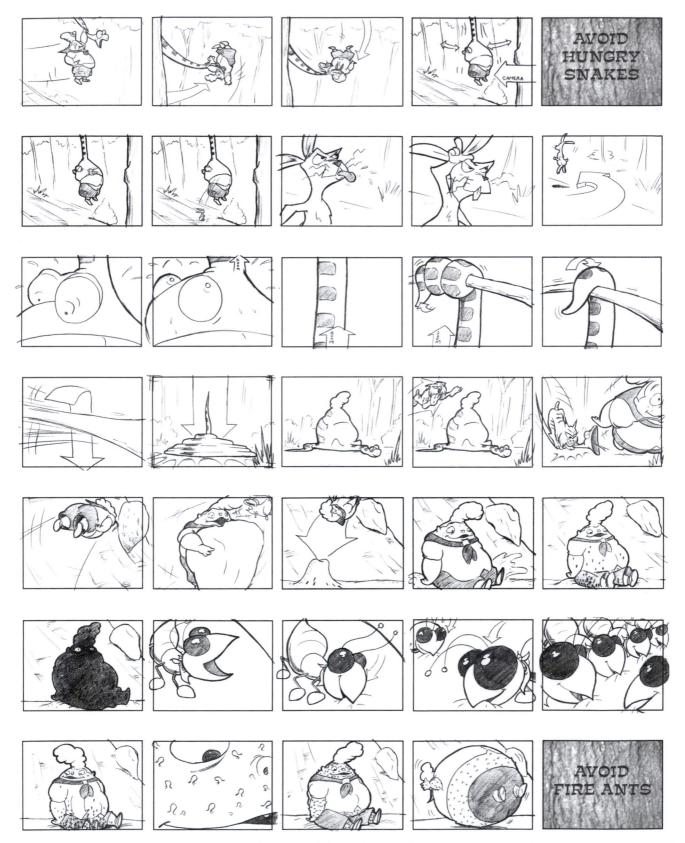

Figure S.21 *Timmy's Lessons in Nature* script and storyboards by Mark Simon for A&S Animation, Inc. (© 2006 A&S Animation, Inc.)

Figure S.22 Adidas commercial director's boards by Mark Simon of Animatics & Storyboards, Inc.

Figure S.23 *Santo Bugito* production boards for the episode "Carmen Tango." (© Klasky Csupo.)

Figure S.24 *The Brothers Flub*, episode "Guapos Galore." Storyboards by Wolverton of Animatics & Storyboards, Inc. (© Sunbow Entertainment.)

Figure S.25 UFO Encounter boards for a walk-through experience for Renaissance Entertainment by Mike Conrad of Radical Concepts, Inc.

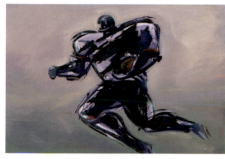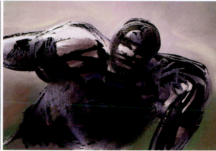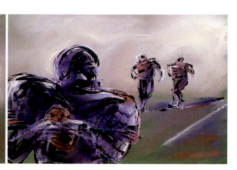
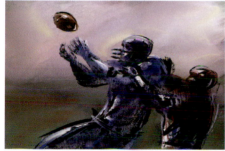

Figure S.26 Painter digital storyboards by John Ryan.

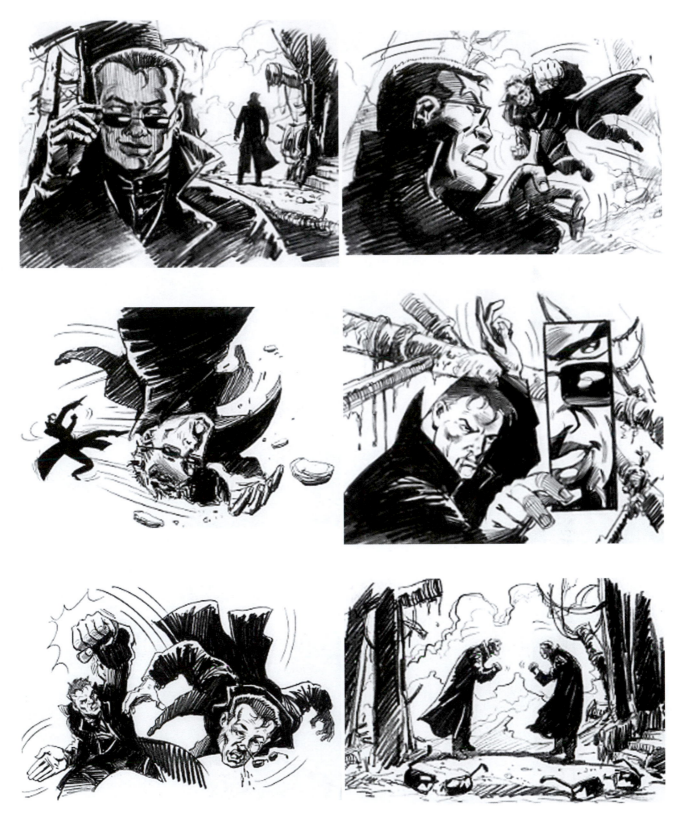

Figure S.27 Storyboards by German artist Ovi Hondru.

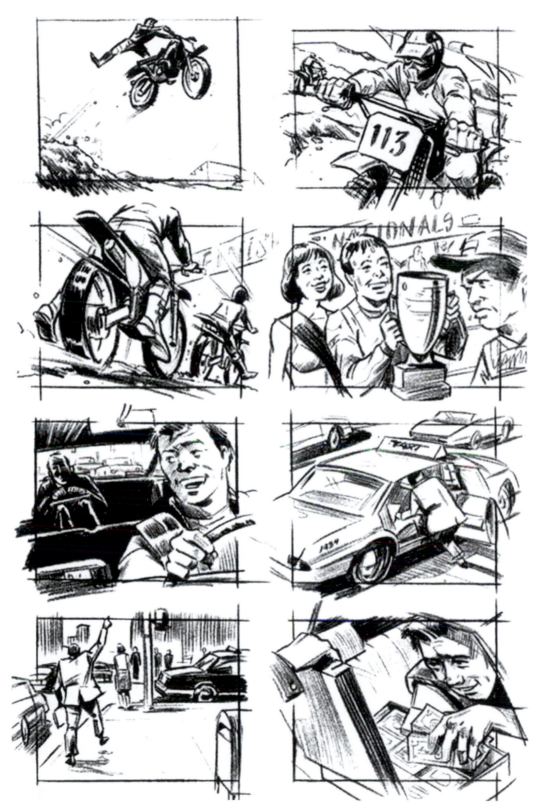

Figure S.28 Storyboards by Lyle Grant.

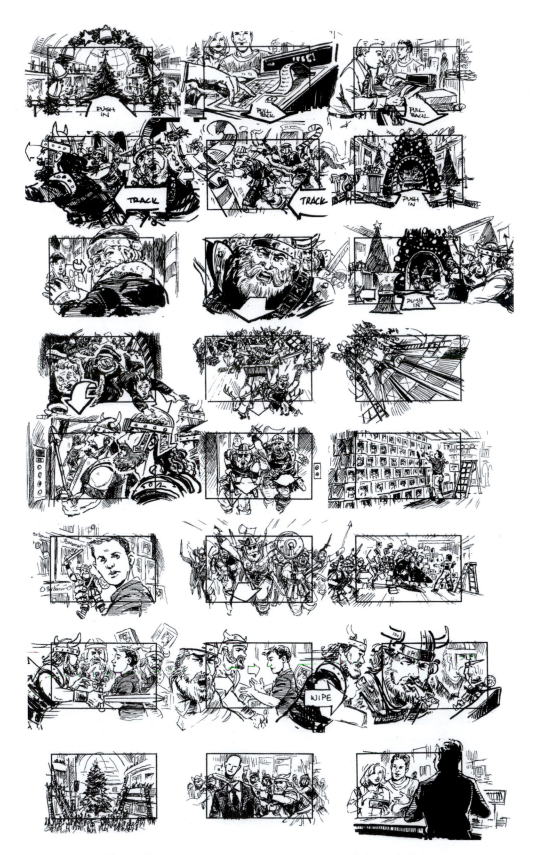

Figure S.29 Capital One commercial storyboards by Josh Hayes.

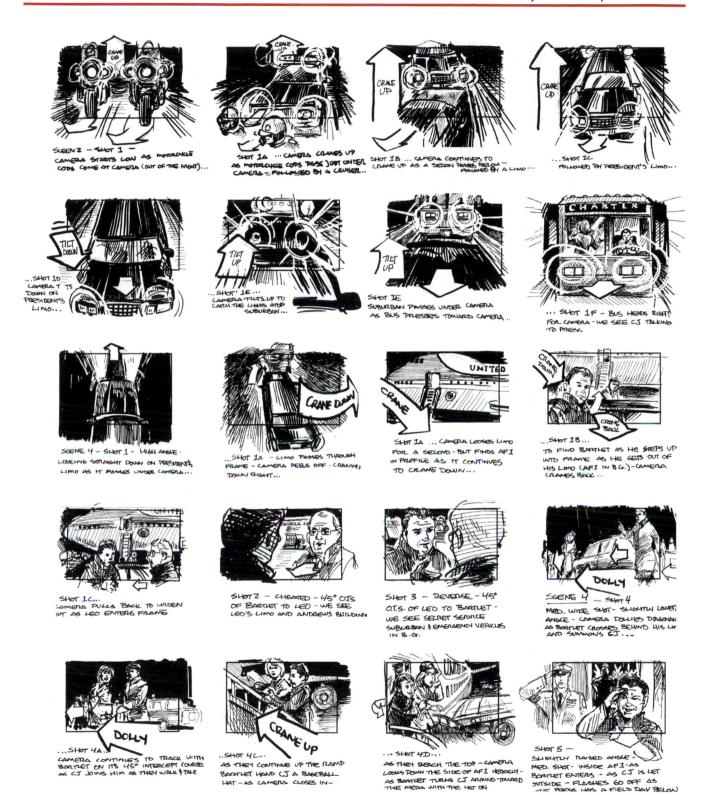

Figure S.30 *The West Wing* storyboards by Josh Hayes. (Courtesy of Warner Bros. All rights reserved.)

Figure S.31 *Cousin Kevin* pitch boards by Charlie Chiodo of Chiodo Bros. Productions, Inc.

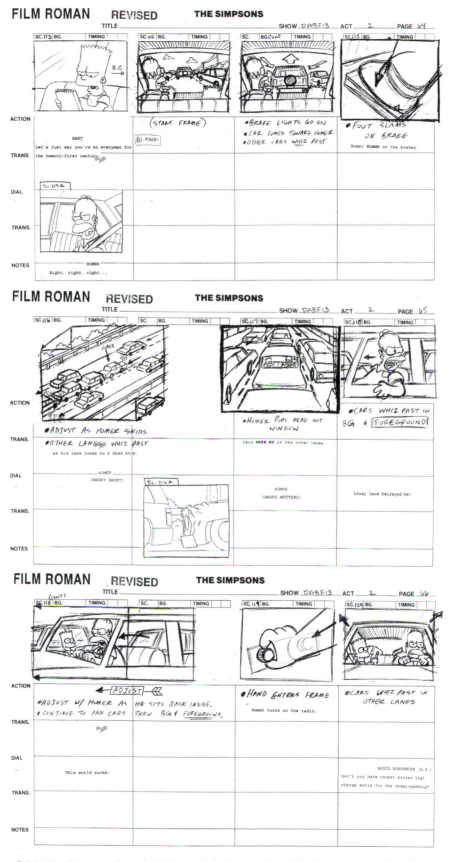

Figure S.32 *The Simpsons* boards. (© Twentieth Century Fox Film Corporation. All rights reserved.)

Figure S.33 Conceptual illustration by Mark Simon of Animatics & Storyboards, Inc. All the fireworks are photos comped into the image, as are the lampposts and the image projected on the screen.

Figure S.34 Concept art for a gaming video series, *The Gamer* by Mark Simon. The clouds and marble are photo textures manipulated to show roundness and depth. (© 2003 A&S Animation, Inc.)

Figure S.35 Concept art for a TiVo infomercial set by Mark Simon of Animatics & Storyboards, Inc.

Figure S.36 Concept art for *The Creepers* by Travis Blaise for Animatics & Storyboards, Inc. (© 2006 Lyons Entertainment, Inc.)

Glossary

There are a number of industry terms that you will be hearing as you work in the field of storyboarding and in most any area of filmmaking. Here is a list of the most common terms as they relate to drawing storyboards.

Aerial. Extremely high-angle shot, usually taken from a plane or helicopter.

Aspect ratio (Field ratio). The relationship of the horizontal dimension to the vertical dimension for any given film or tape format. For example, the aspect ratio for TV is 4 : 3; that is, a TV screen is 4 units wide by 3 units high.

BG (bg)—Background. Action or items behind the subject on which the camera is focusing.

Bird's-eye view. The camera is up high looking down.

Blocking. Action and positioning of the actors as determined by the director.

Boom up or down. This is where the camera moves vertically.

B-roll. Preexisting footage edited into a project.

Breakdowns (Breakdown a script). Drawn or written shot descriptions based on a script.

Camera shake. A jerking or shaking of the camera to simulate an earthquake, rumbling, turbulence, or impact.

Canted frame (Twisted, Chinese, or Dutch angles). The framing of the horizon is not parallel to horizontal. This is used to disorient the viewer or show that a character is out of sorts.

Cleanups. Finished pencil or ink over initial rough storyboards.

Cont. (Continued). Action or dialogue continues from one panel or scene to the next.

Continuity. An unbroken flow of actions and events.

Countering. Camera moving in the opposite direction to that of the subject.

Cover shot. *See* Master Shot

Crosscutting. Showing parallel action by alternating between shots of two or more scenes.

Cross-dissolve. One scene on the screen dissolves or fades into the next as a soft transition; used to slow the pace of a scene or show a transition in time.

Crossing the line. Placement of the camera in relation to the action and an invisible line, which when crossed causes the action to look like its direction has reversed. Action has crossed the line when the subject appears to go in the opposite direction in successive cuts. This happens when shot A shows the subject going from left to right on the screen and shot B shows the subject going from right to left.

CU—Close-up. This shot should include the tops of an actor's shoulders and head, with a little headroom.

Cut. Hard edit from one shot to the next.

Cutaway. *See* Insert.

Cycle. A repetition of animated drawings over time.

Deal memo. A letter or short contract stating employment terms.

Deep focus. Keeping the extreme foreground and the background in focus at the same time.

Depth of field. The distance from the camera lens that is in focus.

Diagonal. In animation, a tilted pan. In live action, a camera move up and to the side.

Dissolve. One scene on the screen dissolves or fades into the next as a soft transition; used to slow the pace of a scene or show a transition in time.

Dolly (truck or travel). This is the movement of the camera along a horizontal line. If the camera is to be mounted on a dolly, then the term *dolly* is most appropriate.

Double time. Double the pay per hour.

Downshot. Same as high angle and bird's-eye view.

ECU—Extreme close-up. Any extremely close shot of an actor or an object.

Establishing shot. A wide shot at the beginning of a scene to inform viewers of a new location and to orient them to the relative placement of characters and objects.

Fade in and Fade out. Fade from black to a scene and from a scene to black, respectively. Used in scripts as "begin" (fade in) and "end" (fade out).

FG (fg)—Foreground. Items or actors closer to the camera than other elements in the frame.

Field. The area inside the camera frame. In animation terms, a field is a measurement term 1 inch wide by ¾ of an inch. A normal television frame is 12 field, or 12 inches wide by 9 inches high.

Field in. To zoom the camera closer to the animation.

Flash cut (Flash frame). Extremely brief shot, sometimes only one frame. Used as an effect, such as a white frame, for a gunshot or lighting effect.

Focus pull (Follow focus). Refocusing the lens to follow a character or object.

Follow shot. A truck pan or zoom that follows a moving subject.

Footage. The length of an actual piece of 35 mm film used to describe a length in time. A 1.5-foot scene equals 24 frames and one second of screen time.

Full shot. Head-to-toe framing of a subject.

Golden time. Double the pay per hour.

HA—High angle (bird's-eye view). The camera is up high looking down.

Halftone. A digitized version of a photo or piece of art that breaks the image into very tiny dots that print and reproduce very well. Newspaper photos are halftones.

Headroom. Amount of space between the top of an actors head and the top of the frame.

Horizon. The horizontal line in the distance where the sky meets the ground.

Insert (Cutaway). A close shot of some article or minute action that is edited into the scene and that supports the main action. For example: There is an alert at an army base and guards are trying desperately to maintain control. During all the commotion there may be cutaways of flashing lights or of a finger flipping a switch.

Intercut. Cutting back and forth between two scenes.

Jump cut. Shots that appear to jump out of proper continuous time. For example, a single camera shot with a portion of that shot edited out, which makes the characters seem to jump to new positions without warning or reason.

LA—Low angle (worm's-eye view). The camera is down low looking up.

Layout. The visual design of a scene.

Lead space. The amount of room between the front of an actor and the side of the frame.

Line of action. Same idea as *screen direction,* but it represents an invisible line that the camera cannot cross without looking like the action reversed (called *crossing the line*). The direction a character has to look to another actor or the direction a character needs to move to look like he or she is continuing toward the same goal.

Live-action. A scene filmed with live actors.

Local (as in "a local"). A crew member who will work in a city where he or she does or doesn't live and still charge a local rate. In other words, the person is not taking an extra fee for mileage, hotel, or per diem.

Locked-off camera. The camera is stabilized for a steady shot. Often used for effects shots where multiple images are to be combined.

Loose. A shot composition where there is plenty of space around the subject.

LS—Long shot. The use of a long lens to show action far away.

Main unit (First unit). The production crew that shoots the bulk of a production, including most of the actors' dialogue, with the director overseeing each shot.

Master shot (Cover shot). A viewpoint wide enough to establish the physical relationships between the characters and close enough to understand all the action.

Match cut. A transition between scenes. A movement in one shot lines up and matches another movement in the next shot.

MCU—Medium close-up. The proper definition is: tight enough so that the top and bottom of the head are cut out of the frame, or tighter than a close-up. Some directors and producers use this term to mean: a little *wider* than a close-up. Should an MCU come up in the storyboarding process, make sure you define it.

Montage. A short portion of a story where a number of short, related elements are edited together to show background or the passage of time.

Morgue. A file or collection of reference photos.

Morph. The changing of an object from one form into another. For example, a lazy character could be shown to morph into an eggplant.

Motivated shot. A shot dictated by the action of the previous shot. For example, a woman looks up in one shot and the motivated shot would be her POV of the moon.

MS—Medium shot. Shows a character from the waist up.

OL—Overlay. Animation term meaning a portion of a drawing that is on the uppermost level of animation, allowing action to happen behind it.

OS (OC)—Offstage or Off camera. This is when dialogue, sound effect, or action takes place beyond the view of the camera shot.

OTS—Over the shoulder. When the camera is looking from just behind and over the shoulder of an actor.

Overtime. Time and a half pay per hour, normally after 8 hours of work.

Pan. The camera is stationary and rotates in one direction, left or right, on an axis.

Panel. One frame or illustration of a storyboard.

Per diem. An amount of money paid to crew members for every day in a production they stay in a city other than where they live. This money is meant to cover the cost of food, primarily.

Photo boards. A storyboard generated using stock or custom photos; usually made by agencies for presentations.

Plot Plan. Overhead view or blueprint of a location or set.

POV—Point of view (Subjective shot). The viewer sees what the actor would be seeing.

Principal photography. The main photography of a film.

Pull back. Zoom or dolly back to a wider shot.

Rack focus. The camera starts its focus on one subject and changes focus to another subject.

Reaction shot. One character listening or reacting to another character or event.

Reverse angle (Shot). A shot that is 180° opposite the preceding shot.

Roughs. Unfinished sketches of a storyboard used to lay out the scene and get approvals.

Rule of thirds. A design rule that breaks a frame into vertical and horizontal thirds and then places the main subject at the intersections of the lines.

SA—Same action. An animation term describing a portion of the frame that does not change or move over consecutive storyboards.

Scene. In classic 2D animation, a scene is one shot on one background. In CG and live action, a scene comprises all the shots in one location at one point in time.

Screen direction. The direction a character has to look to another actor or the direction a character needs to move to look like he or she is continuing toward the same goal.

Second unit. Secondary crew of a film shoot. Usually shoots effects, stunts, or cutaways.

Sequence. A collection of shots and/or scenes that tells one portion of a story.

Setup. Each choice or setup of a camera angle.

Index